PANACHE **DIRECTORY**
dallas

RECOMMENDED
PROFESSIONALS,
PRODUCTS
AND SERVICES

CLOSETS AND STORAGE

CALIFORNIA CLOSETS®

California Closets
Brian Honeyman
4441 Lovers Lane
Dallas, TX 75225
(214) 351-1000
Bhoneyman@Calclosetsdfw.com
www.calclosets.com

WINDOW TREATMENTS AND DRAPERIES

'Curtain Couture'

Curtain Couture
Mary Ann Young
17390 Preston Road, Suite 280
Dallas, TX 75252
(972) 267-2200
windows@curtaincouture.com
www.curtaincouture.com

LIGHTING

SOLARA
LIGHTING
IRONWORKS

Solara Lighting
Malena Gutierrez
142 Howell Street
Dallas, TX 75207
(214) 744-9900
Mtgutierrez@solara.tv
www.solaralighting.com

The **PANACHE DIRECTORY** is an exclusive collection of elite professionals-professionals recommended as the best-of the-best by their clients and peers alike. Selected for their outstanding craftsmanship and unbeatable service, these professionals have a reputation for setting the bar in their respective trades; for delivering exceptional quality in every detail of every job.

Visit **WWW.PANACHEDIRECTORY.COM** to view more information on these elite, talented professionals

PANACHE

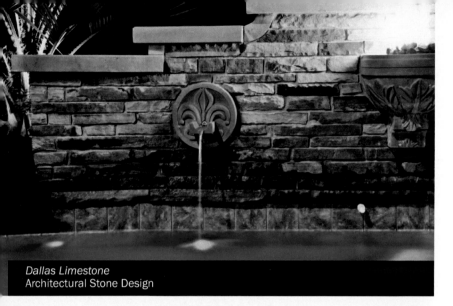

Dallas Limestone
Architectural Stone Design

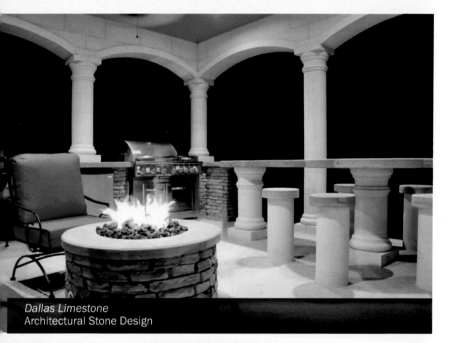

Dallas Limestone
Architectural Stone Design

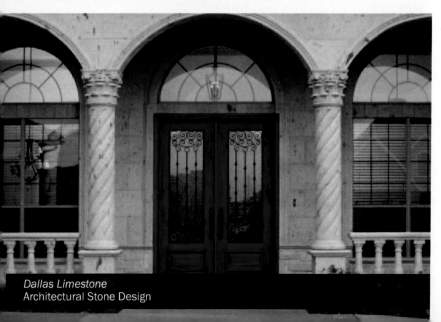

Dallas Limestone
Architectural Stone Design

The Panache Directory is an exclusive

collection of elite professionals-professionals

recommended as the best-of-the-best by their

clients and peers alike. Selected for their

outstanding craftsmanship and unbeatable service,

these professionals have a reputation for setting

the bar in their respective trades; for delivering

exceptional quality in every

detail of every job.

Visit **WWW.PANACHE.COM** to see our complete portfolio of award-winning coffee table books.

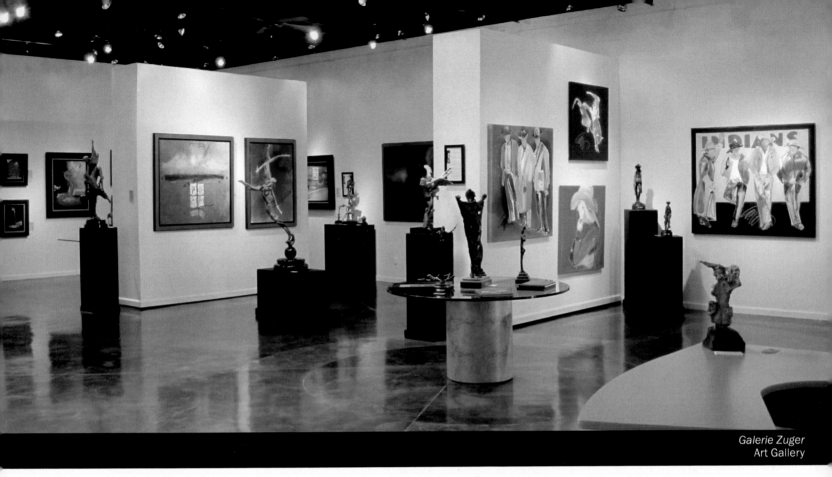

Galerie Zuger
Art Gallery

APPLIANCES

Morrison
Jon Day
1331 East Plano Parkway
Plano, TX 75074
(972) 309-0521
jrday@morsco.com
www.morsco.com

MORRISON

Jon Day
5001 North Bryant Irvin Road
Fort Worth, TX 76107
(817) 259-0920
jrday@morsco.com
www.morsco.com

ARCHITECT

Ikemire Architects, LLC
Ross Ikemire, AIA
16660 Dallas Parkway, Suite 2900
Dallas, TX
(972) 248-2486100
ross@ikemirearchitects.com
www.ikemirearchitects.com

ARCHITECTUAL STONE DESIGN

Dallas Limestone
Israel Juarez
12904 Eastgate Drive, Suite D
Mesquite, TX 75181
(972) 203-9816
sales@dallaslimestone.com
www.dallaslimestone.com

ARCHITECTURAL INTERIOR DESIGNERS

Jacquelyn Narrell Architectural Interior Design
Jacquelyn Narrell
Dallas, TX 75028
(214) 686-1955
jacque@grandecom.net

ART GALLERY

Galerie Zuger
Robert Wilborn
1215 Dragon Street
Dallas, TX 75207
(214) 749-7713
info@galeriezugerdallas.com
www.galeriezugerdallas.com

Visit **WWW.PANACHEDIRECTORY.COM** to view more
information on these elite, talented professionals

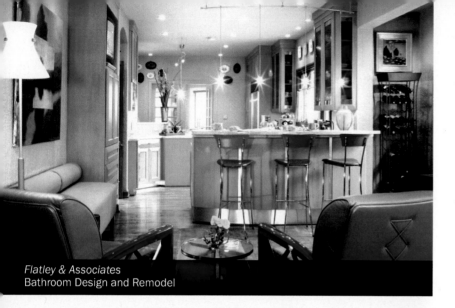

Flatley & Associates
Bathroom Design and Remodel

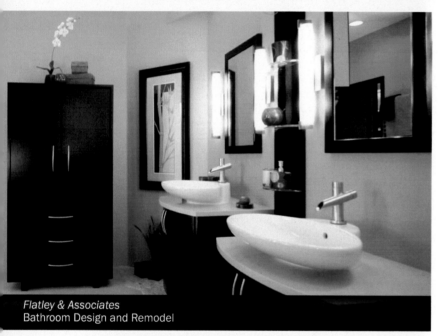

Flatley & Associates
Bathroom Design and Remodel

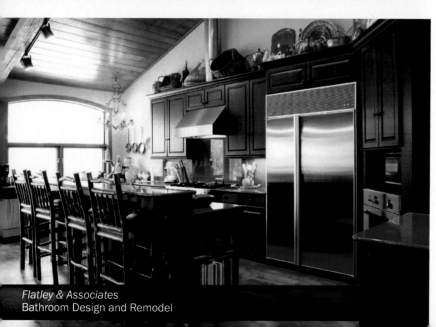

Flatley & Associates
Bathroom Design and Remodel

BATHROOM DESIGN AND REMODEL

Flatley & Associates
Sharon Flatley, CMKBD, ASID
Dallas, TX 75240
(972) 392-3536
sharon@flatleyinteriors.com
www.flatleyinteriors.com

CARPETS

Truett Fine Carpets & Rugs
David Truett
1444 Oaklawn Avenue, Suite #220
Dallas, TX 75207
(214) 748-7550
david@truettcarpetandrugs.com
www.truettcarpetsandrugs.com

CLOSETS AND STORAGE

California Closets
Brain Honeyman
4441 Lovers Lane
Dallas, TX 75225
(214) 351-1000
Bhoneyman@Calclosetsdfw.com
www.calclosets.com

CUSTOM FURNITURE

J Martin Studios LLC
John Martin
2528 Farrington
Dallas, TX 75207
(214) 951-0615
johnmartininc@me.com

Signature
Jeramy Bede
550 Parker Road
Wylie, TX 75098
jeramybede@verizon.net
www.signaturefinefurniture.com

DOORS

Solara Lighting
Malena Gutierrez
142 Howell Street
Dallas, TX 75207
(214) 744-9900
Mtgutierrez@solara.tv
www.solaralighting.com

Visit **WWW.PANACHE.COM** to see our complete portfolio of award-winning coffee table books.

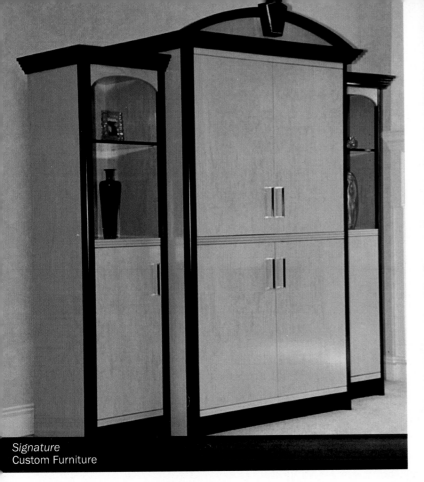

Signature
Custom Furniture

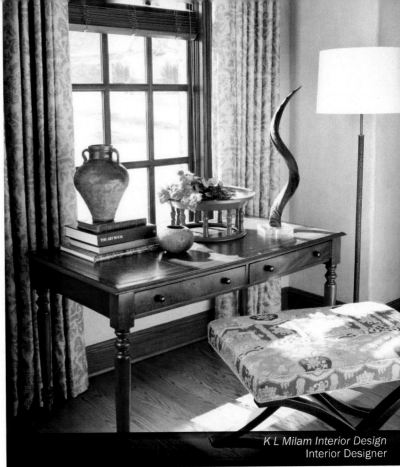

K L Milam Interior Design
Interior Designer

Morrison
Jon Day
5001 North Bryant Irvin Road
Fort Worth, TX 76107
(817) 259-0920
jrday@morsco.com
www.morsco.com

HOME AUTOMATION

Elliston Systems & Design
Steve Elliston
2360 Irving Boulevard
Dallas, TX 75207
(214) 226-9525office
steve@ellistonsystems.com
www.ellistonsystems.com

HOME BUILDER AND REMODELING CONTRACTOR

Beth A. Borden Construction, Inc.
Beth A. Borden
Plano, TX 75093
(972) 971-8027
bbordenconstruct@gmail.com
www.bethbordenconstruction.com

Key Renovations
Bob/Kevin Holte/Key
14540 East Beltwood Parkway, Suite 500
Farmers Branch, TX 75244
(214) 716-0300
info@keyrenovations.com
www.keyrenovations.com

HOME DECOR

Cory Pope & Associates
Cory Pope
150 Turtle Creek Blvd, Suite 205
Dallas, TX 75207
(214) 981-9119
cory@corypope.com
www.corypope.com

Jim Bagwell Associates
Kevin Nichols
171 Oaklawn Avenue
Dallas, TX 75207
(214) 747-3350
kevin@jimbagwell.com
www.jimbagwell.com

Visit **WWW.PANACHEDIRECTORY.COM** to view more
information on these elite, talented professionals

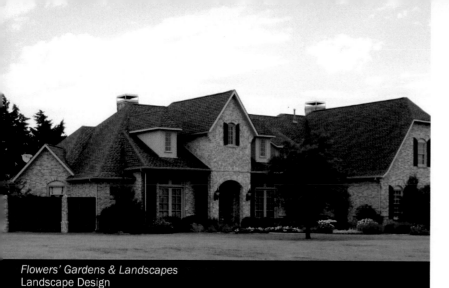

Flowers' Gardens & Landscapes
Landscape Design

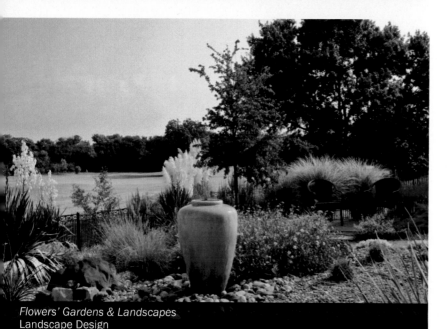

Flowers' Gardens & Landscapes
Landscape Design

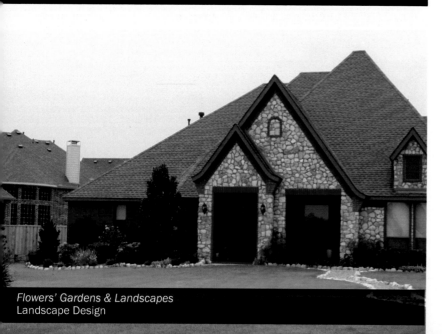

Flowers' Gardens & Landscapes
Landscape Design

INTERIOR DESIGNER

Cheri Etchelecu Interior Design
Cheri Etchelecu
12720 Hillcrest Road, Suite 380
Dallas, TX 75230
(972) 980-1700
cheri@ceid.net

Cory Pope & Associates
Cory Pope
150 Turtle Creek Blvd, Suite 205
Dallas, TX 75207
(214) 981-9119
cory@corypope.com
www.corypope.com

Joanie Wyll & Associates, Inc.
Joanie Wyll, ASID
12740 Hillcrest Road, Suite 160
Dallas, TX 75230
(972) 380-8770
joanie@wyllinteriordesign.com
www.wyllinteriordesign.com

K L Milam Interior Design
Kim Milam
(817) 266-3386
kim@klmilam.com
www.klmilam.com

KITCHEN DESIGN AND REMODEL

Flatley & Associates
Sharon Flatley, CMKBD, ASID
Dallas, TX 75240
(972) 392-3536
sharon@flatleyinteriors.com
www.flatleyinteriors.com

Visit **WWW.PANACHE.COM** to see our complete portfolio
of award-winning coffee table books.

LANDSCAPE DESIGN

Brumley Gardens
Chris Brumley
10540 Church Road
Dallas, TX 75238
(214) 343-4900
brumleygardens@aol.com
www.brumleygardens.com

Flowers' Gardens & Landscapes
Maribeth Flowers, APLD
Wylie, TX 75098
(972) 429-7707
maribeth@flowersgardenslandscapes.com
www.flowersgardenslandscapes.com

XL Land Systems
Chris Jamieson
6100 Bowfin Drive
Fort Worth, TX 75179
(877) 616-2296
chris@xllandsystems.com
www.xllandsystems.com

LIGHTING

Solara Lighting
Malena Gutierrez
142 Howell Street
Dallas, TX 75207
(214) 744-9900
Mtgutierrez@solara.tv
www.solaralighting.com

OUTDOOR KITCHENS AND FIREPLACES

Regenesis Design-Build
Ralph P. Stow
5960 West Parker Road, Suite 278-103
Plano, TX 75093
(888) 318-4753
ralph@regenesisdesignbuild.com
www.regenesisdesignbuild.com

Visit **WWW.PANACHEDIRECTORY.COM** to view more
information on these elite, talented professionals

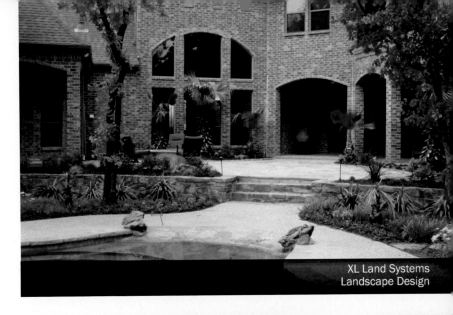

XL Land Systems
Landscape Design

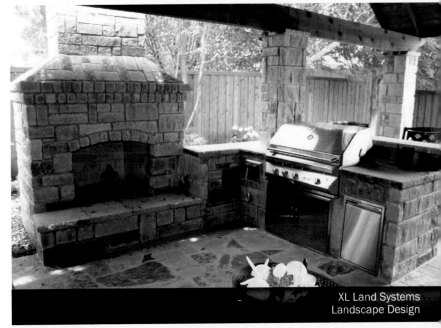

XL Land Systems
Landscape Design

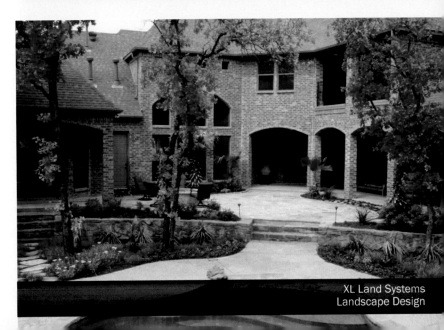

XL Land Systems
Landscape Design

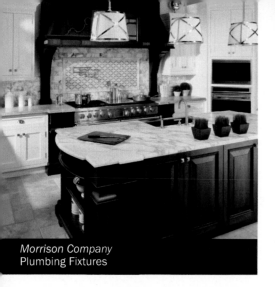

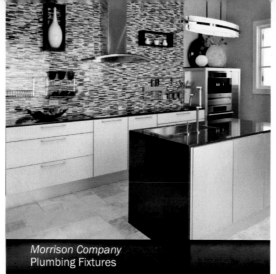

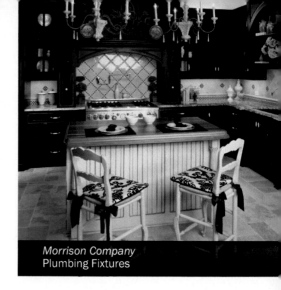

Morrison Company
Plumbing Fixtures

Morrison Company
Plumbing Fixtures

Morrison Company
Plumbing Fixtures

PLUMBING FIXTURES

Morrison
Jon Day
1331 East Plano Parkway
Plano, TX 75074
(972) 309-0521
jrday@morsco.com
www.morsco.com

Morrison
Jon Day
5001 North Bryant Irvin Road
Fort Worth, TX 76107
(817) 259-0920
jrday@morsco.com
www.morsco.com

RUGS

Truett Fine Carpets & Rugs
David Truett
1444 Oaklawn Avenue, Suite #220
Dallas, TX 75207
(214) 748-7550
david@truettcarpetandrugs.com
www.truettcarpetsandrugs.com

SECURITY ALARM SYSTEMS

Apex Protection Services LLC
Shane Turner
Garland, TX 75043
(972) 303-9111
shane@apexprotectionservices.com
www.apexprotectionservices.com

WINDOW TREATMENTS AND DRAPERIES

Curtain Couture
Mary Ann Young
17390 Preston Road #280
Dallas, TX 75252
(972) 267-2200
windows@curtaincouture.com
www.curtaincouture.com

WROUGHT IRON

D'Hierro
Rocio Perez
Southlake Town Center, 1466 Main Street
Southlake, TX 76092
(817) 310-3321
Rocio@Dhierro.com
www.dhierro.com

D'Hierro
The Shops At Legacy, 7300 Lone Star Drive C145
Plano, TX 75024
(972) 943-9924
Rocio@Dhierro.com
www.dhierro.com

Visit **WWW.PANACHE.COM** to see our complete portfolio
of award-winning coffee table books.

FABRIC PROTECTION

Fiber-Seal
Rose Ann Wray
9865 Chartwell Drive
Dallas, TX 75243
(972) 889-8807
rwray@fiberseal.com
www.fiberseal.com

FLORAL DESIGNER

Jim Bagwell Associates
Kevin Nichols
171 Oaklawn Avenue
Dallas, TX 75207
(214) 747-3350
kevin@jimbagwell.com
www.jimbagwell.com

FULL SERVICE REMODELING

Regenesis Design-Build
Ralph P. Stow
5960 West Parker Road, Suite 278-103
Plano, TX 75093
(888) 318-4753
ralph@regenesisdesignbuild.com
www.regenesisdesignbuild.com

FURNITURE

D'Hierro
Rocio Perez
Southlake Town Center, 1466 Main Street
Southlake, TX 76092
(817) 310-3321
Rocio@Dhierro.com
www.dhierro.com

D'Hierro
The Shops At Legacy, 7300 Lone Star Drive
C145
Plano, TX 75024
(972) 943-9924
Rocio@Dhierro.com
www.dhierro.com

Visit **WWW.PANACHEDIRECTORY.COM** to view more
information on these elite, talented professionals

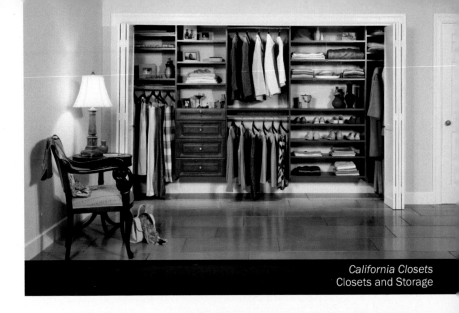

California Closets
Closets and Storage

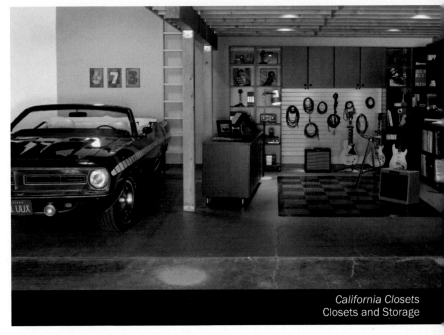

California Closets
Closets and Storage

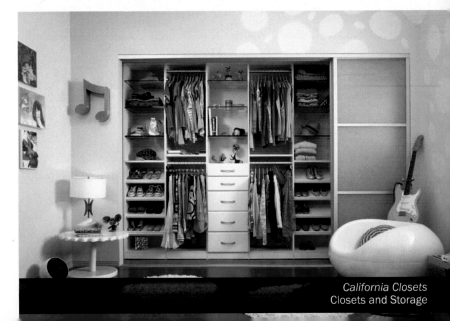

California Closets
Closets and Storage

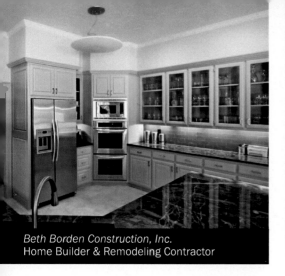
Beth Borden Construction, Inc.
Home Builder & Remodeling Contractor

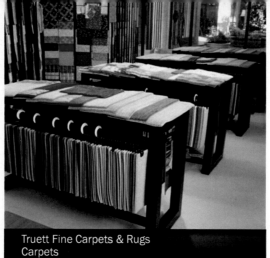
Truett Fine Carpets & Rugs
Carpets

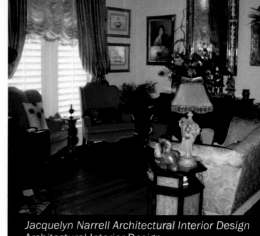
Jacquelyn Narrell Architectural Interior Design
Architectural Interior Design

GAME ROOMS

Billiard Factory
1803 Airport Freeway West
Euless, TX 76040
(817) 355-1355
bfonline@billiardfactory.com
www.billiardfactory.com

Billiard Factory
2061 South Stemmons Freeway
Lewisville, TX 75067
(972) 434-4434
bfonline@billiardfactory.com
www.billiardfactory.com

Billiard Factory
2080 North Collins Blvd.
Richardson, TX 75080
(972) 234-4697
bfonline@billiardfactory.com
www.billiardfactory.com

Billiard Factory
8202 State Highway 121
Frisco, TX 75034
(972) 712-4232
bfonline@billiardfactory.com
www.billiardfactory.com

HANDYMAN SERVICES

Andy OnCall Handyman Service
Stephen Scannell
3415 Custer Road, Suite 127
Plano, TX 75023
(972) 312-8009
email@helpmeandy.com
www.andyoncall.com/dallasplano-tx/

HARDWARE

Morrison
Jon Day
1331 East Plano Parkway
Plano, TX 75074
(972) 309-0521
jrday@morsco.com
www.morsco.com

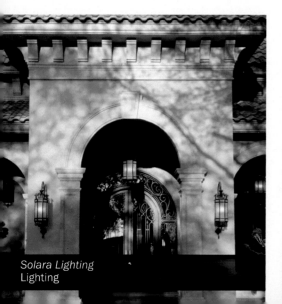
Solara Lighting
Lighting

Joanie Wyll & Associates, Inc.
Interior Design

Apex Protection Services LLC
Security Alarm Systems

Beautiful Homes
of Texas

A COLLECTION OF THE FINEST DESIGNERS IN TEXAS
by Jolie Carpenter

Published by

SIGNATURE
PUBLISHING GROUP

13747 Montfort Drive, Suite 100
Dallas, Texas 75240
972.661.9884
f: 972.661.2743
www.spgsite.com

Publisher: Brian G. Carabet
Publisher: Jolie M. Carpenter
Associate Publisher: Karla Setser
Art Director: Michele Cunningham-Scott
Designer: Ben Quintanilla
Editor: Sarah Toler

Printed in Malaysia

Distributed by Independent Publishers Group
800.888.4741

PUBLISHER'S DATA

Beautiful Homes of Texas

Library of Congress Control Number: 2007920189

ISBN - 13: 978-0-9792658-1-5
ISBN - 10: 0-9792658-1-9

First Printing 2007

10 9 8 7 6 5 4 3 2 1

Previous Page: Toni McCallister, McCallister Designs
See page 301 Photograph by Swain Edens

This Page: Julie Evans, JEI Designs, Inc
See page 23 Photograph by Mark Knight

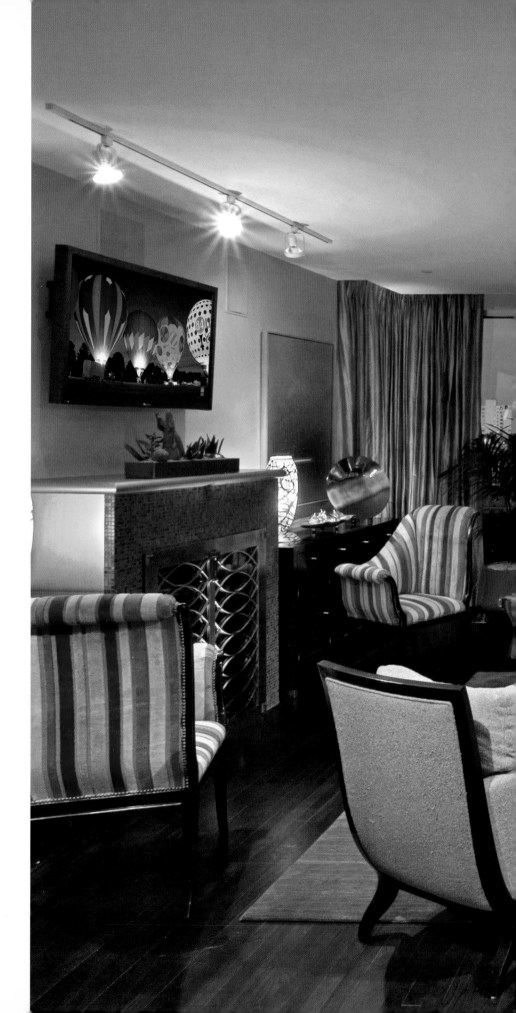

Beautiful Homes
of Texas

A COLLECTION OF THE FINEST DESIGNERS IN TEXAS
by Jolie Carpenter
with Sarah Toler

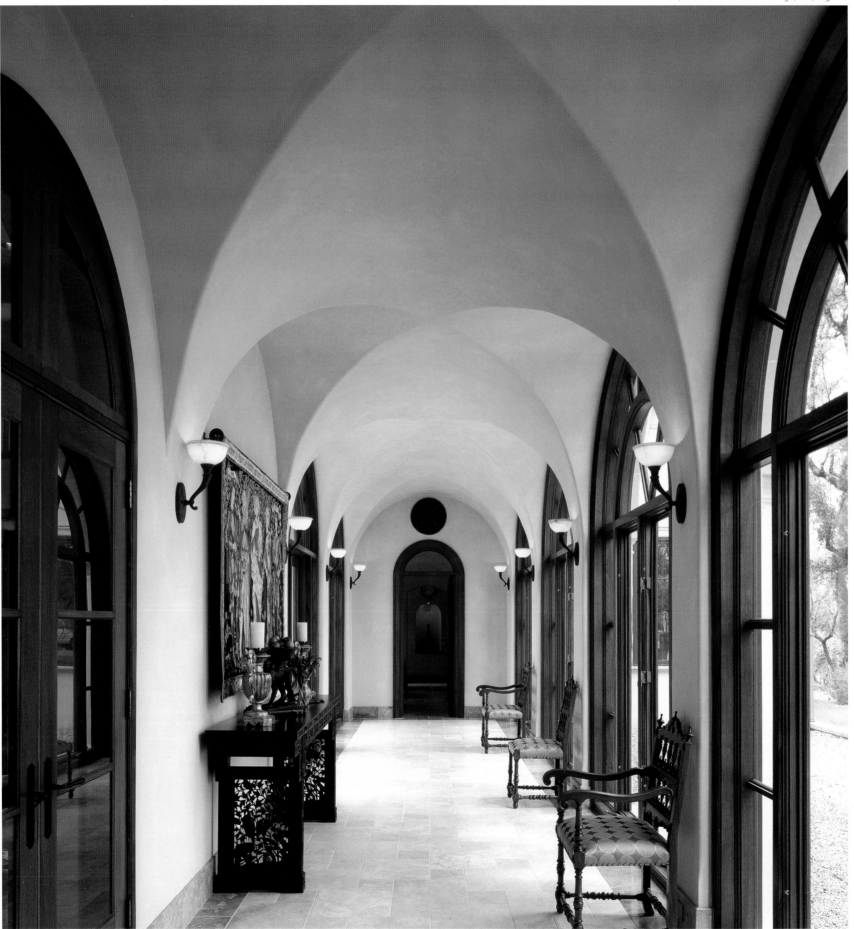

TABLE OF CONTENTS

INTRODUCTION

Thank you to all the decorators and designers who trusted in my vision for this second-edition book and allowed your beautiful work to grace the pages of what is now the largest book our publishing group has ever produced to date. A special thank you to my friend and colleague Karla Setser, who helped me identify the professionals featured in this beautiful collection.

Each chapter is lavishly illustrated with photos that feature beautiful furniture, art and a wealth of other luxurious interior furnishings. Whether it's the designer's home or that of a client, the photographs define exemplary decorating and design excellence. There is something for all to appreciate, from a breathtaking French-style mansion in Houston to a contemporary and sophisticated high-rise penthouse overlooking the Dallas skyline.

A home is not truly beautiful unless it's filled with love, whether that's the love of an art collection, the love of entertaining family and friends or the love of antique furniture. In my home, love is in the moments spent with friends I adore, who inspire my creativity and bring me peace; the smell of my golden retriever's head when I lean down to kiss him; the sound of laughter over wine with my girlfriends and the feeling of soft cotton sheets. I encourage you to surround yourself with whatever material comforts that bring you joy, and also with cherished friends and family who make a home truly beautiful. On the following pages, you will find plenty of inspiration to motivate the decorator in you to make your home truly beautiful.

All the best,

Jodie Carpenter

Photograph by Emily Kattan

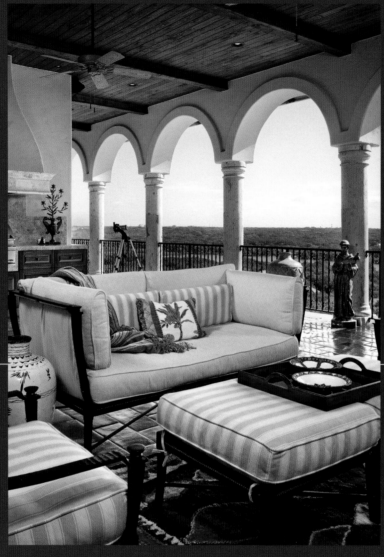

DESIGNER: Sandy Senter, Senter Construction and Design, *Page 67*

AUSTIN

AN EXCLUSIVE SHOWCASE OF AUSTIN'S FINEST DESIGNERS

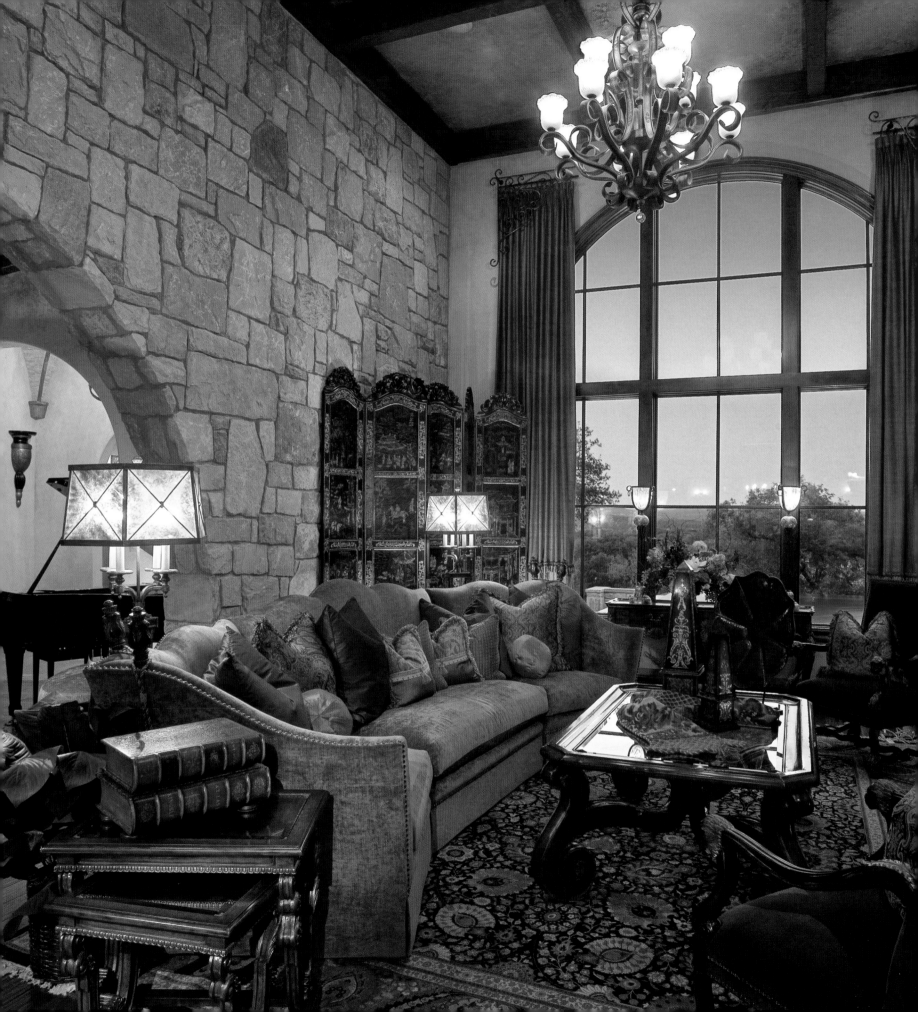

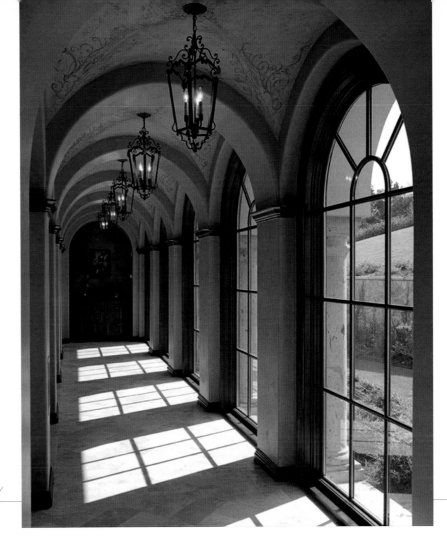

David Bravo

BRAVO INTERIOR DESIGN, LLC

Celebrating the recent opening of his firm, David Bravo has captured the imagination and loyalty of a growing clientele. After graduating from the University of Texas at Austin, David began his innovative career in the design industry more than 17 years ago. Flourishing as a top designer in the Austin area, David has gathered an impressive portfolio of both residential and commercial projects ranging from Old World to soft Contemporary.

David's work can be seen across the country, including projects in San Diego, Las Vegas and a spectacular mountain-top home in Colorado with views for miles. But, you can tell that David is a true Texas designer by his desire for excellence. "The philosophy that drives my firm is to always design beyond my clients' expectations." With sophisticated architectural features, David leaves no detail to chance, creating a signature sensory experience, combining both the rural and refined.

Capable of a gallery of styles, David's signature approach and juxtaposition of elegant and rustic elements have won him rave reviews in publications such as *Austin Home & Living* and *Austin House & Home*. His work has also been showcased in several Austin Symphony and Home Builders Association showhouses, earning him much deserved recognition.

ABOVE:
Natural light infuses the arched hallway of a Tuscan-style, waterfront home.
Photograph by Tom McConnell

FACING PAGE:
From ceiling to floor, every detail reinforces the European countryside ambience. The design was featured in the 2006 Parade of Homes.
Photograph by Mark Knight

BRAVO INTERIOR DESIGN, LLC
David Bravo, Allied Member ASID
4412 Spicewood Springs Road, Suite 101
Austin, TX 78759
512.372.0700
f: 512.372.0702

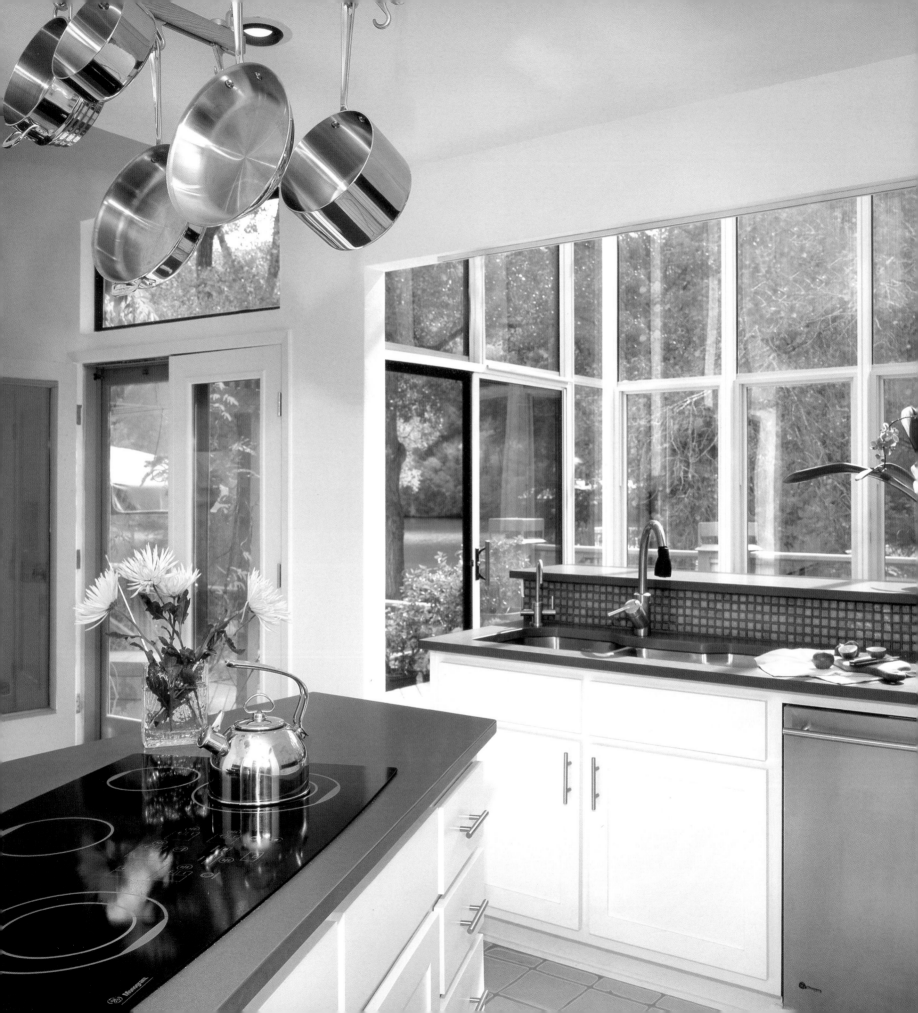

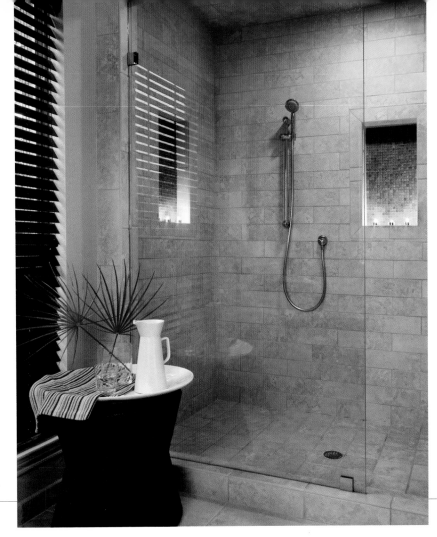

Laura Burton

LAURA BURTON INTERIORS

Upon graduating from the University of Texas School of Architecture, Laura worked for years in the corporate world, but dreamed of pursuing her passion for interior design. In 2004 she established Laura Burton Interiors, and within two years she has experienced rapid growth in her client base as well as professional notoriety and recognition. Laura was a recipient of an ASID "Legacy of Design Award," and also an ASID Austin "Design Excellence Award," both for projects in 2006. Already she is making a name for herself as a fresh new face in the Austin design community.

Laura is not out to create "show homes," but rather comfortable spaces that each unique client will love. As first a wife and mother of three, she understands the importance of designing for real people and the way they live. "My aim is not to force a signature style or trend, but rather to see my clients' vision through their eyes and help them realize that vision." Blending styles while at the same time steering toward clean and simple, Laura's interiors reflect the "casual elegance" that she loves.

ABOVE:
The clean lines and rich materials of this bathroom remodel (dark cherry, travertine, and glass tile) create a calm and relaxing retreat.
Photograph by Tre Dunham

FACING PAGE:
This Lake Austin kitchen design is clean and simple, drawing attention to the beautiful view. The iridescent glass tile backsplash echoes the shimmering lake beyond.
Photograph by Tre Dunham

LAURA BURTON INTERIORS
Laura Burton, Allied Member ASID
9608 Crenata Cove
Austin, TX 78759
512.497.6465

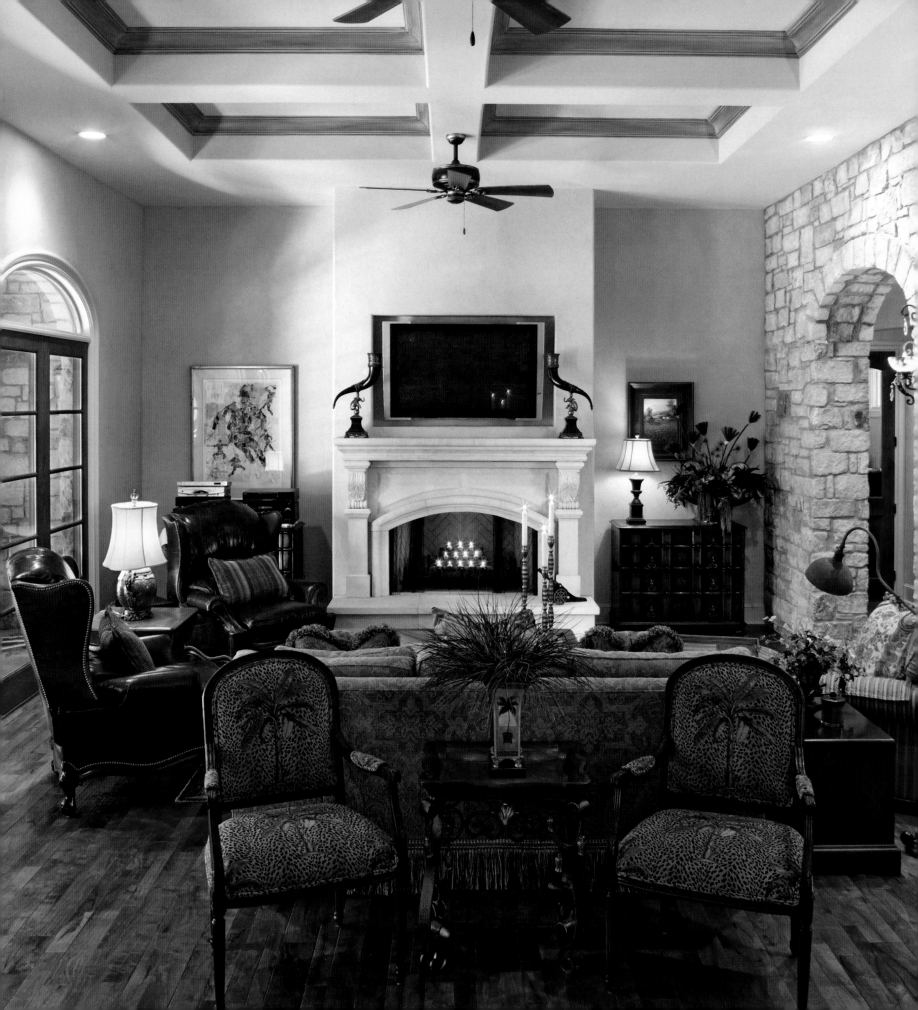

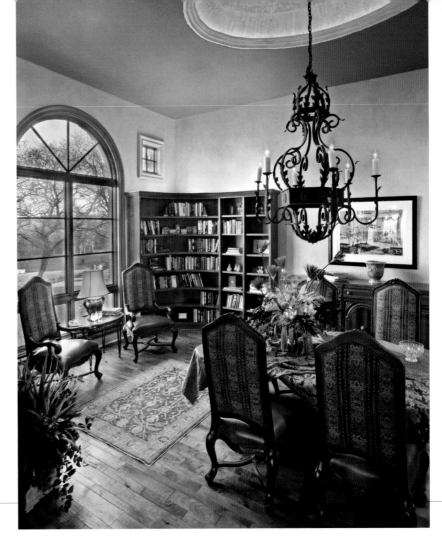

Susan Connolly

DOUG CONNOLLY BUILDER, LTD.

Susan Connolly loves a little of the unexpected. Clean, simple forms with a bit of pop to draw the eye around a beautiful space, such as a chandelier with crystal drops juxtaposed against rustic stone walls and beams, epitomize Susan's eye for design.

Residing in Austin, Texas, a city famous for its thriving business community, diversified lifestyles and natural beauty, Susan and her husband build and design homes in the Austin metropolitan area and bring to their clients over 30 years of combined experience. They strive to meet their clients' needs and expectations while keeping in mind both style and function. Susan formulates concepts that are appropriate, purposeful and engaging with a flow inspired by the rhythms of each individual.

Communication is the key to not only the lasting relationships Susan and Doug have built with an extraordinary portfolio and impressive list of

clientele, but also to the secrets of their design success. With an inherently sharp eye for detail and fundamental attention to quality workmanship and unparalleled service, Doug Connolly Builder expertly establishes direction from the outside in, ultimately refining the overall design, building beautiful homes with rich interiors of architectural detailing and then appointing each space with noteworthy furnishings and finishes.

This husband-and-wife team strives towards creating an environment in which their clients feel comfortable from their first step in the door. Whether

ABOVE:
This dining room boasts a beautiful iron-forged chandelier, hanging from a lighted dome ceiling, which was painted to look like stone. Carved alder wood bookshelves, at the end of the room, create a library ambience.
Photograph by Cole Hairston

FACING PAGE:
This room features special milled mesquite hardwood floors, a real stone arched wall, and a hand-carved limestone fireplace. The customer's own chairs were recovered with this fun leopard print and used in the room.
Photograph by Cole Hairston

15

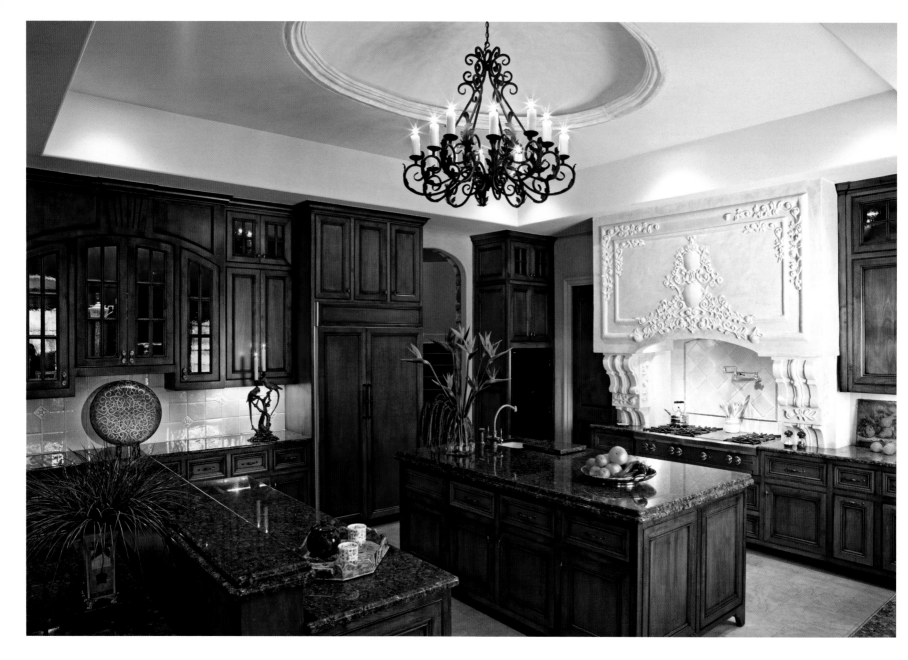

the room's intended purpose is entertaining or evenings at home with the family, spaces are warm and inviting, incorporating a skillful mix of new pieces with family heirlooms to nurture the sense of home. Enriching the lives of their clients is of utmost importance, as well as delivering environments that suit their function, regardless of style.

Awarded the 2006 "MAX Award for Best Custom Design $750,000 to $1,000,000" by the Home Builders Association, Doug Connolly Builder is currently working on several spectacular projects including a unique country home that, according to Susan, is truly stunning. "It is stone, inside and out. It creates a challenge, but when it is completed, it will be breathtaking."

Both Susan and Doug love to travel, and each locale has its designated purpose—Mexico to relax, Europe to explore and New York City for the spice of life that you truly cannot get anywhere else.

ABOVE:
This country kitchen with stained alder cabinets features hand-applied coffee glaze and functional dual islands. An artist skillfully hand-carved the beautiful faux limestone cooktop surround into a stunning focal point.
Photograph by Cole Hairston

FACING PAGE TOP:
This master bedroom is painted in a serene shade of blue green while the attached turret becomes a private reading retreat for homeowner. The beautifully carved bed seems appealing to all "family members."
Photograph by Cole Hairston

FACING PAGE BOTTOM:
The master bath is luxurious and spacious but still has a comfortable spa-like atmosphere. The huge walk-in master shower is just beyond the whirlpool tub. Features include dark green marble and gold tile with his-and-her vanities and separate makeup area.
Photograph by Cole Hairston

Q&A

more about susan ...

WHAT COLOR BEST DESCRIBES YOU AND WHY?
Red, because it can be low key or vivacious. I am very easy going, but I can take charge when needed.

DESCRIBE YOUR DESIGN PREFERENCE.
I love the European feel, a mix of rustic with razzle-dazzle; classic styles that have just a little surprise are very refreshing.

WHAT IS THE HIGHEST COMPLIMENT THAT YOU'VE RECEIVED PROFESSIONALLY?
I feel like the highest compliment I have received is upon completion of a project, my clients tell me that they really feel like they are home.

WHAT EXCITES YOU MOST ABOUT BEING A PART OF *BEAUTIFUL HOMES*?
It is a wonderful opportunity for both Doug and me to be recognized and showcased as a team.

DOUG CONNOLLY BUILDER, LTD.
Susan Connolly, Allied Member ASID
11719 Bee Cave Road, Suite 102
Austin, TX 78738
512.263.7944
f: 512.263.5002

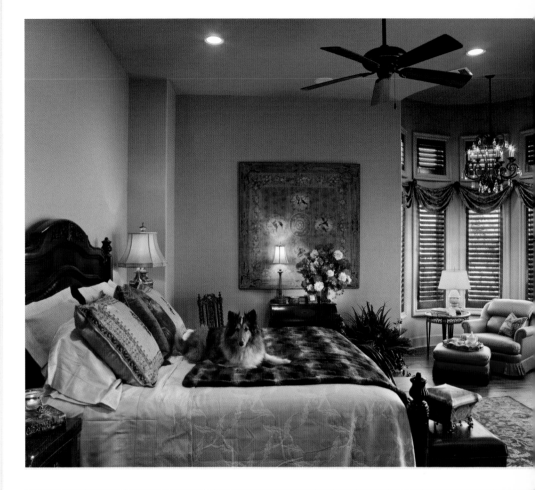

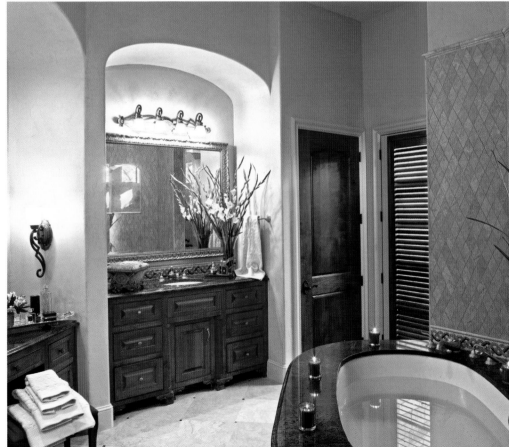

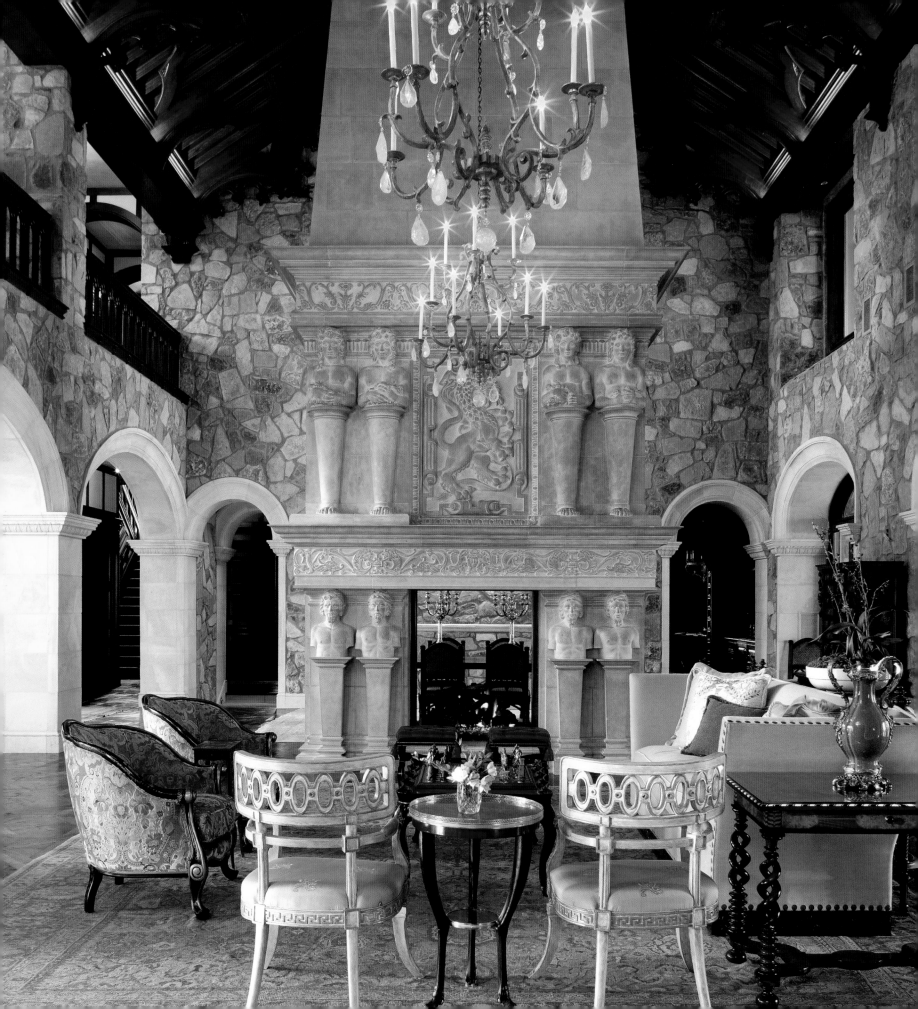

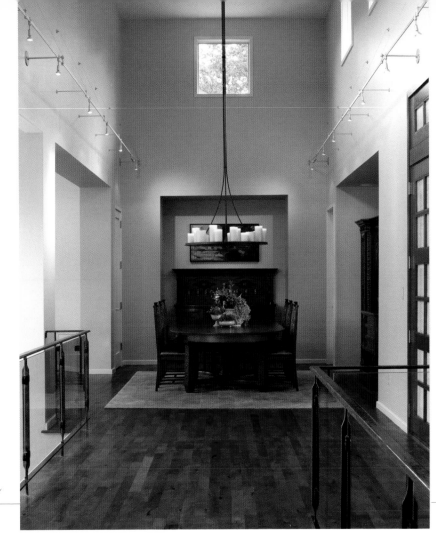

Mark Cravotta
CRAVOTTA STUDIOS

Mark Cravotta is a designer who listens. Working with clients, he is a blank canvas; an expert who absorbs information from the environment to figure out how to work his magic in a way that is at once adaptable and indispensable. But he is also adept at the less glamorous project management side of the business where vendors and creative teams are coordinated and quality is carefully monitored.

Cravotta is one of those rare souls who can be at home on both sides of the line between practicality and beauty. Early in his career he managed a staff of over 100 people for a high-tech manufacturing company, but he also studied fine arts at Stephen F. Austin University and went on to take an apprenticeship and later a partnership with interior designer Teri Lea Barber. With a firm grasp of aesthetics on one hand and a sensible approach to resources on the other, Cravotta started Cravotta Studios 10 years ago. Since its start in 1996,

the company has shaped life in high-end residences in Austin, Houston, Dallas, San Antonio, Crested Butte, Aspen, Vail and Grand Cayman.

Cravotta Studios boasts a client roster that ranges from a Hollywood celebrity to founders and CEOs across a wide variety of industries, along with a variety of others. In the end, everything Cravotta creates—from architectural detail specifications and space plans, to custom furnishings of Mark's design or

ABOVE:
The use of hand-forged iron and glass railing and rustic mesquite floors provide an organic warmth to the clean modern architecture. The space was designed to host the antique Russian dining set that has been in the family for generations.
Photograph by Paul Bardagjy

FACING PAGE:
A striking room consistent with the rest of the house reflects a quality of craftsmanship and detail reminiscent of time long gone. The grand central fireplace was collaboratively designed by Cravotta and Joseph and Holly Kincannon of Archaic Stone. It was carved by hand and took six of Archaic's artisans over one year to complete.
Photograph by Paul Bardagjy

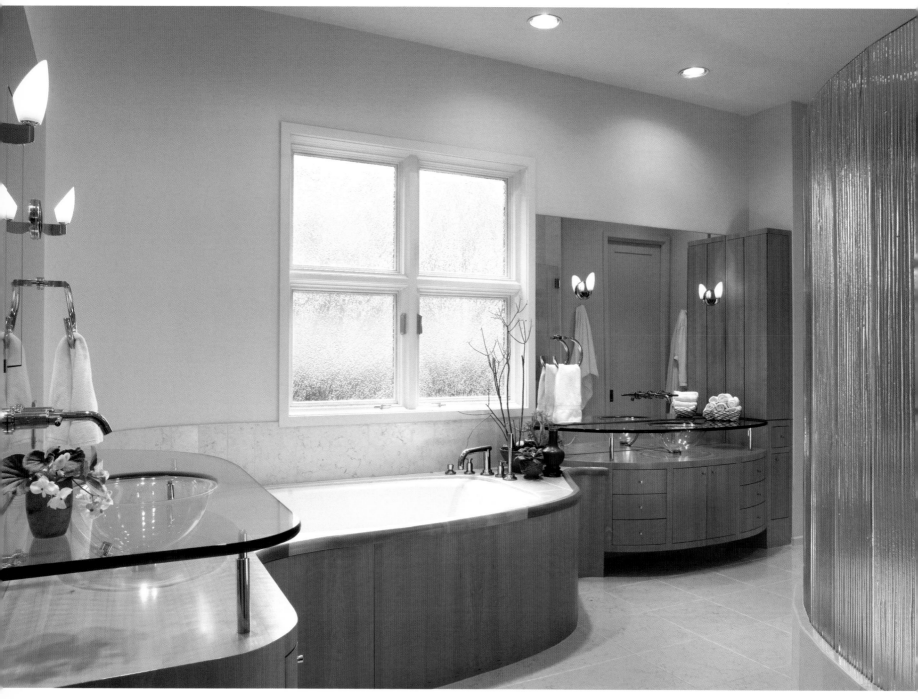

ABOVE:
Integrated glass sinks and countertops appear to float above the custom cabinets below. Hand-poured glass panels around the shower add textural interest to a graceful system of curves.
Photograph by Paul Bardagjy

FACING PAGE:
An elegant chinoiserie desk and leather chair sit in a serene corner of the guest room. Hand-woven carpet, designed to look like an antique rug, and opulent embroidered silk drapes play well against soft blue-green plaster walls polished with gold mica wax.
Photograph by Paul Bardagjy

Q&A

more about mark ...

WHAT IS THE BEST PART OF BEING AN INTERIOR DESIGNER?
I have always had a passion for the visual arts. In fact, it is where I concentrated most of my education and early experience. Most art forms are a solitary endeavor, yet designing interiors creatively and meeting a wide variety of people is what is wonderfully appealing about interior design. Each project provides a distinct sense of community while still being an expression of art.

DESCRIBE YOUR DESIGN STYLE OR PREFERENCES.
I am a student of a wide variety of styles. I specialize in discovering and developing a unique style that captures my clients' personalities.

WHAT ONE PHILOSOPHY HAVE YOU STUCK WITH OVER THE YEARS THAT STILL WORKS FOR YOU TODAY?
I am pretty insistent that if there is an element of the classic it will never be old and tired. Most of my designs incorporate both traditional and modern elements, and the classic gives it the timeless look that keeps it from ever feeling trendy or dated.

WHAT IS YOUR FAVORITE PIECE IN YOUR OWN HOME?
My favorite piece is a mosaic canvas that I had commissioned by Ryah Christensen. It is an allegorical image of my wife, Monica, and it is absolutely stunning!

WHAT IS YOUR IDEAL PROJECT?
I prefer a "ground up" project in which I am an integral part of the client/architect/builder relationship. I work extremely well in a collaborative atmosphere, leading the creative team. Those types of projects have proven quite fulfilling for both my clients and me.

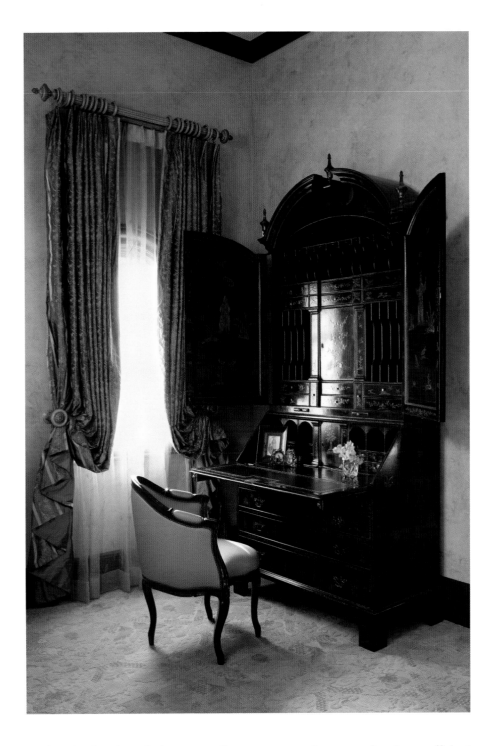

interior hand renderings—contributes to an environment that is an efficient reflection of his clients' personalities and lifestyles. But often it results in more because of the dual nature of his talents. Cravotta cannot produce mere function; his work must also be exquisite.

CRAVOTTA STUDIOS
Mark Cravotta
3601 South Congress Avenue
Building C, Suite 303
Austin, TX 78704
512.499.0400
f: 512.499.0413
www.cravottastudios.com

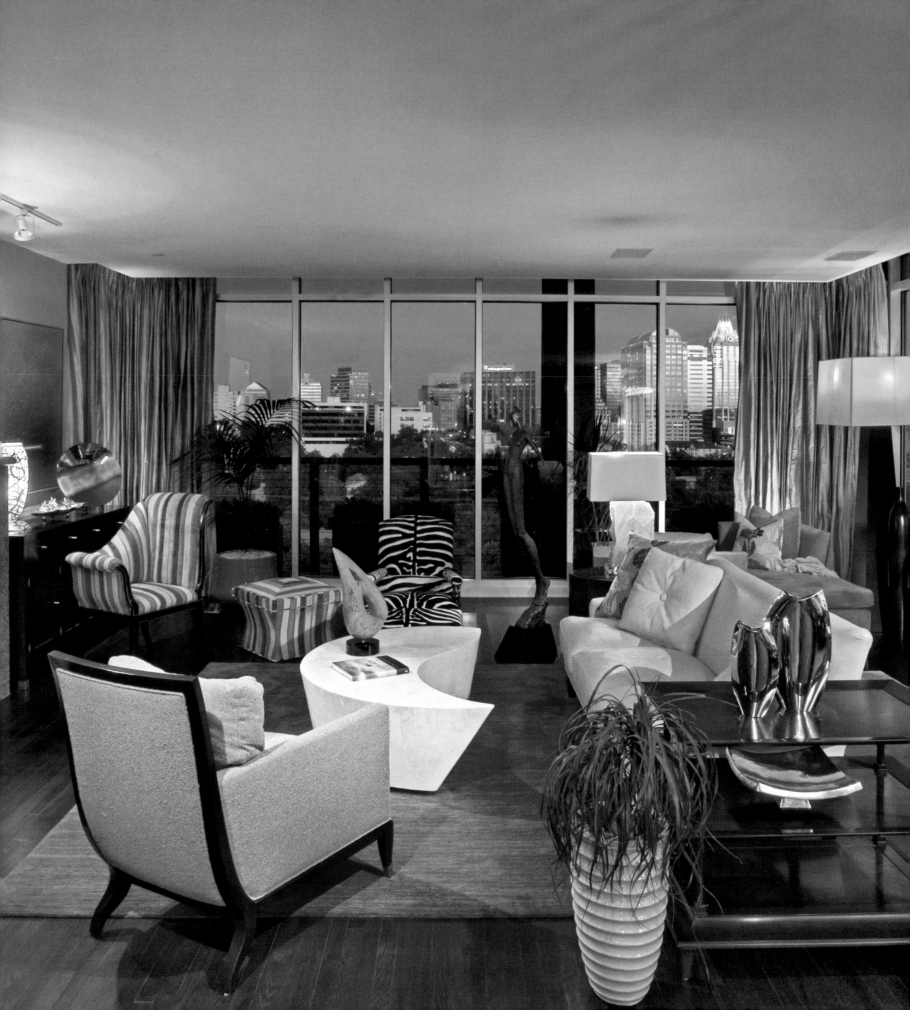

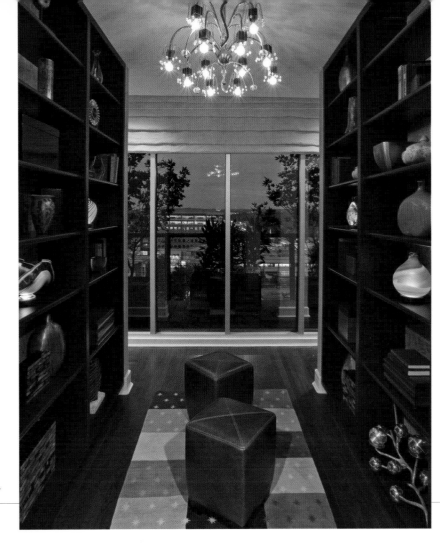

Julie Evans

JEI DESIGNS, INC

Born in Dallas and growing up in San Antonio, Julie Evans has lived most of her life in the Lone Star State except for a period of nine years in which she lived in Australia. Attending the University of Texas at Austin, Julie originally studied psychology and excelled in math and science, three disciplines that would undoubtedly serve her well in her as yet undiscovered future as an interior designer. Soon, Julie's creativity got the best of her and she chose to pursue interior design and truly engage her passion for art and antiques.

Julie began her own firm in 1983 and has practiced from her home base in Austin since 1995. She has been featured on HGTV's "Generation Renovation" and "Designing Texas," been published in *Spectacular Homes of Texas* and has been the honored recipient of several notable awards including the Home Builders Association "MAX Award," numerous Austin ASID "Design Excellence Awards" and three statewide "Legacy of Design" awards.

Able to instinctively interpret her clients' tastes and needs, Julie pulls together interiors that always exceed expectation. Bringing personality, life and rhythm into spaces, each project stands on the merit of its individuality and is custom-tailored to suit each client's unique lifestyle.

ABOVE:
A small hall is anchored with a custom Deco light fixture which was created for the client with a subtle monogram designed into the lines of the fixture. The art-glass collection is up-lighted in a shadow-box effect.
Photograph by Mark Knight

FACING PAGE:
With sweeping views of both the Austin skyline and the Texas Hill Country, the penthouse-level living room defines transitional style. Eclectic and Deco elements were used to create a highly stylized atmosphere.
Photograph by Mark Knight

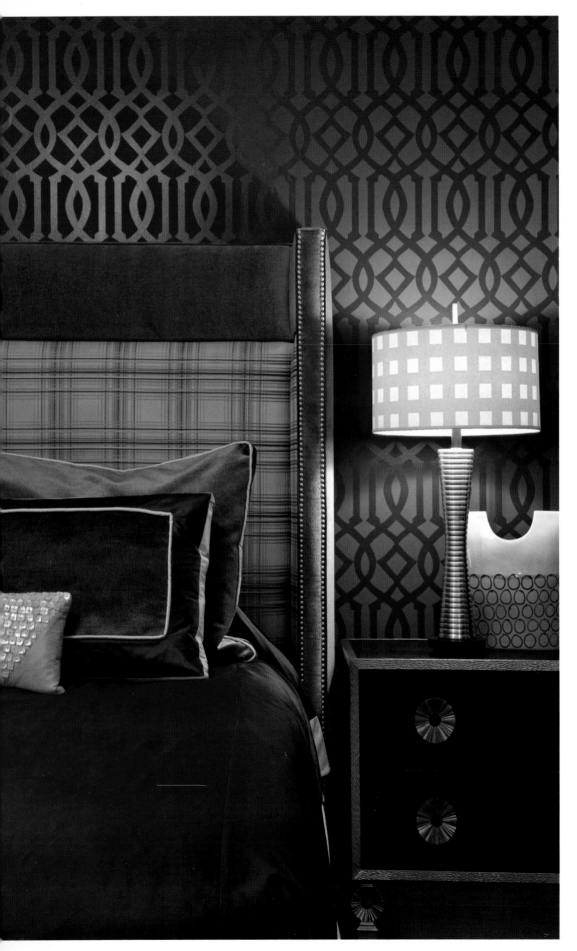

A recognizable characteristic of Julie's exquisite design is the discreet embellishment that offers a delightful surprise. At first glance, these embellishments almost go unnoticed, seamlessly tied in as fine details, such as a family logo integrated into the custom fireplace screen. These small but important elements become the substance of the design, creating cohesion between the beautifully appointed furnishings and the intended purpose of the space.

Recently, Julie opened a retail space, the JEI Design Collection, to showcase some of her favorite things that she has used for her clients over the last 25 years. The style of the store is a mix of Traditional and Contemporary, which is the perfect blend for the lofts going up all around the store's location off of Sixth Street and Lamar.

LEFT:
The guest bedroom becomes a study in balance and scale with the blend of colors, textures and shapes. Detail, detail, detail makes the clean-lined room playful and interesting.
Photograph by Mark Knight

FACING PAGE:
The selection of each item keeps a balance of elegance and style. The stainless steel dining table complements the leather chairs. The narrow space with low ceilings challenged the space planning, calling for two custom light fixtures.
Photograph by Mark Knight

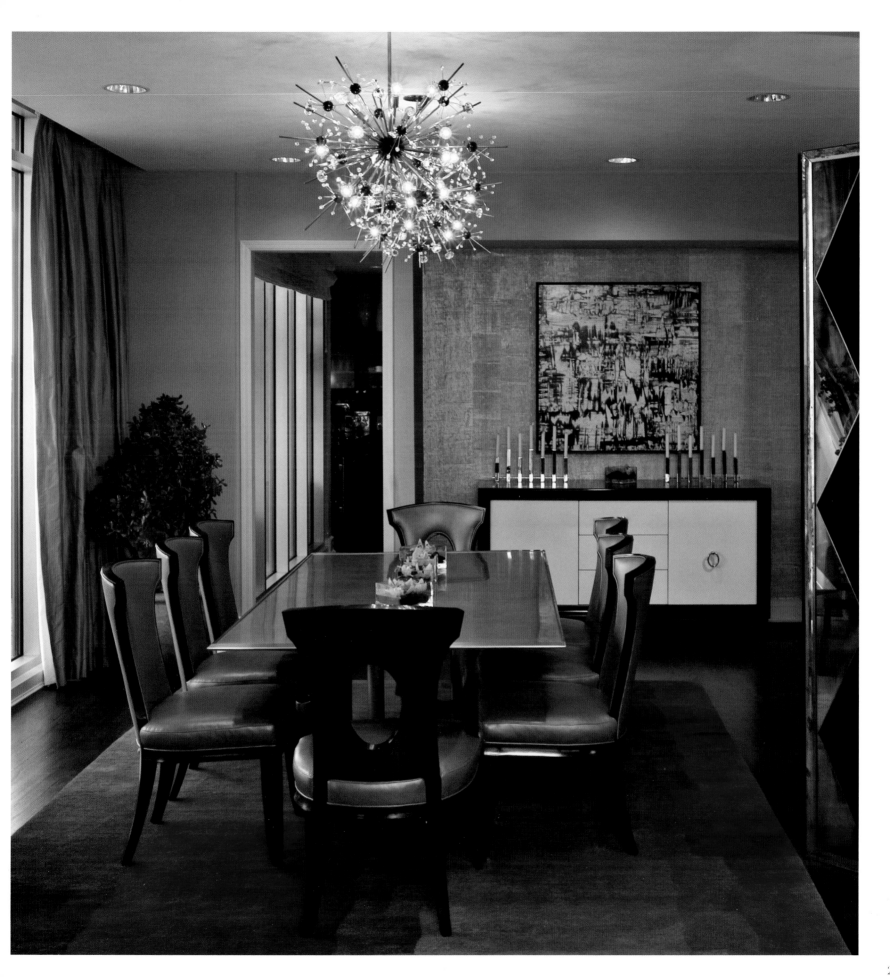

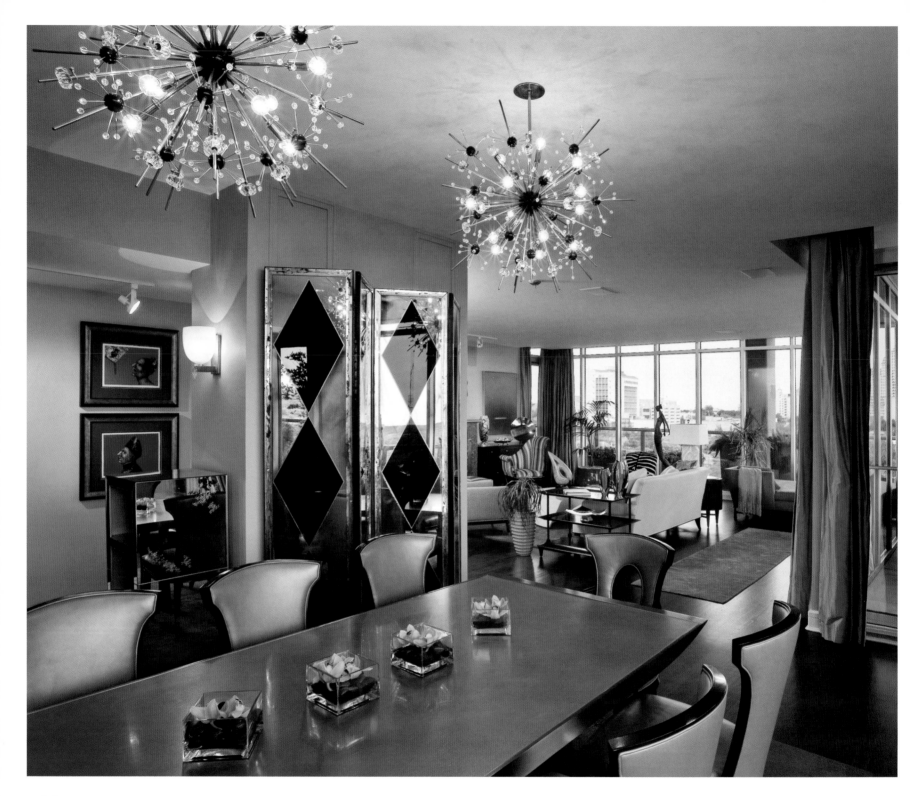

ABOVE:
Befitting a CEO, the commanding dining room is the perfect balance of elegance and style. The exquisite stainless steel dining table is complemented by the graceful lines of the dining chairs.
Photograph by Mark Knight

FACING PAGE LEFT:
A judicious blend of fabrics and finishes combine with some very fabulous antiques to maintain the dynamic established with this Italian-inspired formal dining room.
Photograph by Thomas McConnell

FACING PAGE RIGHT:
As one enters the home an inspired, hand-painted Italian mural captures one's attention. The elegant repeating stone arches echo the strong architectural details found throughout the home.
Photograph by Thomas McConnell

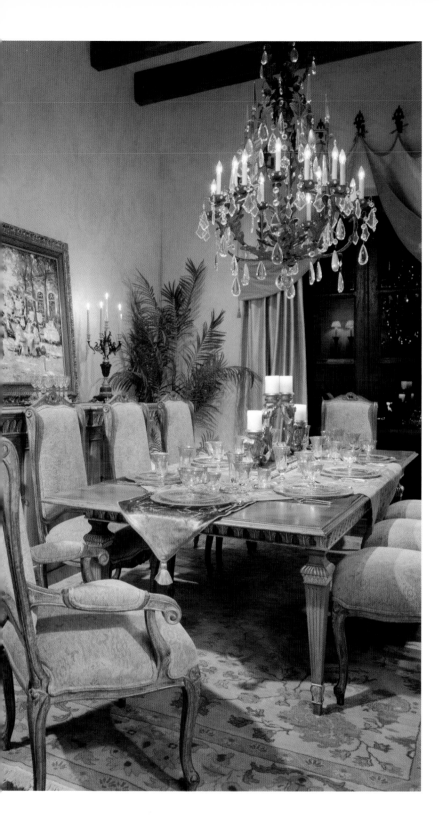

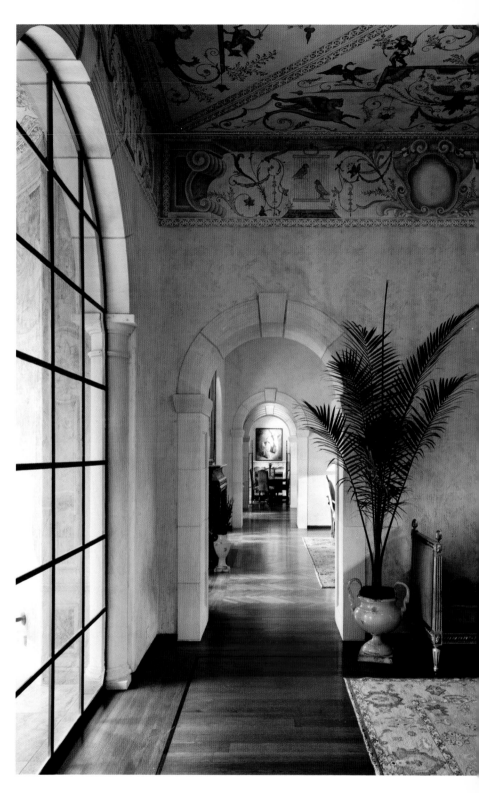

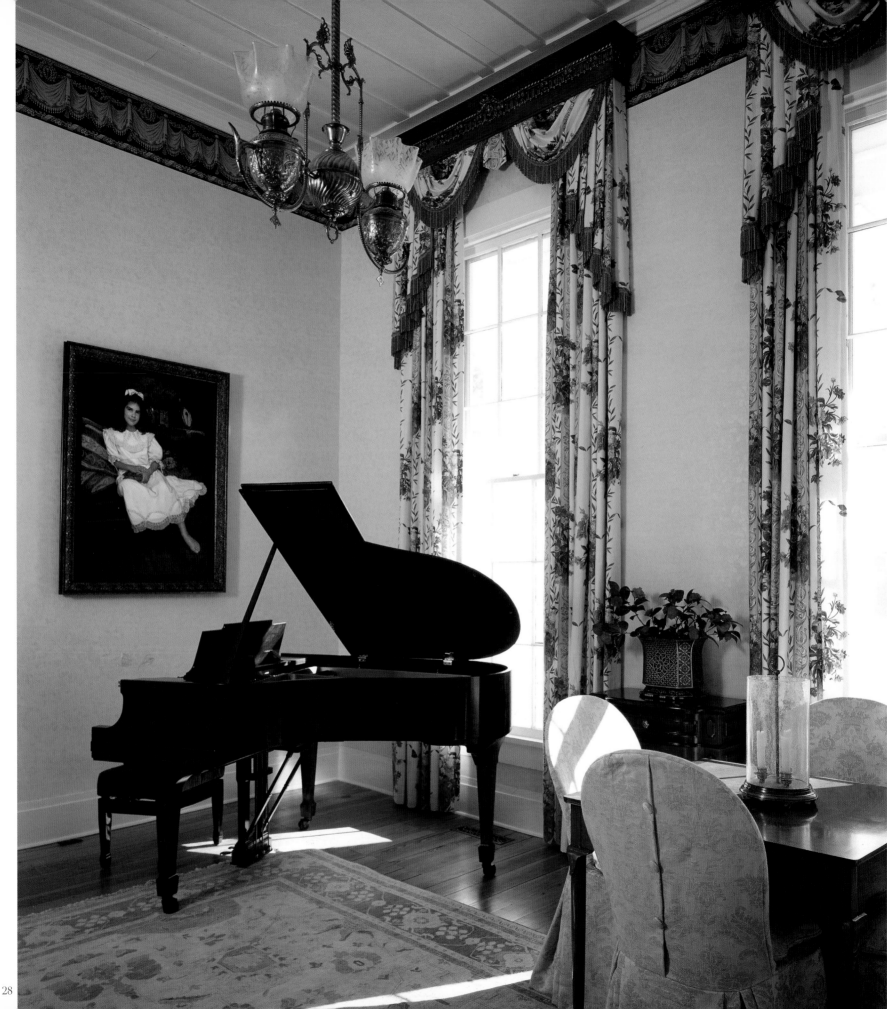

Q&A

more about julie ...

WHAT IS THE BEST PART OF BEING AN INTERIOR DESIGNER?
The best part of being a designer is the end result, which is a happy client.

WHAT IS THE HIGHEST COMPLIMENT YOU'VE RECEIVED PROFESSIONALLY?
Aside from the awards, which are decided by my professional peers, being asked to do additional projects from satisfied clients.

WHAT ELEMENT OF STYLE HAVE YOU STUCK WITH OVER THE YEARS THAT STILL WORKS FOR YOU TODAY?
I always stay with classic elements. Good design always incorporates balance, scale and proportion.

WHAT IS YOUR FAVORITE PIECE IN YOUR OWN HOME?
My favorite piece is sentimental. It is the dining table and chairs that my husband and I bought together. It was the first good piece of furniture we had ever purchased. At the time, we couldn't believe that we were spending that much money, but it is a gorgeous piece that now, I can't live without.

JEI DESIGNS, INC
Julie Evans, Allied Member ASID
2808 Bee Cave Road
Austin, TX 78746
512.330.9179
f: 512.328.9666
www.julieevans.net

JEI DESIGN COLLECTION
at the Galleries at Whit Hanks
1009 West Sixth Street, Suite 111
Austin, TX 78703
512.236.9070
f: 512.236.9071
www.jeidesign.com

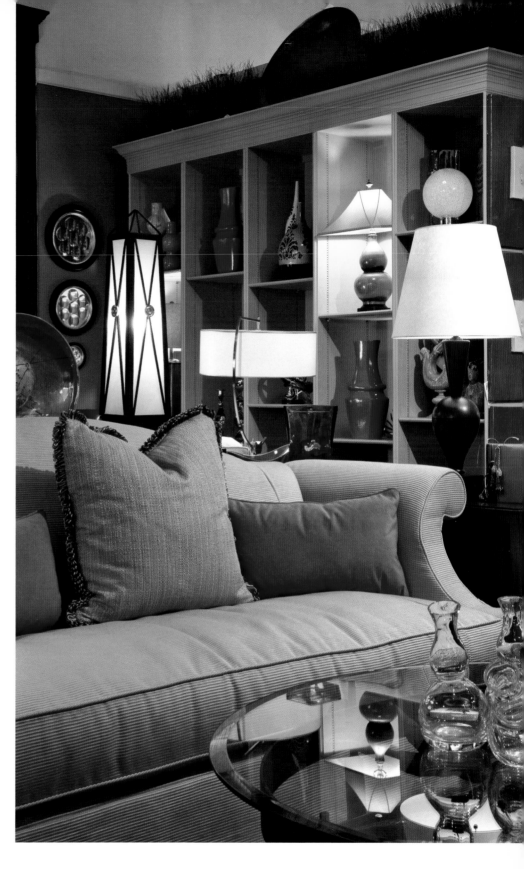

ABOVE:
The JEI Design Collection carries a collection of many of the wonderful furniture pieces and accessories that JEI Design uses in the homes they decorate. The retail space is located at 1009 West Sixth Street, Austin, Texas.
Photograph by Mark Knight

FACING PAGE :
The soft yellow glow of the music room in this remodeled 1850s' farm house reminds us of simpler times. Fresh garden flowers and slip-covered chairs keep the room fresh and informal.
Photograph by Mark Knight

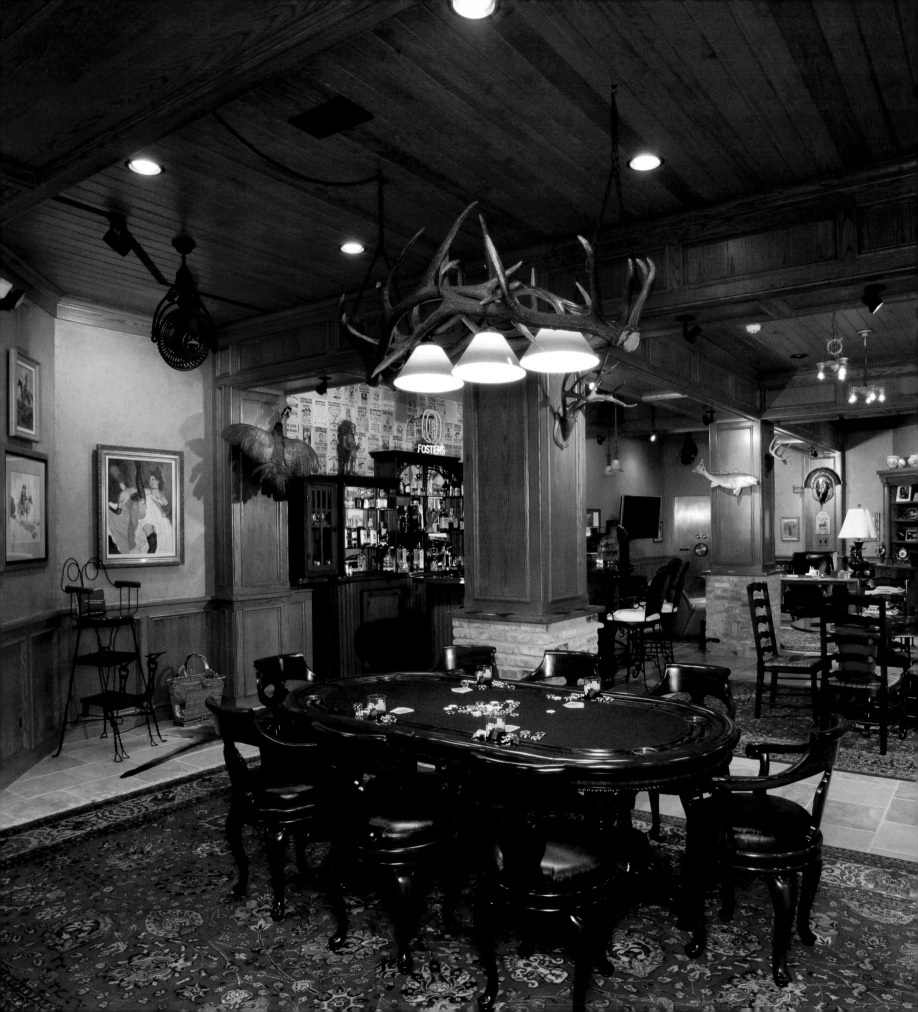

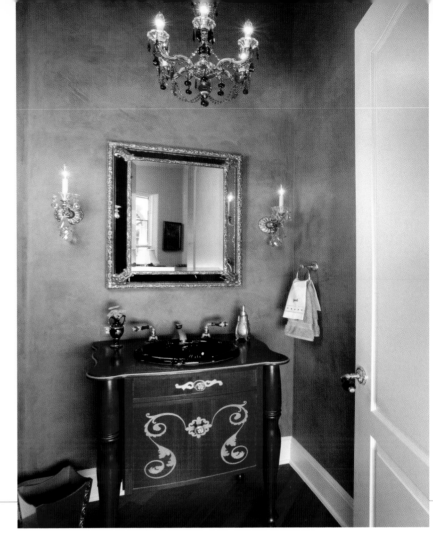

Mike Forwood
Lindy Colter

LOUIS SHANKS OF TEXAS

Louis Shanks of Texas, a long-standing institution in Texas, has been providing the finest in home furnishings for more than 60 years. Family owned and operated since its founding in 1945, Louis Shanks Furniture boasts one of the largest inventories and broadest selections of any fine furniture retailer in the country. Comprised of five showrooms across the Lone Star State, Louis Shanks Furniture offers high-end, eclectic furnishings and accessories from the most exotic marketplaces in the world.

One of the fastest growing, high-end furniture retailers in the nation, Louis Shanks has cultivated a noteworthy reputation for quality craftsmanship, carrying the finest names in the industry. Displaying pieces for living rooms, dining rooms and bedrooms as well as fine flooring, window treatments and fabrics, each showroom features custom-designed vignettes, assisting their clients to envision the furnishings in a home environment. Richly appointed

pieces in supple leathers, hand-carved walnut, chiseled stone, hand-worked metals, glass and marble artfully showcase the superiority that is synonymous with the name Louis Shanks.

Like so many other Texas establishments, Louis Shanks Furniture had humble beginnings that grew from roots in the Hill Country. After graduating high school in the 1930s, Louis Shanks had the choice of either continuing his education in college or going to work for Kroehler Furniture. Luckily for the

ABOVE:
A bejeweled chandelier illuminates the powder room. Custom-finished walls echo the amethyst sink, which is accentuated with a 24-karat gold faucet and hardware.
Photograph by Vernon Wentz

FACING PAGE:
The poker room of this private residence boasts a bar, circa 1880, that was originally situated in a hotel in Big Spring, Texas.
Photograph by Tre Dunham

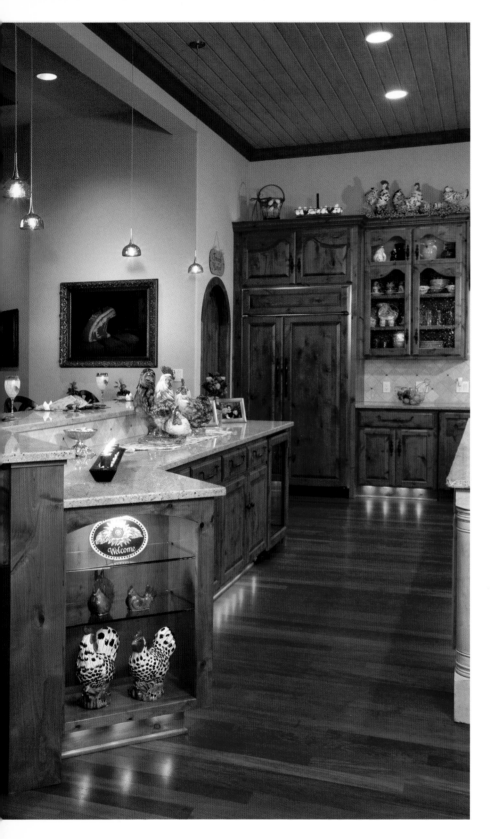

state of Texas, Louis took the job, gleaning invaluable knowledge which he then used to open the first Louis Shanks store on Congress Avenue in Austin.

Mike Forwood, current president and grandson of founder Louis Shanks, has participated within the family business since his youth. Joking that he "has sawdust in his blood," Mike quenched an insatiable appetite for learning under the guidance of his grandfather and then his father. Carrying on the family tradition, Mike believes in pampering his clients while providing them with upscale luxury.

Now, Louis Shanks of Texas has hundreds of thousands of square feet of showrooms, with their Houston location claiming an incredible 130,000 square feet all its own. Imparting distinctive service through knowledgeable staff, the burgeoning company continues to grow, employing more than 300 associates and more than 90 in-house interior designers. With a strong emphasis on customer experience, Louis Shanks' staff of fully accredited ASID and state-licensed designers has countless years of combined experience in custom design to assist in articulating the perfect style for each client. Delivering excellence through quality, Louis Shanks of Texas provides the reliability of more than a half century of customer satisfaction where each staff member and designer stands ready to create the room of their clients' dreams.

ABOVE:
A distinct rooster motif is woven throughout this Country French-inspired kitchen.
Photograph by Vernon Wentz

FACING PAGE:
Fresh popcorn, a good movie and a dozen of the residents' closest friends make for an enjoyable evening in this 15-seat home theater.
Photograph by Vernon Wentz

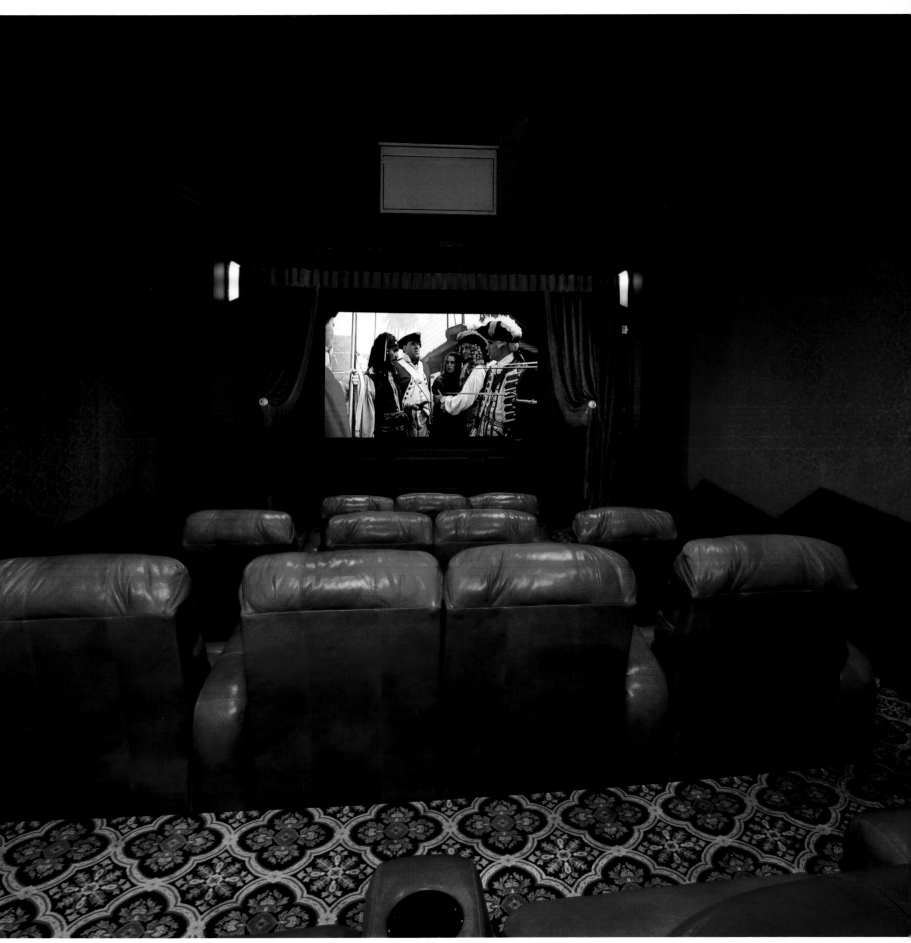

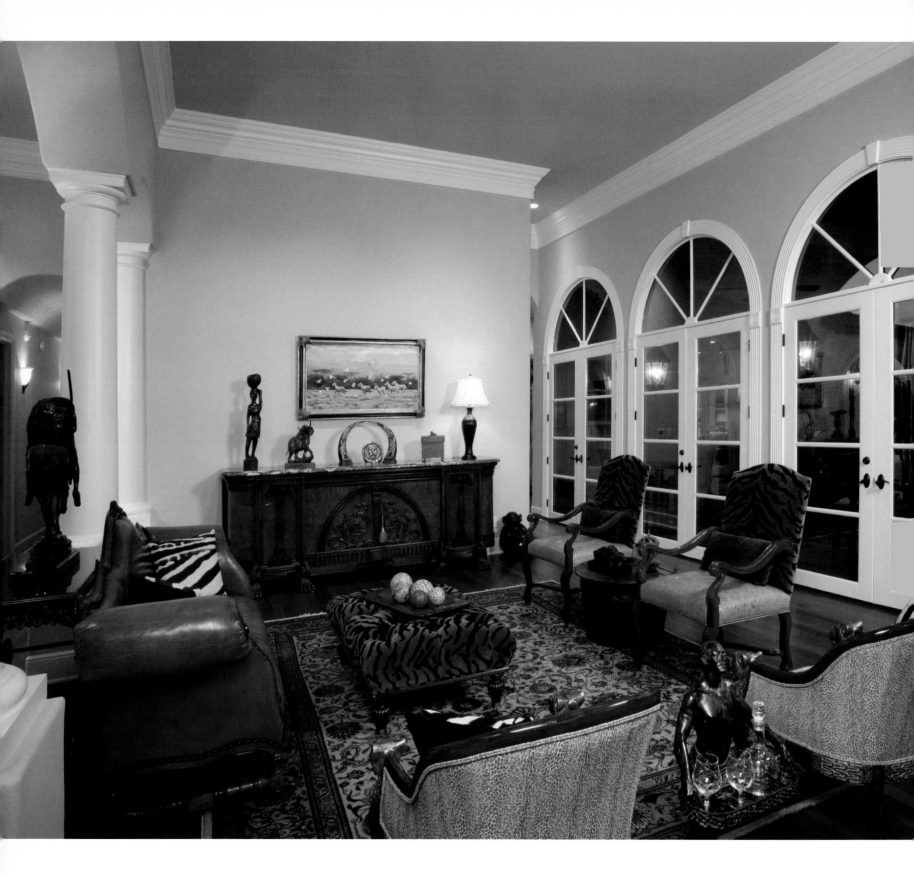

ABOVE:
Ralph Lauren textiles, French antiques and Southwest bronze sculptures adorn the front room.
Photograph by Vernon Wentz

FACING PAGE:
Specks of black add even greater depth and interest to this elegant master bathing area.
Photograph by Vernon Wentz

One such designer is Lindy Colter, who has been designing with Louis Shanks Furniture for 10 years. Lindy, who was instrumental in the design of the home featured on these pages, is a sixth-generation Texan whose grandmother owned three antique stores in West Texas while her mother was a furniture buyer and decorator. Interior design was certainly in her cards, but Lindy admits it is now the love of her life.

Lindy enjoys working for an established, well-recognized firm. Providing her clients with expertise in creating their perfect space, she is also able to present them with the assurance that every last detail will be to their complete satisfaction. Louis Shanks' long-standing reputation instills a confidence that their needs will be met with thoughtful consideration, and Lindy's remarkable skill ensures their vision will be eloquently communicated in the final design.

Talented and dedicated, Lindy is delighted by referrals from current and previous clients, feeling they are the highest compliment she can achieve in her profession. An astute listener, Lindy truly hears not just her clients' desires, but also their concerns, meeting them with the promise that even the smallest hurdles will be handled in a timely and graceful manner.

It is designers and associates such as Lindy that provide the character and service that Louis Shanks of Texas is famed for providing. Recognized by their peers for their superior merit, Louis Shanks has received several "ARTS Awards" and been featured in numerous publications. And that prized character extends farther than just to their stores and employees. In the spirit of the community which they serve, Louis Shanks Furniture is

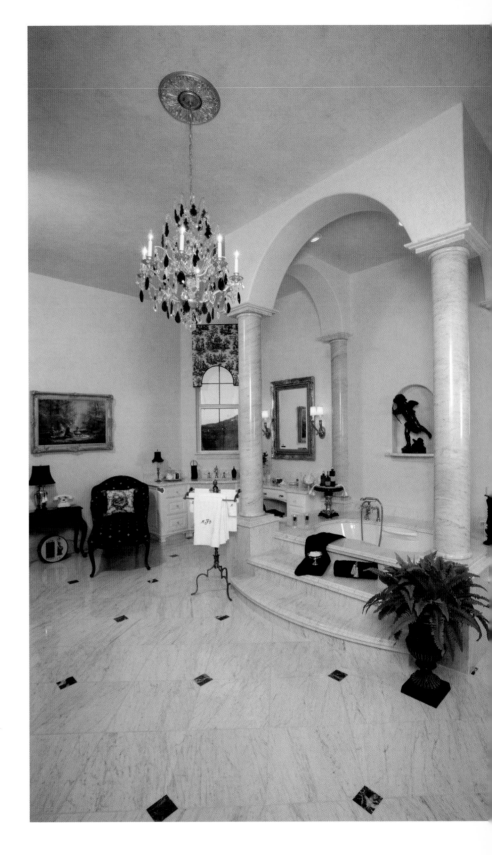

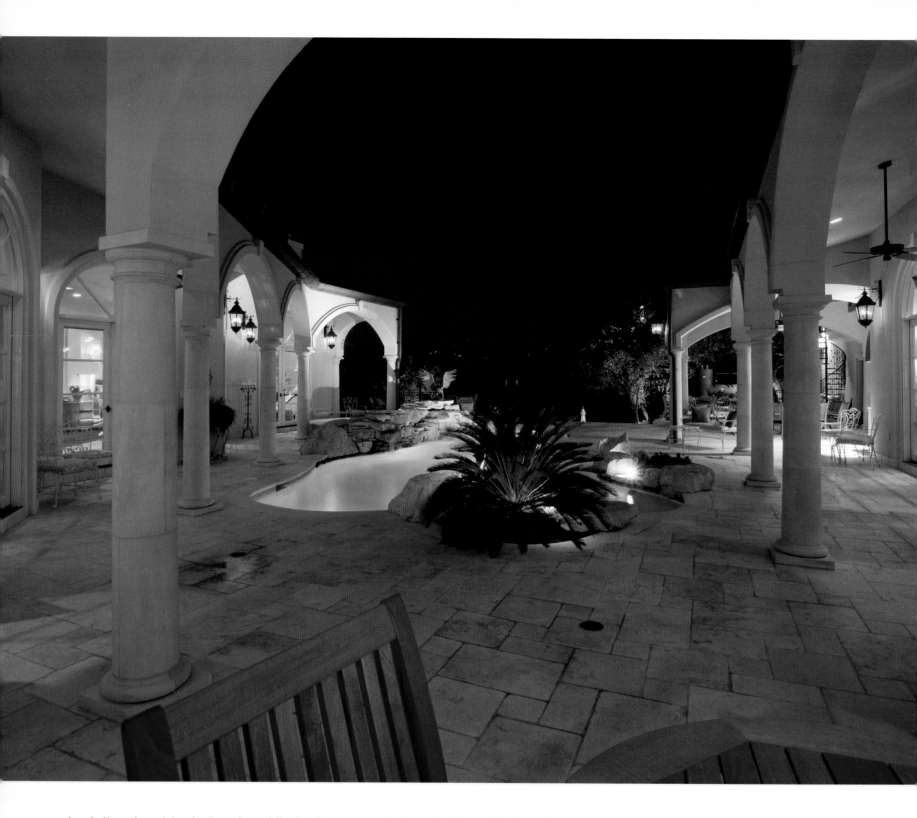

also dedicated to giving back to the public that has supported them wholeheartedly. Recently, the retailer partnered with a vendor to support a local children's hospital in addition to the many other charitable programs in which they participate, including the Texas School for the Deaf and Toys for Tots. Along with their uncompromising quality, dedication to community and unparalleled service, Louis Shanks is at the forefront of its trade, setting the bar, and the example, for the rest of the industry.

Q&A

more about mike ...

DO YOU HAVE A FAVORITE PIECE IN YOUR OWN HOME?

We have a French Bregier chair in our bedroom that we absolutely love. About 25 years ago, Pope John Paul came to San Antonio and needed a chair to sit in and address the audience. His entourage came to our store and chose this chair for him, and once the festivities were over, I brought the chair home for my wife and she placed it in our living room. Every time someone came to our home, our children would guard that chair; no one was allowed to sit in the Pope's chair! We love it now because of the history it has with our family.

WHAT IS YOUR FAVORITE STYLE PERSONALLY?

My style is eclectic, but tends more toward the Traditional than the Contemporary. I enjoy classic design that blends antiques with contemporarily designed furniture. I also love to go to old castles and see the original pieces of which we are doing reproductions.

DO YOU SEE EDUCATING YOUR CLIENTS AS A PART OF YOUR ROLE?

Yes, though much of it depends on the client. Some need more guidance than others. In today's changing environment, we educate our clients on quality level.

IS YOUR WORK STILL EVOLVING, AND DO YOU SEE IT TAKING A CERTAIN DIRECTION?

Each project and client presents its own unique challenges and opportunities; each new job takes on a life of its own. The industry is not evolving or changing drastically, but each client and working relationship changes. It keeps things fresh and the job interesting; it's never the same thing day in and day out.

LOUIS SHANKS OF TEXAS
Mike Forwood
PO Box 10448
Austin, TX 78766
512.451.6501
f: 512.617.0469
www.louisshanksfurniture.com

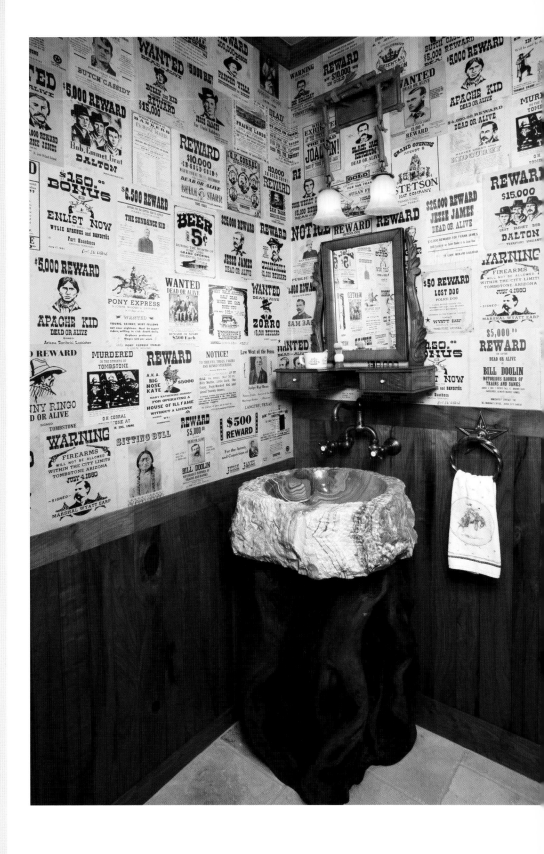

ABOVE:
An antique lighting fixture, mirror and cypress sink base nicely complement the bold wall covering of this "real man's bathroom."
Photograph by Vernon Wentz

FACING PAGE:
A graciously sized courtyard and pool area allow the majestic Texas Hill Country to be enjoyed day and night.
Photograph by Tre Dunham

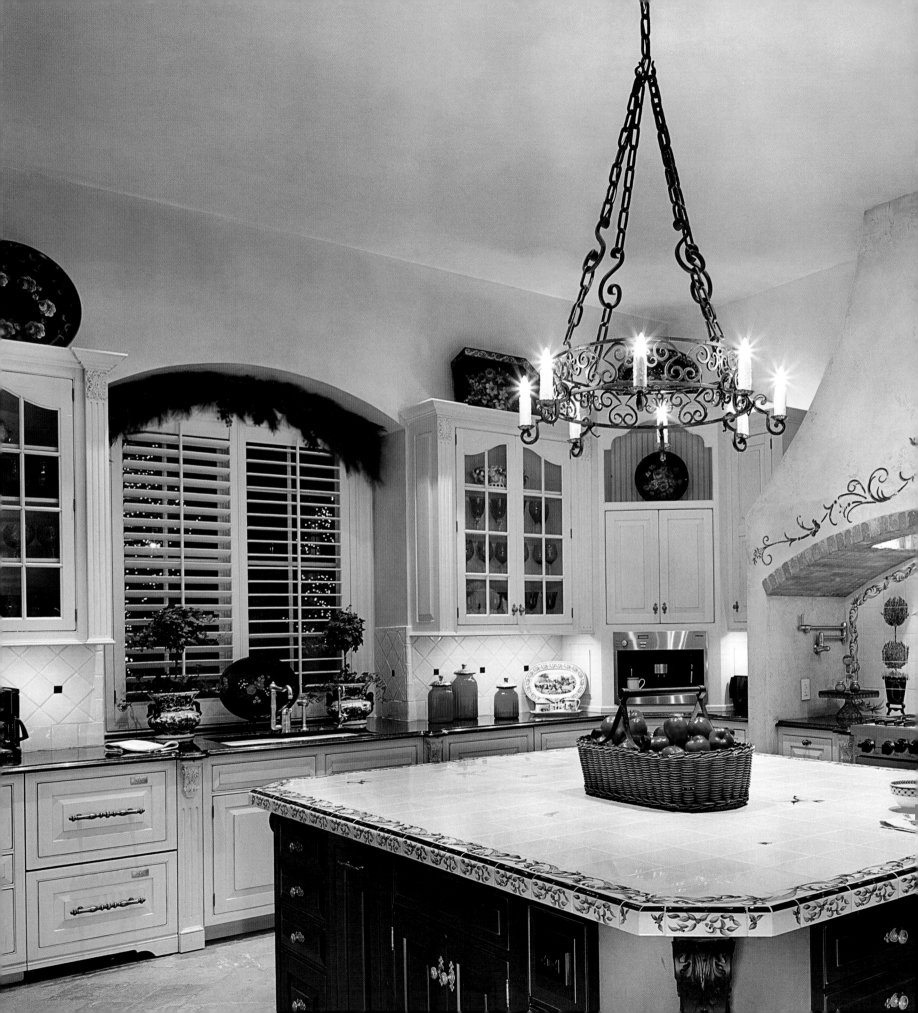

Pam Barrett Hart

PMB INTERIORS

Both living and practicing design in Austin for the last 20 years, Pam Barrett Hart, principal and owner of PMB Interiors, designs spaces consisting of a classic, casual chic with neutral palettes, lots of texture, and clean, simple lines. Able to skillfully communicate her client's vision into tangible, beautiful design, Pam hand-tailors each environment to suit her client's sensibilities as well as the intended purpose of the room. Pam values the opportunity to help her clients discover their own unique style, encouraging them to follow their instincts and thus developing a rare rapport that fosters creativity and character in her designs.

LEFT:
The cozy atmosphere in this large kitchen makes it the ideal place for family to gather. Custom tiles, hand-painted by Joyce Ahearn of The Tile Gallery in Houston, grace the island and the wall behind the stove, and Austin's In Your Space provided the walls' beautiful faux-finishing work.
Photograph by Tre Dunham

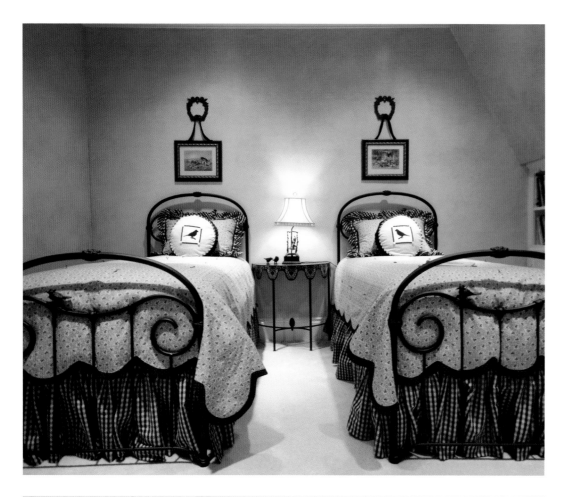

Pam is also quick to tell that her husband, an Austin-based builder, is her biggest supporter and the main source of inspiration in her career, encouraging her to trust her intuition and take her own path. And he is not the only one to sit up and take notice of Pam's remarkable work; she has also been featured in both *Country Living* and *Better Homes and Gardens*.

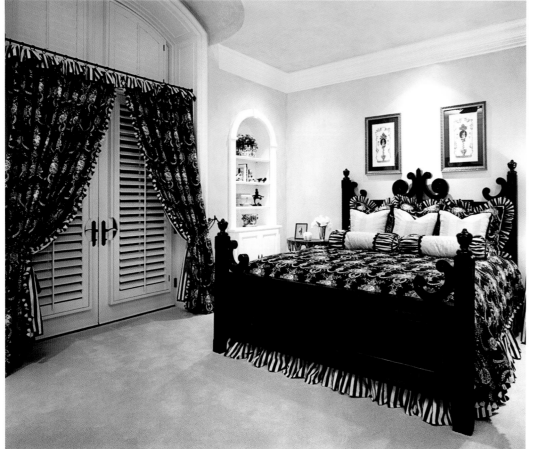

TOP LEFT:
Children enjoy sweet dreams in this nursery. The custom French toile bedding was designed by Janee of Designer Fabrications to coordinate with that of the adjoining couple's suite, located through French doors.
Photograph by Tre Dunham

BOTTOM LEFT:
The couple's suite's warm yellow walls, faux-finished by In Your Space, nicely contrast the dark toile bedding and window treatments that frame the French doors, custom-designed by Janee of Designer Fabrications.
Photograph by Tre Dunham

FACING PAGE TOP:
The nursery's built-in bookshelf creates a special reading area for the children. The window treatment was custom-designed by Janee of Designer Fabrications to complement the bedding.
Photograph by Tre Dunham

FACING PAGE BOTTOM:
This dreamy, vintage bedroom features a cozy window seat, the perfect spot for a young girl to curl up with a good book. Light gold accents beautifully balance the whimsical blue walls, faux-finished by In Your Space.
Photograph by Tre Dunham

Q&A more about pam ...

WHAT IS THE BEST PART OF BEING AN INTERIOR DESIGNER?
I most enjoy the relationships I build and maintain with my clients and the ability I have to help them develop their own style.

WHAT ONE PHILOSOPHY HAVE YOU STUCK WITH FOR YEARS THAT STILL WORKS FOR YOU TODAY?
Layering and mixing old elements with the new.

YOU CAN TELL I LIVE IN AUSTIN BECAUSE ...
Of the smile on my face—hills and lakes everywhere—what a great place to be!

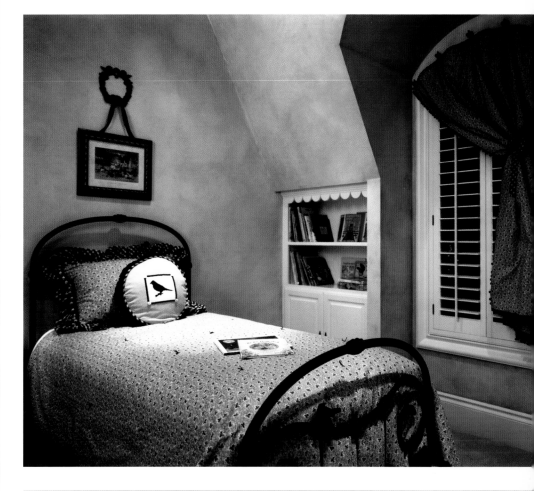

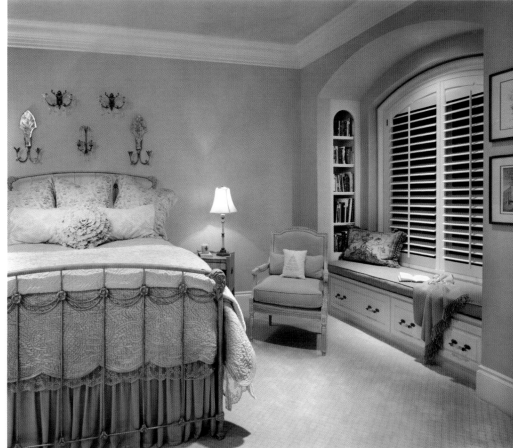

PMB INTERIORS
Pam Barrett Hart
6010 Long Champ Court, Suite 117
Austin, TX 78746
512.658.2587
f: 512.732.0021

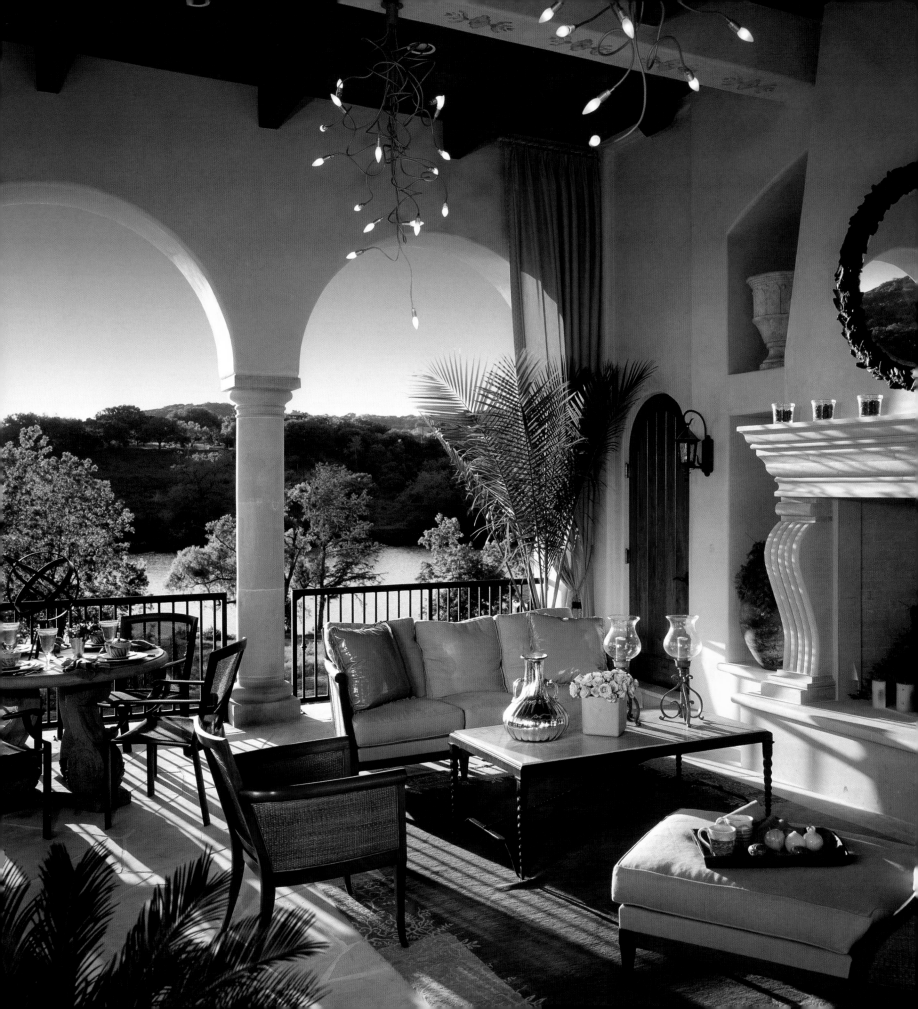

Susie Johnson

SUSIE JOHNSON INTERIOR DESIGN, INC.

Striving to create interiors that enhance architecture and reflect the taste of each client, Susie Johnson has throughout her 16-year design career more than accomplished that goal on each project she has completed. She and her design team at Susie Johnson Interior Design, Inc. work from the preliminary design concept through construction and selection of interior furnishings, all the while placing an emphasis on excellent service and communication with the client. Defining her clients as "happily codependent soon after we start a project," Susie's clients are her greatest testament to a job well done.

While clients are grateful for Susie's designs, which surpass their visions, she is equally as grateful for the opportunity to work with homeowners who are "fabulously unique, thoughtful, highly intelligent and fun to be with." Having lived in the Westlake area of Austin for 24 years, these clients are also Susie's neighbors and more often than not, friends. Working in and around the area on beautiful lots with lakefront or hilltop views, the designer genuinely appreciates the strong emphasis on natural materials that Austin architecture provides. "It is a joy to be able to work with such astonishing materials and the talented artisans of Austin," she declares.

Published in over a dozen publications, Susie and her firm have also received a plethora of awards including ASID "Design Excellence Awards" as well as a number of ASID "Texas Legacy of Design" awards. The path to these awards

ABOVE:
Linens in colors of vanilla, Tuscan gold and pale mossy green create the airy, casual feel of an Italian villa in this guesthouse bedroom.
Photograph by Mark Knight

FACING PAGE:
Graceful arches and columns, a classical stone fireplace and comfortable furnishings bring the luxury of the indoors to the outdoor space. Contemporary chandeliers are a fun surprise.
Photograph by Mark Knight

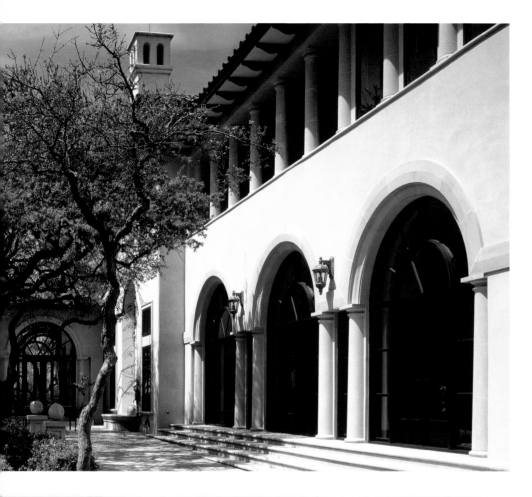

and accolades was led by two accomplished designers who continue to inspire Susie: John Saladino and Mary Douglas Drysdale. Endeavoring to present designs that display a timeless sensibility accompanied by her trademark mingling of the unpredictable, Susie describes her personal style as tailored and edited with classical references. Translating that divine sense of style to her clients, each detail is custom-tailored from simple window treatments with dressmaker details to lighting improvements that transform the space.

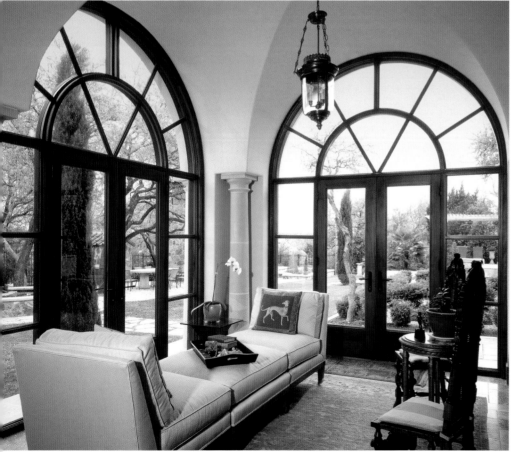

TOP LEFT:
Graceful arched double doors line the exterior of the lower loggia of this Italian-style home. The classical architecture flows seamlessly from the outside to the inside.
Photograph by Mark Knight

BOTTOM LEFT:
The airy reading corner in the lower loggia of this Italian-style home mixes comfortable contemporary seating with 17th-century carved accents.
Photograph by Mark Knight

FACING PAGE:
Contemporary lighting contrasts with vintage-style, cream-colored cabinetry in this serene yet dramatic kitchen. The antique French pine table is set with stylish Italian tableware.
Photograph by Mark Knight

SUSIE JOHNSON INTERIOR DESIGN, INC.
Susie Johnson, ASID
2808 Bee Cave Road
Austin, TX 78746
512.328.9642
f: 512.328.9666
www.susiejohnson.com

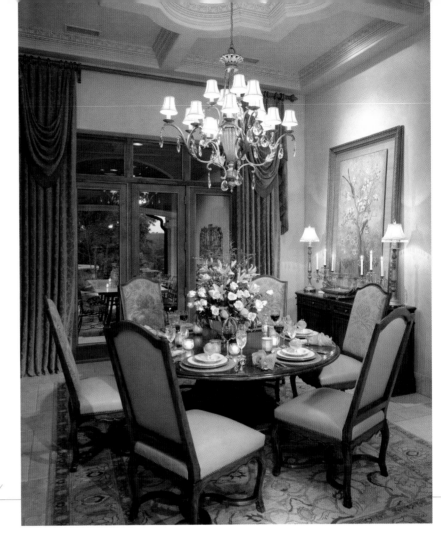

Linda McCalla

LINDA McCALLA INTERIORS

Approaching the design process honestly and with architectural integrity in mind, Linda McCalla, founder of Linda McCalla Interiors, begins first by defining the details that will remain and then highlighting them through complementary pieces. "The end result will always be successful if you play into the architectural backdrop that is already in place." she says. Linda steers clear of trends in favor of quality design that truly reflects her client's lifestyle. Whether bold statements with a modern flair or a more subtle palette reminiscent of organic ingredients, Linda ultimately pulls together the finished space in ways that reveal her client's personality and style from the first moment their home is entered.

Georgetown has its own quaint and unique character, one that Linda has been intimately involved in preserving. One of the first small cities in the country to embrace an economic revitalization of its historic downtown area, Linda signed on to oversee the project, directing the vast but rewarding restoration of Georgetown's historic treasures. The renovation of the city's center led to the refurbishment of many historical homes as well, including several by Linda, two of which were her own homes. With so much invested in the rebirth of her town and its residents, Linda became truly connected to her community.

ABOVE:
A dramatically detailed ceiling with hand-painted dome and delicate chandelier defines this formal dining room which inspires intimate gatherings around a striking round table.
Photograph by Thomas McConnell Photography

FACING PAGE:
A hand-carved limestone mantel graces the fireplace in this luxurious master bedroom. Plush Neoclassical armchairs create an inviting seating area for quiet conversation.
Photograph by Thomas McConnell Photography

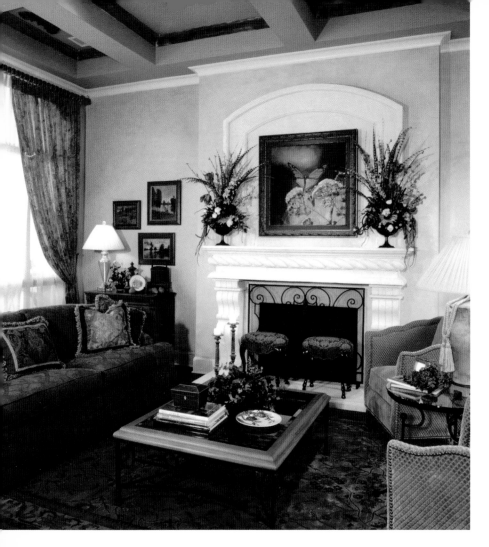

After more than 30 years as a designer, Linda has gathered an impressive repertoire ranging from estates to cottages. Her stunning designs have been regularly recognized by the ASID with "Design Excellence" awards as well as by the press with features in such highly praised publications as *Southern Living*, *Better Homes and Gardens* and *USA Today*. Loving the Hill Country, its blend of rustic and sophisticated elements and relaxed environment, Linda continues to create exquisite, aesthetically pleasing, comfortable interiors for distinctive clients from the heart of Texas.

After completing her interior design degree and graduating with honors from the University of Texas at Austin, Linda took a position with a firm in Philadelphia beginning her career, but it was not long before she returned to her roots in Texas. Linda made her home in Georgetown and established her firm there 25 years ago. Just a short drive from Austin, Linda enjoys the small-town feel of Georgetown and easy access to the cultural hub of Texas.

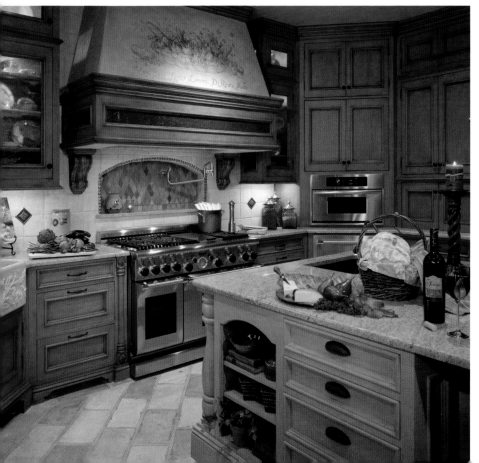

TOP LEFT:
Apricot glazing warmly enhances this elegant living room. Rich textures and colors are combined with accent pieces, fine art and accessories for a comfortable, inviting look.
Photograph by Tina Weitz Photography

BOTTOM LEFT:
At the heart of this opulent European Country home is a generous, well-appointed kitchen that is as handsome as it is functional.
Photograph by Thomas McConnell Photography

WHO HAS HAD THE BIGGEST INFLUENCE ON YOUR CAREER?
Two people immediately come to mind; the first is Buie Harwood, one of my professors at UT. She was a wonderful teacher with an immense knowledge of interior design. She had high standards, was professional and enthusiastic about her work and what she was teaching us. She taught me to love interior design. The second person is my late husband, Kenneth McCalla. He was a wise, astute businessman. When I was young and new to design and insecure about the business world, he gave me encouragement and confidence. He taught me a lot about the way things work in the world.

TELL US SOMETHING MOST PEOPLE DON'T KNOW ABOUT YOU.
I went on a medical mission to Honduras; what a rewarding experience!

YOU CAN TELL I LIVE IN AUSTIN BECAUSE...
I love the Texas Hill Country and the design that reflects it—natural materials, earthy colors and the relaxed, casual feel.

WHAT IS THE BEST PART OF BEING AN INTERIOR DESIGNER?
Interior design is a relational job and oftentimes at the end of a project, I have become friends with my clients or the architects and contractors. You spend so much time working together that a wonderful, lasting friendship often develops. It is great to have that trust and respect.

WHAT WOULD BE YOUR IDEAL PROJECT?
Working with a wonderful, long-term client on their second home in a really amazing location like Southern France, Italy, Hawaii or the Caribbean. It is great to collaborate on projects where the relationship is in place and you just move right into the creative part of the process with a lot of trust and enthusiasm.

LINDA McCALLA INTERIORS
Linda McCalla, ASID
604 South Church Street
Georgetown, TX 78626
512.930.9987
f: 512.869.0666

ABOVE:
Though small in size, this elegant powder bathroom is spectacular in detail. A hand-painted Italian vanity sits smartly against Venetian plaster walls.
Photograph by Paul Finkel, Piston Design

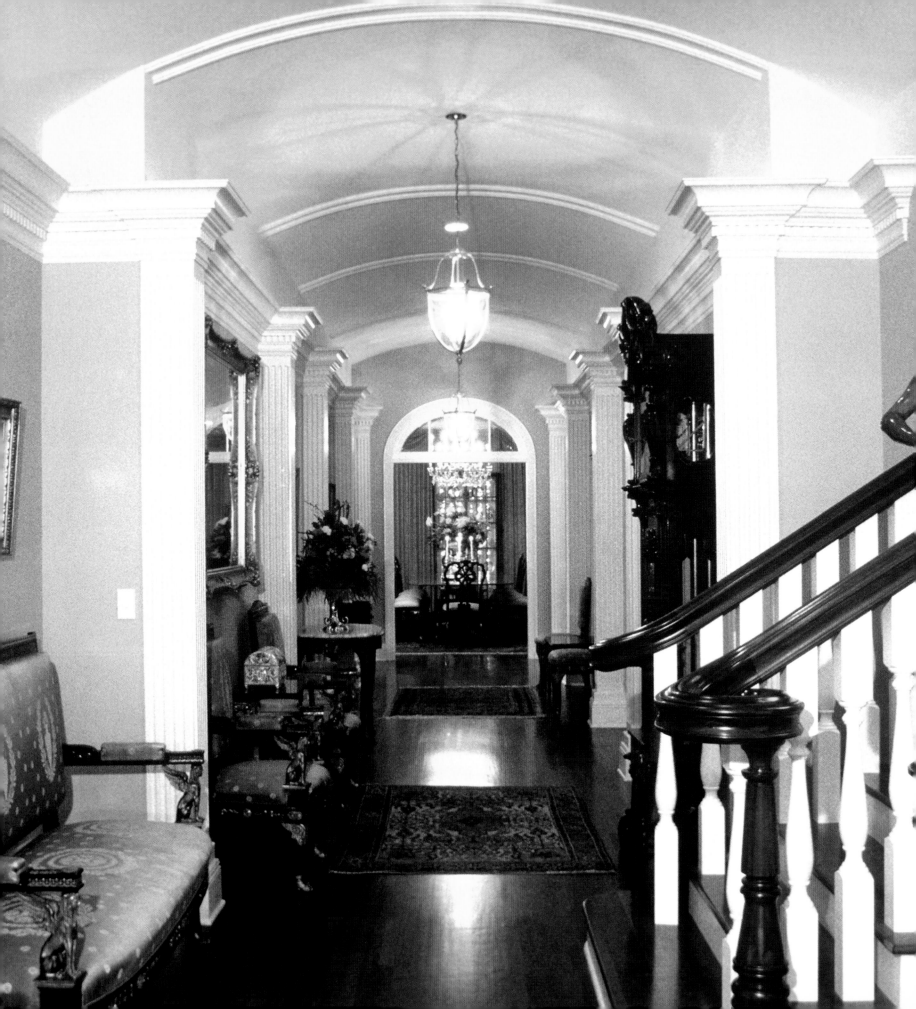

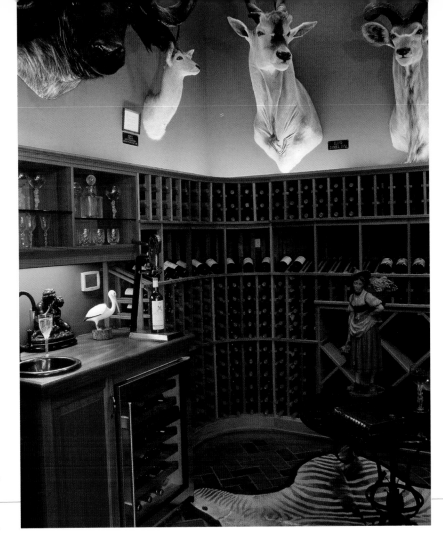

Maureen Miller

MILLER MANOR HOMES, INC.

An interior designer since 1973, Maureen Miller of Miller Manor Homes, Inc. began her career as sole designer in her private practice in Louisiana. It was at the request of a client so impressed by her decorating and design skills that she constructed and designed her first home in Louisiana. By the time she finished the project, she was inundated with requests from homeowners who had heard of the striking quality of her designs. Maureen's first project in Austin easily set the benchmark: the 6,500-square-foot custom concrete residence captured her creative spirit and presented a strong challenge to other area builders.

Today, she inspires her clients in Texas as she discovers ways of incorporating individual, unique lifestyles into the décor of the homes. She loves to travel, which provides her with essential learning experiences to recharge her talent and keep things interesting for her clients. In fact, she even lived in Athens,

Greece as a young girl: a place full of influential history and architecture which has stayed with Maureen to this day.

Maureen's unique vision and unlimited design techniques have earned her features in publications such as *Southern Living* and *Builder/Architect* where she was the first female builder published in Austin, Texas. This exquisite designer's philosophy has always been that there is always more than one solution to a design; a philosophy that obviously plays a vital role in her elegant creations, which scream individuality.

ABOVE:
The wine room offers a unique opportunity to showcase a world-class collection of trophies. These represent several continents on which the owner hunted.
Photograph by William E. Shaddock

FACING PAGE:
The central gallery sets the Georgian styling of the home and is the axis for entry to all the major rooms of the residence.
Photograph by Rex Spencer

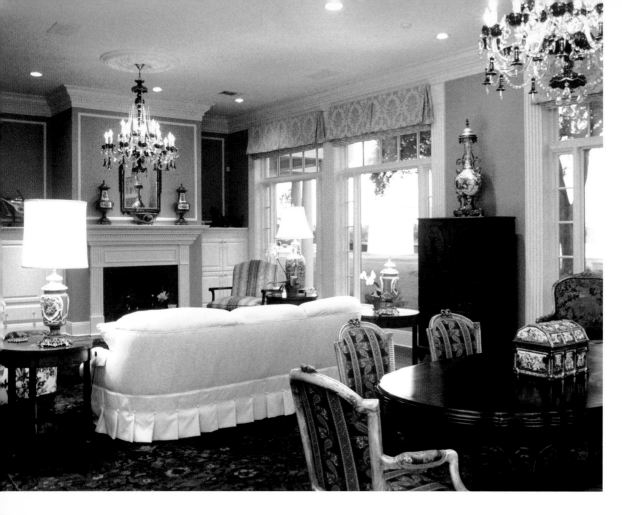

Detail in design is part of Maureen's passion when creating a client's vision; listening to the client is one of the most important aspects of what Maureen does as a designer. This allows her to reflect back on the client's design and style preferences with the added input of Maureen's professional knowledge and experience. From materials to furniture to layout, Maureen is there for her clients every step of the way to ensure nothing less than perfection.

Above all, Maureen's ultimate goal is the satisfaction of her clients, to help her clients develop the perfect home for their lifestyle. As she draws on inspiration from her travels, listens to her client's every word and works on a project until every detail is in place, Maureen's creations will forever stand the test of time.

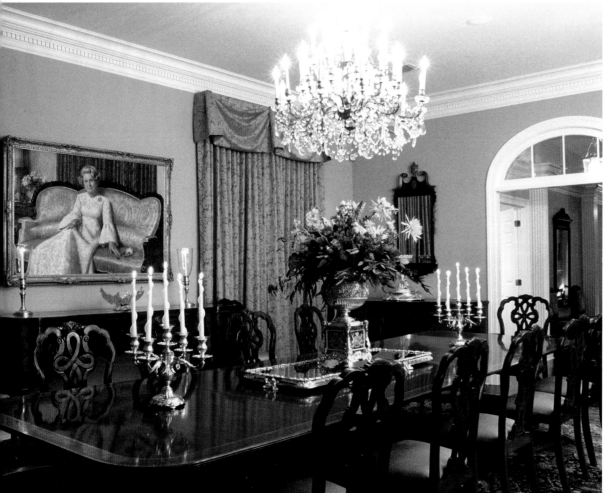

TOP LEFT:
The family's living room features matching crystal chandeliers from London and a commanding view of the lake. Fine antiques live comfortably with soft upholstery and make the room a favorite family gathering place.
Photograph by Rex Spencer

BOTTOM LEFT:
The dining room glows with the color of the salmon rose featured in the family portrait. It is repeated in the Brunschwig & Fils Albertini linen damask drapery, which creates a rich tone-on-tone statement, especially elegant in the evening light.
Photograph by Rex Spencer

Q&A

more about maureen ...

WHAT COLOR BEST DESCRIBES YOU?

Black is a color that I find shows up somewhere in my work each time. It is a great punctuating element that emphasizes all other colors.

IF YOU COULD ELIMINATE ONE DESIGN/ARCHITECTURAL/BUILDING TECHNIQUE OR STYLE FROM THE WORLD, WHAT WOULD IT BE?

None. They are each a reflection of historical significance to events of the time. We just continue to renew them all.

WHAT SETS YOU APART IN THE DESIGN WORLD?

My practice involves working from concept through construction to completion, and I have built the skills and experience to advise clients on every level of the project.

WHAT DON'T MOST PEOPLE KNOW ABOUT YOU?

That I am an introvert who has learned to be more extroverted.

WHAT IS UNIQUE ABOUT YOUR DESIGN OF THE SHADDOCK RESIDENCE?

The Georgian home was designed to appear as if it had always been on the property. It features classical details which reflect the period styling of the house and sets a background for the clients' three-generation collection of antiques. The interior design nicely complements the Georgian vernacular.

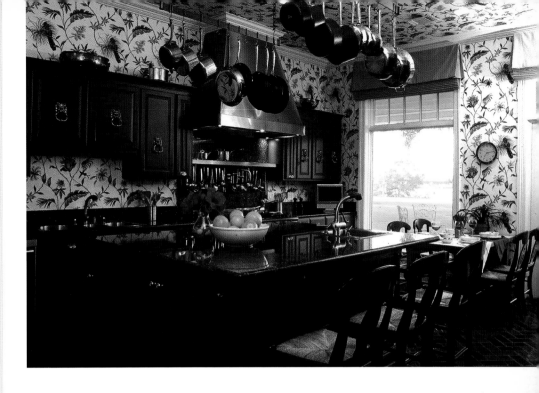

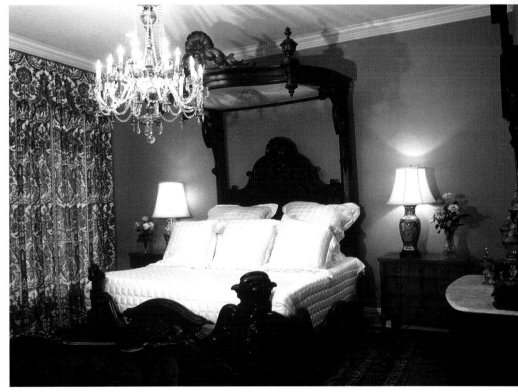

MILLER MANOR HOMES, INC.
TALBOT STUDIOS
Maureen Miller, ASID, NCBDC
4525 Golf Vista Drive
Austin, TX 78730
512.502.1818
f: 512.794.0245
www.millermanorhomes.com

ABOVE TOP:
The kitchen is highly detailed for the husband and wife who love to cook and entertain. Heavy brass door knockers become cabinet hardware, and blue pearl granite complements the Paris green cabinetry.
Photograph by Rex Spencer

ABOVE BOTTOM:
The master bedroom is a Wedgewood blue oasis which serves as a backdrop to the Mallard-styled rosewood bed and half tester. Matching dresser and armoire complete the furnishings, and Scalamandré fabric dresses the French doors with a view to the lake.
Photograph by Rex Spencer

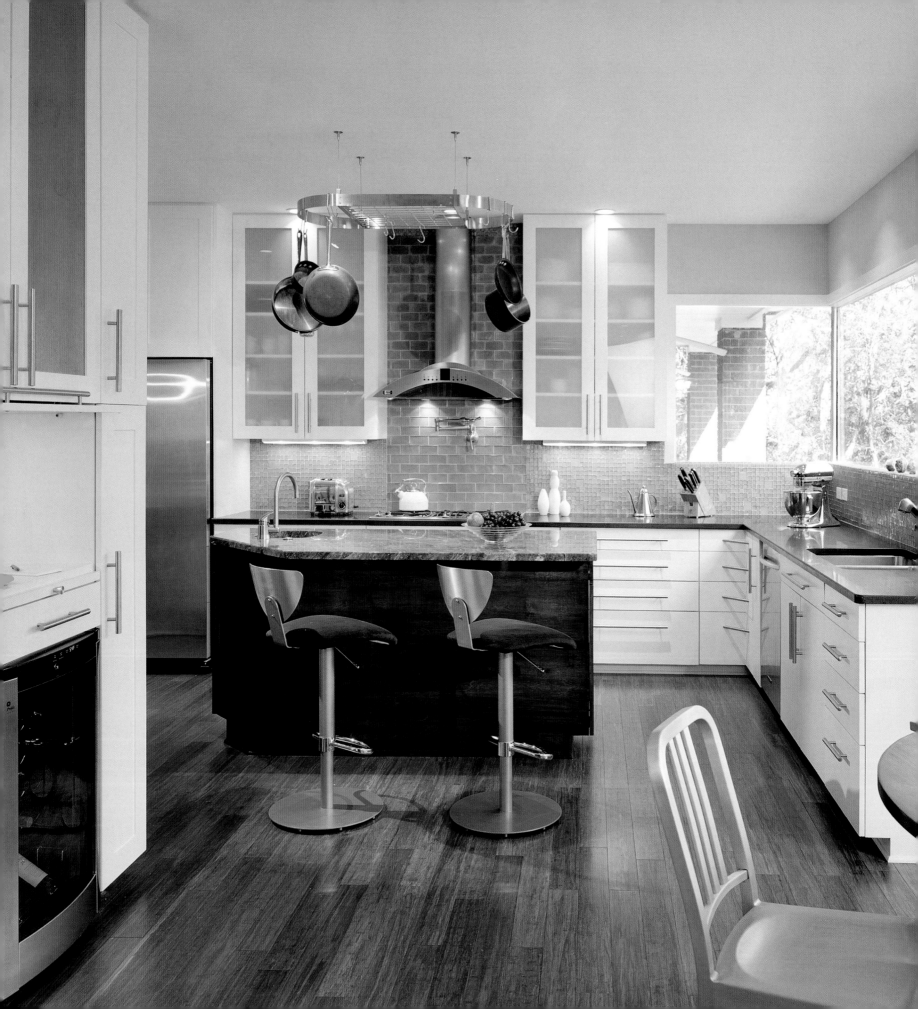

Sharon Radovich

PANACHE INTERIORS

Fundamentally conservative with a modern flair, Sharon Radovich, principal of Panache Interior Design, believes real elegance is about thoughtful choices in color, texture and form. She classifies her style as "livable luxury," which incorporates quality materials and classic design for a sense of ease and grace in everyday life. Clients value her astute solutions to their individual project needs and her ability to innovate at the grand level, while maintaining careful attention to the smallest detail.

An art advocate and collector, Sharon encourages the use of original art for her projects and organizes exhibits to showcase local artists' work. In addition to promoting art, she generously donates her talents to many compassionate projects and cultural fundraisers. She is licensed by the Texas Board of Architectural Examiners and is a member of the American Society of Interior Designers.

Sharon constantly questions the ordinary in search of surprising, long-lasting experiences. Her growing firm continually challenges itself and their talents are in demand coast-to-coast with a growing contingency in Southern California. She believes the risk in design is not being different or innovative; the risk is remaining static and predictable.

ABOVE:
Energized by metallic-silver walls and a striking red sectional, this sophisticated living area features a sleek walnut entertainment center and mid-century modern art.
Photograph by Osborn Photography

FACING PAGE:
This renovated kitchen now boasts a panoramic view and ample cabinetry. Trendy yet timeless elements include icy-blue glass tiles, honed black granite and a rich bamboo floor.
Photograph by Thomas McConnell

PANACHE INTERIORS
Sharon Radovich
5621 Shoal Creek Boulevard
Austin, TX 78756
512.452.7773
www.panacheinteriors.com

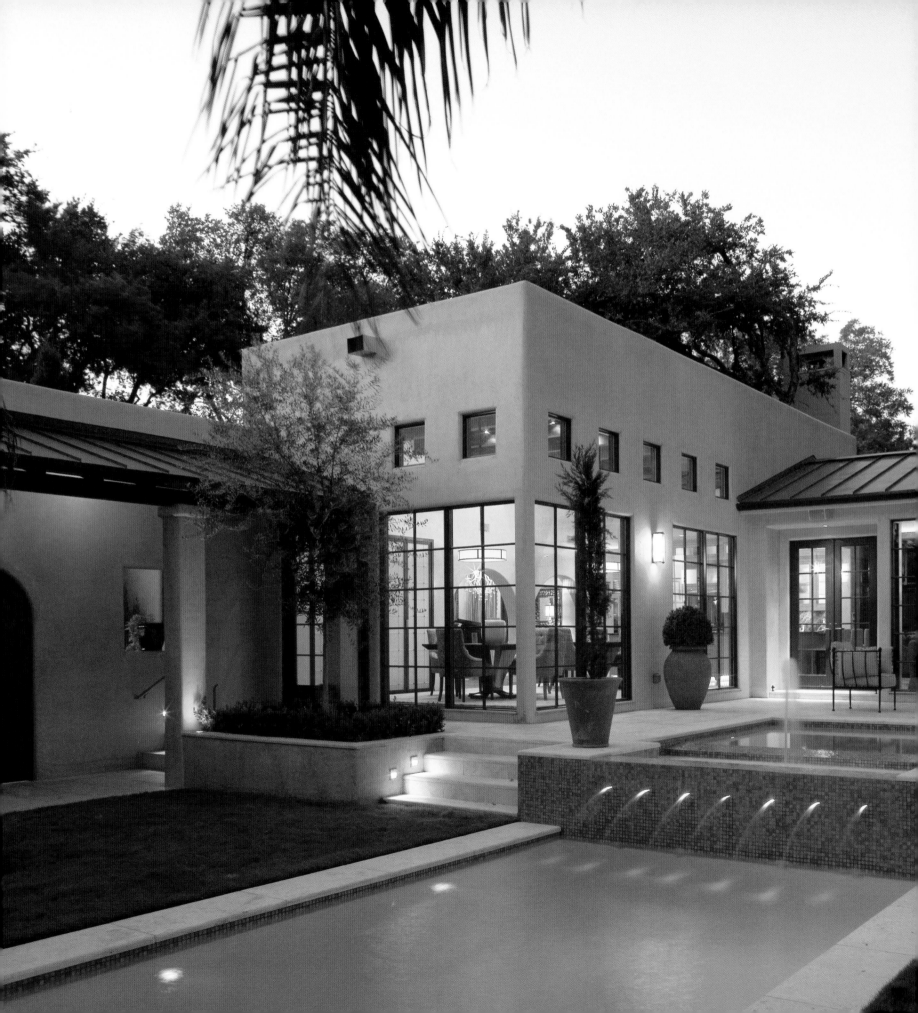

Victoria Reed

VICTORIA REED DESIGN

A University of Texas at Austin graduate, Victoria Reed launched Victoria Reed Design in 1984— a four employee design boutique that has been featured in various regional publications. "Simplicity doesn't have to be boring, I like mixing wonderful pieces regardless of era to create a client's sanctuary. I team that with my background in lighting to create spaces that have a functional aesthetic but are characterized by comfort, peace and serenity. I like to organize a room to be a living, breathing space that reflects the client's moods."

The Austin area provides a wealth of opportunities for this truly Texan designer, from city lofts to sprawling estates, even ranches where homes are nestled inside of expansive acres with rolling landscapes, and Victoria's sought-after skills have provided her the occasion to work on a varied range of projects both inside and outside of the city limits. One such project was a stunning Hill Country

LEFT:
The linear pool visually connects the main house to the outdoor kitchen and cabana. The materials consist of organic stucco and neutral limestone contrasted with modern light fixtures and glimmering mosaics.
Photograph by Paul Baradgjy

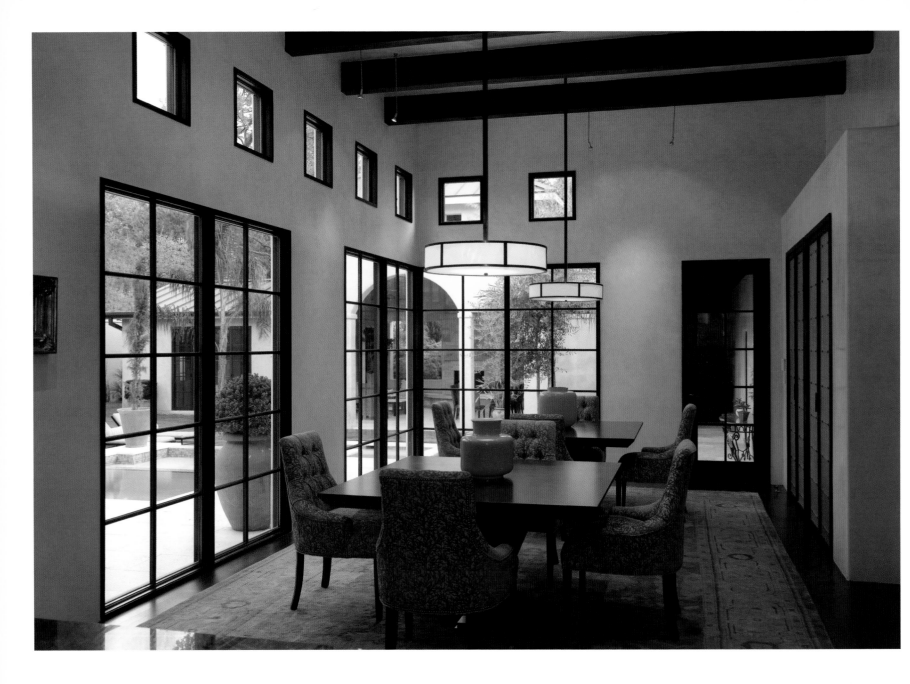

summer retreat for a family of five, complete with exotic game animals they were raising on their land.

Creating a home that mirrored the natural beauty of the surrounding environment, Victoria used native materials to create many of the ranch's incredible features. Chandeliers were handmade of the antlers found on the ranch grounds and the limestone walls and fireplace of the master suite were built from deposits unearthed in the backyard. Victoria was also able to use reclaimed supplies from Fredericksburg and East Texas as architectural details on the outside, as well as in the kitchen of the home.

Keeping the function of the home solidly in mind, the rustic yet refined interiors of the ranch house are clearly family-friendly, a requirement of the owners. Spaces are beautiful and functional, meeting both aesthetics and need, and Victoria has also enjoyed her many visits back to the ranch. Acknowledging that design is not only about spaces, but more about people, Victoria most enjoys the personal relationships she develops with clients while designing.

Q&A
more about victoria ...

WHAT ELEMENT OF DESIGN MOST REFLECTS YOUR LIFESTYLE?
My Mexican upbringing has always been a dominant influence for me in my creation of unique Hacienda-style living spaces.

IS THERE A PARTICULAR STYLE YOU EMPLOY IN MOST OF YOUR DESIGNS?
My love of outdoor spaces is often seen in many open-air kitchens I have designed and I prefer to mix the modern fixtures with traditional materials. I also like to use walls that are textured marvels of stucco or old dark wood to produce a warm, inviting space, and succulent cacti frequently adorn my alfresco creations.

WHAT ADVICE WOULD YOU GIVE TO A CLIENT?
Do away with clutter! Decorate your open spaces with big pieces you love—this will produce a clean look that reflects your personality.

VICTORIA REED DESIGN
Victoria Reed
1703 Elton Lane
Austin, TX 78703-2913
512.474.5084
f: 512.474.4665

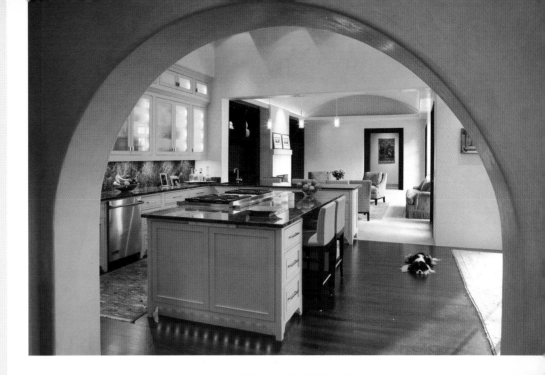

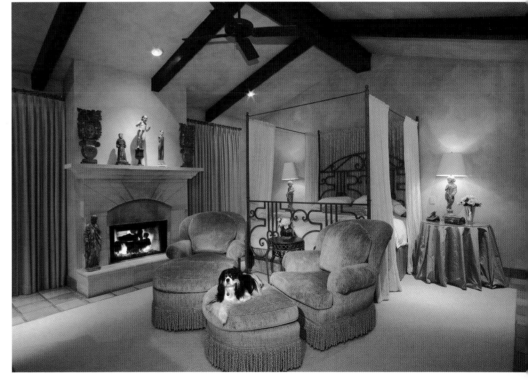

ABOVE TOP:
Lighting was very important in the design of the kitchen, illuminating the new design features such as the volume of the space and elegant materials of mahogany and marble.
Photograph by Paul Baradgjy

ABOVE BOTTOM:
Comfort is the key to this bedroom, which opens to the pool side. Custom stone fireplace works as a backdrop for religious Colonial art pieces.
Photograph by Paul Baradgjy

FACING PAGE:
The large architectural windows in the dining room allow the outdoors into the indoor living areas. A pair of custom-built mahogany dining tables fills the space, while creating a unique dining experience.
Photograph by Paul Baradgjy

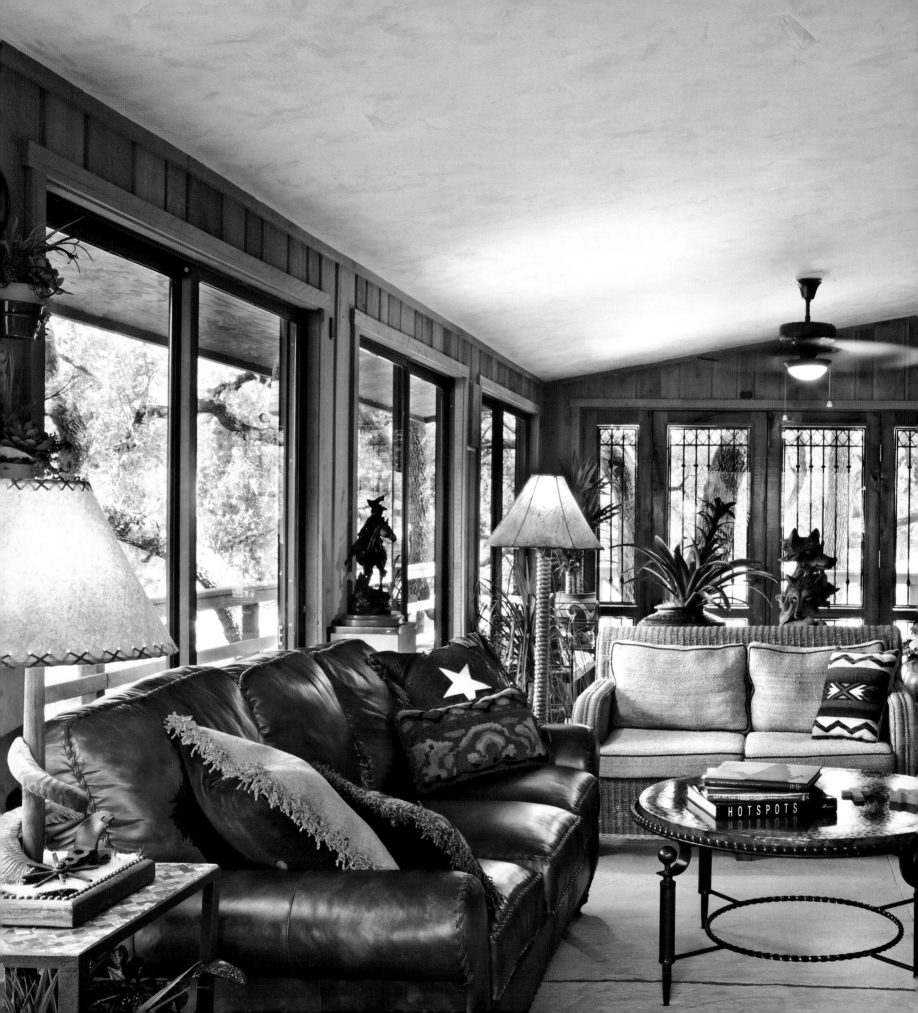

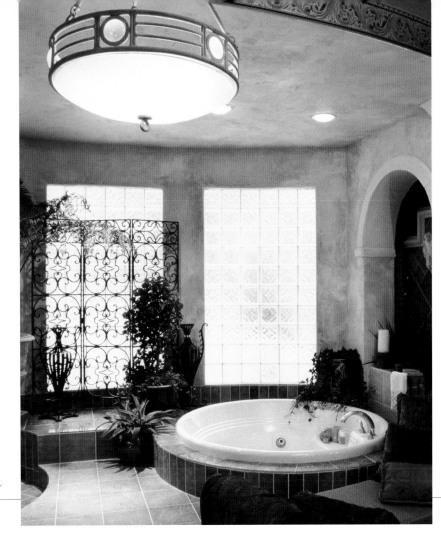

Patti Riley-Brown

PATTI RILEY-BROWN, ASID & ASSOCIATES

By definition, interior design should reflect a client's needs while presenting a pleasing aesthetic. For Patti Riley-Brown, it is a challenge she loves to meet every day. With integrity as her driving force, Patti takes each project, and her client's trust, very seriously, meeting their standards with the utmost dedication and professionalism while always striving to exceed expectation.

Patti's 40 years of experience and full accreditation (ASID, IDEC, NCIDQ) places her and her firm, Patti Riley-Brown, ASID & Associates, with the most elite in the business. Bestowed by the American Society of Interior Designers with one of their highest honors, Patti served on the National Board of Directors after becoming an ASID medalist. Patti has also received numerous "Design Excellence" awards from ASID as well as the "John Robinson" award from TAID. Additionally, Patti's extraordinary work has been featured in the pages of *Designers West, Southern Living, Austin Home and Living* and *The Austin American Statesman*. She was very instrumental in obtaining registration for Texas interior designers. Her own license number in the state is #003!

After receiving a Bachelor of Science degree in interior design from the University of Texas, Patti began her prolific career in Austin and has practiced there ever since. And what does she love most about Austin, Texas? "Texas Hill Country people are just wonderful," she says. "They reflect the freedom and beauty that surrounds this area of Texas."

ABOVE:
This luxurious master bath is featured in a villa on Lake Austin, Austin, Texas.
Photograph by Tracy Kimmons

FACING PAGE:
Warm sunlight fills the entry/sunroom within this ranch residence near New Braunfels, Texas.
Photograph by Cole Hairston

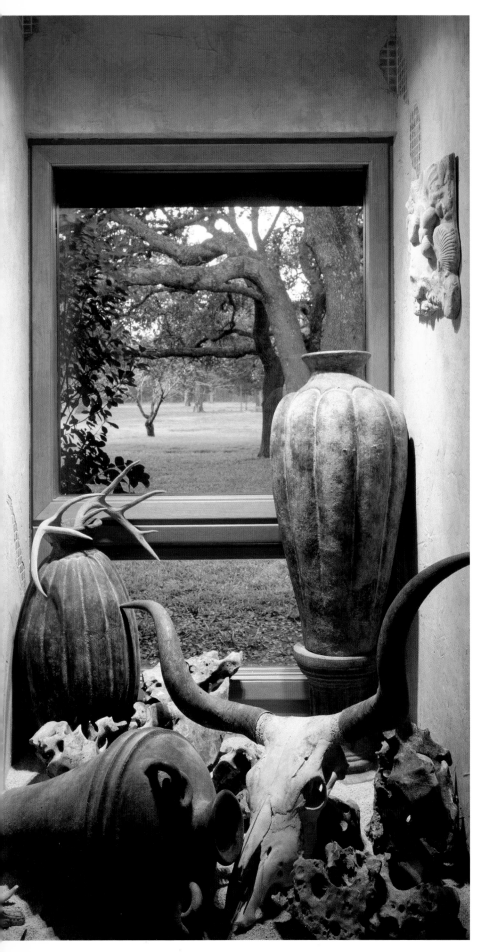

Along with her valued friend and long-time employee and associate, Linda Davis, ASID, Patti Riley-Brown boasts a remarkable client roster that ranges from executives to royalty. "I had the amazing opportunity to design a town house in the Chelsea area of London, England for the royal family of Saudi Arabia. Strangely enough, it was not without budget restrictions, but it came out beautifully." She also has installations in three other foreign countries, 13 U.S. states and the District of Columbia.

Giving careful consideration to the balance, proper scale and proportion of each space, Patti ensures the success of the design as a whole. With her extensive background in construction, remodeling has become a large part of her current practice. Whether designing new interiors or refurbishing existing ones, Patti skillfully expresses her client's lifestyle and preferences using her creative expertise.

When asked what she loves most about interior design, Patti passionately declares that bringing ideas to fruition gives her the most satisfaction and hearing her clients express their pleasure with the result is "worth it all."

LEFT:
A vignette in this customized hall niche was designed to reflect existing ranch surroundings near San Marcos, Texas.
Photograph by Patrick Wong

Q&A *more about patti ...*

WHAT IS YOUR DESIGN STYLE OR PREFERENCE?
I prefer an uncluttered, straight-forward look but always defer to the requirements of the project. Traditional environments require more detail than their contemporary counterparts, and much depends on my clients' tastes.

TELL US ONE THING PEOPLE MIGHT NOT KNOW ABOUT YOU.
I am a rock hound. I love to collect geodes and minerals and try to find them on my own. I also love to sing and really belt it out at church where no one will notice in the crowd!

WHAT IS THE MOST UNUSUAL OR DIFFICULT DESIGN TECHNIQUE THAT YOU'VE USED?
Trying to get a boardroom table into an office where it would neither fit through the halls or doors was difficult. We had to lift by crane the huge, beautiful table through the window of the 13th-floor office.

PATTI RILEY-BROWN, ASID & ASSOCIATES
Patti Riley-Brown, ASID
3837 Steck Avenue
Austin, TX 78759
512.345.5047
f: 512.345.8482

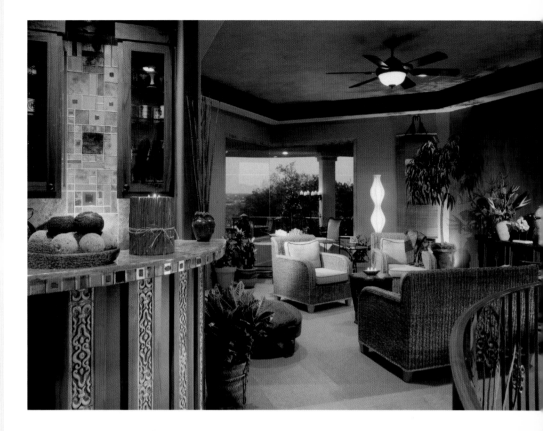

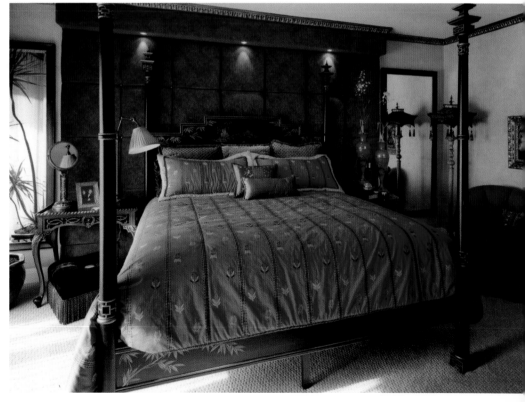

ABOVE TOP:
The family room and bar overlooks a shining golf course in Austin, Texas.
Photograph by Mark Knight

ABOVE BOTTOM:
This elegant master bedroom was created for a single lady who preferred Oriental décor. It features an engaging upholstered wall. Austin, Texas.
Photograph by Thomas O'Connell

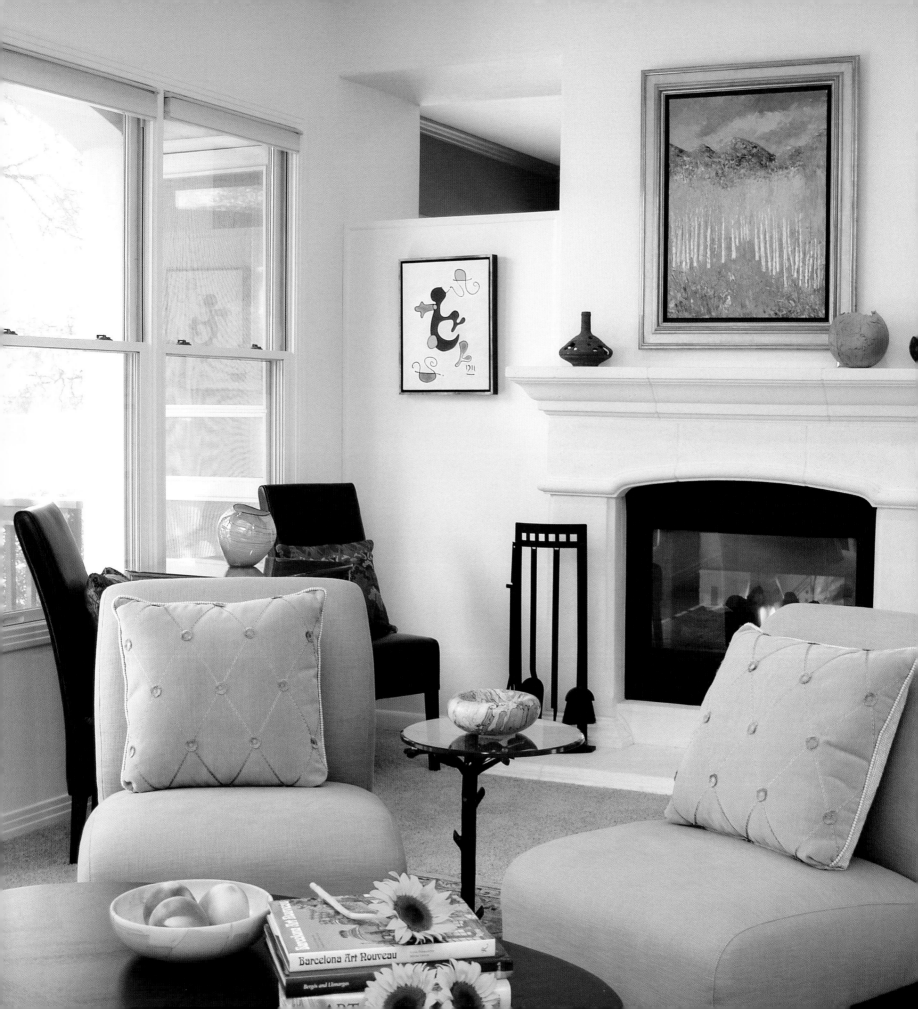

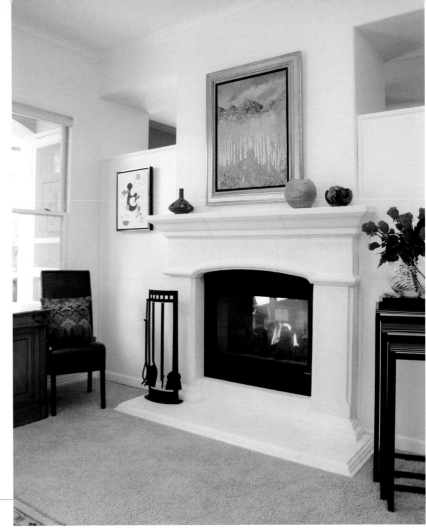

Molly Scott

MOLLY INTERIORS

or Molly Scott, artistic ability runs in the family. Molly's parents and grandparents were both creators and entrepreneurs, so it was only fitting that she would become an interior decorator and establish her own firm, Molly Interiors. A graduate of the University of North Texas, Molly also studied architectural styles, period furniture and interior design at the University of London. Now Molly Interiors, her Austin-based firm, specializes in residential interiors, organization and space planning, accessorizing, home furnishing, feng shui interpretations and preparations for selling a home.

Clients come to Molly because they know she is the designer that can help heighten and enhance the visual aesthetics and functionality of their homes.

ABOVE:
A miniature gallery functions as a backdrop for this home's principal public space. Passionate collectors, the owners have chosen their objects with purpose. Each piece has a tale to tell and needs its own spot from which to shine.
Photograph by Chris Diaz

FACING PAGE:
Cool, languid conversations punctuated with bright bursts of laughter stretch across lazy hours in this sitting room where a serene aura of light washes over open space, changing day by day, hour by hour.
Photograph by Chris Diaz

MOLLY INTERIORS
Molly Scott
612 Highland Avenue
Austin, TX 78703
512.496.9857
www.mollyinteriors.com

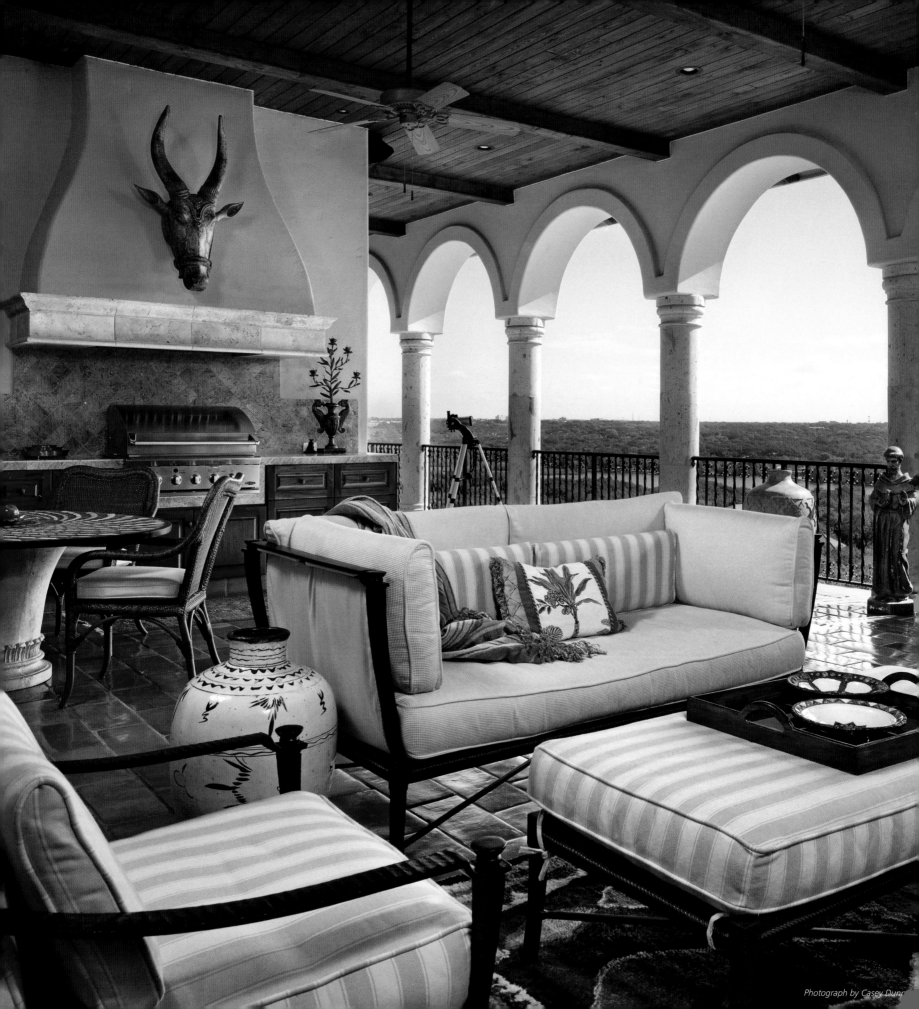

Sandy Senter

SENTER CONSTRUCTION AND DESIGN

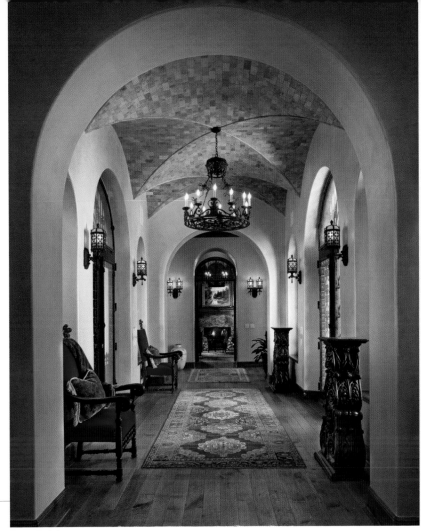

Photograph by Casey Dunn

Sandy Senter attended the University of Texas, but after landing a job with the Sergeant at Arms in the Senate, he found himself spending much more time at the Capitol than on campus. Through his years with Mark White in the Attorney General's Office and the Governor's Office, he had an established political career and found many high-profile friends and colleagues. Among them was the legendary Bob Bullock, the late Lieutenant Governor of Texas, for whom Sandy acted as a liaison to the State Preservation Board which included the Capitol Restoration Project. So thrilled with this project that it no longer felt like work, his budding interest in construction and design fully blossomed.

Breaking from politics, Sandy paired his natural aptitude with his brother Mike's knowledge of the construction industry; Senter Construction and Design was established. Specializing in million-dollar homes, Sandy found that previous professional relationships soon provided him with an abundance of business. Sandy's client list does not only consist of politicians; his client roster also boasts Andy Roddick, "Stone Cold" Steve Austin and The Crown Prince of Morocco and many prominent Texans.

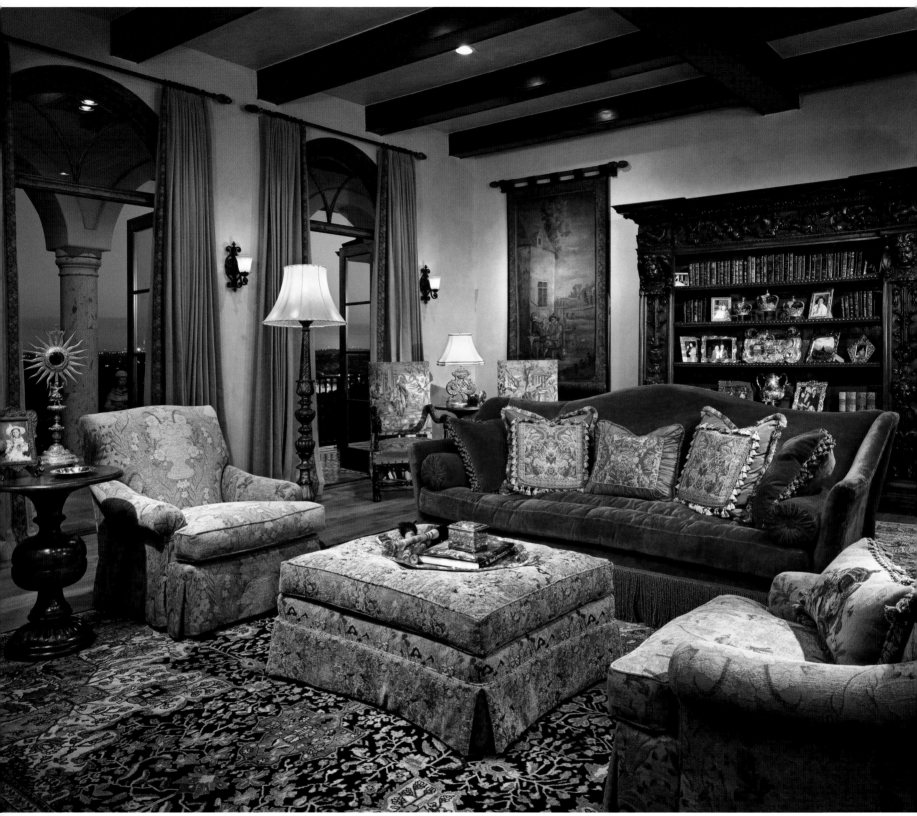

Photograph by Casey Dunn

Q&A

more about sandy ...

IS THERE ONE PROJECT THAT STICKS OUT IN YOUR MIND AS BEING ESPECIALLY OUTSTANDING?
The project that is featured in this book was particularly special to me because the end result was so fantastic. The client and I developed such a wonderful partnership and they were pleased with each and every detail. The client's satisfaction is really the mark of a successful project.

WHAT DO YOU LIKE MOST ABOUT DOING BUSINESS IN AUSTIN?
The Austin vibe is laid back and people here don't take themselves too seriously. There's a quality of lifestyle here that is hard to find anywhere else.

WHO HAS HAD THE BIGGEST INFLUENCE ON YOUR CAREER?
My association with the State Preservation Board was instrumental in the development of my career. The opportunity to be involved in the Capitol Restoration Project was a defining moment in my life path. There have also been many mentors in architecture, design and construction that have shaped my ideas along the way.

WHAT IS THE BEST PART OF BEING AN INTERIOR DESIGNER?
Making new friendships with clients is the best part of what I do. This is such a personal business; I am constantly in my clients' personal space, so it's very important to click with the client on both a professional and personal level.

WHAT SETS YOU APART FROM OTHER GREAT DESIGNERS?
Most importantly, I do so much more than just design interiors. It is an integral part of my process that I am involved in construction, design and all aspects of the progression.

SENTER CONSTRUCTION AND DESIGN
Sandy Senter
2608 Thomas Drive
Austin, TX 78703
c: 512.917.5193
f: 512.479.6077

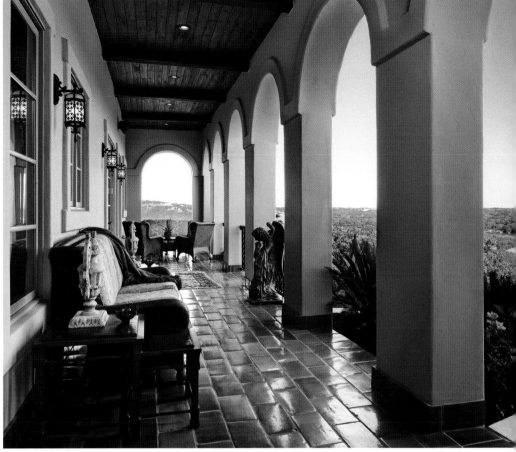

Photograph by Casey Dunn

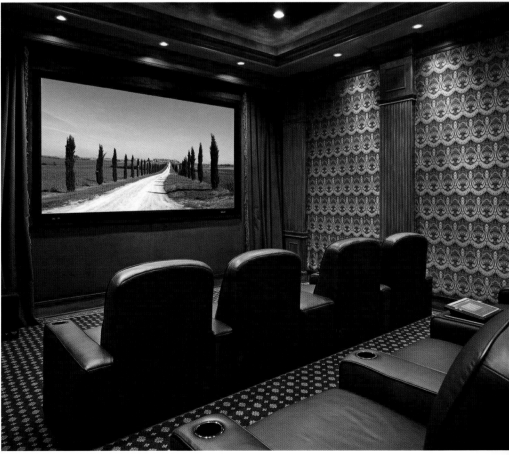

Photograph by Casey Dunn

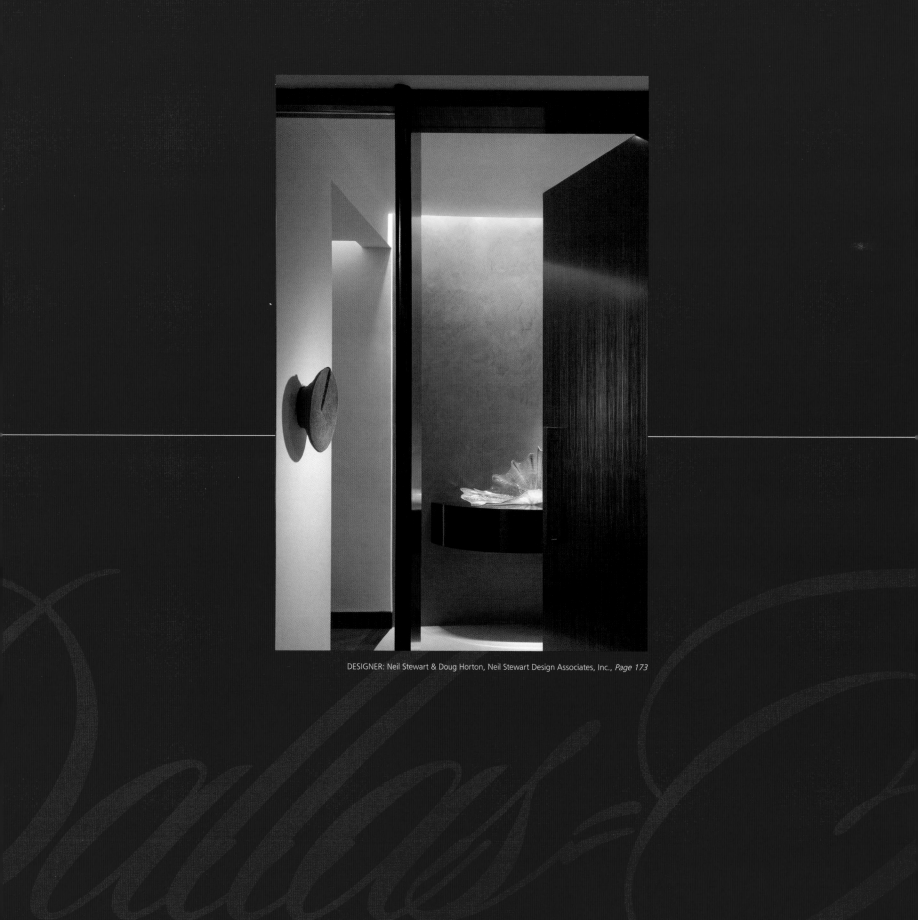

DESIGNER: Neil Stewart & Doug Horton, Neil Stewart Design Associates, Inc., *Page 173*

DALLAS / FORT WORTH

AN EXCLUSIVE SHOWCASE OF DALLAS / FORT WORTH'S FINEST DESIGNERS

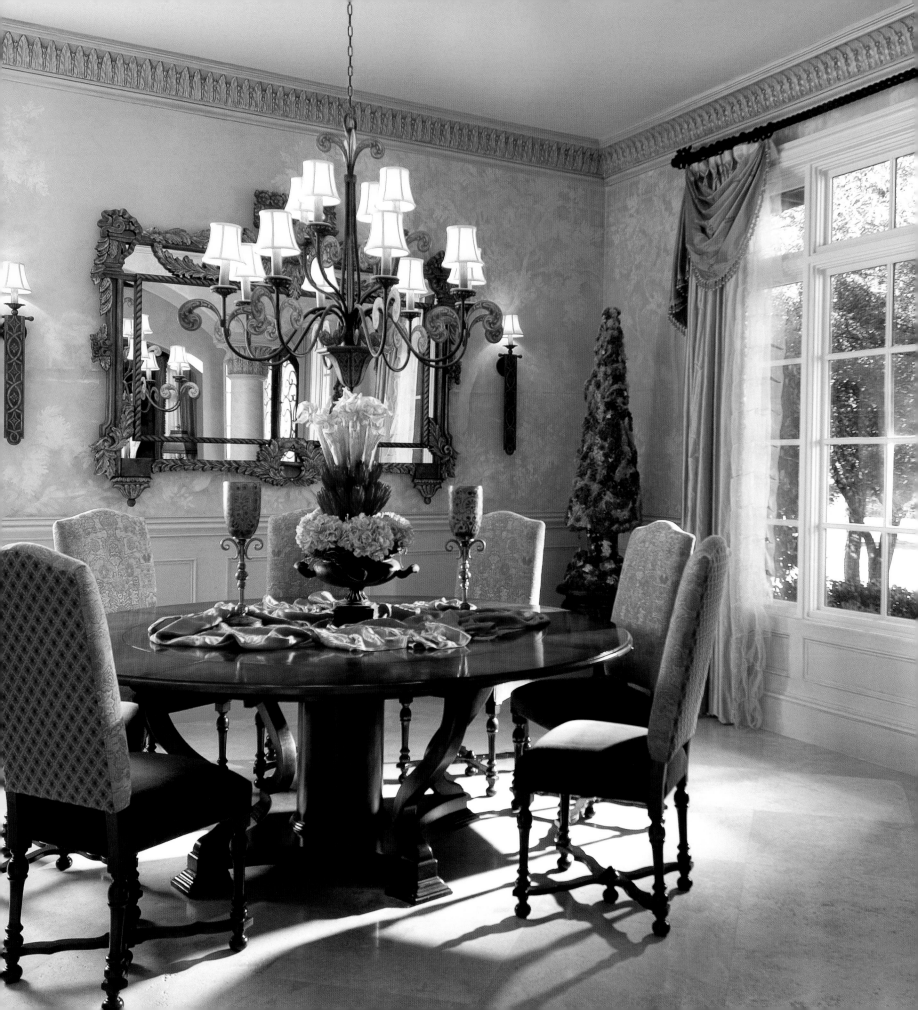

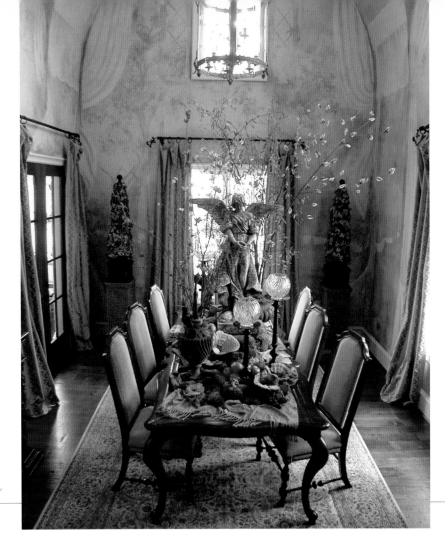

Ashley Astleford

ASTLEFORD INTERIORS

*Y*ou would never guess that Ashley Astleford started out as a shy child. But, when she began studying interior design, she felt she had truly found her niche and emerged from her shell a confident, bold, dynamic and energetic woman.

All of these expressions also describe Ashley's radiant designs. A self-professed color fanatic, Ashley uses bold color as her inspiration, then infuses homes with balance and symmetry. Artfully crafted and expressed, her lush interiors present organic elements in unique and exhilarating ways. Rich tones and flowing lines add refinement while texture and breathtaking finishes add drama to the space.

And, Ashley has yet to meet a style that she doesn't like! Using each opportunity to immerse herself in her client's dream, she transforms raw space into rooms of life and personality. Each home, each interior, is a pure reflection of her client's sensibilities and meets necessity with approachable elegance. Drawing character from the details, classic proportions are bordered with touches of whimsy, articulating the enthusiasm Ashley exudes for each design.

ABOVE:
In this award-winning dining room, Ashley interprets an outdoor wedding banquet through natural details and exquisite artistry.
Photograph by Danny Piassick

FACING PAGE:
This space lends itself perfectly to a natural style of design that Ashley loves. Soft and relaxing elegance is accomplished by surrounding the room with a tonal Japanese garden wall finish. Perfect for conversation, the round dining table establishes balance and symmetry. A unique drapery sheer adds just a touch of whimsy.
Photograph by Jim Dodd

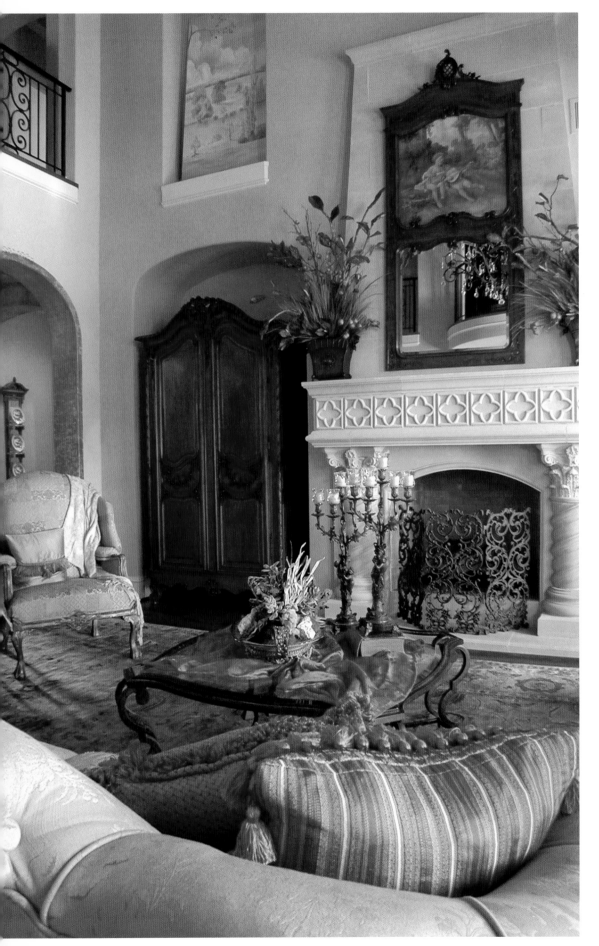

Recently, Ashley's interpretation of a French Normandy Chateau earned the award for "Best Overall Interior Design" in the 2005 Dallas Home Builders Association Parade of Homes. The award is certainly fitting acknowledgement for one of the area's finest designers.

LEFT:
A collection of French antiques is joined by warm color to create this commended rendition of a chateau great room. Elements such as the antique armoire, candelabras, trumeau-style mirror, and even the bronze and crystal chandelier peeking down from above the fireplace blend seamlessly to draw one into its grand presence.
Photograph by Jim Dodd

FACING PAGE:
This warm and inviting living room contains pieces assembled from a variety of sources. The client's acquired pieces such as the antique grandfather clock, new furnishings and eclectic pieces come together to form a livable environment. Red mohair armchairs represent the pops of color that bring an added energy to the space. The palatial-sized antique fireplace screen purchased in Belgium was left in its current unrestored condition. Burned out needlework from years past brings charm and truth to the design.
Photograph by Danny Piassick

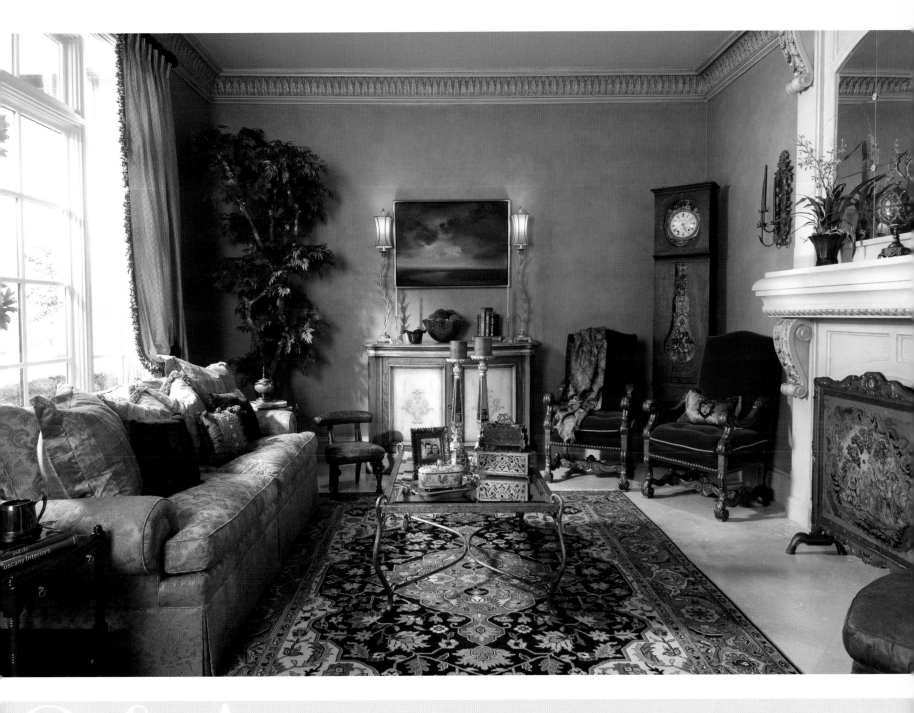

Q&A

more about ashley ...

HOW LONG HAVE YOU BEEN AN INTERIOR DESIGNER?
Since 1995 and I started my own firm in 2000.

WHAT COLOR BEST DESCRIBES YOU?
Red, because it is bold, strong and very in control.

WHAT IS THE HIGHEST COMPLIMENT YOU'VE RECEIVED PROFESSIONALLY?
I was once told by a business consultant that I was the young Michael Jordan of the design industry. I was deeply honored.

YOU CAN TELL I LIVE IN TEXAS BECAUSE ...
My Texas accent immediately gives me away.

ASTLEFORD INTERIORS
Ashley Astleford, ASID
5604 Turtle Way
McKinney, TX 75070
972.529.2061
f: 972.529.9546
www.astlefordinteriors.com

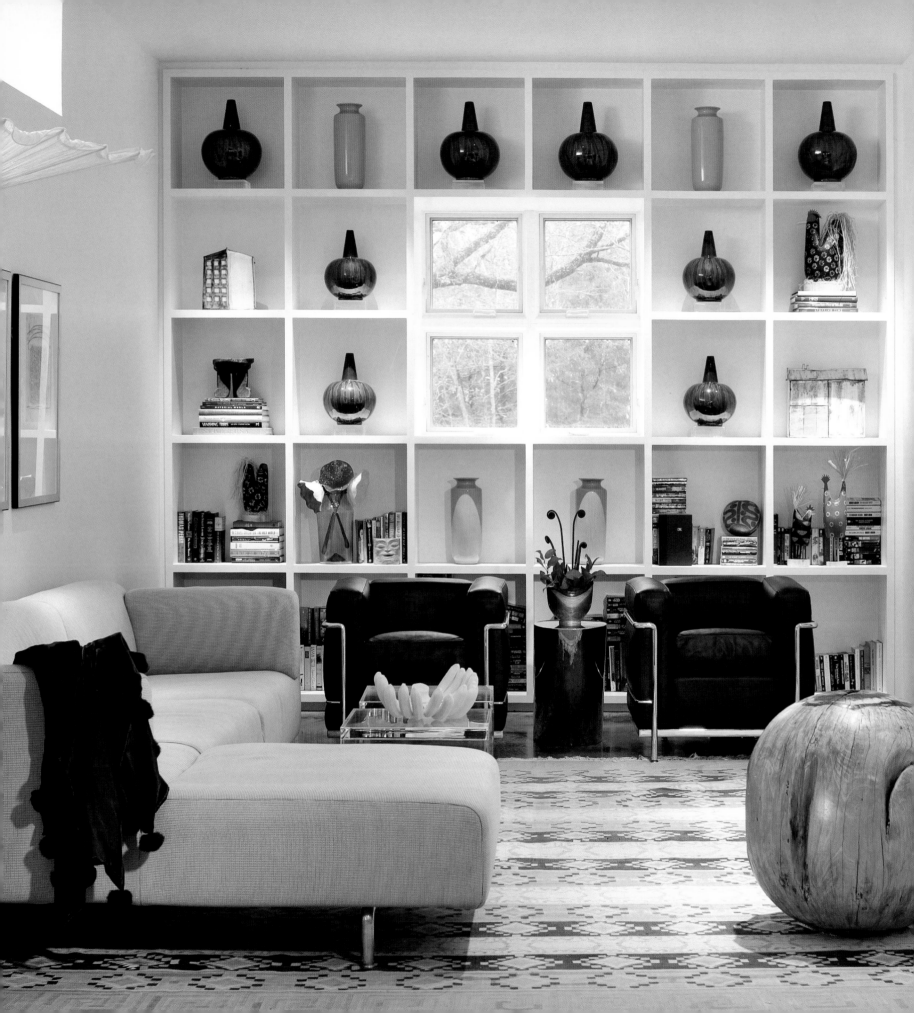

Donn Bindler

DONN BINDLER ASID

Founding his business in his childhood hometown in East Texas in the late 1960s, Donn Bindler has since established a remarkable design firm and a reputation to match. During his practice which has spanned over 40 years, Donn has been closely connected to Dallas and the Design District. In addition to his design practice, he has owned two showrooms focusing on presenting contemporary furniture and defining the modern movement. Showcasing Donn's eye for the extraordinary, many of these lines were new to Dallas in the mid-1990s and years later, continue to flourish in prominent showrooms throughout the Design District.

It seems that once clients find Donn and his work, they hold on to what they know is a good thing. Many of his early clients remain his best clients, and he has had the joy of watching their children mature, their professions emerge and their lifestyles change. An example of his incredible ability to build lasting relationships lies in a current project in which he is involved for a client who has been living and working in his spaces for over 40 years. Currently designing a residence in East Texas for this client, he has also worked on their three previous homes, a lake house, several offices and even dorm rooms for the children at college.

ABOVE:
The red spiral staircase leads from the kitchen to the third-floor roof, which is an observation and entertaining space overlooking an East Texas lake.
Photograph by Danny Piassick

FACING PAGE:
The design of the bookcase wall in the library echoes the two-by-two window structure that is prevalent throughout the house. Sofa and chairs are by Cassina, the stainless steel table is one of the designer's favorites: J. Wade Bean's zephyr table for Brueton. The large tamarind wood ball doubles as sculpture and a seating option.
Photograph by Danny Piassick

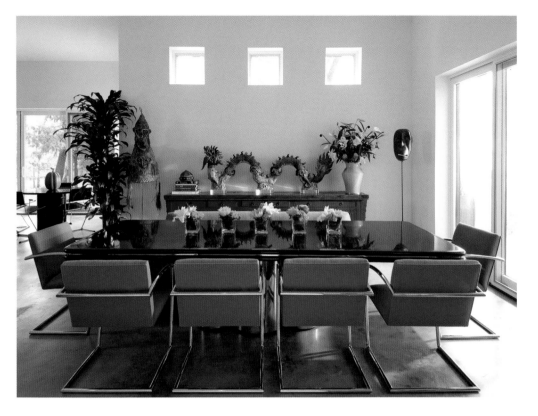

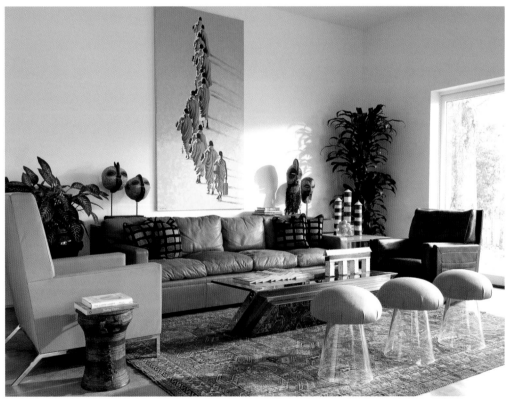

The home featured in this book belongs to another client who shares a relationship with Donn that spans over 40 years. This lake residence is a frequent weekend retreat for the client, the designer and their friends. "It is unique that a designer gets to live in a home he designed for a client. I get firsthand experience with the successes and mistakes of the project," Donn shared. He also feels that working with the same client multiple times keeps him more inventive and challenged as a designer and gives him the ability to take himself and his client to a "new edge."

Prevalent in much of Donn's work is his priority to the project's scale, balance and purity. He defines scale as keeping the interiors true to the architecture; balance as the symmetry that teeters on perfection and teases the mind as it pleases the eye and the soul; and purity as simply knowing when to quit. The perfect cohesion of all three elements is critical to success and visible in each project he completes.

ABOVE TOP:
The focus of the dining area is the 19th-century dragon—a Vietnamese roof tile—which established the house's name: Dragon House. The table and chairs are from Brueton and the accessories are the owner's collection of tribal art.
Photograph by Danny Piassick

ABOVE BOTTOM:
The living room is "watched over" by a large painting of ascending monks by Mia Wae Aung. Furnishings are Ralph Lauren and Brueton.
Photograph by Danny Piassick

Q&A

more about donn ...

WHAT IS THE MOST UNIQUE HOME WITH WHICH YOU HAVE BEEN INVOLVED?

I have recently had the pleasure of creating a retreat on the sea of Cortez in Baja Mexico for East Texas clients of 20 years. I was with the client when they purchased the property and selected the builders, engineers and architects. Every item was purchased for the home during the design process, including furniture, art, dishes, linens, fixtures and antique doors which were incorporated into the scale and design of the house. This structure was truly created for the owner and for the site. I cannot imagine this home belonging to anyone else or being anyplace else other than this cliff. That is what design means to me.

WHAT DO YOU LIKE MOST ABOUT DOING BUSINESS IN DALLAS?

During the years I have had the opportunity to visit some of the major design centers in the United States and Europe, but I keep coming back to the Dallas Design District for product knowledge and inspiration. In part, I attribute my success to the dedication of the independent showrooms in the city such as Sutherland, Walter Lee Culp, George Cameron Nash, Allan Knight Associates and Scott-Cooner.

DONN BINDLER ASID
Donn Bindler
PO Box 192253
Dallas, TX 75219
214.638.4449
f: 214.628.4464

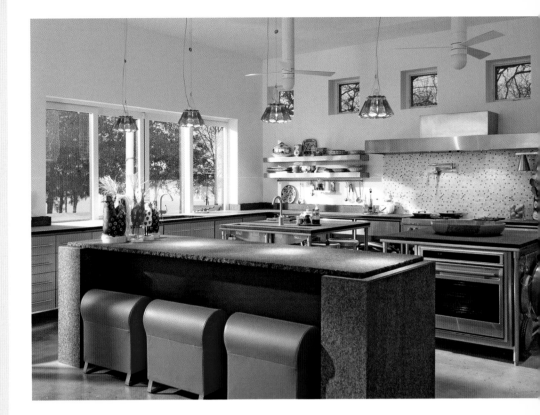

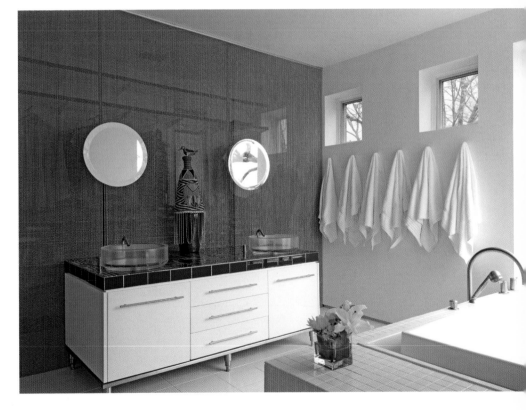

ABOVE TOP:
The kitchen is a true "working kitchen" with multiple islands made of stainless steel and flamed granite. The pendant lights, made from Campari bottles, are from Scott-Cooner, the red leather saddle stools are from Ling Roset.
Photograph by Danny Piassick

ABOVE BOTTOM:
The master bath features a Kohler "sok" tub. The wall of stainless steel beads, with custom ceiling-mounted mirrors peeking through, creates a curtain wall hiding the closet. The lav bowls are from Porcher.
Photograph by Danny Piassick

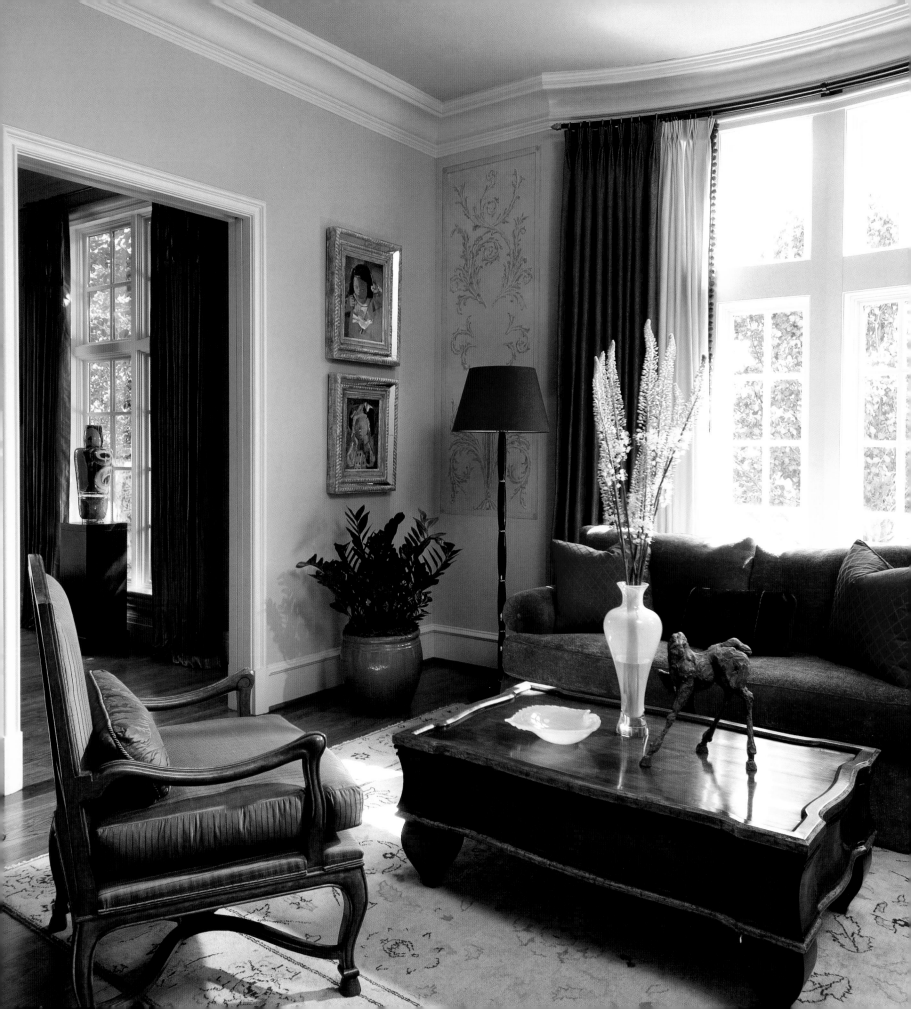

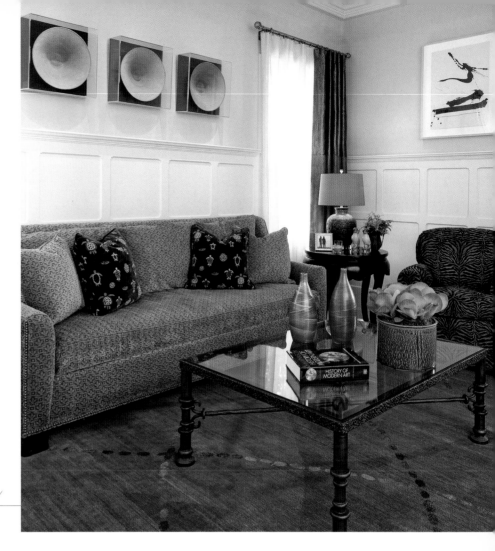

Anne Marie Bostrom

A.M. BOSTROM INTERIORS

*A*part from the close relationships that she forms with her clients, the one thing that Anne Marie Bostrom enjoys most about design is that no two projects are alike. This offers her the opportunity to find creative solutions while designing vastly different yet beautiful interiors.

Growing up in Guyana, South America, she enjoyed a truly international upbringing. Two months a year, her parents would take Anne Marie and her siblings abroad to visit family and friends and explore new countries and cultures around the world. Anne Marie's young interest in design was piqued by the unique and distinct environment of each new place she visited. Living in Europe also had an enormous impact on Anne Marie's design sensibilities; the contrast of exquisite, traditional architecture and clean, modern design was put together in a very stimulating way.

Finding global styles refreshing and vital, Anne Marie's international travels have also influenced her approach to design. Working closely with

clients and hopefully expanding their horizons, she encourages the addition of personal touches and preferences, incorporating treasured possessions to create an atmosphere that reflects each individual's personality accurately, comfortably and with understated yet elegant chic.

Beginning her design career in Las Cruces, New Mexico, Anne Marie interned with Charles Inc. Design where she gained invaluable, firsthand insight into the intricacies of the design process as well as the handling of projects from start to finish. A designer now for 12 years, Anne Marie has spent half of those years building her now steadily growing firm and impressive portfolio.

ABOVE:
Black accents add definition and a touch of drama to an understated, informal living room.
Photograph by Danny Piassick

FACING PAGE:
The starting point of this intimate living room comes from the vibrant color palette of oil paintings by Raymond Kanelba. Exquisite silk and linen draperies by Custom Rods & Draperies.
Photograph by Danny Piassick

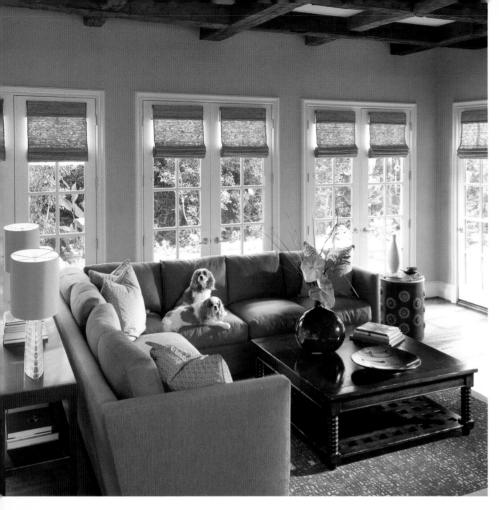

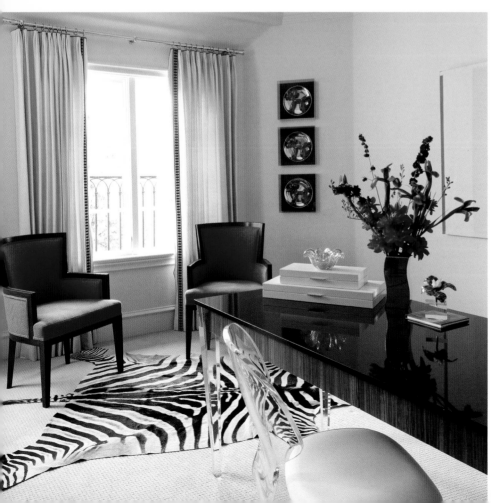

With a natural attention to detail, Anne Marie pulls together stunning mixes of traditional pieces with modern and ethnic elements. Neutral backgrounds and furnishings allow the layered textures and magnificent artwork full of color to pop while organic essentials enliven the space. With each project, Anne Marie is careful to follow a philosophy of quality over quantity, a doctrine that has served her well in her career. Anne Marie always purchases with the value of each piece firmly in mind and makes sure that while contributing to the overall scheme of the room it also stands steadfastly on its own.

In general, Anne Marie's inspiration comes from the architecture and location of a home. Views of the home's exterior and how it relates to its surroundings, town, country or seaside serve to rouse the direction of its interior. It is a talent that works well for Anne Marie as her proven expertise and skill are widely sought to design beautiful homes across the country. Currently, she is designing homes in Montecito, California, and Edwards, Colorado as well as many local projects in Texas.

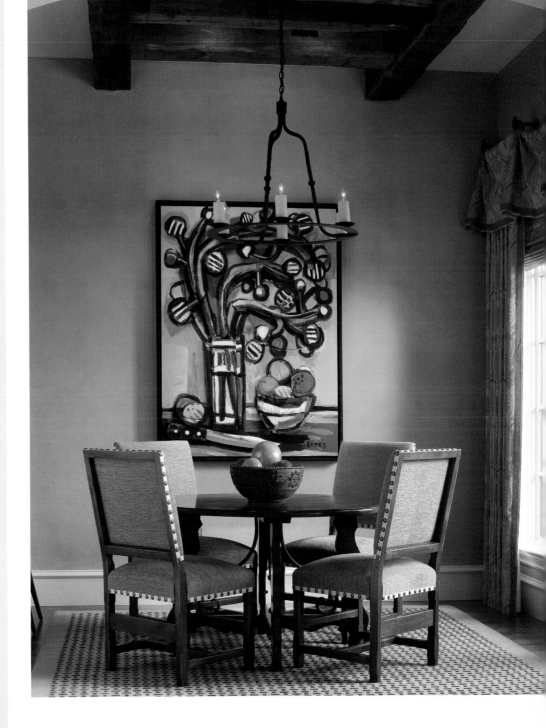

Q&A
more about anne marie ...

ON WHAT PERSONAL INDULGENCE DO YOU SPEND THE
MOST MONEY?
Clothes and shoes. Somehow there always seems to be the
dilemma of nothing to wear!

WHAT EXCITES YOU ABOUT BEING A PART OF *BEAUTIFUL HOMES*?
I am thrilled to be a part of this book because it is a wonderful
acknowledgement of the quality of work I have done to
this point.

YOU WOULDN'T KNOW IT BUT MY FRIENDS WOULD TELL
YOU I AM ...
Very feisty, as far as work goes. I have the highest expectations
from all those associated with my projects and have little
tolerance for problems that arise unnecessarily which could have
been simply avoided.

WHAT IS YOUR IDEAL PROJECT?
My ideal project would be a home with a wonderful coastal view,
lots of natural light and a lush landscape. The client would be
open minded and enthusiastic and would trust me implicitly to
direct the design.

A.M. BOSTROM INTERIORS
Anne Marie Bostrom
PO Box 802815
Dallas, TX 75380
214.762.9632
f: 972.392.3389

ABOVE:
David Bates is front and center to the breakfast room which is open to the adjoining family room.
Photograph by Danny Piassick

FACING PAGE TOP:
Reclaimed beams, woven shades and a custom-colored rug add warmth and texture to the otherwise monochromatic
family room. A plush sectional is a favorite spot for a client and her Cavalier King Charles Spaniels.
Photograph by Danny Piassick

FACING PAGE BOTTOM:
A neutral backdrop acts as a blank canvas to the contemporary artwork and bold use of color in this home office. The
acrylic legs of the desk and chair, from Allan Knight, keep the space light and open.
Photograph by Danny Piassick

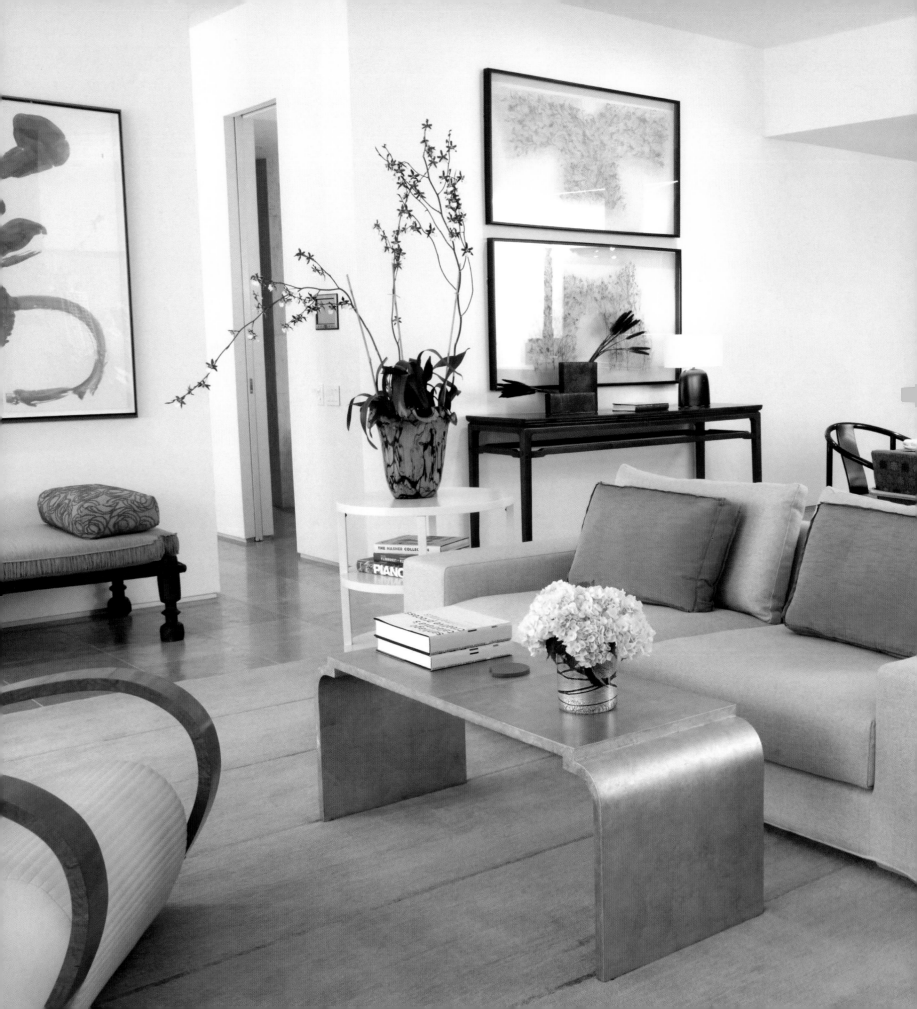

David Cadwallader

CADWALLADER DESIGN

*D*avid Cadwallader knows that there is nothing like getting your hands in the mix; he recognizes that he learned the most about the practice of interior design during a two-year apprenticeship in New York and from simply being on the job. David acknowledges that his clients drive him to excel, challenge him to be more imaginative and consistently refine his talents with each project.

David truly enjoys living and working in Dallas, particularly with his offices just minutes from the best design showrooms, craftsmen and antiques dealers in the city. Providing distinctive, individualized services to discriminating clients for both residential and commercial projects for 35 years, David's pared-down luxury coupled with a modern no-nonsense edge have positioned Cadwallader Design as an innovator in design solutions. His astute attention to the finest detail is the hallmark of his projects.

LEFT:
Simple furnishings and a neutral palette are characteristic of Cadwallader Design projects.
Photograph by Brian McWeeny

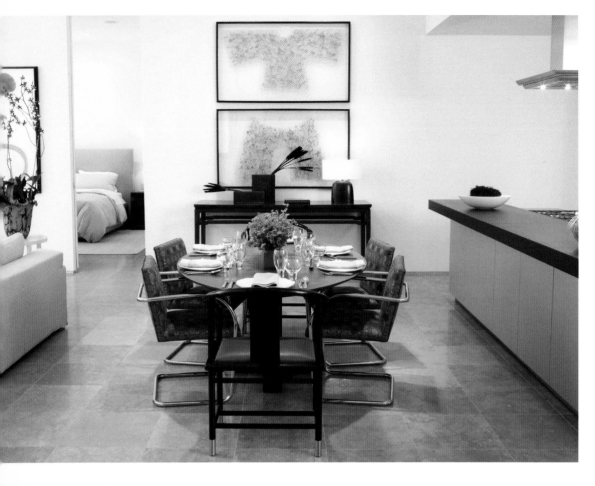

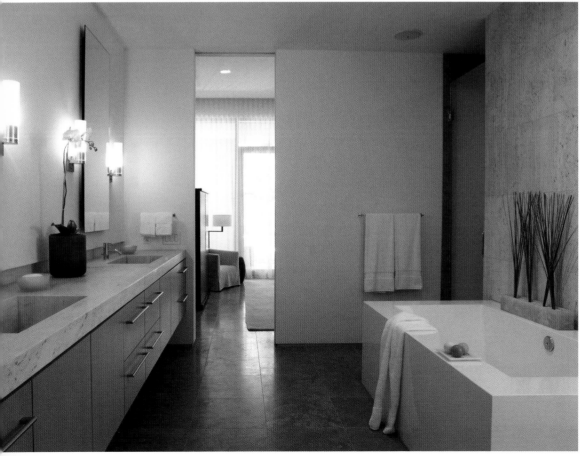

Striving for a timeless quality in combination with pure, simple elegance are the distinct signatures of his approach to design.

Expertly intuiting his client's personal style, David and his team deliver graceful environments that are tailored to function seamlessly with their intended purpose. Juxtaposing organic shapes with clean, flowing lines and neutral backdrops, David effects a translucent framework that provides appropriate dimension, showcases fine pieces and allows the eye to deliberately focus on the thoughtfully chosen art.

A study in balance, David's light and capacious environments reflect his intrinsic knowledge of spatial volume. Replete with architectural details and eclecticism, each design is uplifting and serene, encompassing personal sensibilities while reflecting the collaborative process so vital between designer and client.

David proves consistently that a number of stylish options are possible in creating personalized, refined and relaxed interiors. His artistic taste is instrumental in the successful transformation of each restrained, yet finely detailed space.

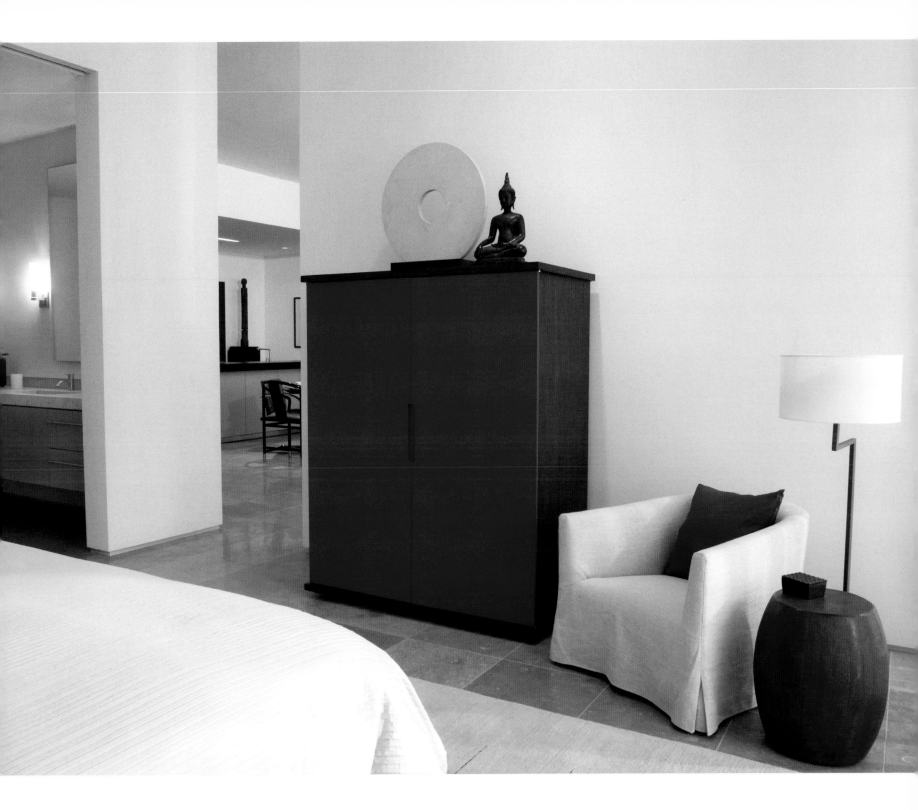

ABOVE:
A space with a modern look and the warmth of Asian flavor.
Photograph by Brian McWeeny

FACING PAGE TOP:
Asian flavoring adds depth to the bold, contemporary spaces.
Photograph by Brian McWeeny

FACING PAGE BOTTOM:
MSM Architecture detailed the spacious master bath.
Photograph by Brian McWeeny

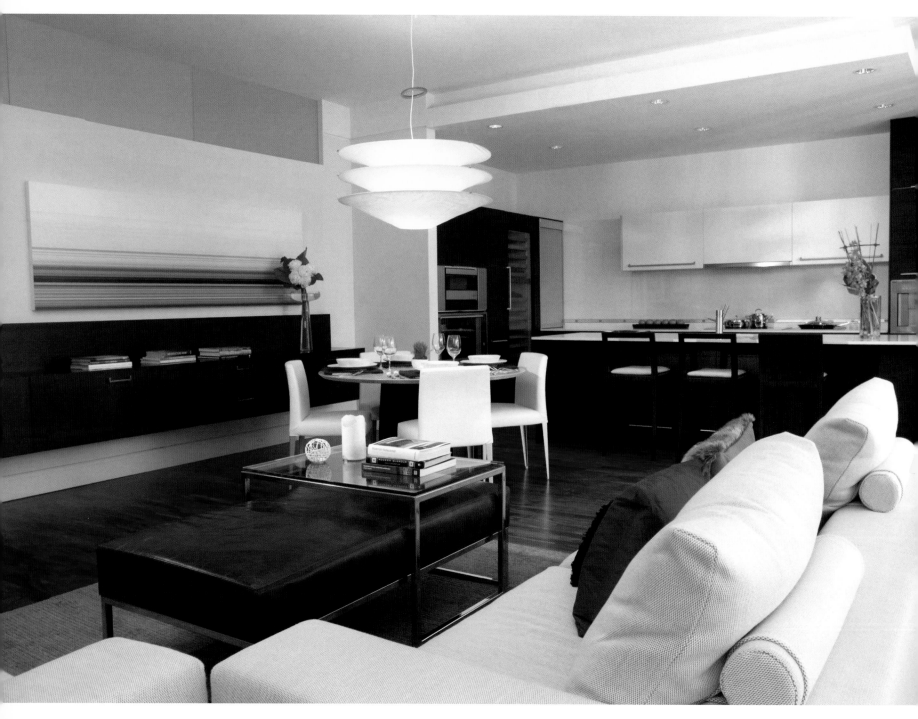

ABOVE:
David designed the interior spaces and furnished this high-rise condominium.
Photograph by Brian McWeeny

FACING PAGE:
Making the most of a small space for a trendy, sexy powder bath.
Photograph by Brian McWeeny

more about david ...

IS THERE ONE ELEMENT OF STYLE OR PHILOSOPHY YOU'VE STUCK WITH OVER THE YEARS THAT CONTINUES TO WORK FOR YOU?
I always choose timeless keystone furnishings that are comfortable and well made.

HAS YOUR WORK BEEN SHOWCASED IN OTHER PUBLICATIONS?
Interior Design, Better Homes and Gardens, *D Home* and *Modern Luxury Dallas*.

ON WHAT INDULGENCE DO YOU SPEND THE MOST MONEY?
Art from regional artists, and great shoes from designers such as Prada!

TELL US SOMETHING THAT PEOPLE MIGHT NOT KNOW ABOUT YOU.
I am fluent in Spanish.

WHAT SINGLE THING WOULD YOU DO TO BRING A DULL HOUSE TO LIFE?
Without question, add art, always art; the furniture can come later.

CADWALLADER DESIGN
David Cadwallader, ASID
1501 Dragon Street, Suite 103
Dallas, TX 75201
214.880.1777
www.cadwalladerdesign.com

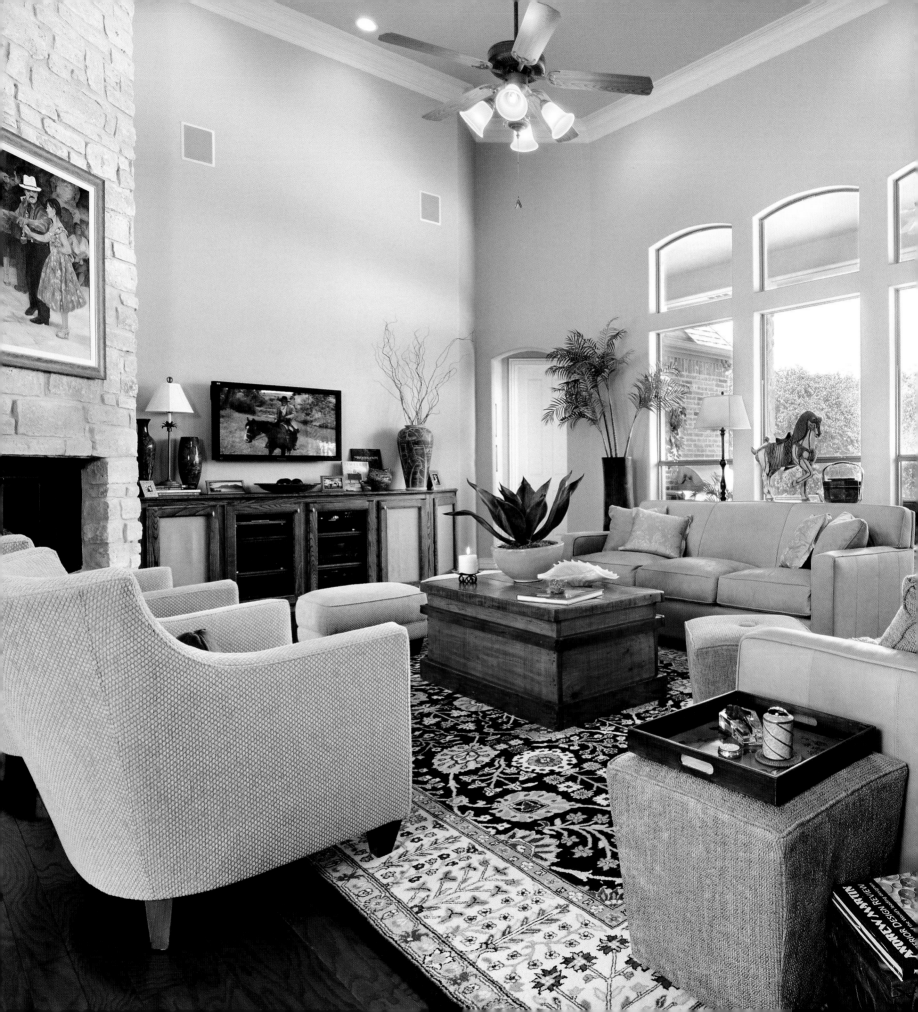

Debbie Chirillo

THE ARTEC GROUP, INC.

Debbie Chirillo's innate eye for design ensures that she will find unique items for her clients. Her firm, The Artec Group, Inc., is founded on the premise of Debbie's intuitive ability to determine her clients' tastes and design dreams and turn them into realities. Rigorously passionate about what she does, Debbie enjoys the challenge of design, and the friendship of those she serves is the foundation of her progress.

With over 15 years of design experience, Debbie has truly cultivated the art of identifying the design needs and tastes of her clients and encouraging the expression of personal style. "I bought an older home and had an idea of how I wanted it to look, but did not see how I was ever going to be able to do it. Debbie took my ideas and hers, put them together and made it absolutely perfect. She has made the whole experience

LEFT:
The Dance Contest over the fireplace is by Gerald Peterson. Buttery leather sofa and love seat by Precedent. Custom trunk of 100-year-old cypress doubles as a coffee table. Soft colors with many blended textures and a unique collection of original art and hand-blown glass by glass artisan and University of Texas professor, David W. Keens.
Photograph by Terri Glanger

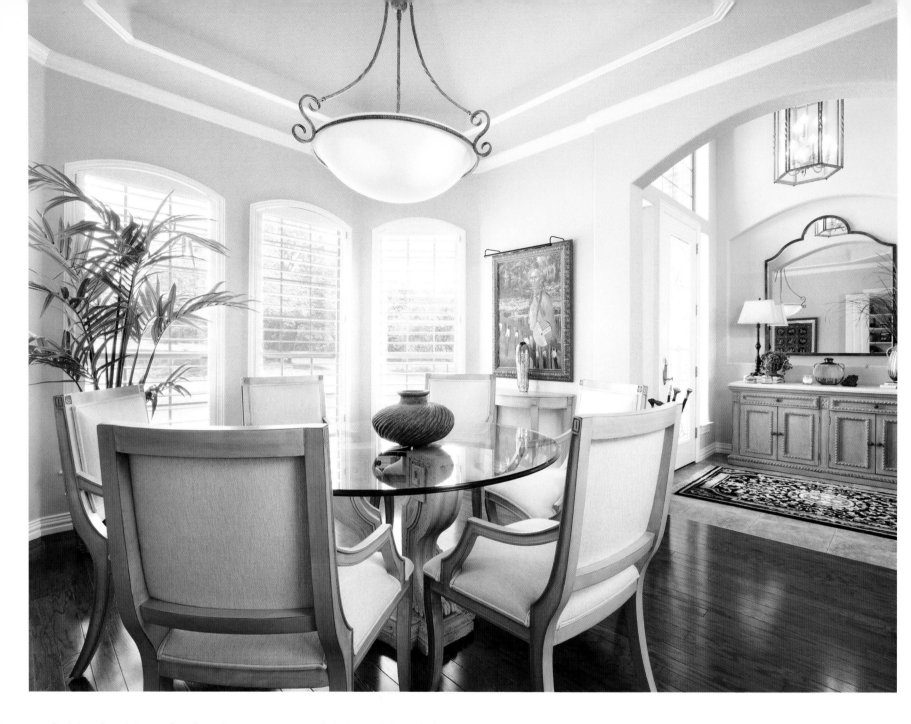

wonderful and exciting and truly a dream come true. It is beautiful—and she was a joy to work with!"

Always up for a challenge, Debbie enjoys searching out that perfect, unique piece that finishes a room and really brings her clients' personalities to the forefront. Mixing Traditional and Contemporary, from furnishings to accessories, each piece defines "home," creating a warm and inviting interior, whether the space is used for entertaining guests or feet-up evenings at home with the family.

When she is not hard at work putting together beautiful rooms for her clients, Debbie loves to relax at the beaches of Cabo San Lucas and California, as well as travel to Chicago and take in a fine meal. She also finds it pure heaven to just stay at home in a pair of jeans, riding her horses with her husband at their ranch in Fort Worth, Texas.

more about debbie ...

WHAT IS THE MOST UNUSUAL DESIGN TECHNIQUE YOU'VE EVER USED IN ONE OF YOUR PROJECTS?

Hanging a very expensive, 14-foot-high, eight-foot-long Oriental screen would probably be one of the most difficult and expensive things I have done!

WHAT COLOR DESCRIBES YOU AND WHY?

Aqua, blue and turquoise are my favorite colors. They remind me of the sky, ocean and water, and that has a wonderful calming effect on me.

THE ARTEC GROUP, INC.
Debbie Chirillo, NKBA Member
109 East Bozeman Lane
Fort Worth, TX 76108
817.448.9053
c: 817.528.1027
www.artecgroupinc.com

ABOVE:
An inlaid bamboo cabinet is anchored by a striking horse portrait above. The bamboo flute, Avo humidor and guitar are personal keepsakes that bring harmony to the room.
Photograph by Terri Glanger

FACING PAGE:
Kreiss Collection dining room ensemble allows formal seating for six. A commissioned painting by Fort Worth artist Roger Ikers of famed Texas Indian Chief Quannah Parker, as he may have looked in his younger years, hangs in dining room.
Photograph by Terri Glanger

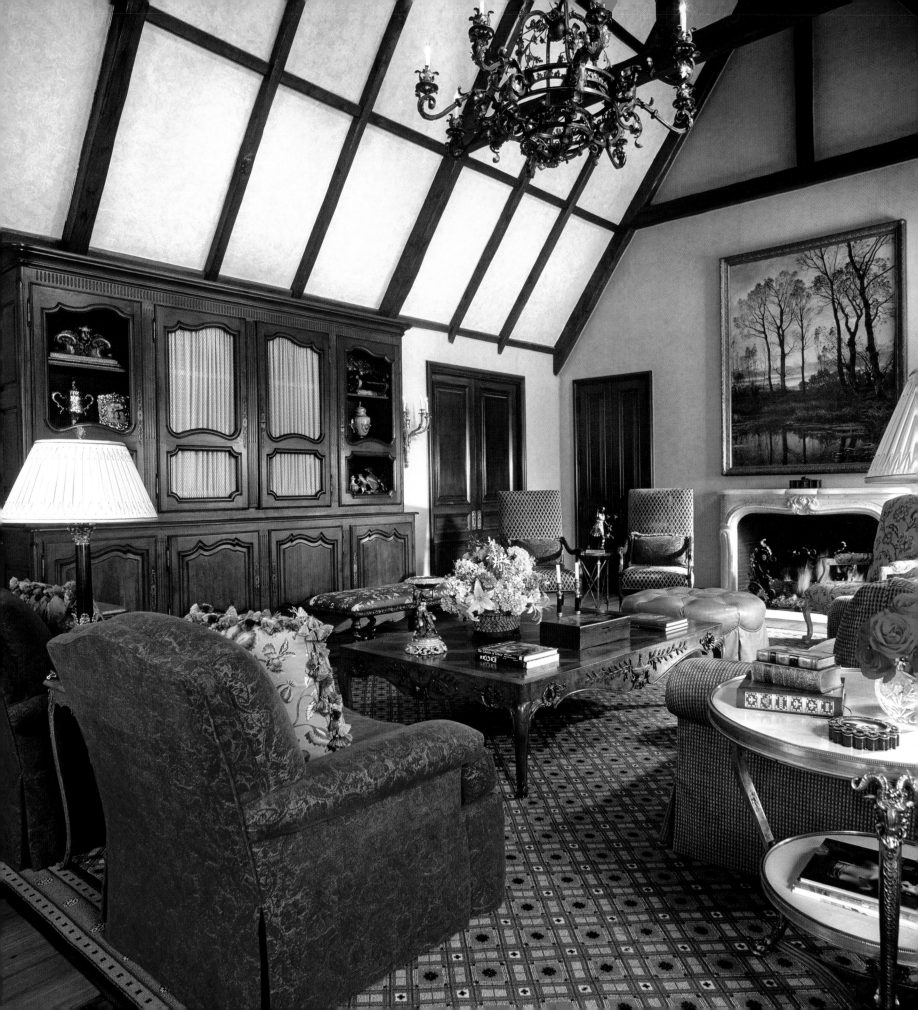

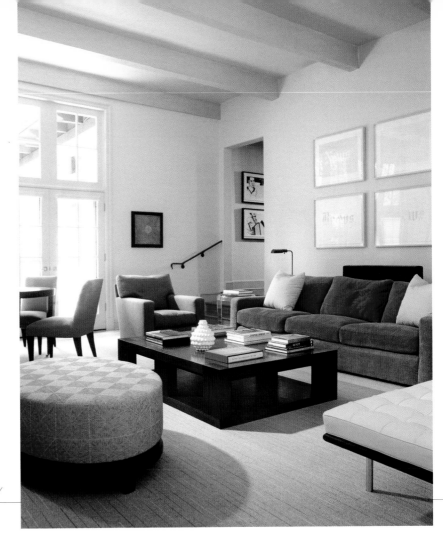

David Corley

DAVID CORLEY INTERIOR DESIGN

Based in the heart of Dallas' Design District, David Corley, founder of David Corley Interior Design, is a nationally acclaimed designer who not only offers full design services, but in-house custom furniture finishing and antique restoration. In addition to his Dallas-based business, he and his wife, Mary, also own a popular and well respected antiques store in Santa Fe, New Mexico. The pair travels to Europe to hand-select each piece for the store and David's design projects.

Contributing to David's stellar reputation are the two associate designers he has been working with for over 10 years, Dawn Bergan and Julie Stryker. Both proficient designers in their own right, they each share David's drive to always provide a superior product. Together with Dawn and Julie, David has developed a firm that prides itself on full service and beautiful interiors.

ABOVE:
The clean lines of the furniture accentuate the art collection in this contemporary Dallas family room.
Photograph by Danny Piassick

FACING PAGE:
This traditional Dallas family room is both elegant and functional. The custom reproduction cabinet holds a large flat-screen television.
Photograph by Danny Piassick

DAVID CORLEY INTERIOR DESIGN
David Corley, ASID
909 Dragon Street
Dallas, TX 75207
214.742.6767
f: 214.748.9178
www.davidcorley.com

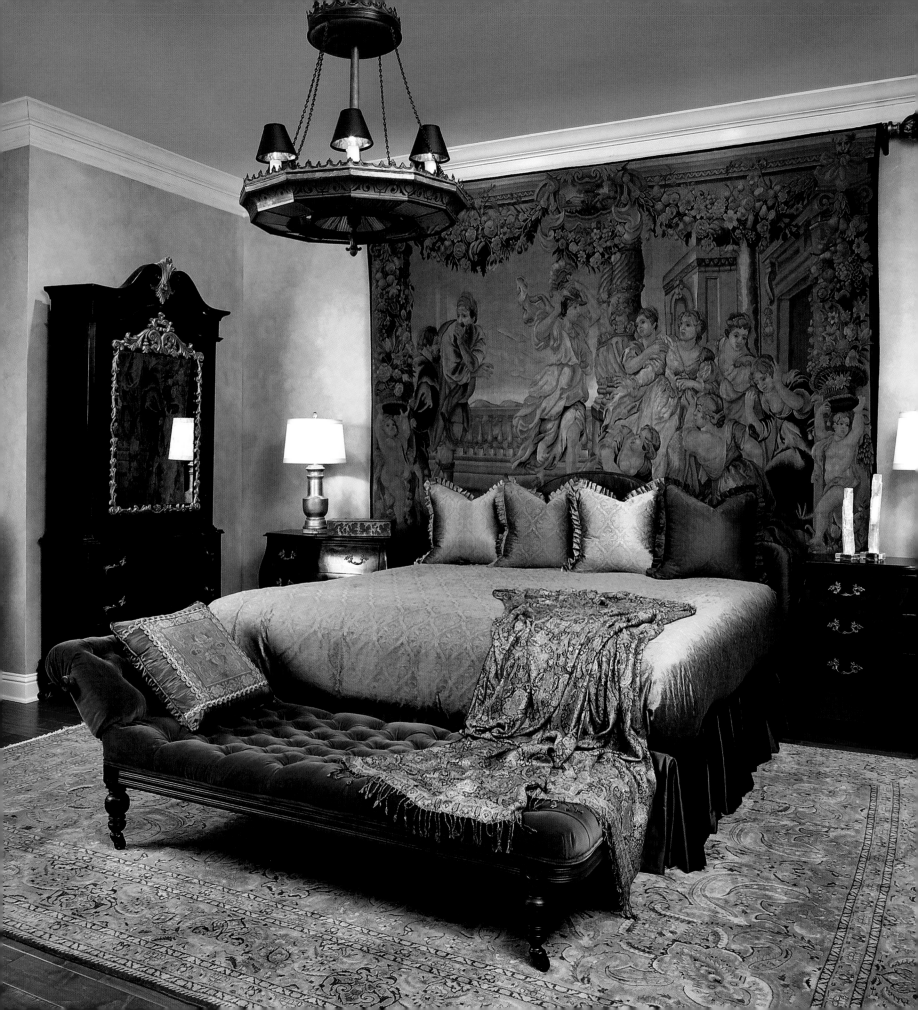

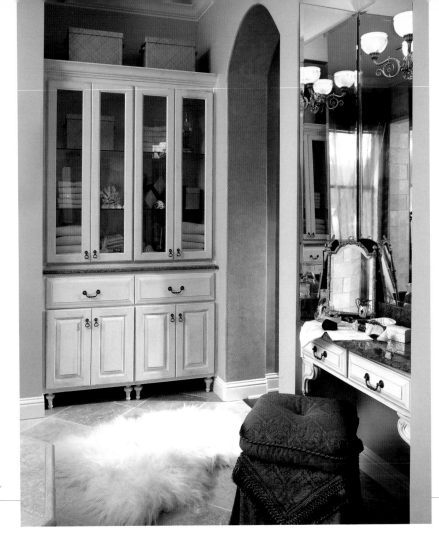

Catherine Dolen

CATHERINE DOLEN & ASSOCIATES

Catherine Dolen is a 20-year interior design veteran whose outstanding work has been commended throughout Texas, where she is an undisputed leader and exemplary creative professional. Just this year, Catherine received the prestigious "2006 Design Ovation Award for Corporate Design," given by the Dallas Chapter of the American Society of Interior Designers. Her first-place design for a corporate space under 5,000 square feet combines clean, classic lines and minimalist sensibilities with lots of inviting light and luxurious shocks of tropical color in just the right places. She was also awarded two Texas ASID "Legacy of Design Awards" in 2006, including first place for corporate design of "singular space" for this same project and the "Award of Merit" for a traditional residence under 3,500 square feet, a lakeside project she completed in Waco.

Catherine Dolen & Associates, a division of JCD Development, Inc., is a full-scale firm that specializes in comprehensive space planning and interior design services. Their work encompasses both residential and commercial design. Projects include work in Texas, Colorado and California. In addition to Catherine, the staff includes two degreed interior designers: Stephanie West, Allied Member, ASID; and Abigail Leonard, ASID.

Catherine attributes her firm's success to its ability to see both the bigger picture and the smallest detail in any project. She also sees every client and project as a unique challenge, and effortlessly applies her own confident

ABOVE:
Custom-designed cabinetry provides elegant display, storage, and vanity space for this sumptuous master bath.
Photograph by Bill Bolin

FACING PAGE:
Soothing colors, luxurious fabrics, and elegant Italian furnishings combine to create the special ambience of this master bedroom.
Photograph by Bill Bolin

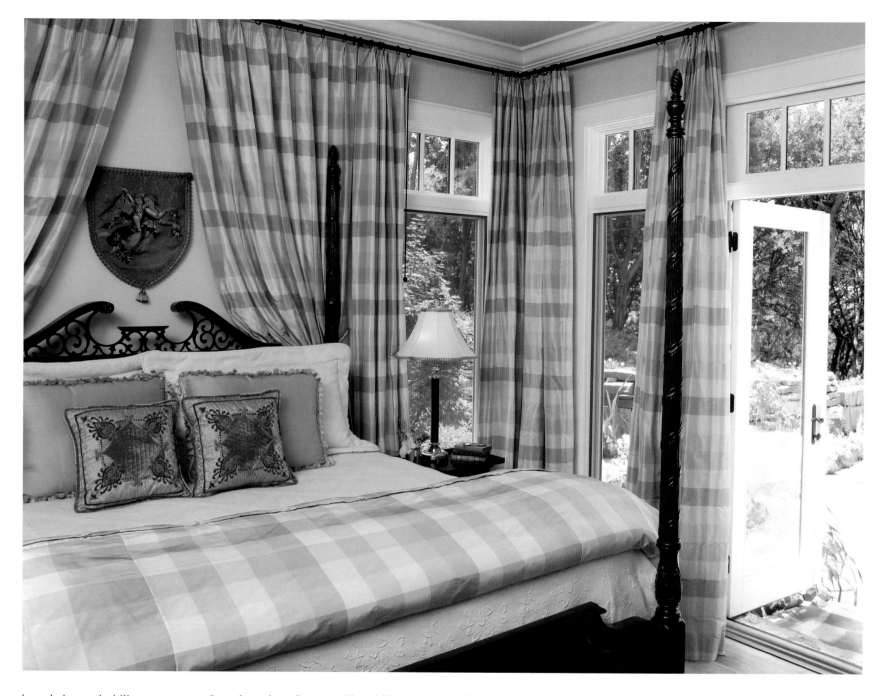

knowledge and ability to any set of needs and preferences. Her ability to work with existing architecture and design elements is a major strength, as is her commitment to working closely with each client throughout a project.

From start to finish, from floors and drywall to furniture and antique artwork, from the studs out, Catherine Dolen delivers polished Texas elegance and unwavering Texas practicality, every time.

ABOVE:
This lovely bedroom encased in silk plaid drapery affords a view of the gardens surrounding this lakeside home.
Photograph by Bill Bolin

FACING PAGE:
A vintage tub and antique crystal chandelier add to the character of this luxurious bath.
Photograph by Bill Bolin

Q&A

more about catherine ...

IN WHAT PUBLICATIONS HAS YOUR WORK BEEN FEATURED?
My work has been featured in *Designed in Texas, Dallas Modern Luxury, Wacoan Magazine, Waco Today* and recently appeared on the cover of *Dallas/Ft. Worth Design Guide*.

WHAT ARE YOUR PROFESSIONAL QUALIFICATIONS?
I graduated from Baylor University with a degree in Interior Design. I'm a Professional Member of the American Society of Interior Designers (ASID) and the International Interior Design Association (IIDA). I'm also a Registered Interior Designer with the Texas Board of Architectural Examiners.

WHAT SETS YOU APART FROM OTHER GREAT DESIGNERS?
My love for teaching! I'm a former lecturer in the Interior Design program at Baylor University and routinely present design-related programs for various organizations. I also developed a design seminar series in which I periodically instruct through my firm.

WHAT DO YOU LIKE MOST ABOUT DOING BUSINESS IN TEXAS?
Texans love sophisticated, beautiful, even grandiose design, but they're always friendly and down to earth. It's the best of both worlds!

CATHERINE DOLEN & ASSOCIATES
Catherine Dolen
4700 Bosque Boulevard, Suite L
Waco, TX 76710
254.751.0803
f: 254.751.1153

5222 Goodwin Avenue
Dallas, TX 75206
1.888.800.0803
www.catherinedolen.com

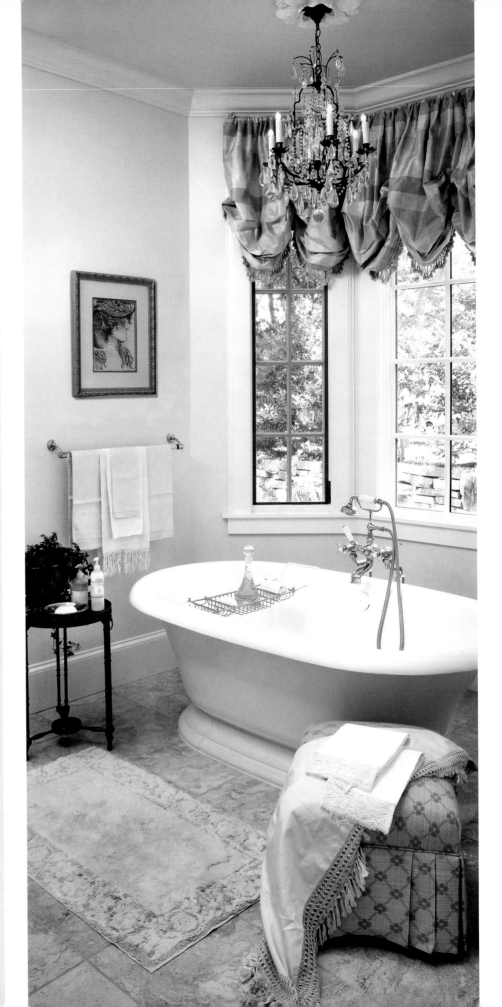

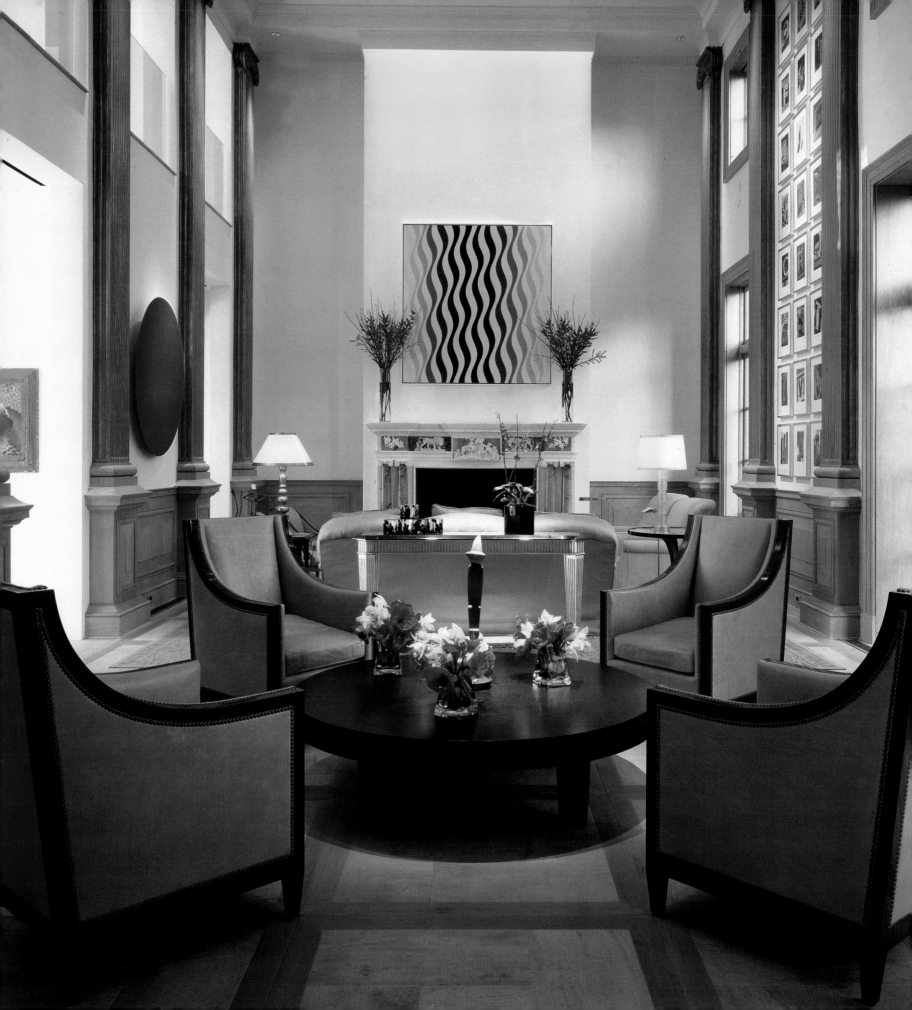

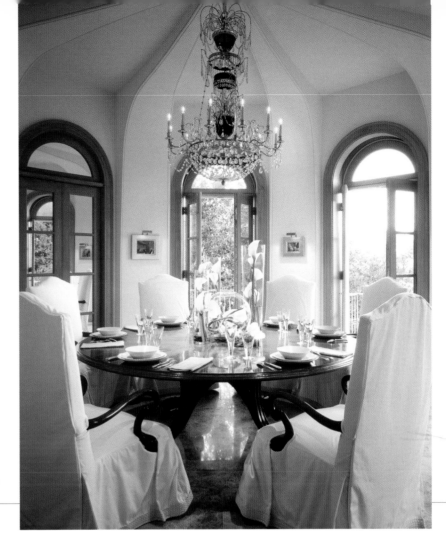

Paul Draper

PAUL DRAPER AND ASSOCIATES

A truly international designer, Paul Draper attended University of Oregon School of Interior Architecture and Waseda University in Japan. Drawing on that background and over 30 years of experience, Paul approaches every project with creativity and a strong sense of space, admitting that good design is as much about what you do not do as it is about practices you execute.

Paul's design philosophy incorporates an honest use of structure and natural materials with functional and beautiful results. Focusing on elements such as light, volume and the ambience created with finishes and furnishings, Paul's broad repertoire of skill and knowledge allows him to work within a myriad of styles, breaking out of the mold that can confine other designers to particular periods. Most of all he enjoys an international aspect of design, bringing in those details where appropriate.

Expertly articulating the sensibilities of his client while enhancing lifestyle, Paul's greatest satisfaction comes from knowing his clients thrive in environments he creates. "My approach to design is as much about enriching clients' lifestyles as it is a quest for aesthetics," he says. The evidence is a clientele who return repeatedly for his undeniable expertise.

ABOVE:
This formal dining room features a beautiful antique Russian chandelier. Two sets of dining chairs were selected for the room: The large dining chairs allow seating for six, while the smaller armless dining chairs (not shown) allow seating for 10.
Photograph by Ira Montgomery

FACING PAGE:
This great room was designed for a client who wanted a warm, comfortable space to display his collection of important contemporary art. The classical 18th-century French architecture was brought into the interior with a lighter, soft contemporary edge.
Photograph by Ira Montgomery

PAUL DRAPER AND ASSOCIATES
Paul Draper
4106 Swiss Avenue
Dallas, TX 75204
214.824.8352
f: 214.824.0932

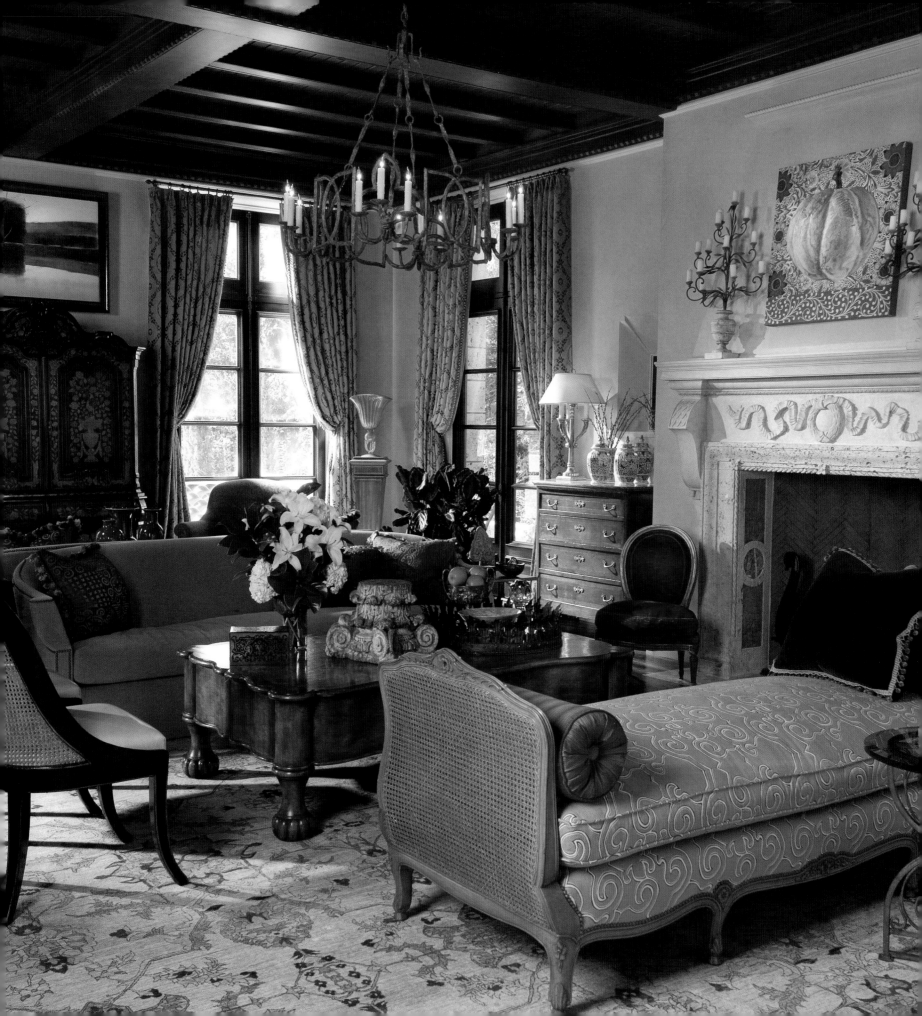

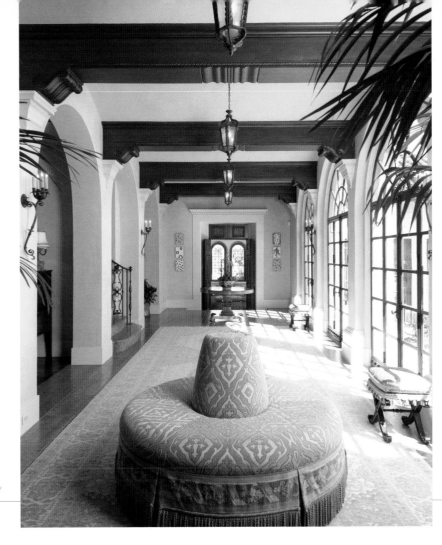

Cheri Etchelecu

CHERI ETCHELECU INTERIOR DESIGN

Cheri Etchelecu has been designing spaces and enhancing her clients' lives for over 20 years, 15 of which have been spent at her own firm, Cheri Etchelecu Interior Design. With the philosophy that interior design should augment her clients' lives by improving function and ensuring maximum enjoyment of their surroundings, Cheri designs the home to reflect the essence of the client and what they love. "We all want that elegant, yet comfortable home, but I believe that means different things to different people. Your home, should evolve with you, but that does not mean that you should constantly redecorate," she shares.

Drawing inspiration from her clients, nature, historic design and the renowned design masters, Cheri believes in educating her clients beyond their current understanding, so that they are happy and recognize the value of their design scheme for years to come. She is appreciative of contrasts in shapes and styles,

the old and new, and mixing in refined pieces with everyday objects. Cheri's designs are acclaimed not only by her clients, but also by the design institution ASID, which awarded her the "Southern Accents National ASID Competition first runner up award" as well as the ASID "Design Ovation Award."

ABOVE:
This gallery, with barrel vaults separated by mahogany beams, opens to the living room—a central gathering space for the family.
Photograph by Danny Piassick

FACING PAGE:
Stunning features of the living room include mahogany beams in the ceiling and a hand-carved limestone mantel combined with exterior shellstone and marble inlay.
Photograph by Danny Piassick

CHERI ETCHELECU INTERIOR DESIGN
Cheri Etchelecu, ASID
12720 Hillcrest Road, Suite 380
Dallas, TX 75230
972.980.1700
f: 972.980.1707

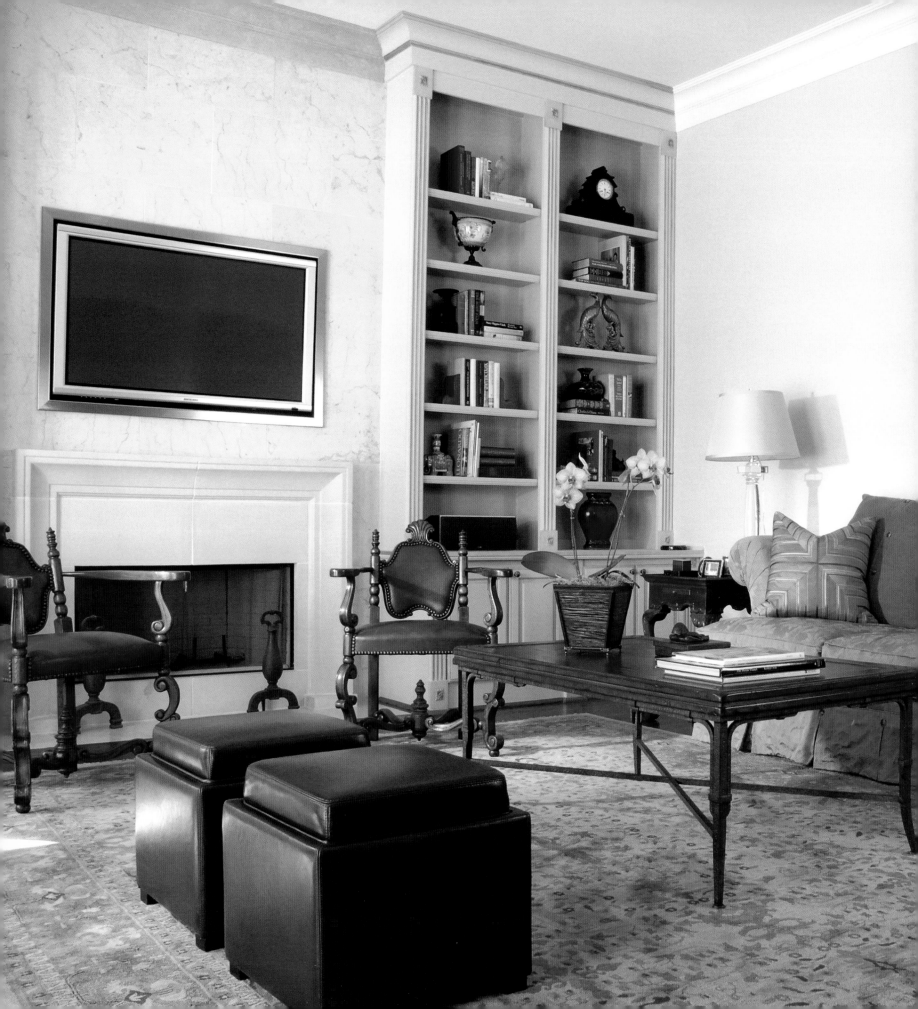

Shirley Flabiano
Roger Leighton

SAS INTERIORS

The artistic spirit is alive and thriving in the works of interior designer Shirley Flabiano, ASID and her partner, artist Roger Leighton. This dynamic duo form a very creative and artistic team who love the challenge of carrying out and enhancing any design dream. Their unique combination of artist and designer works well, as they create unique and distinctive environments that mirror their clients' needs, dreams and lifestyles. Believing the home is a sanctuary, they fashion comfortable, elegant interiors that are also livable. This is due to an inspirational process that captures the essence and personality of their clients.

Shirley and Roger utilize balance, rhythm, color and a strong dose of love of their craft to create designs for the senses. "People are more savvy and sophisticated about interior design these days, so we try to offer them a little more edge within their comfort zone," Shirley explains. It is easy to see why she was recently selected as one of the "Dynamic Women of Dallas." Style, service and solutions are the fundamentals in which Shirley functions and on which her business is founded.

LEFT:
Custom-designed built-in cabinets and original art by artist Roger Leighton lead the way in making this eclectically designed family room a warm and inviting space to relax or entertain.
Photograph by Michael Hunter

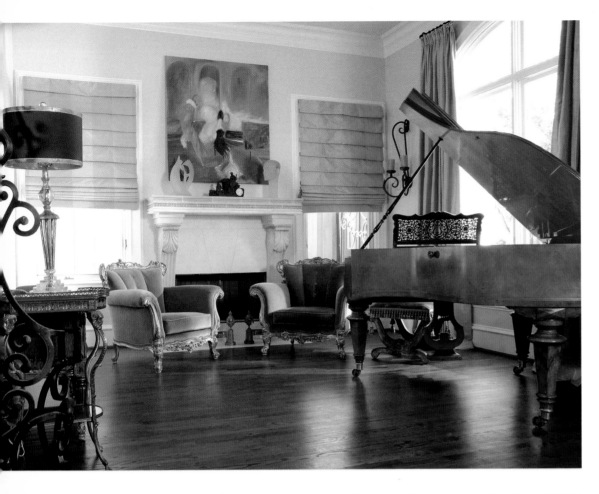

Roger's European art and architecture training allows him to view each room of a home as a blank canvas, waiting to be filled with beautiful objects and sensations that exceed clients' expectations. His custom-designed furniture collection allows SAS interiors to offer each client one-of-a-kind works of art to be incorporated into their interiors. It is this artistic vision combined with high-quality workmanship that differentiates SAS Interiors from their peers. They are able to take the ordinary and turn it into the extraordinary.

Recently, SAS won first place in "ASID Design Ovation" for one of its projects. They have also had the honor of being named one of *Architectural Digest's* "Outstanding Interior Designers of Texas" in addition to being featured on the cover of *Dallas-Fort Worth House & Home Magazine*. Additionally, SAS Interiors was the only Dallas, Texas design firm to be featured in the book series *Leading Residential Designers*.

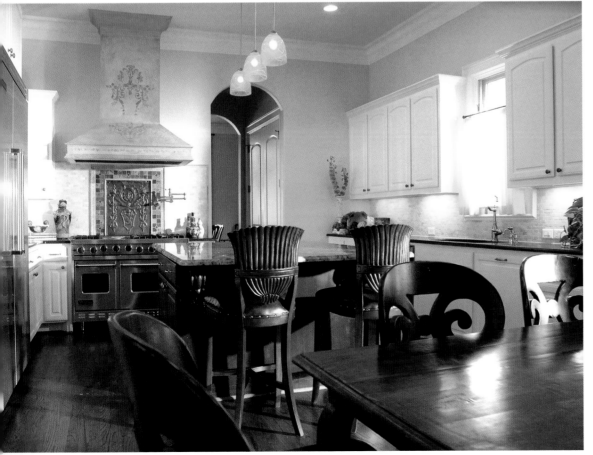

Clients of SAS Interiors enjoy full-service design expertise from space planning and special paint finishes to complete remodeling, updating and more. While Shirley and Roger run the gamut when it comes to making a home complete, their clients are also thrilled with their sheer artistic flair. Given their talent for understanding the clients' vision and transforming that vision into inspirational and elegant spaces, they successfully complete any design. Simply stated, Shirley Flabiano and Roger Leighton create design "magic" for their clients.

Q&A

more about shirley & roger ...

WHAT ONE PHILOSOPHY HAVE YOU STUCK WITH FOR YEARS THAT STILL WORKS FOR YOU TODAY?
Design is about creating the room of our clients' dreams and making those dreams come true.

DO YOU HAVE A PARTICULAR STYLE THAT YOU TEND TO FOLLOW?
Our "look" is all about our clients. From urban Contemporary to Old World classic design, it is all about the clients' style and desires.

WHAT IS THE BEST PART OF BEING AN INTERIOR DESIGNER?
We love the variety of projects on which we have the opportunity to work. Challenge is our forte. From Eclectic to Traditional to somewhere in between, we can make it work and make it work fabulously.

SAS INTERIORS
LEIGHTON ART
Shirley Flabiano, ASID
Roger Leighton, Artist
1323 Levee Street
Dallas, TX 75207
972.661.9114
f: 972.661.9065
www.sasinteriors.com

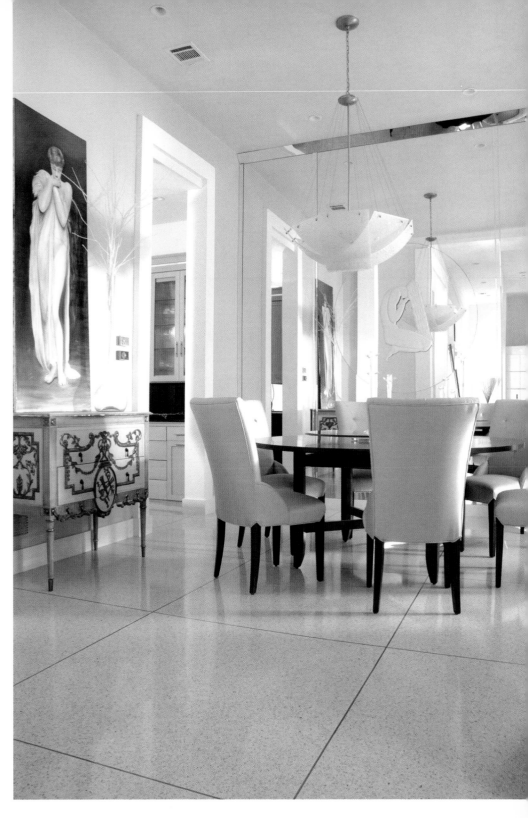

ABOVE:
From an originally traditional space to a remodeled contemporary/Old World blend, the dining room combines a one-of-a-kind server, custom-designed chairs and a classic original painting by artist Roger Leighton.
Photograph by Michael Hunter

FACING PAGE TOP:
Simple but simultaneously elegant, this formal living room shares an antique piano with Baroque chairs and silk window treatments to give a serene yet spacious feeling to the room.
Photograph by Michael Hunter

FACING PAGE BOTTOM:
Think cozy, inviting, warmth and beauty. What more can a kitchen be? This picture showcases a little bit of Europe in the original art above the range combining artistic beauty with the functionality of a well-designed space.
Photograph by Michael Hunter

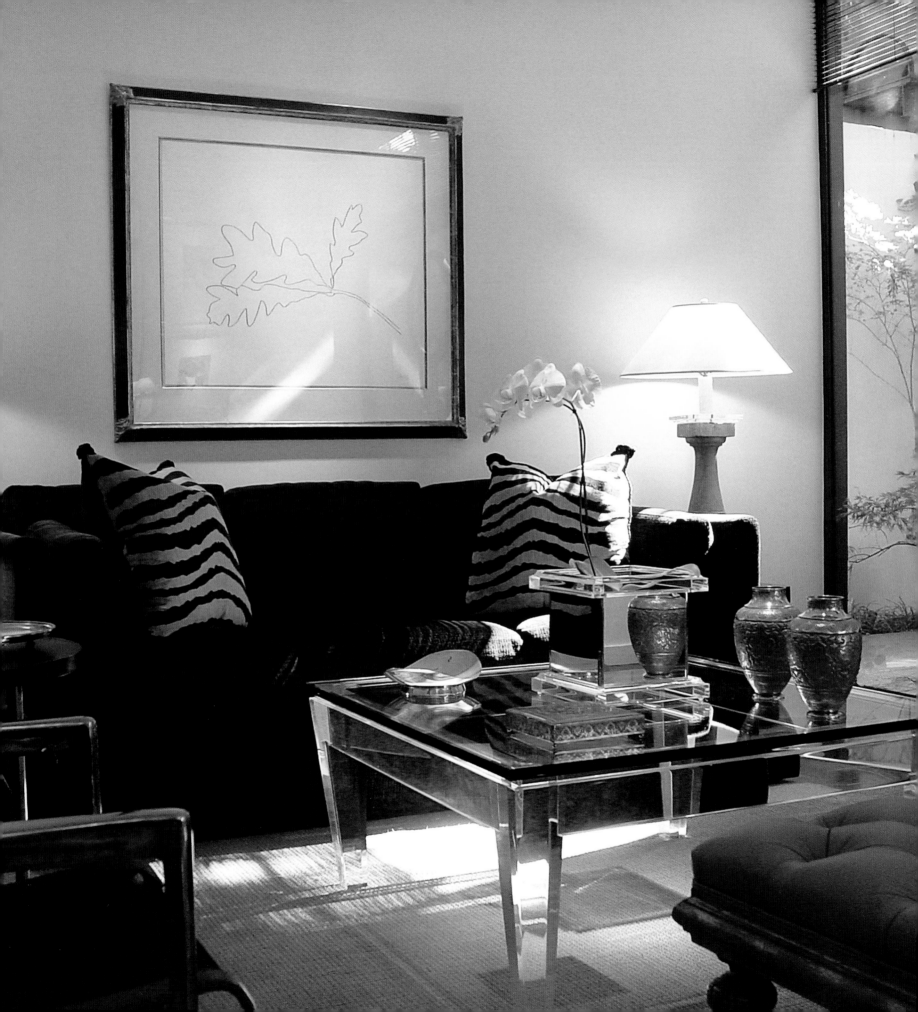

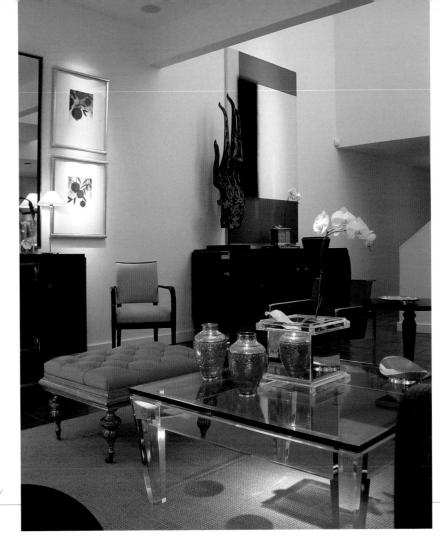

Marco French

MARCO FRENCH STUDIO

Marco French draws on his voyages and design experiences across the globe in places such as England, Scotland, France, Monte Carlo, Italy, Russia, Egypt, Japan, Indonesia and Singapore to create fresh looks for each client. His travels avail him to sources for treasures of unique and unusual character; his goal is to incorporate and combine the collections of his clients' art, artifacts and antiques in a fresh and unexpected way, blended with skill to great effect. With a Bachelor of Art in Architecture from the University of Texas at Austin, Marco went on to study at Oxford University in England where he immersed himself in advanced studies of architectural history and design. His architectural degree instilled in him a fundamental understanding that soon translated into his ability to develop interiors that are seamlessly combined and timeless in character.

While his clientele is diverse, his abilities cover an even broader spectrum, as his design style knows no bounds or locale. Rather than retaining a particular style, he works hands-on with each client to facilitate the creation of their own style. From opulent to Traditional, Contemporary to Transitional, Marco is adept at incorporating favorite collections or beginning anew, pulling together interior environments that are personable, inviting and always reflective of the individual.

Expanding sensory experience through fundamental detail, Marco brings together spaces that exceed expectation with imaginative mixes of geometric

ABOVE:
A unique combination of objects from around the world—including an antique Thai architectural fragment in the shape of a hand and an abstract painting by German artist Lienhard von Monkiewitsch—create a uniquely stylish interior in the designer's home.
Photograph courtesy of Marco French

FACING PAGE:
Textures and a neutral palette of black, white and silver abound in the living room of the designer's Bud Oglesby–designed townhome. A classic 1980s' Merritt Emanuel acrylic coffee table and clear, crisp architectural lighting by Craig Roberts add drama.
Photograph courtesy of Marco French

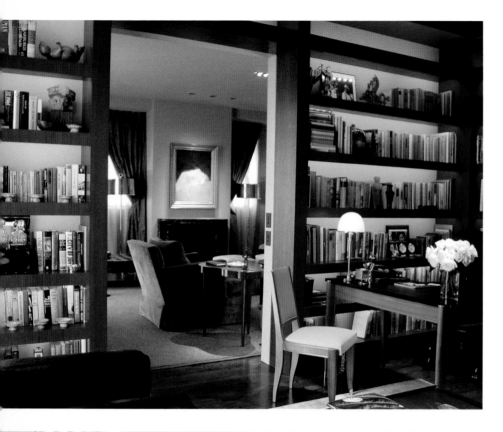

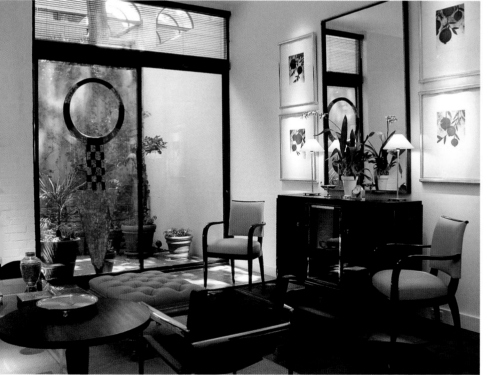

shapes, vivid regional and international accents and architectural and artistic elements. Sleek and uncluttered, Marco's clean designs incorporate classic proportion: Sculptural facets with durable, rich materials of color and texture, accomplishing a timeless environment. He ardently believes that scale, proportion and lighting are critical to the success of any design. With a sense of style that can all at once be labeled subtle, quiet, grand, mysterious and always magical, it is his ability to creatively combine the client's personal taste and treasured collections of both old and new that create a memorable and personal interior.

His experience on global projects in exotic locales has given Marco a unique perspective which carries over to the furnishings Marco French Studio offers. A fine collection of exclusive, exceptionally beautiful antiques and vintage fittings brought in from all over the world include select furnishings of French, Danish and Syrian origin. Exquisitely inlaid with exotic and alluring materials such as silver, mother-of-pearl, ebony and bone, Marco's collection presents exciting accents to complement all discriminating tastes.

Not only does Marco cater to each unique client's design dreams and desires, he and his company also assist the clients in managing each project as liaison to other consultants and subcontractors; yet another step Marco takes in his clients' favor to ensure a stress-free design experience. Less worry for his clients allows them to more thoroughly enjoy the process of realizing their vision.

ABOVE TOP:
Custom ribbon sapele bookcases replete with individual shelf lighting were added to this library to house the client's extensive book collection. Readers can sit at the 1930s' Leleu French Deco desk or cozy up near the adjoining living room's fireplace, featuring a gold portoro marble surround.
Photograph courtesy of Marco French

ABOVE BOTTOM:
French Deco takes center stage in the designer's living room: A 1930s' French Deco leather-upholstered wood chair nicely complements the Leleu bar from the same era. Brad Durham lithographs in silver-leafed frames accent the slim, black-and-silver mirror, enhancing the modern feel.
Photograph courtesy of Marco French

Q&A

more about marco ...

DESCRIBE YOUR DESIGN STYLE OR PREFERENCES.
There is no formula to a "Marco Style," rather I create interiors unique to each client.

WHAT ONE ELEMENT OF STYLE OR PHILOSOPHY HAVE YOU STUCK WITH FOR YEARS THAT STILL WORKS FOR YOU TODAY?
No matter the style, each design and each space is tailored and uncluttered yet warm and welcoming. Clients should see "home," never a design.

IN WHAT PUBLICATIONS HAS YOUR WORK BEEN FEATURED?
My projects have been published in *D Home, D Magazine, Dallas Home and Design, Restaurant & Hospitality Design, Interior Design Magazine* and *Veranda*.

MARCO FRENCH STUDIO
Marco French
4434 Travis Street
Dallas, TX 75205
214.521.2745
f: 214.521.5055
www.marcofrench.com

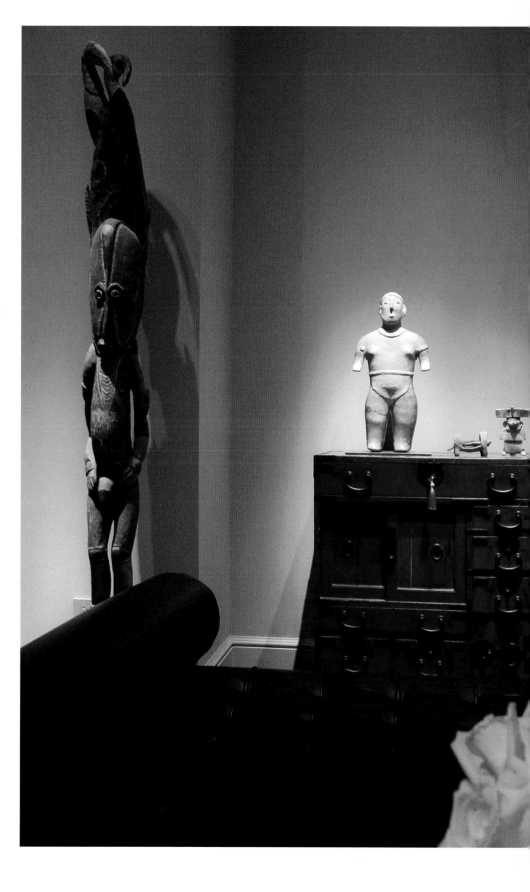

ABOVE:
A Japanese lacquered chest topped with pre-Columbian artifacts and an ethnic carving from New Guinea share space with a 1928 Mies van der Rohe daybed in this Turtle Creek high-rise.
Photograph courtesy of Marco French

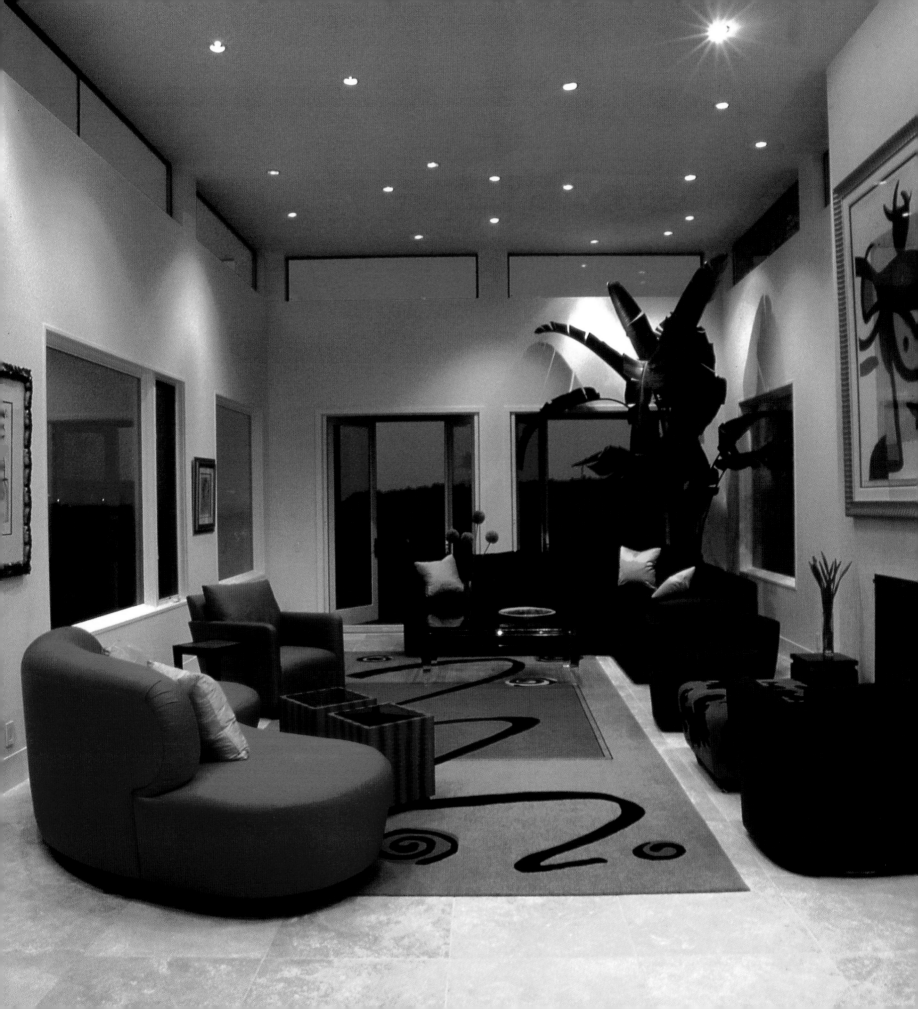

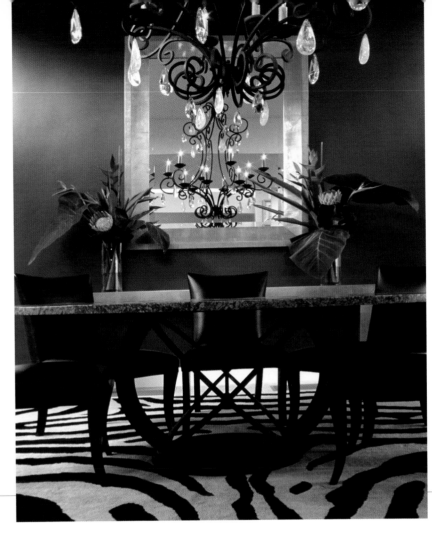

Sherry Garrett

SHERRY GARRETT DESIGN

Sherry Garret specializes in creating custom interiors that uniquely suit her clients' sensibilities and functional needs, executing each with an uncompromising attention to detail. Sherry, whose work has been published internationally, has an eye for sophistication that is matched only by her ability to capture the individual character of her clients while offering just a pop of the unexpected to take a room from beautiful to fabulous.

Practicing for 28 years throughout Texas and two years in Los Angeles, Sherry's influence is drawn from her studies abroad in France and Spain. Personally favoring an eclectic style juxtaposing modern elements with global antiques, Sherry expertly blends interesting textures with accents of pure color, delivering spectacular results that exceed expectation time and again.

Sherry also designs and produces a custom line of exquisitely crafted furniture aptly named The Sherry Garrett Collection. Featuring rare and exotic hides, the pieces are offered in an extensive and exciting color palette. The line includes traditional neutral selections to the most avant-garde to please the most discriminating tastes in every style.

ABOVE:
This elegant and warm dining room features a silver-leaf mirror and console and a chandelier with rock-crystal teardrops. Tailored leather chairs surround the inlaid Italian marble-topped table with iron base, custom-designed by Sherry, which sits atop a dramatic zebra-print rug.
Photograph courtesy of Sherry Garrett Design

FACING PAGE:
The colors in this living room were inspired from the Miro above the fireplace. Rug, calfhide ottoman and a pair of red snakeskin tables from the Sherry Garrett Collection.
Photograph courtesy of Sherry Garrett Design

SHERRY GARRETT DESIGN
Sherry Garrett
322 Chimney Rock Drive, Suite 801
Tyler, TX 75703
214.663.9623
903.581.9808
f: 903.581.1610
www.sherrygarrett.com

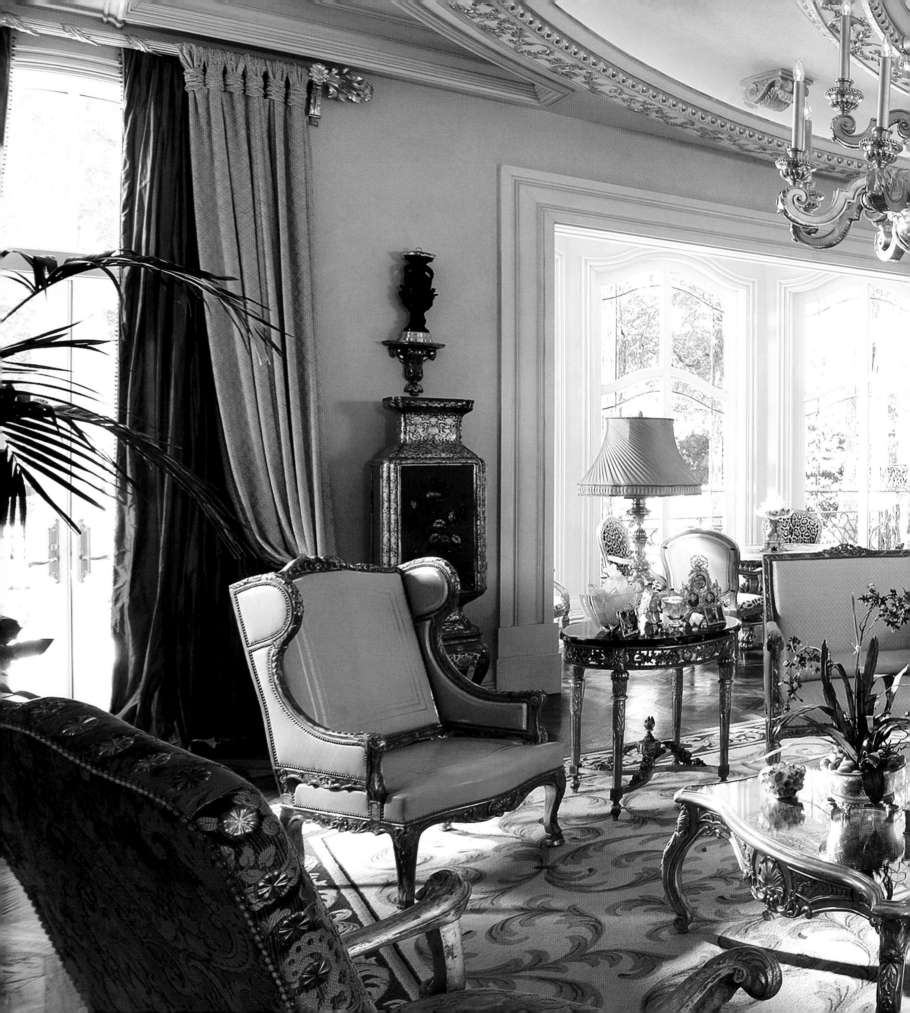

Sherry Hayslip

HAYSLIP DESIGN ASSOCIATES, INC.

Sherry Hayslip does not take herself too seriously; this is quite evident in her voracious reading lists. Never one to sit still for very long, she loves to read multiple books at once, combining the more serious editions with the considerably less sedate. One moment finds her perusing the pages of a philosophical classic and the next thumbing through the most scandalous magazine she can find.

Sherry believes there is a balance to strike in life and this philosophy shows through in her exquisite designs. Hayslip Design Associates is recognized as one of the foremost design firms in Texas and with a staff of 16 in every age range and skill set, Sherry's team collaborates to provide her clients with the highest level of service and diversity, no matter the style.

Sherry received her bachelor's degree with honors and went on to study abroad attending the Parsons School of Design, The National Institute of Design and the Cooper-Hewitt graduate studies programs in Italy. These international pursuits created a broad influence in Sherry's designs. There is a thread that connects every style in classical proportions and is the inspiration for every space, even the most extreme Contemporary.

ABOVE:
Hand-carved Lucite bases elevate the owner's gilt bronze vases, emphasizing their detail and decorative properties.
Photograph by Danny Piassick

FACING PAGE:
A combination of classical detailing, fine antique furniture and rich textiles create a glowing palette for this formal living room.
Photograph by Danny Piassick

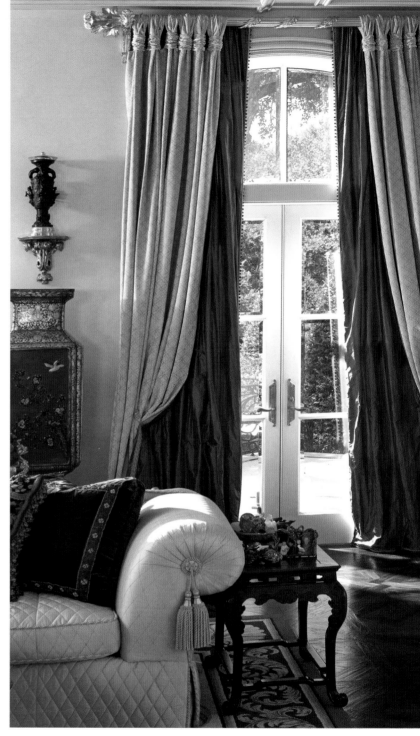

ABOVE LEFT:
Dry-set stone walls create an ochre-toned backdrop for a 17th-century Portuguese chair and antique cabinet in this wine-tasting room.
Photograph by © John Smith, Smith Photography Studio, LLC

ABOVE RIGHT:
Tall double-layered draperies add lush color and texture to this creamy room with gilded detailing.
Photograph by Danny Piassick

FACING PAGE:
This Montana dining room overlooks forests and glaciers as well as framing a view to the steel-clad vent hood in the kitchen beyond.
Photograph by Photos@RobertReck.com

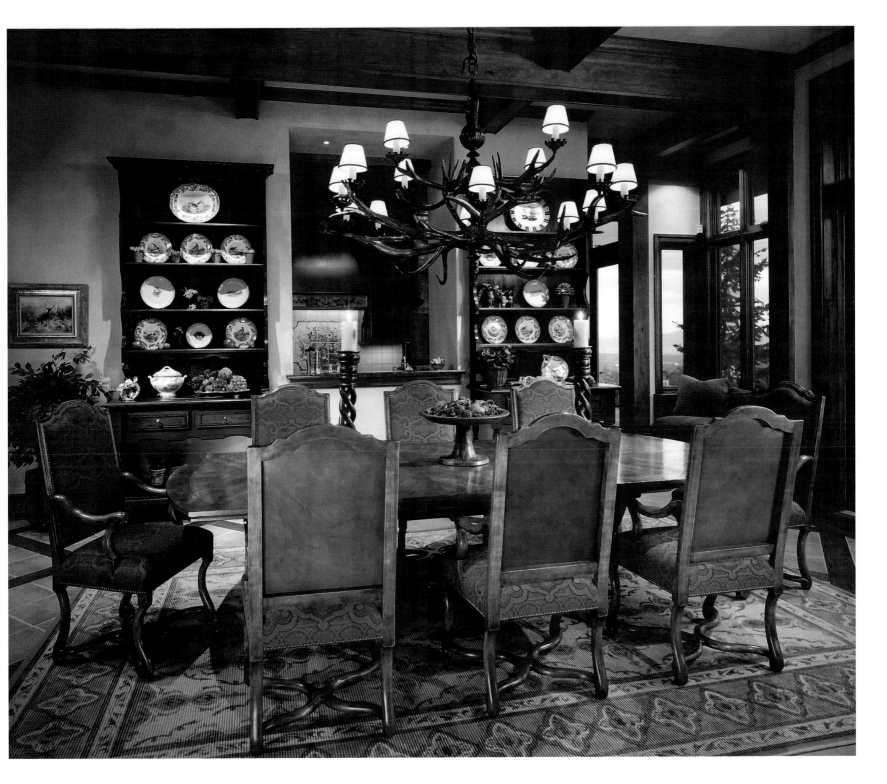

The most important aspect of Sherry's design is a sense of coherence to the clients who live and work in her spaces. Favoring one-of-a-kind, custom pieces and commissioned art, Sherry strives to create unequaled and masterfully refined rooms that work both within the context of a client's tastes and desires as well as with the room's architectural integrity. Each project allows Sherry an opportunity to approach each venture as a learning experience. Delving into unknown territory and becoming an expert on its architecture and decorative style is one of her secrets of success.

ABOVE:
Raking afternoon light illuminates denim, leather, horn and pine objects in this Colorado guest room.
Photograph by Photos@RobertReck.com

FACING PAGE:
An old pine dough bin is transformed into a roomy vanity including a low marble shelf piled with toiletries and topped by an antique Swedish mirror.
Photograph by Ira Montgomery

Q&A

more about sherry ...

WHAT COLOR BEST DESCRIBES YOU AND WHY?
Orange, pink, red, chocolate and/or charcoal. Red, pink and orange because they are vibrant and alive! They are colors that project energy. Chocolate and charcoal because they are timeless and grounded.

WHAT ELEMENT OF STYLE HAVE YOU STUCK WITH FOR YEARS THAT STILL WORKS FOR YOU TODAY?
A room should be comfortable no matter how elegant the furnishings.

WHO HAS HAD THE BIGGEST INFLUENCE ON YOUR CAREER?
My husband, Cole Smith, because he challenges, inspires and teaches me.

WHAT DO YOU LIKE MOST ABOUT DOING BUSINESS IN DALLAS?
I feel very connected to Dallas. Our office is located in a 100-year-old, three-story house in the heart of Uptown, a very popular part of the city. Entrepreneurs, artists and antique galleries all surround us, which creates energy and excitement to permeate the whole area!

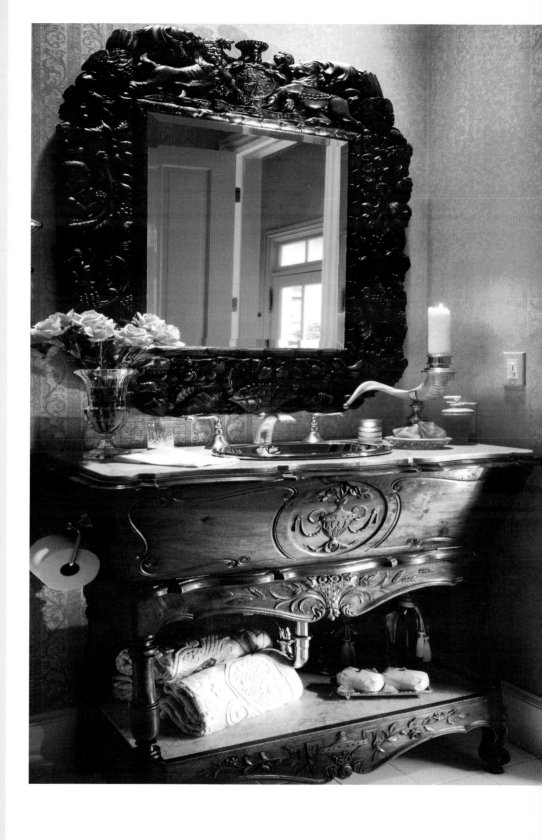

HAYSLIP DESIGN ASSOCIATES, INC.
Sherry Hayslip, ASID, IIDA
2604 Fairmont Street
Dallas, TX 75201
214.871.9106
f: 214.880.9049
www.hayslipdesign.com

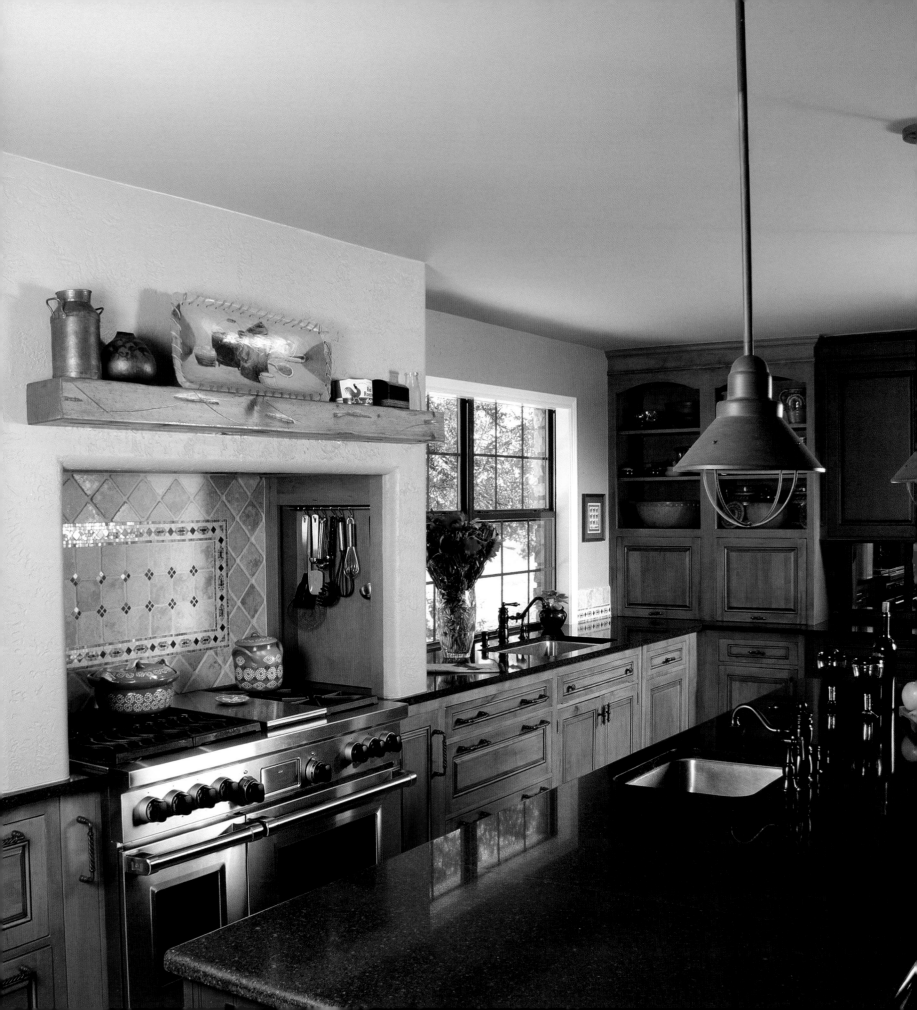

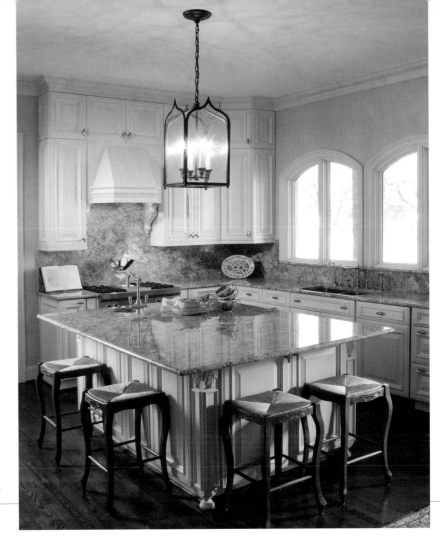

Bob Johns
THE KITCHEN SOURCE

Originally a businessman with a background in finance, Bob Johns served as an actuary in the insurance industry in the beginning of his professional career. Not exactly the type of position that immediately comes to mind when imagining what early projects would lead into design, but after just a few minutes with the savvy owner of The Kitchen Source, it easily becomes clear that he was destined to fulfill a rather specialized need in design.

Bob's family has been active in the kitchen business since 1963 when his father started his own company in Hot Springs, Arkansas. Never really thinking that his destiny was intertwined with that family business, Bob went on to earn a master's degree in finance from the University of Texas at Austin, entering into a very specialized area of the insurance industry. Then, in his late 20s, he decided to take a different route. Embracing his family legacy, Bob saw an opportunity to fill a need for high-quality kitchen and bath design

and production. His young family took a leap of faith moving to Little Rock in 1981 where he opened his first showroom. Five short years later he returned to Dallas and created today's The Kitchen Source.

As The Kitchen Source's reputation grew, so did their facilities. With their flagship showroom located in the heart of the Dallas Design District and currently completing a new 10,000-square-foot floor space displaying exceptional kitchen, bath and interior options, Bob's initial gamble has become nothing short of a smashing success. In 1993, Bob opened his second location and since that

ABOVE:
This elegant kitchen incorporates details such as hand-carved mouldings, Golden Beach granite countertops and backsplashes along with ample seating for guests at the island.
Photograph by Kevin Hunter Marple

FACING PAGE:
This rustic ranch-style kitchen still gives the luxury feeling of a gourmet kitchen with its commercial-level appliances, quartz countertops and tumbled marble backsplash.
Photograph by Kevin Hunter Marple

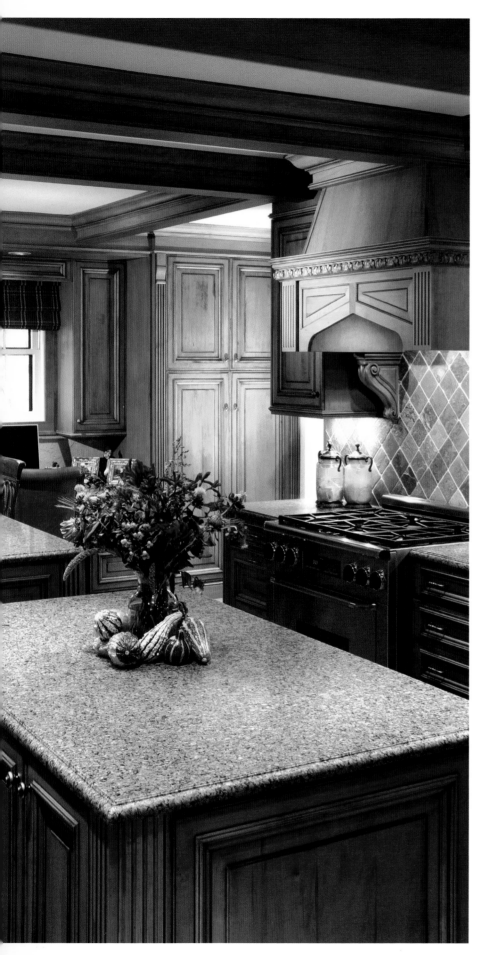

time The Kitchen Source has amassed an impressive client roster and portfolio rivaled only by the most experienced and sought after in the design world.

Regardless of the aesthetic or functional need, The Kitchen Source creates exceptional designs while providing first-class service. Exuding professionalism, Bob's philosophy carries through to the very basic level with a common goal of brilliant concept and incomparable results. With senior designers available to create the kitchen or bath of their clients' dreams, Bob's thriving company is also able to provide the logistics behind the design, creating a one-stop shop for every need. Providing what Bob describes as a hybrid between engineering and design, this expertise in the details of what builds, powers, and keeps the design working efficiently and aesthetically eliminates the need for major revisions to the original plans as the process moves along. By keeping the integrity of the design, The Kitchen Source provides the beautiful environment that their clients fall in love with the first time, never having to compromise or change a thing.

LEFT:
With thoughtful attention to detail and design, this kitchen functions wonderfully for cooking, storage, and entertaining while keeping it formal yet inviting.
Photograph by Kevin Hunter Marple

FACING PAGE TOP:
This updated kitchen perfectly reflects its 1930s' Tudor shell. Commercial-style appliances, granite countertops and Wood~Mode custom cabinetry finish the space impeccably.
Photograph by Kevin Hunter Marple

FACING PAGE BOTTOM:
The built-in appliances equip this kitchen with efficiency for myriad meal preparations, including storage space for kitchen equipment and glassware.
Photograph by Kevin Hunter Marple

Q&A *more about bob ...*

WHAT ONE PHILOSOPHY HAVE YOU STUCK WITH FOR YEARS THAT STILL WORKS FOR YOU TODAY?
Customer service is the key; exceed expectation and there will be no shortage of customers.

ON WHAT PERSONAL INDULGENCE DO YOU SPEND THE MOST MONEY?
Golf and spoiling my wife of 33 years.

NAME ONE THING PEOPLE MIGHT NOT KNOW ABOUT YOU.
Honestly, I can't think of one thing. I am a pretty easy read and don't have secrets. What you see is what you get! I believe that anything is possible and everyone has the potential of being great, they just have to tap into it.

WHAT DO YOU LIKE MOST ABOUT DOING BUSINESS IN DALLAS?
Getting to know people well. It's very fulfilling to meet someone, discuss their initial ideas, create the concept and then bring it to fruition. It's a great feeling to see a project through to completion and have a very satisfied client who appreciates what you have done. I am an artist at heart and it means a great deal to me when someone truly loves what I have created for them. It is exciting to be in business in this area of explosive growth and to be a part of the changing landscape of the Dallas business community.

THE KITCHEN SOURCE
Bob Johns
1544 Slocum Street
Dallas, TX 75207
214.741.1912
f: 214.741.9122
www.thekitchensource.net

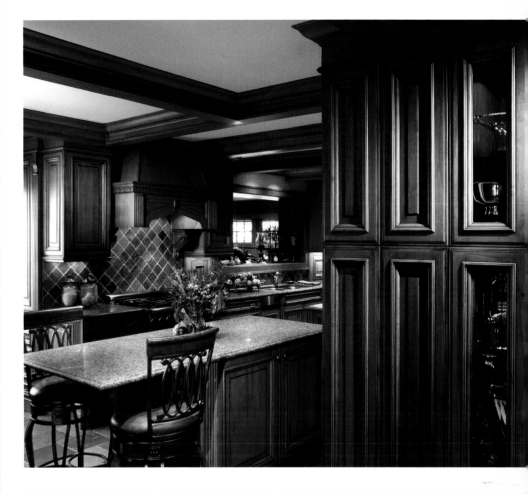

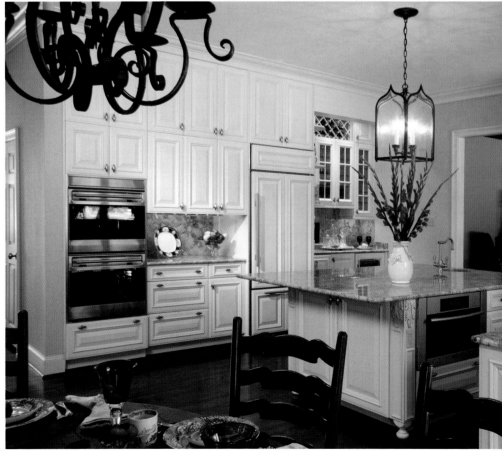

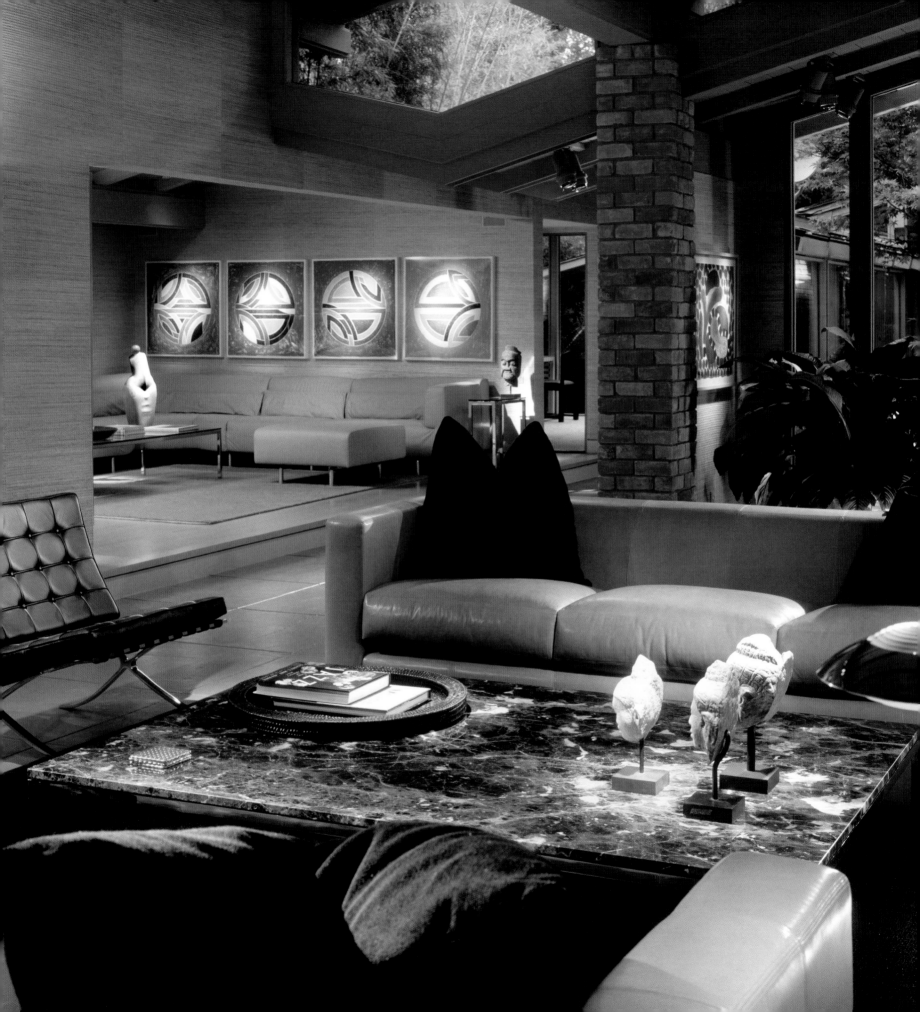

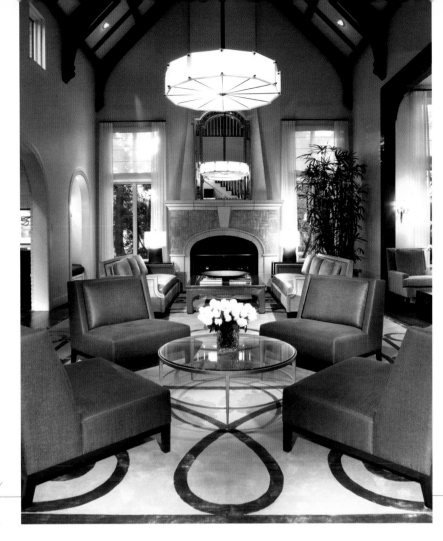

Allen Kirsch

ALLEN KIRSCH & ASSOCIATES, INC.

Allen Kirsch has been designing house plans since he was eight years old, so it is understandable that he would describe his vocation as more of a calling than a career. "It is something that I am meant to do, supposed to do," Allen says.

Inspired by one of the pioneering masters of modern architecture, Mies van der Rohe, Allen says his style is characterized by clean, straight lines. "I like to build a space without disjointed colors, with a common theme and a keen eye on proportion as well as attention to detail." This attention to detail is most evident in Allen's hands-on approach to a project. He outsources nothing, preferring to do all the work himself.

The second-generation Dallas native is a graduate of the University of Texas at Austin where he also studied fine art and architecture. Having had his own business since 1979, Allen Kirsch & Associates, Inc. has now grown into an operation that has completed projects in 13 cities in nine states. His firm has been featured in *D Home* as well as other publications like *The Dallas Morning News*.

ABOVE:
Allen Kirsch's thoughtful attention to scale and proportion made it possible to beautifully blend his clients' love for modern furniture and furnishings with their Tudor-style home.
Photograph by Charles Davis Smith

FACING PAGE:
As a part of this meticulous mid-century remodel, Allen Kirsch removed walls, expanded windows and lifted ceilings to significantly improve the natural lighting and enhance the client's important art collection.
Photograph by Ira Montgomery

ALLEN KIRSCH & ASSOCIATES, INC.
Allen Kirsch
4446 Westway Avenue
Dallas, TX 75205
214.526.5496
f: 214.526.5498
www.allenkirsch.com

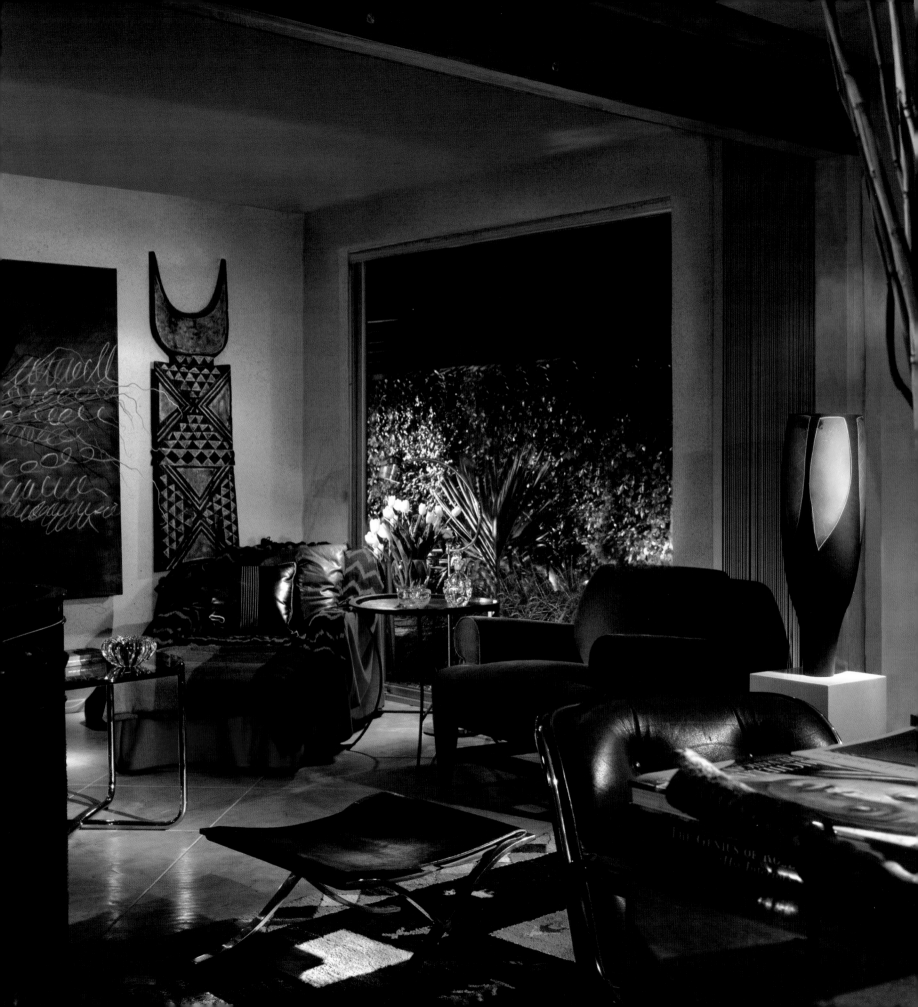

Diane Linn

LINN & ASSOCIATES, INC.

The foundation of Diane Linn's design practice is the commitment to her grandfather's philosophy, learned at an early age, that the ideal space is achieved through an integrated design process and communication between the designer, architect and landscape architect. Her grandfather was an innovative architect and developer; her father is an engineer and her brother, an architect. Earning her bachelor's degree in Interior Architectural Design from Moore College in Philadelphia was therefore a natural progression.

Linn first moved to Dallas to provide design services for The Plaza of the Americas in downtown Dallas. After building two separate firms with partners, she subsequently founded her own firm, Linn & Associates, Inc. in the late 1980s. Linn's business spans a broad spectrum of work including corporate offices, commercial spaces, retail/restaurant, residential, and exclusive high-rise developments.

Each project design is tailored to a specific client's taste or is site specific. She does not have a signature style. As an empathic observer, she intuitively understands her clients, creating interiors that are infinitely personal and express the client's personality, not her own.

ABOVE:
The table holds the overflow of an extensive book collection. Art in foreground by Paul Rotterdam; background piece by Victor Miro.
Photograph by Ira Montgomery

FACING PAGE:
A condominium in the Turtle Creek area mixes Classic, Contemporary, ethnic and Traditional designs. Overlooking a small urban courtyard garden, the room connects with the exterior, yet remains private.
Photograph by Ira Montgomery

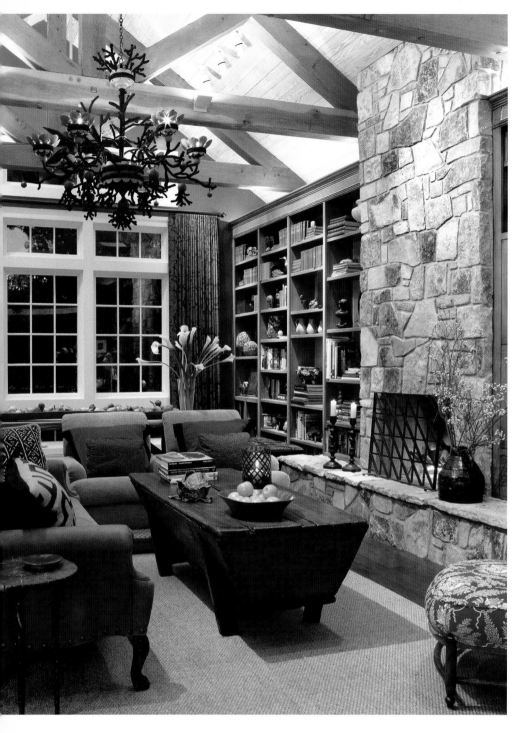

Well known for her ability to visualize spaces three dimensionally and comprehend architectural elements, her trademark is a delicate balance of style and panache as opposed to following trends or fashion. While she enjoys adding an element of surprise or intrigue to a project with the unconventional application of materials, she incorporates classic detailing, finishes and furnishings that will stand the test of time.

Diane Linn says she is very lucky because her work aligns with her passion for living. Gaining inspiration from all aspects and styles of design, she continually researches detailing methods, design elements and materials in the industry. Ongoing education and awareness of products are the edge that separates her from the competition.

ABOVE:
This Texas lake house's main living area is positioned to take full advantage of the lake view and breezes.
Photograph by Emily Minton-Redfield

FACING PAGE TOP:
Master bathroom stone selections are indicative of the indigenous materials throughout the residence.
Photograph by Emily Minton-Redfield

FACING PAGE BOTTOM:
Fortuny fabric graces the linens in this master bedroom.
Photograph by Emily Minton-Redfield

Q&A

more about diane ...

WHAT IS ONE THING THAT MOST PEOPLE DON'T KNOW ABOUT YOU?

Many people are surprised if they call the office after hours and don't get my voice mail because I answer the phone. I don't believe in wasting a moment when creativity takes hold, no matter what the time is.

WHAT DESIGN ELEMENTS ARE PREVALENT IN YOUR OWN HOME?

My home is always a work in progress, sometimes a testing ground for future design ideas, but mostly comprised of classic contemporary furnishings, contemporary art, mixed with traditional accents and antiques. My love for landscape architecture, reflected in my urban courtyard, echoes both my taste and the Dallas climate.

WHAT IS THE BEST PART OF BEING AN INTERIOR DESIGNER?

I enjoy working with clients to create unique interiors specifically for their lifestyle. My work is my passion.

LINN & ASSOCIATES, INC.
Diane Linn
2728 Welborn Street, Suite 127
Dallas, TX 75219
214.521.0878
f: 214.521.0879

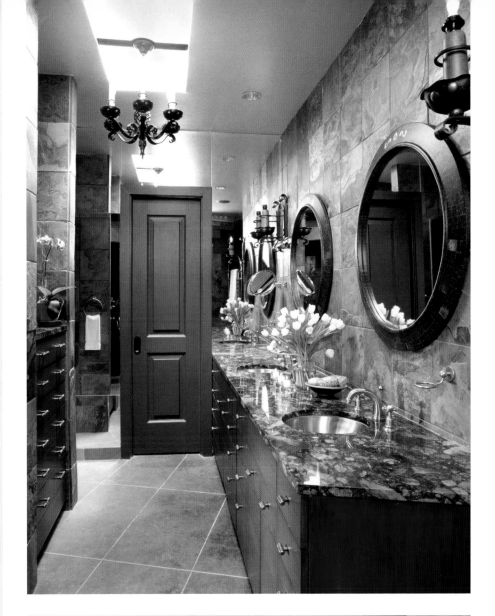

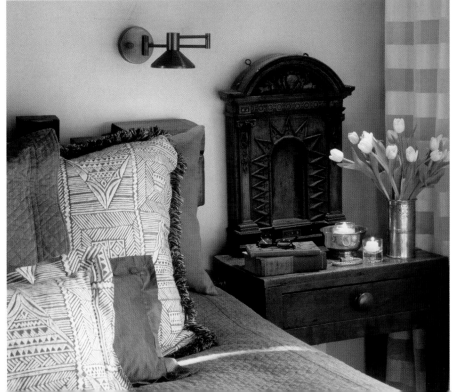

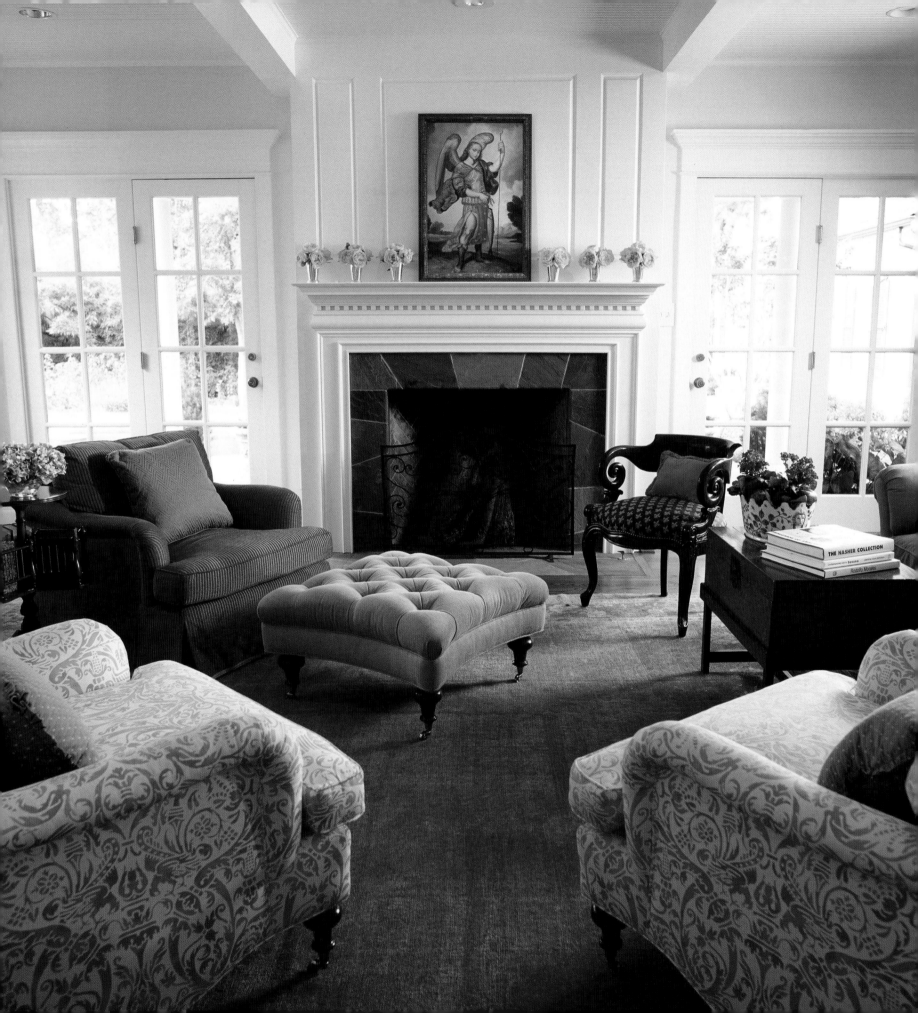

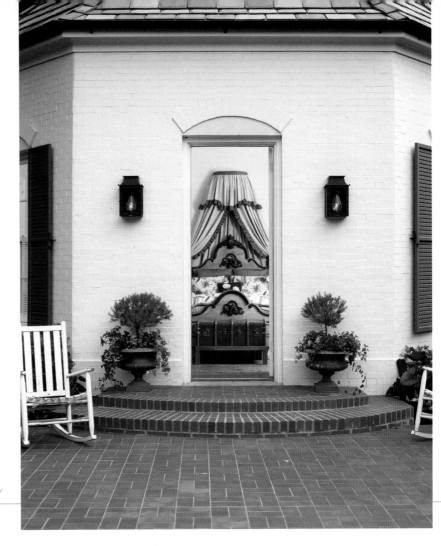

John Marrs

JOHN PHIFER MARRS, INC.

Based out of Dallas, John Phifer Marrs, Inc. provides custom residential design for clientele all across the United States. John draws on his love for the South to create comfortable yet unbelievably charming and stylish interiors personalized for every client. His projects include major residences, vacation homes, executive offices and even the official residence of a United States Ambassador.

As one of the largest fully staffed design studios in Dallas, his firm designs, project manages and installs beautiful interiors in Dallas and throughout the United States. His clients admire his talent to not only have the design "vision" but also the follow-through to carry the project to completion. Combining elegance with fresh new ideas and timeless Southern charm, John intertwines personality with individuality and vast design experience to lead clients near and far towards obtaining that perfect space.

Along with completion of the National Council for Interior Design Qualification examination, John conducted post-graduate studies in the United States as well as in the European Program at the Parsons School of Design in both Paris and Rome. In recognition of John's vast success in the industry, his work has been published in major shelter magazines, including *Better Homes and Gardens, D Home, Traditional Home, The Catalogue of Antiques & Fine Art* and the renowned *Architectural Digest.* When not

ABOVE:
Styled after the garconnieres of Louisiana plantation homes, this guest cottage blends easily with the architecture of the main house.
Photograph by Danny Piassick

FACING PAGE:
Once proclaimed the ugliest room in the house, the family room was enlarged and updated. Marrs designed the custom-upholstered furniture so its scale would fit the space.
Photograph by Danny Piassick

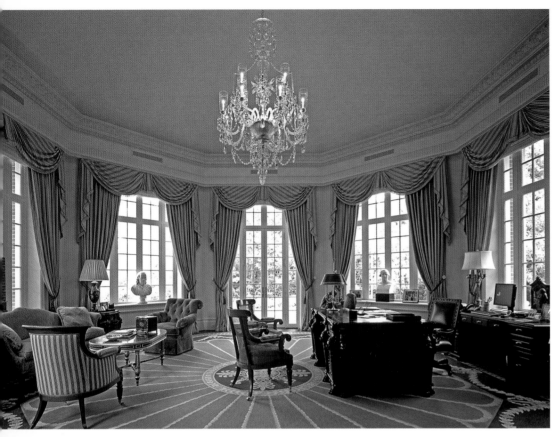

busy creating beautiful new visions, he can sometimes be found acting as guest lecturer or emcee for various organizations and design events, where his friendly nature and sense of humor shine through. His leadership roles include the Texas Chapter President of the American Society of Interior Designers and Chairman of the ASID Dallas Association.

A lover of the past and of antique treasures, John unites his Southern roots with inventive style and functionality for an end result that is personalized for each client's taste. From Dallas to D.C., John and his knowledgeable staff are never out of design's reach.

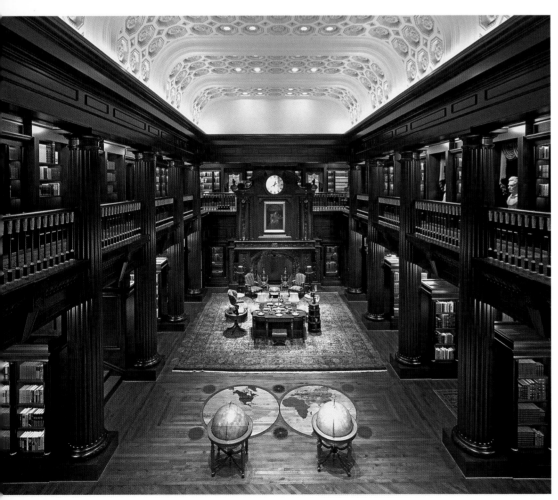

Q&A

more about john ...

WHAT ONE ELEMENT OF STYLE HAVE YOU STUCK WITH FOR YEARS THAT STILL WORKS TODAY?

Comfort and beauty ... a well-done room should have both! Many refer to our designs as the "New Southern Style."

WHAT IS A SINGLE THING YOU WOULD DO TO BRING A DULL HOUSE TO LIFE?

Everyone needs a collection of beautiful things ... china, porcelain or crystal—just find something you love and start shopping! Nothing says Southern Style better than a polished mahogany table, beautiful cut crystal and your family silver.

WHAT DO YOU LIKE MOST ABOUT DOING BUSINESS IN TEXAS?

I am able to reflect my Southern roots in my design—rooms that are functional for the client, yet gracious and welcoming.

WHAT IS THE HIGHEST COMPLIMENT YOU HAVE RECEIVED PROFESSIONALLY?

I have been told that my "gracious interiors are the hallmark of the South"—what a flattering remark!

JOHN PHIFER MARRS, INC.
John Marrs, ASID
4623 West Lovers Lane
Dallas, TX 75209
214.352.4949
f: 214.352.9696
www.johnmarrs.com

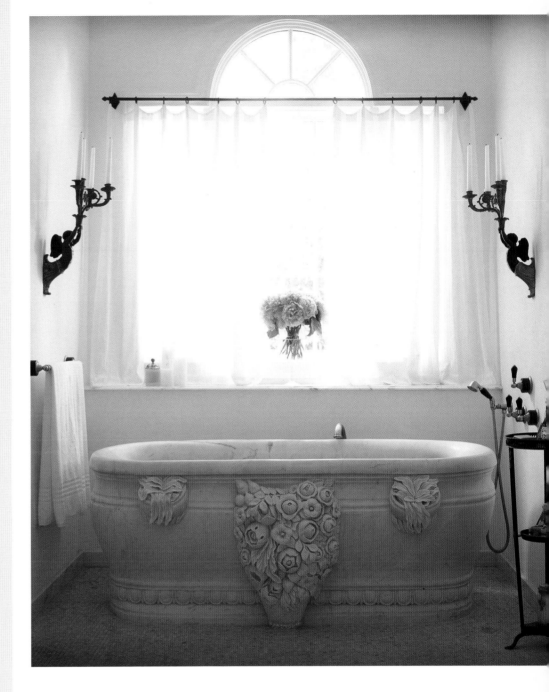

ABOVE:
A freestanding, hand-carved marble tub is the focal point of the new master bathroom, where a Palladian window relates back to the home's original architecture.
Photograph by Danny Piassick

FACING PAGE TOP:
This domed octagonal home office is accented with period furniture and a custom-designed area rug.
Photograph by Dallas Visual Design

FACING PAGE BOTTOM:
The 6,000-square-foot, mezzanine library is grand in scale, fitting for the owners' museum-quality collection of documents, art and antiques.
Photograph by Dallas Visual Design

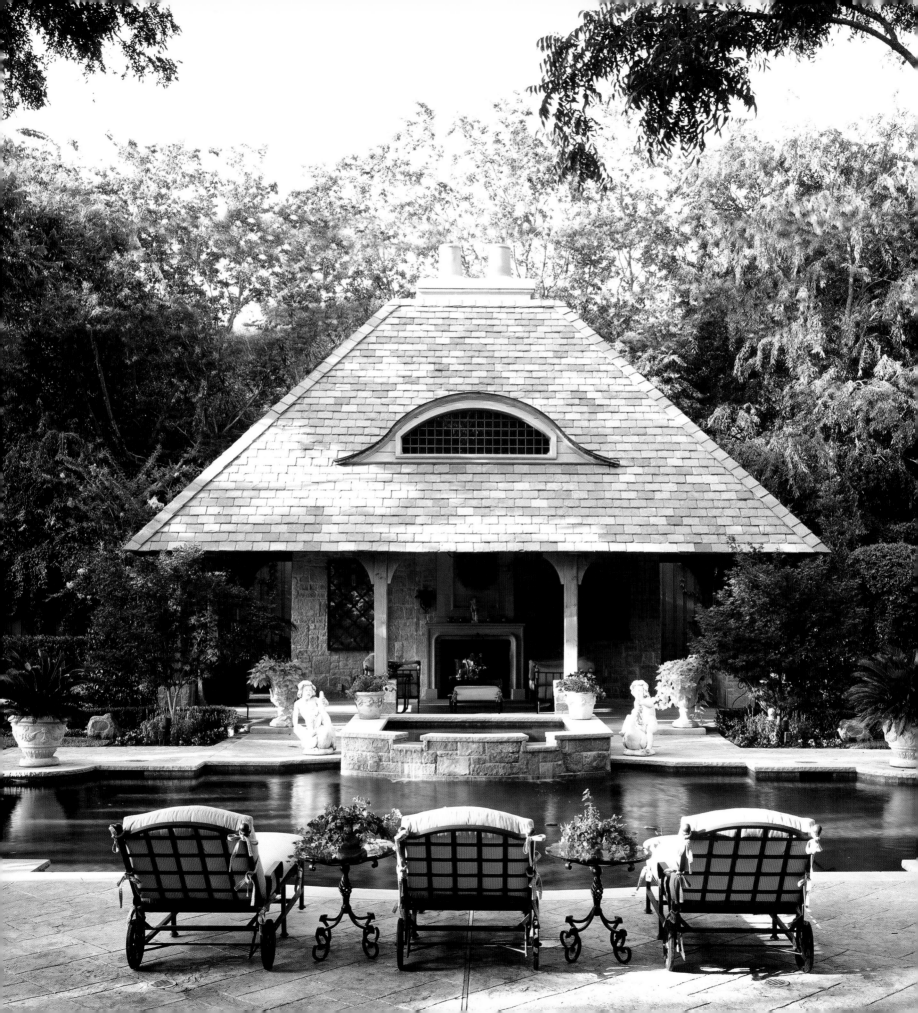

Barbara J. McCutchin

BARBARA J. McCUTCHIN & ASSOCIATES

Celebrated designer Barbara McCutchin's interior design preferences often lean toward antiques sprinkled with classic contemporary pieces and contemporary art which she describes as eclectic and timeless with a balance of color, texture and warmth. In a world of many designers, it is her passion for her career, attention to detail and a love of people that sets her apart from her peers.

In addition to her innately illustrious eye for design that guides her through each project, Barbara also listens carefully to her clients' wishes and weighs their lifestyle and budget while developing a vision of a home reflecting the owner's personality. "However, if you're lucky, you'll get a client that gives you no boundaries, especially financial," she adds.

A native Dallasite, Barbara has practiced here for 35 years and has been featured in various publications including *D Home* and *Secrets of French*

Design by Betty Lou Phillips. Noted by design publications and clients alike, it is easy to appreciate her design genius; a client's five-year-old daughter said she wanted to hire Barbara to decorate her "grown up" home. Barbara happily accepted!

ABOVE:
Dramatic Country French powder bath features antique Louis-Philippe mirror, antique hand-painted French chest, custom gold leaf wall covering, and priceless Dutch artwork.
Photograph by Ira Montgomery

FACING PAGE:
Luxurious outdoor living area features Murray Iron Works furnishings and antique Belgian garden statuettes.
Photograph by Ira Montgomery

BARBARA J. McCUTCHIN & ASSOCIATES
Barbara J. McCutchin
3701 Turtle Creek Boulevard, Suite 8-A
Dallas, TX 75219
214.641.3695
f: 214.443.7939

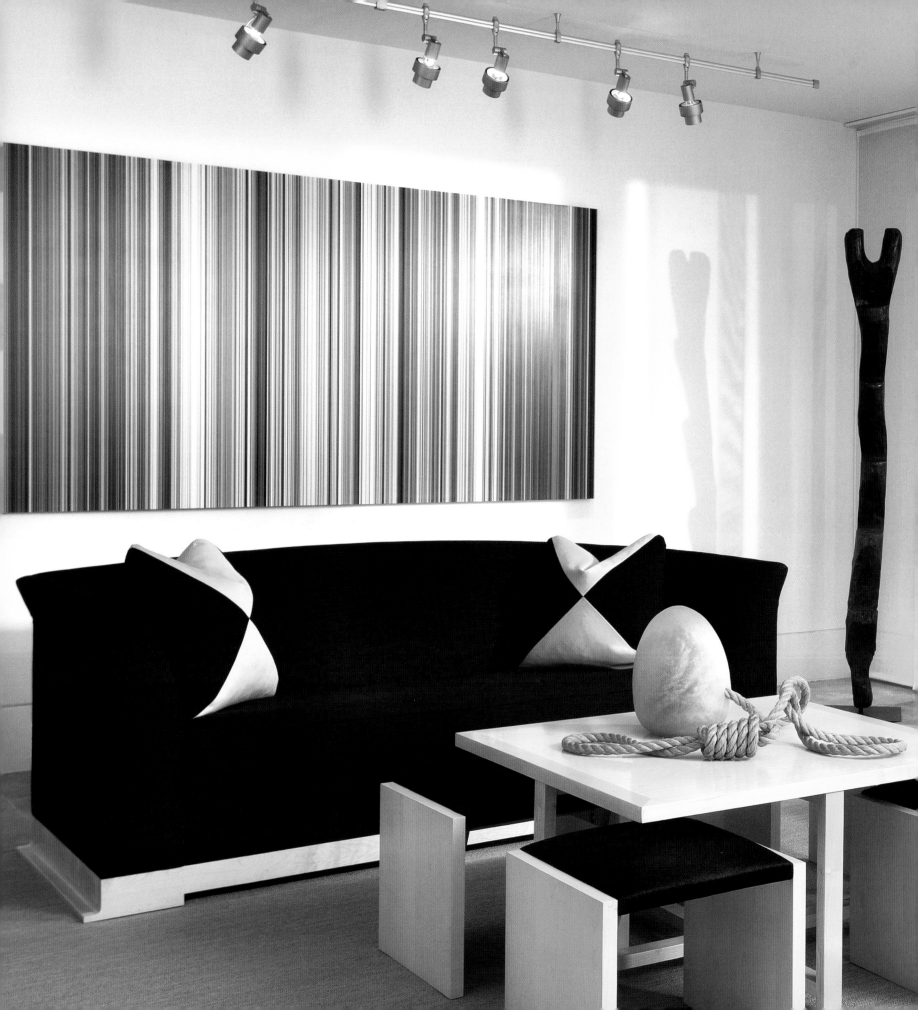

Robyn Menter

ROBYN MENTER DESIGN ASSOCIATES, INC.

Robyn Menter, founder of Robyn Menter Design Associates, Inc., prides herself on creating distinguished spaces for a discerning clientele around the world. Since establishing the firm in 1994, Robyn has worked in an array of different styles, both Traditional and Contemporary, always translating the practical needs of the clients into innovative solutions. After emigrating from South Africa in the early '80s, Robyn made Dallas her home. With over 30 years of experience, she still loves Dallas, and the design opportunities the city has to offer. Robyn appreciates the accessibility to showrooms and vendors with global representation as well as the talented craftspeople who are able to fabricate her custom designs. With the continual evolution of design, each project creates a new challenge to incorporate diverse taste and styles.

Largely inspired by many of the modern design masters like Le Corbusier, Mies van der Rohe, Louis Kahn, Richard Neutra and Frank Lloyd Wright, Alicia Quintans, AIA, an associate of Robyn Menter Design Associates, relies on architectural foundations in all of her designs. With a background and training in

LEFT:
In the living room, Robyn juxtaposes an antique African ladder with European-designed furniture and local Texas art to complement the architecture and surrounding wooded creek.
Photograph by Danny Piassick

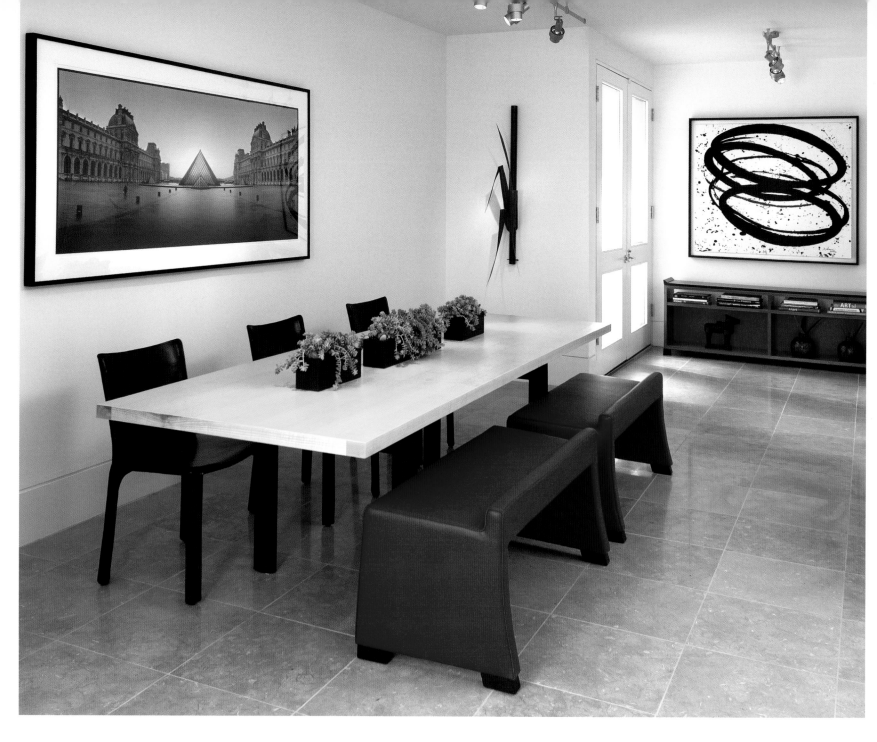

architecture, her favorite part of the interior design process is manipulation of the interior space. "So much detailing is involved in architecture that is hidden to the eye—these are important to the function and durability of the building, yet most go unnoticed and are taken for granted. Interior design allows for exquisite, refined details that are seen and enjoyed by building inhabitants each day," she shares.

Robyn's firm is well-known amongst colleagues and clients alike for her stellar design genius. Her clients, with an appreciation for good design,

motivate her to continually strive to achieve original and exceptional work. Whether the project is new construction, renovation, a restaurant or furniture design, her ultimate goal is to achieve perfection. Robyn and her professional staff consistently execute architectural and interior design projects—from conception to reality—that leave her clients astounded.

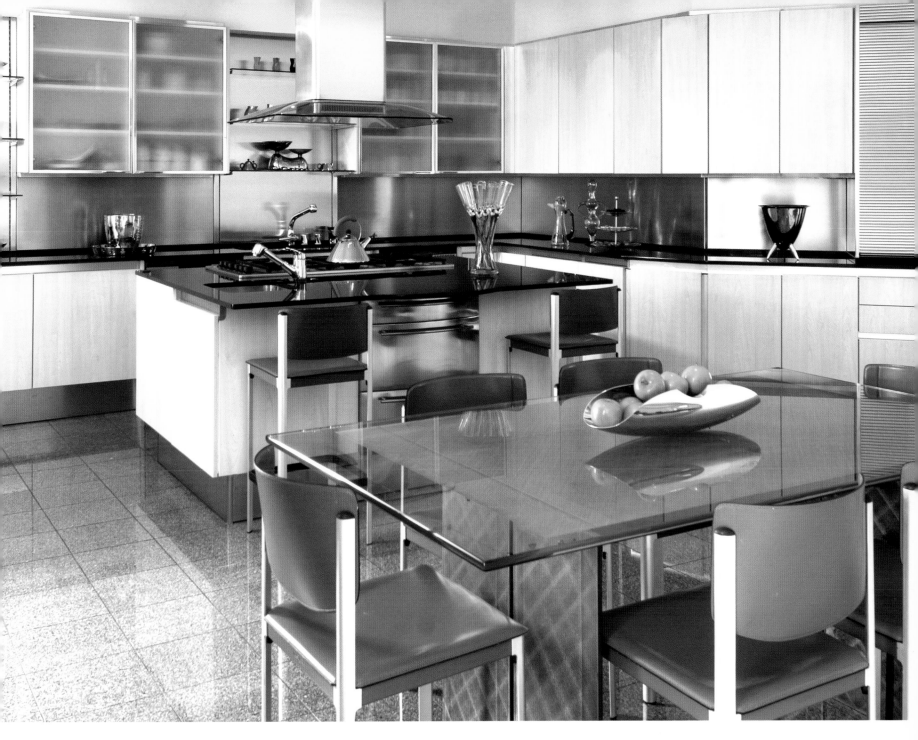

ABOVE:
This kitchen was remodeled for a gourmet cook. Functionality, simplicity and ease of maintenance were the priorities while the ability to accommodate groups of guests, who invariably gravitate towards the kitchen, was essential.
Photograph by Danny Piassick

FACING PAGE:
A limestone floor, extensive use of natural light and minimal lines in the furnishings allow for a relatively small space to appear larger and draw attention to the client's eclectic art collection.
Photograph by Danny Piassick

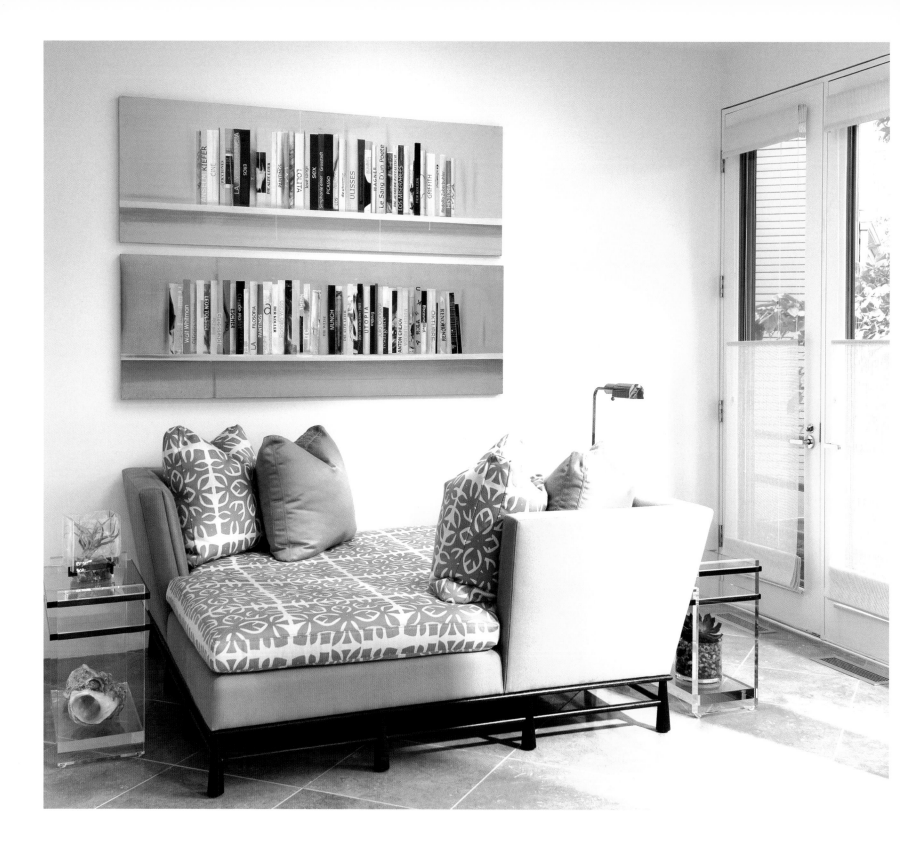

ABOVE:
The square daybed and pair of Pancho Luna paintings are the focal point of the area. Ideally used as a retreat to relax with a glass of wine and good book after a long day.
Photograph by Danny Piassick

FACING PAGE:
The closet, with extensive use of mirror to optimize the space, was designed to accommodate the clothing collection of a true fashionista. The glass doors provide visibility and protection of the hanging pieces. Shoes are stored in individual acrylic drawers and the pullouts have custom, divided interiors.
Photograph by Danny Piassick

Q&A

more about robyn ...

WHAT IS THE MOST UNIQUE HOME WITH WHICH YOU HAVE BEEN INVOLVED?

I once had the privilege to work on a schoolhouse in Pennsylvania that was converted into a home and placed on the National Historic Register. We were able to remodel parts of the residence while maintaining the original design intent: updating bathrooms and living spaces and using a combination of the client's existing antiques together with new furnishings to create a unique home.

WHO HAS HAD THE BIGGEST INFLUENCE ON YOUR CAREER?

My husband who encouraged me to pursue my career and continues to be a constant source of inspiration.

WHAT ELEMENT OF STYLE OR PHILOSOPHY HAVE YOU STUCK WITH FOR YEARS THAT STILL WORKS FOR YOU TODAY?

Clean, simple design with the focus on quality and craftsmanship.

WHAT IS THE HIGHEST COMPLIMENT YOU'VE RECEIVED PROFESSIONALLY?

A referral is always the best compliment.

WHEN YOU'RE NOT DESIGNING, HOW DO YOU SPEND YOUR FREE TIME?

I travel extensively—specifically on educational trips associated with national museums where the primary focus is art and architecture. The most exciting of my recent travels has taken me to India to study the history of textiles and the architecture of Rajestan and Northern India. I also recently traveled to Japan where I was invited to visit the atelier of the renowned architect, Tadao Ando, and had the opportunity to participate in some in-depth study of his museum and residential projects.

ROBYN MENTER DESIGN ASSOCIATES, INC.
Robyn Menter
3131 Turtle Creek Boulevard, Suite 820
Dallas, TX 75219
214.526.4176
f: 214.528.6449
www.robynmenter.com

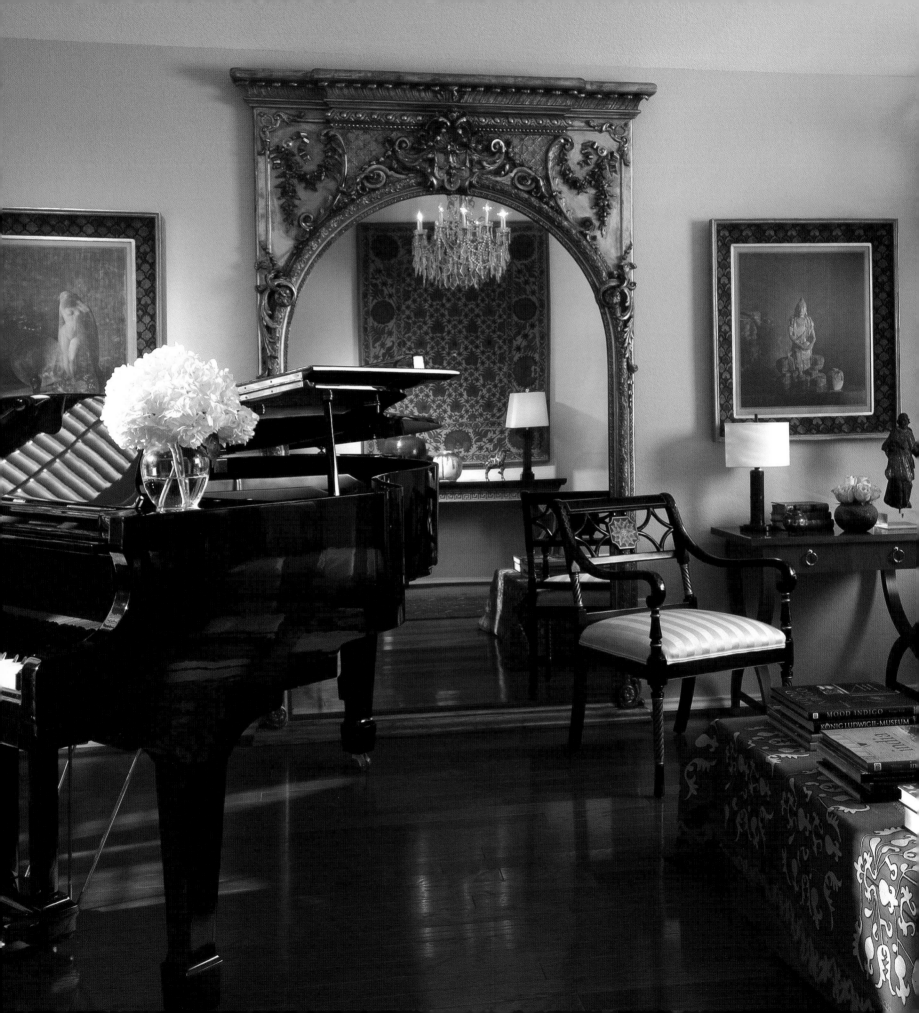

Kim Milam

KL MILAM INTERIOR DESIGN

Staying true to timeless design, Kim Milam's philosophy is simple: avoid trends and always remain faithful to the architecture of a home. Though at times it can be a challenge with so many of today's homes being constructed as amalgams, making it difficult to identify any one essence to draw upon, Kim takes them head on, drawing on her creative ingenuity to create modern masterpieces.

Vigilant in eluding an idiosyncratic flavor in her work, Kim is able to create any style a client desires, gracefully weaving their personality into the details of a room. Infusing color, eliminating clutter and introducing organic elements into each project, she simplifies, creating clean lines and elegant interiors that are as enduring as they are beautiful.

ABOVE:
Document English fabric circa 1760 covers the custom sofa and pairs wonderfully with the Italian cut velvet wrapping the antique wingback chair. The French bouillotte lamp is 18th century.
Photograph by Danny Piassick

FACING PAGE:
A vintage Middle Eastern tapestry and a collection of Raku pottery is reflected in the 19th-century French gilt mirror. The book-laden coffee table is clad in a Turkish susanni. A rare antique Santos from Southeast Asia rests on the English side table.
Photograph by Danny Piassick

KL MILAM INTERIOR DESIGN
Kim Milam
6721 Briarwood Drive
Fort Worth, TX 76132
817.266.3386

Photograph by Karen Pfleger

143

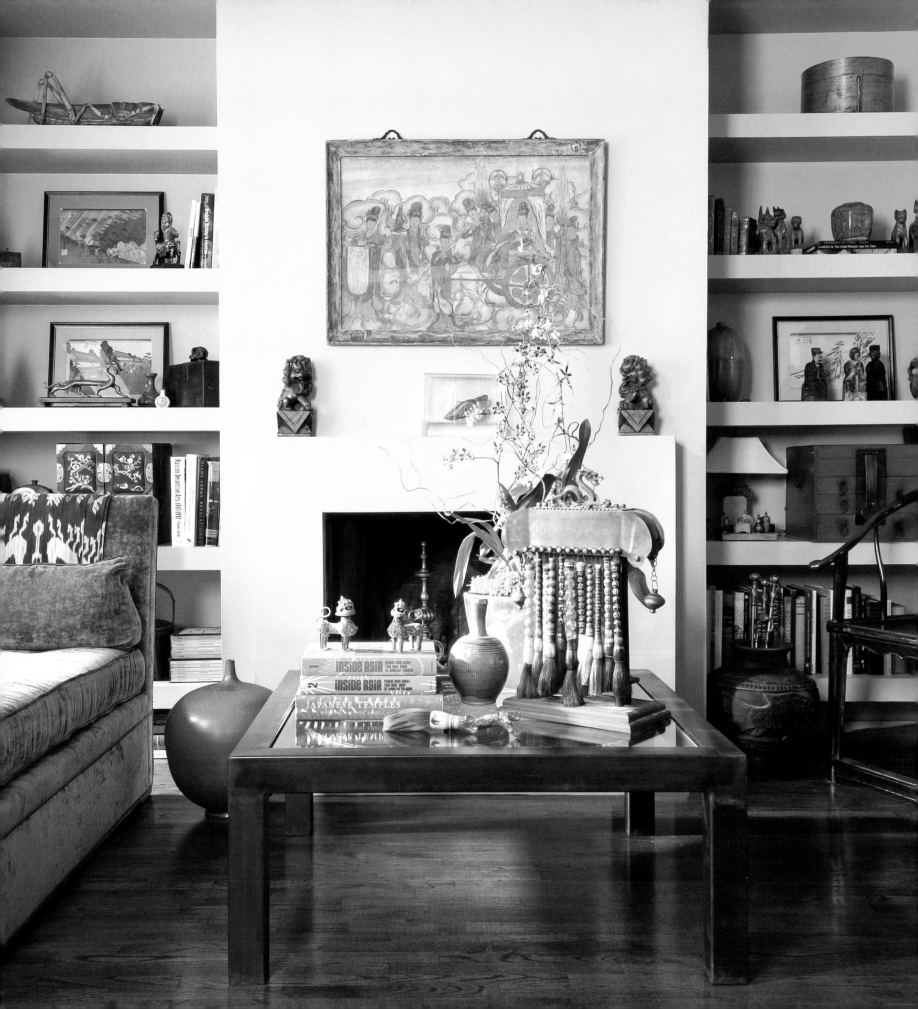

Debra Owens

DEBRA OWENS INTERIORS, INC.

Debra Owens loves the Dallas area not only for the trendsetting lifestyle but also for the diverse trailblazing insight to future trends. Since planting her roots in Dallas 16 years ago, Debra has established her designs on the forefront of Dallas' jet-setting clientele.

Debra is resolute in her philosophy that quality is not expensive, it is priceless. Following that truth with unbending dedication and aligning herself with the very best craftsmen in the city assures her clients that they are receiving the finest workmanship while Debra provides a stellar performance from start to finish.

LEFT:
A blend of ancient Asian artifacts adorn 21st-century architectural design to create a timeless mise-en-scène for relaxation and inspiration. The intricate detail of a very rare kesi slit tapestry with silver and gold couched metallics from the Ming dynasty captures the imagination. An 18th-century Chinese watercolor painting of a procession hangs above an encased silk lotus slipper, accenting the contemporary lines of the fireplace.
Photograph by Danny Piassick

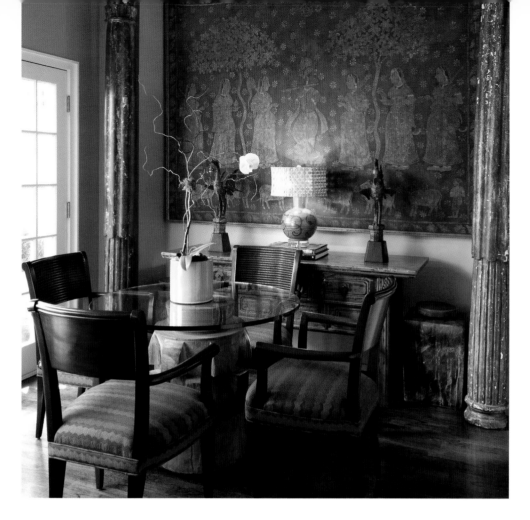

Her unstoppable commitment to uncompromising service has earned her a loyal clientele and features in *D Magazine* and *Dallas Home Design*. Although Debra's design preferences run the gamut, there is a common thread in her work: A blended, well-rounded niche creating timeless panache. Firmly incorporated conceptual direction and architectural integrity mix easily with treasured family heirlooms and custom design creating environments that are experienced as much as they are revered.

Enhancing spaces with their function solidly in mind, Debra's ageless interiors are versatile and livable. Furnishings, window treatments and accessories abundant with supple forms can be enjoyed through everyday use in Debra's soothing, understated elegance.

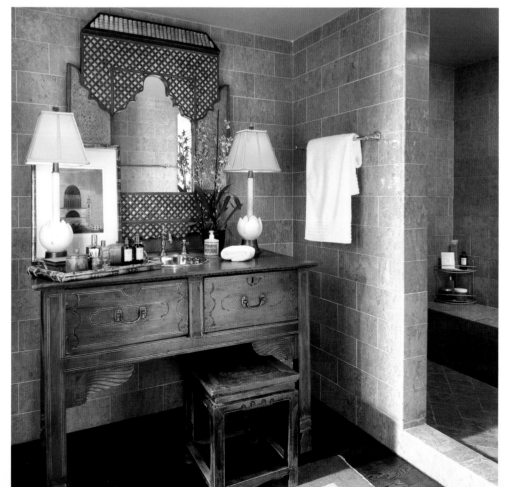

TOP LEFT:
The juxtaposition of contemporary Donghia chairs paired with an antique sugar press, turned dining table, provide an ideal setting for harmonious dining and conversation. Giant tea jars and old Guatemalan columns frame a rare pichwai cloth, painted in 19th-century India.
Photograph by Danny Piassick

BOTTOM LEFT:
The master bath walls covered in rare yellow marble are a luxurious backdrop to the exquisite Moroccan mirror floating above the antique, customized vanity. 19th-century alabaster lotus lamps add a warm glow to the overall feeling of peace and tranquility.
Photograph by Danny Piassick

FACING PAGE TOP:
The second-floor guest suite is an exotic blend of colors and textures from around the world. The steel-tubed bed with integrated lanterns and antique Korean chest are among many one-of-a-kind finds from Allan Knight and Associates.
Photograph by Danny Piassick

FACING PAGE BOTTOM:
A pair of whimsical turquoise and coral Foo Dogs from Nick Brock Antiques remind Debra of the joy that can be found in the smallest of treasures.
Photograph by Danny Piassick

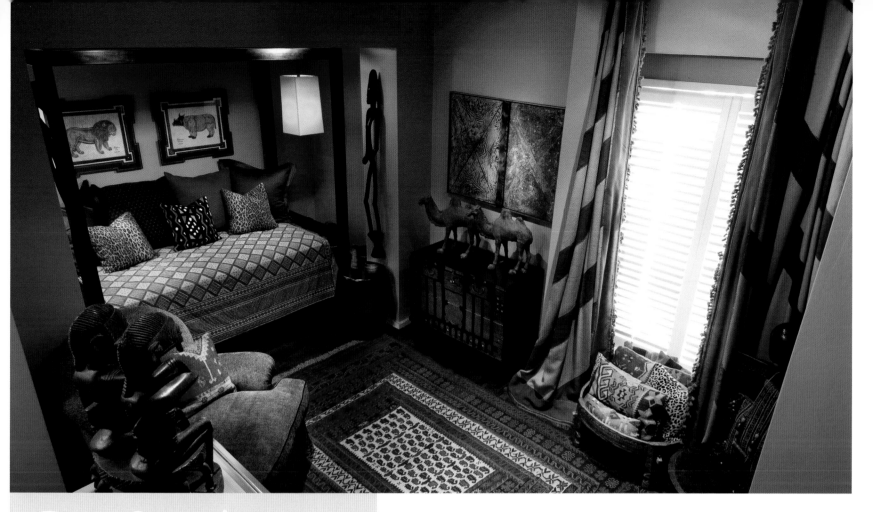

more about debra ...

WHAT EXCITES YOU ABOUT BEING FEATURED IN *BEAUTIFUL HOMES*?
It's amazing to be associated with the sterling reputation of Texas'
finest and most talented designers.

WHAT COLOR BEST DESCRIBES YOU AND WHY?
Green; all shades from sage to lime because it represents new
growth, calm reflection and uncontainable enthusiasm.

WHAT IS THE HIGHEST COMPLIMENT YOU HAVE RECEIVED?
Referrals and repeat business.

YOU WOULDN'T KNOW IT BUT MY FRIENDS WOULD TELL YOU I AM ...
Very shy and sentimental.

DEBRA OWENS INTERIORS, INC.
Debra Owens
4038 Lemmon Avenue, Suite 102
Dallas, TX 75219
214.741.4443
f: 214.720.4448

Gary Riggs

GARY RIGGS INTERIORS

Gary Riggs of Gary Riggs Interiors began to develop his passion for beauty years ago when he discovered his first true love, painting. He began his distinguished career creating sets and scenery for the television and film industry, many of which appeared on national prime time. Gary also applied his artistic talents and knowledgeable use of line, color, texture and balance to dress his own home. Soon the clientele who originally visited his residence to view his artwork began to request that he design their homes. Word of mouth spread rapidly; Gary was soon highly desirable in the world of interior design, thus marking the beginning of his thriving career.

Celebrating over 20 years in the design arena, Gary opened his much anticipated showroom in Allen, Texas just over two-and-a-half years ago. The impressive 30,000-square-foot space boasts upward of two-and-a-half million dollars in available inventory, opulently showcasing rich fabrics, fine furnishings,

LEFT:
The exquisite de Mille residence, located in Frisco, Texas, is home to this opulent master suite featuring an authentic zebra hide ottoman and sumptuous coyote throw.
Photograph by Nick Gaetano

unique accents and distinctive color palettes; all signatures of Gary's luxurious style. Gary Riggs Interiors also prides itself on attracting first-class talent to the firm. Lead designers Mike Reese and Sandy Howard have called GRI home since its inception. The firm has a current, but ever-growing staff of 15 trained professionals that assist in maintaining its status at the forefront of the design industry.

To the delight of his discriminating clientele, Gary approaches every space as though it were a canvas awaiting the brushstrokes that will create magnificence. Applying intrinsic art concepts to environments and never afraid to think outside the box, he encourages clients to embrace what they love, not just what they deem appropriate or trendy. "I want my clients to do

ABOVE:
This inspiring formal dining room evokes that sense of unplanned elegance, which Gary Riggs is famous for creating, with the pieces appearing to be collected over time.
Photograph by Nick Gaetano

FACING PAGE:
The breathtaking de Mille living room features a French antique stove (at right) that was hand-assembled from over 100 pieces of hand-painted porcelain. It is one of only three in existence and the only one of its kind in America.
Photograph by Nick Gaetano

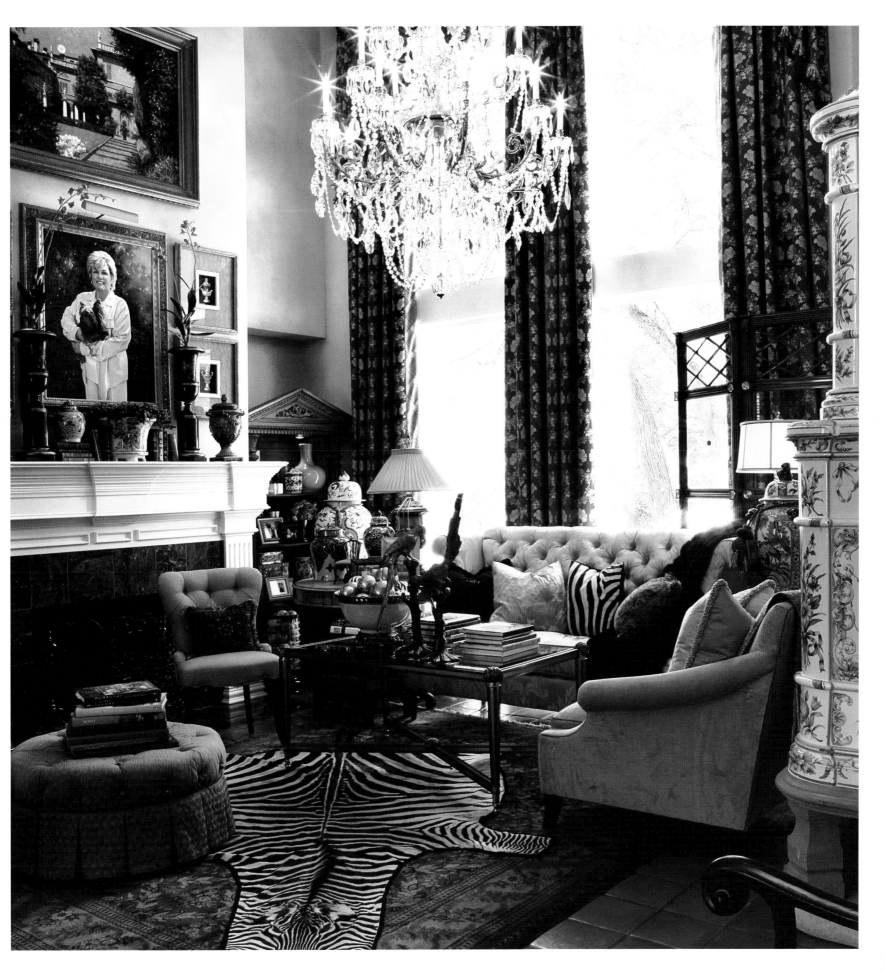

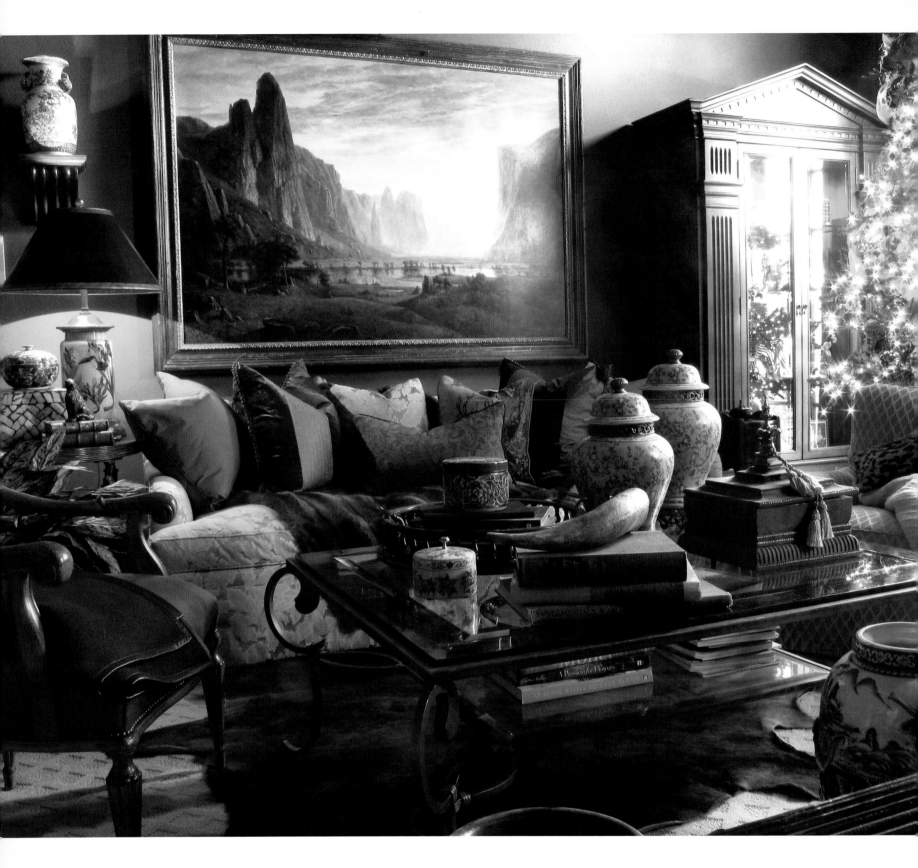

ABOVE:
This genteel master bedroom belongs to the designer himself; a handsome nest of unparalleled comfort.
Photograph by Nick Gaetano

FACING PAGE:
This spectacular bed in the palatial Grisham master bedroom serves as the room's crowning glory; fit for a king and queen.
Photograph by Nick Gaetano

what they enjoy, even if they think it's different," he says. "There is no use in creating a room just so someone else will like it, it should be what you love." Enhancing people's quality of life is essential in each project Gary completes. As an extension of that philosophy, Gary recently designed Presbyterian Hospital of Plano's Women's Diagnostic Center, surgeon and doctor lounges, as well as the highly acclaimed pediatric wing, inlcuding his personal gift of enchanting, original murals.

No matter the project, Gary's lavish environments are stunning as well as comforting. "I want people to walk into my clients' homes and, regardless of their lifestyle or tastes, say, 'This is incredible!' It is that big response I'm after; a response they just can't help."

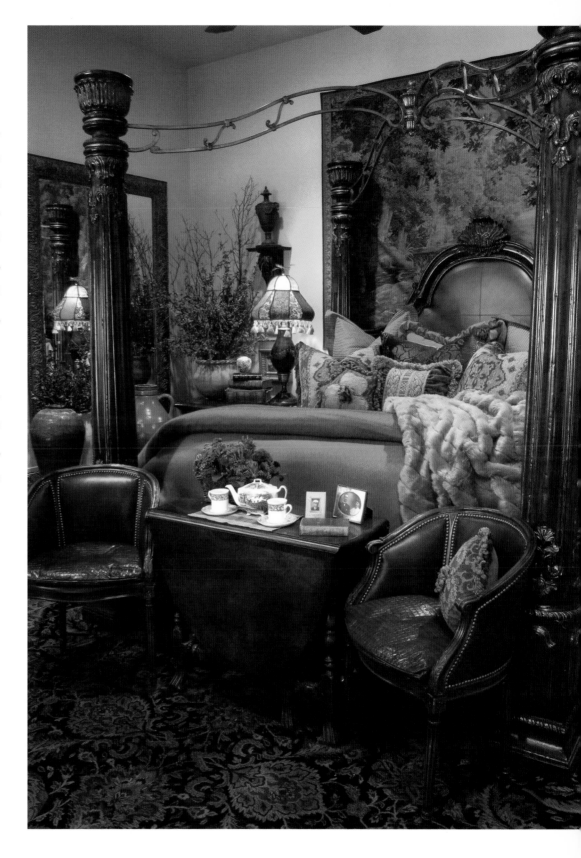

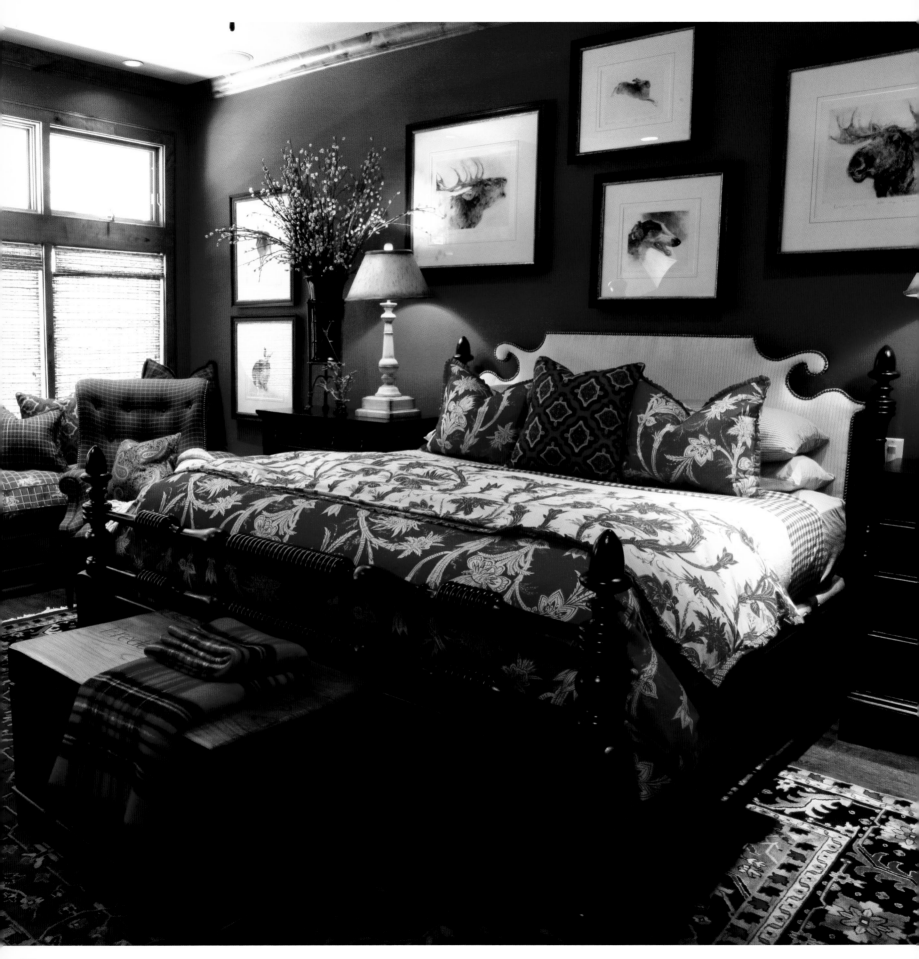

Q&A

more about gary ...

WHAT DO YOU LIKE MOST ABOUT BEING AN INTERIOR DESIGNER?
One of the best aspects of interior design is the people that I meet. So many of my clients are interesting, wonderful people and I have made some great friends. Never in a million years did I think I would wind up working as a designer, but I love the creative process as well as the creative outlet.

DESCRIBE YOUR STYLE OR DESIGN PREFERENCES.
I approach design like painting, my style is very representational but with an edge that makes it quite extraordinary. It is Traditional, but I also interject something Transitional or Contemporary. I want to be sure that my projects feel as though they are collected over time, not as if they have been pulled together immediately like the page of a magazine.

WHAT COLOR BEST DESCRIBES YOU AND WHY?
Green, because I try very hard to get along with everybody and green is a color with which anyone, or anything, will work well.

WHAT DO YOU LIKE MOST ABOUT DOING BUSINESS IN DALLAS?
There are people from every culture and place that make their home in Dallas and that translates into different styles and tastes. The diversity of the city and the sense of community and family are wonderful.

GARY RIGGS INTERIORS
Gary Riggs, ASID, IIDA, NEWH, IFMH
505 Century Parkway, Suite 250
Allen, TX 75013
214.547.1054
f: 214.547.0450
www.garyriggsinteriors.com

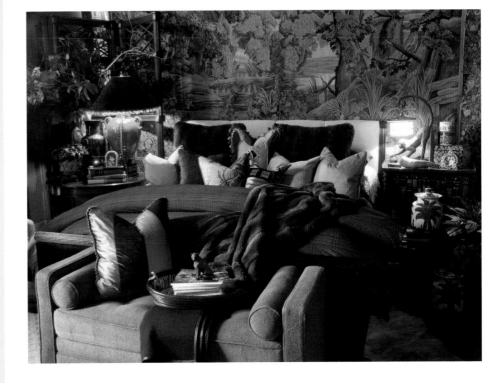

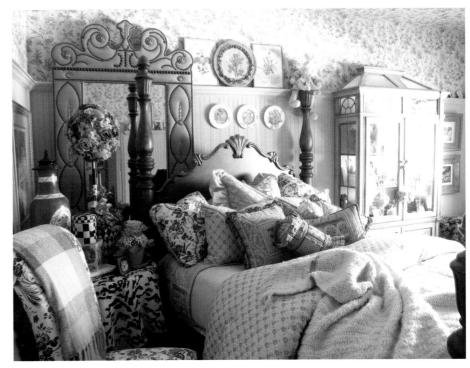

ABOVE TOP:
This decadent bedroom in the home of Gary Riggs boasts an amazing oversized tapestry that seems to take the sleeper into an enchanted land of luxury.
Photograph by Nick Gaetano

ABOVE BOTTOM:
Paris, the designer's daughter, is the happy inhabitant of this graceful space. The feminine glass armoire holds items dear to her heart, while the blush fabric and nail-studded mirror reflects the girl that is dear to his.
Photograph by Nick Gaetano

FACING PAGE:
The Shanafelt lake house is both picturesque and vibrant; designed to encourage rest as well as stimulate a resurgence of energy.
Photograph by Nick Gaetano

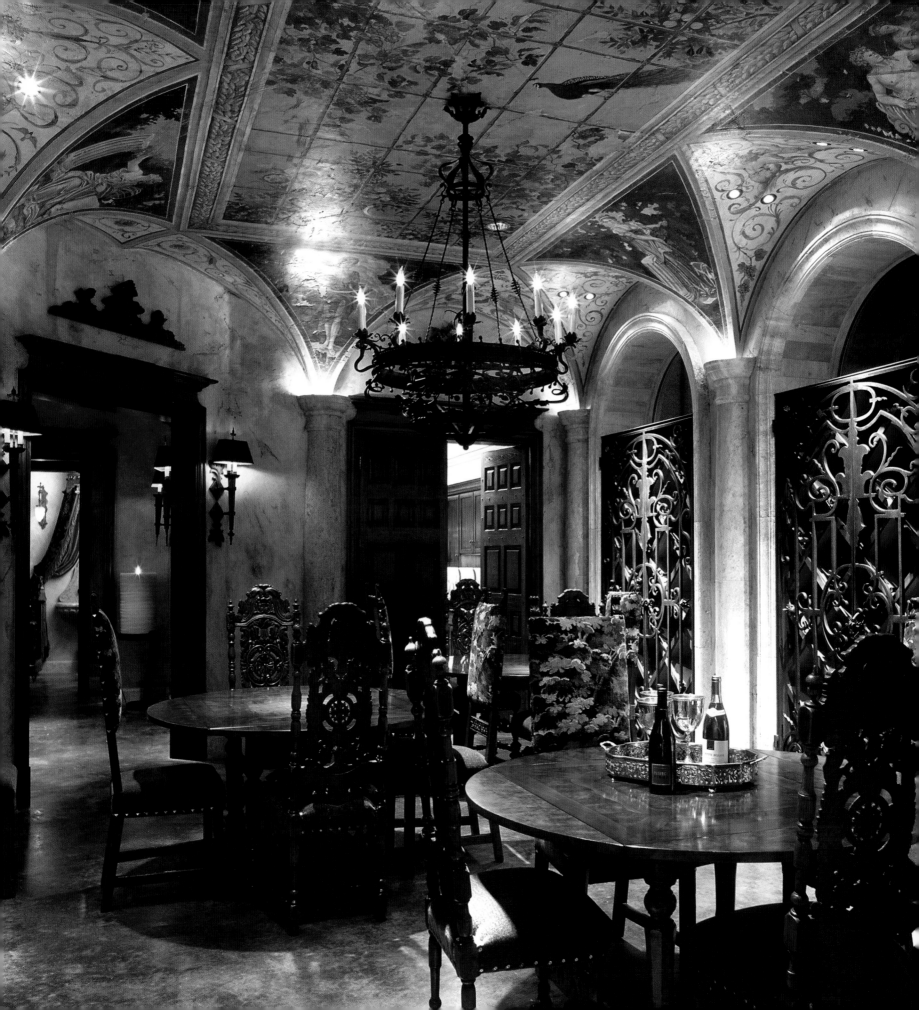

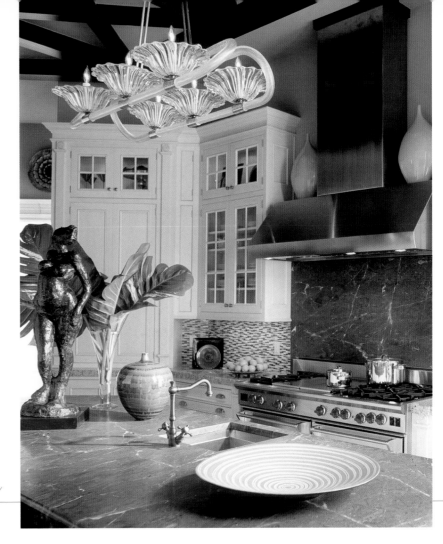

Nancy Anderson Ross

DALLAS DESIGN GROUP INTERIORS

Nancy A. Ross has built an impressive and impeccable reputation over the last 28 years as an extraordinary designer both in Texas and nationally. Her firm, Dallas Design Group Interiors, a vanguard in the design profession, specializes in interior architectural detailing. Using the most innovative technology, Nancy and her creative workforce have remained a benchmark of perfection in all aspects of design from Traditional to Contemporary. While the firm specializes in working with each client from concept to completion including furnishings, custom draperies, bedding, accessories and all the finishing touches, it is their involvement in the early conceptual stages of each project that ensures continuous success.

Working throughout the years to develop their niche in interior detailing, Nancy and her firm have also become well known with designers and clients alike as the design group with a team approach which utilizes custom

homebuilders and architects. This approach has ensured that Dallas Design Group Interiors remains at the forefront of today's design industry. With a staff of 22, the firm is one of the largest interior design firms in Dallas and was recently ranked sixth in the *2005 Dallas Business Journal.*

Built on the principle that each choice made on a project is based on the quality it will ultimately add, Dallas Design Group's mix of consistently flawless expertise and unbridled enthusiasm has proven to be fundamental to the firm's longevity and is a testament to exceptional vision and versatility. This team of

ABOVE:
This kitchen features products inspired from the 1930s' and 1970s' signature styles, including state-of-the-art appliances and a Venetian glass chandelier.
Photograph by Danny Piassick

FACING PAGE:
Painted, hand-crafted plaster walls and ceilings in the fresco manner envelop this sub-level dining space so reminiscent of Firenze. 18th-century Italian and French antiques continue the feeling that "this just might not be Dallas."
Photograph by Danny Piassick

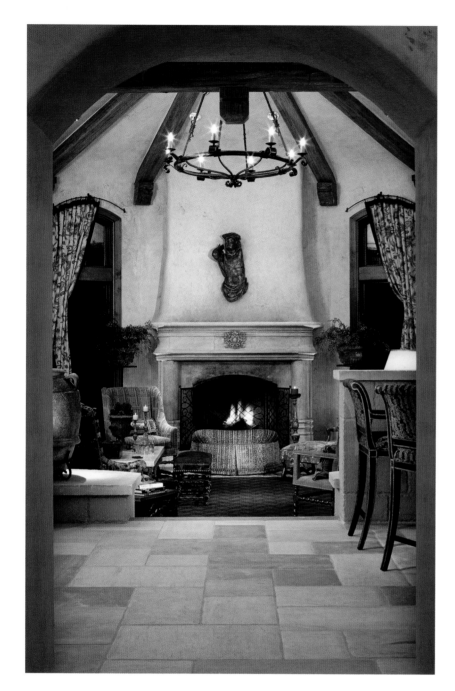

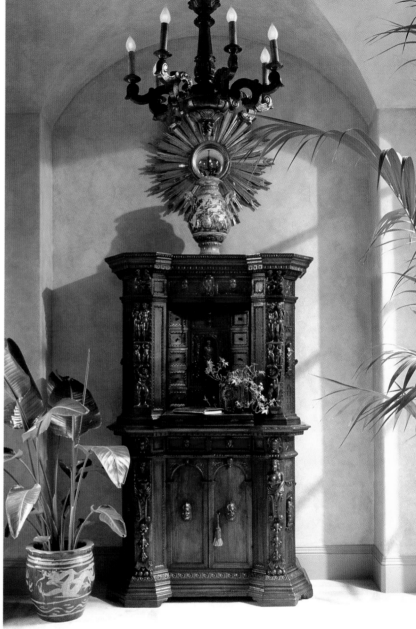

acclaimed designers enjoys the unique opportunity to continually challenge their skills in an industry where the sky, or perhaps an intricately frescoed ceiling, is the limit.

Able to transport a room to another time and place, or simply to create an eclectic mix of style or periods, Nancy and her fellow designers at Dallas Design Group Interiors have a rare ability to finesse the details into finely appointed interiors. The firm has won numerous distinctive honors and merits including ASID's "Legacy of Design" and "Design Ovation" awards and *D Home*'s "Best Designers in Dallas" designation two years running.

ABOVE LEFT:
This space serves as the main entertaining area for this client's vacation home while functioning as the family's main living space. Strong Italian and Spanish influences marry well with the client's taste and need for variety and interest. The dining room can transform from its day-to-day reading space to an entertaining area for 8 to 10 people.
Photograph by Jason R. Jung

ABOVE RIGHT:
This inviting entryway features an 18th-century Italian cabinet and faience jar crowned with gilded solara.
Photograph by Danny Piassick

FACING PAGE:
A European doorway was modified into an entertainment unit for this keeping room. Unexpected objects and art add warmth and proportion for the finishing touches.
Photograph by Danny Piassick

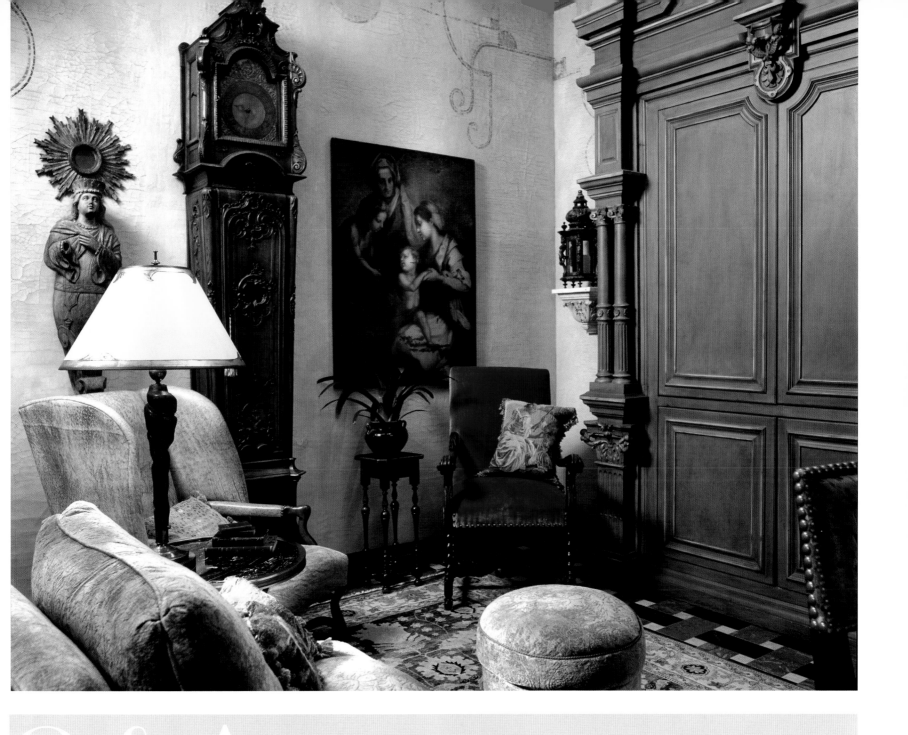

more about nancy ...

WHAT EXCITES YOU MOST ABOUT BEING A PART OF *BEAUTIFUL HOMES*?
I love the idea of being a part of a gorgeous book that so many people will have in their homes both as a work of art itself and as a reference to some of the finest Texas homes.

COULD YOU DESCRIBE YOUR STYLE OR DESIGN PREFERENCES?
Personally, I prefer a European mix with a modern spin. My own home is an eclectic gallery of art, objects and antiques.

WHAT DO YOU LIKE MOST ABOUT DOING BUSINESS IN TEXAS?
The great thing about Dallas is you find so many multigenerational families like mine, but you also have many non-native Texans. It creates a wonderful atmosphere that is not too conservative and there is a nice variety of tastes so I get to do the drama and fun with the Traditional.

DALLAS DESIGN GROUP INTERIORS
Nancy A. Ross, ASID, TAID
100 Glass Street, Suite 201
Dallas, TX 75207
214.752.9005
f: 214.752.9006
www.dallasdesign-group.com

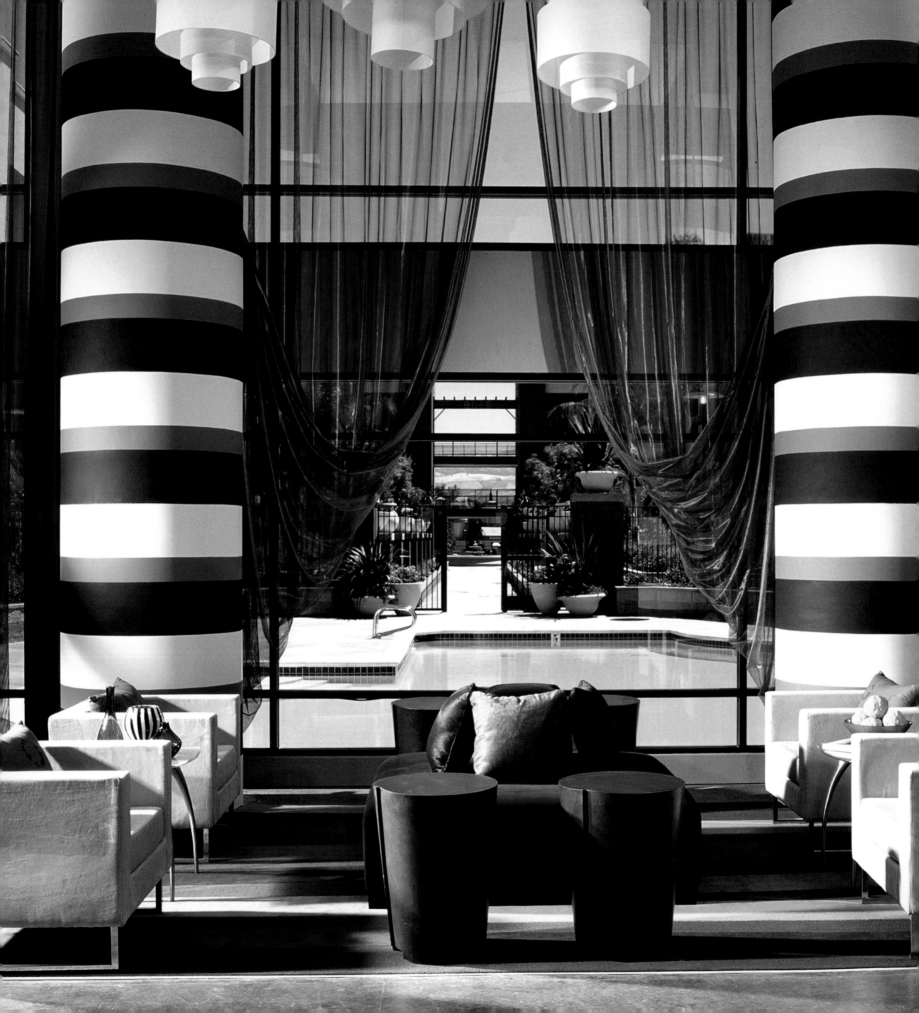

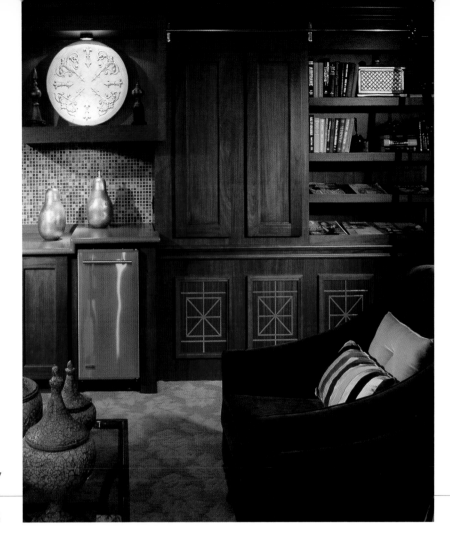

Stacy Sawyer

SAWYER DESIGN ASSOCIATES

A truly bi-coastal firm with offices in Dallas, Las Vegas and Bethesda, Maryland, Sawyer Design Associates is renowned for their ability to bridge the gap between creativity and the bottom line while never compromising style or functionality. Creating signature personalities that complement regional living environments for their clients, Stacy Sawyer's thriving business employs a great team of talented, high-energy, senior-level designers who are proud to work with some of the best clients in the business, making a remarkable difference in the outcome of the design.

Sawyer got her start in the design business as a college intern and has remained in the field ever since. During an internship with a Dallas-based firm, Sawyer found her true calling: commercial interior design. With a little persuading from her supportive husband, John, she decided to make the leap and start her own firm in 1996. Today, Sawyer Design Associates

boasts over 50 employees in the Dallas location alone and has plans to open new offices in San Diego, California within the year. With a roster of such noteworthy publications as *Dallas Modern Luxury, D Home, Dallas Home Design, Dallas Business Journal, The Dallas Morning News* and *Fort Worth Business Press* covering Sawyer Design Associates, it is easy to see that this firm is giving people something to talk about.

With over 400 completed projects and extensive experience in every facet of the industry including hospitality, mid-rise and high-rise condominiums

ABOVE:
Rich custom cabinetry houses a collection of books, and gray mohair club chairs invite warmth and relaxation.
Photograph by Ira Montgomery

FACING PAGE:
This dramatic clubroom combines rich, jewel tones with the clean lines of classic, mid-20th-century style furniture.
Photograph by Ira Montgomery

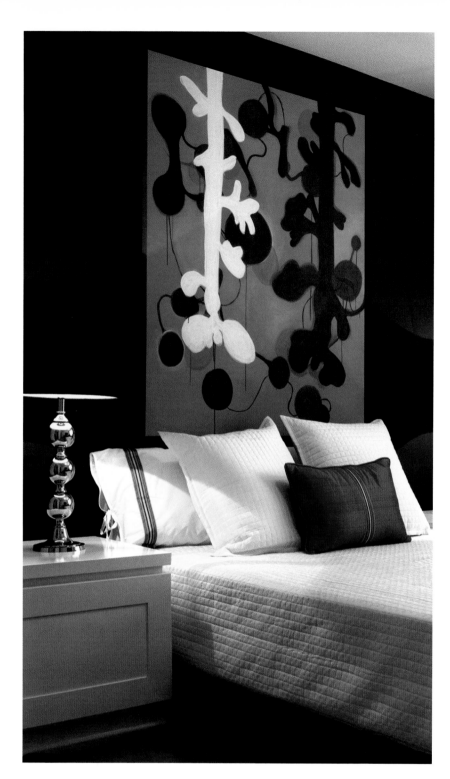

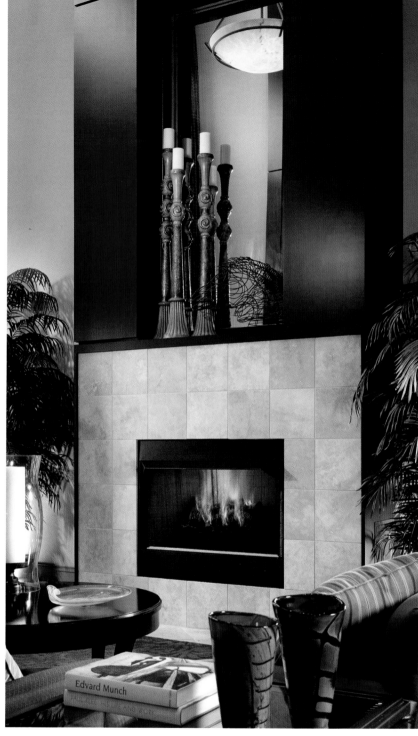

ABOVE LEFT:
Custom artwork takes the place of a traditional headboard in this cozy master bedroom. Vanilla plays against chocolate creating a sultry mood.
Photograph by Stephen Rossler

ABOVE RIGHT:
The fireplace takes center stage in this clubhouse creating an environment that is Traditional with a twist. Natural woods and stone soften the cutting edge.
Photograph by Ira Montgomery

more about stacy ...

ON WHAT PERSONAL INDULGENCE DO YOU SPEND THE MOST MONEY?
I tend to splurge on unique, original art. It has always been a weakness of mine to indulge in pieces that are one-of-a-kind.

WHAT IS THE BEST PART OF BEING AN INTERIOR DESIGNER?
I love having the ability to transform a drab space into something extraordinary. There is nothing more gratifying than walking a client through the design of their space and watching them respond positively to the finished product.

WHAT IS THE HIGHEST COMPLIMENT YOU HAVE RECEIVED PROFESSIONALLY?
An award-winning industry peer paid me the highest compliment of my career. She pulled me aside at a party and said that she sees Sawyer Design Associates as one of the strongest up-and-coming competitors.

WHAT DO YOU ENJOY MOST ABOUT DOING BUSINESS IN DALLAS?
In Dallas, clients are adventurous and willing to try new things. It helps that Dallas has residents who are interested in exploring new trends. It is a designer's dream to work in an environment like Dallas where creativity is allowed to flourish.

SAWYER DESIGN ASSOCIATES
Stacy Sawyer, ASID, IIDA
167 Turtle Creek Boulevard
Dallas, TX 75207
214.443.9090
f: 214.443.9092
www.sawyerdesignassoc.com

and apartments, student housing, multifamily garden apartments, condominium conversions, office buildings, and residential design, Sawyer's projects showcase classic lines and timeless looks with a modern twist. Mixing the old with the new allows Sawyer to develop a distinct style that does not fall into any one category, but rather becomes a fusion of genres that can be seamlessly incorporated into many styles across the board.

ABOVE:
Mediterranean-inspired furnishings reminiscent of Tuscany and a custom-designed rug add warmth and richness to this lobby. Terracotta accents punctuate the space with color.
Photograph by SDA Stock Photography

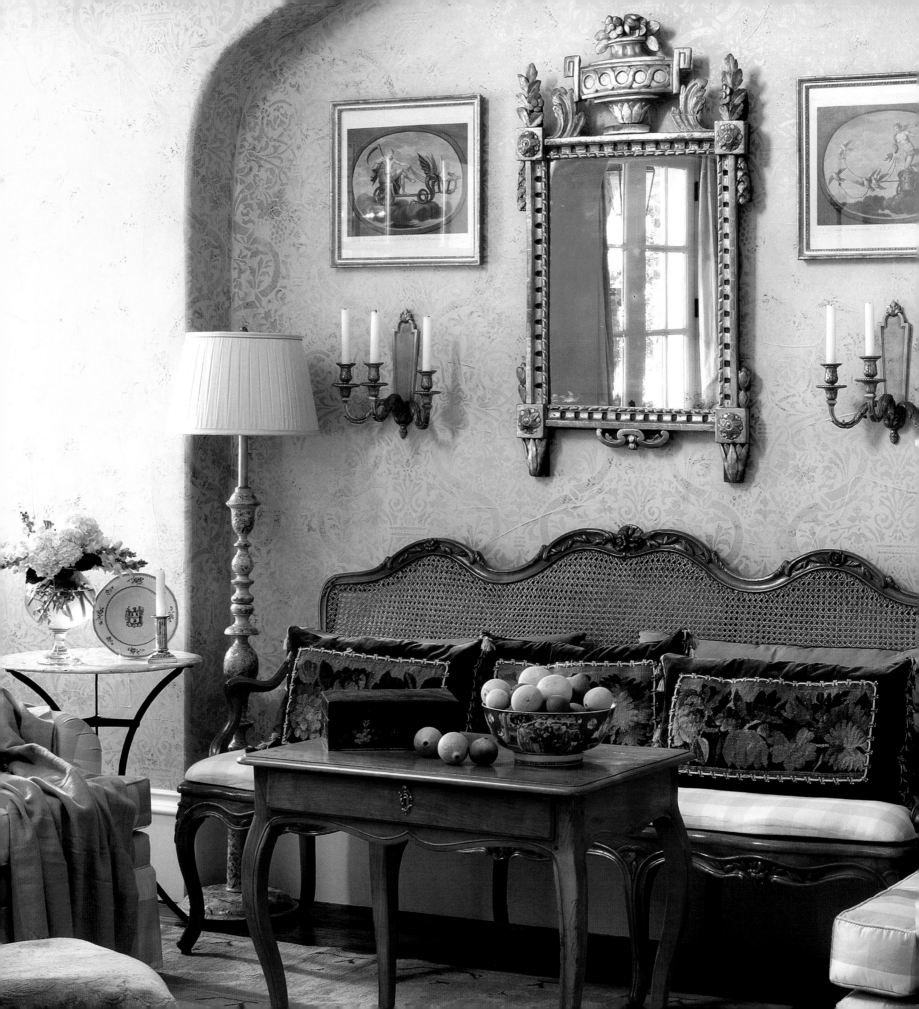

Ann Schooler

SCHOOLER, KELLOGG & COMPANY

Ann Schooler, owner of Schooler, Kellogg & Company, has sustained a thriving career in interior design, serving and satisfying the discriminating tastes of her clientele for more than 22 years. Ann began her career by leading educational group tours of important English houses, studying the impact and inspiration these homes had on the American decorative arts. These groups included lectures given by experts such as Christie's New York and The Victoria and Albert Museum of London.

Studying at the Parsons School of Design summer abroad program in Paris, she became a registered designer in Texas and has continued to work on projects broad in scope and varied in both size and style. Ranging from small neighborhood renovations to grand construction, Schooler, Kellogg & Company maintains a strict philosophy of preserving the architectural integrity of the design while marrying individual tastes, needs and lifestyles. Providing expertise in all aspects of design from consultation and renderings, to full-scale construction and project management,

LEFT:
An 18th-century French canapé anchors a niche in the small salon; stenciled walls by Sean Christopher.
Photograph by Danny Piassick

fine design is both articulated and realized through Ann's artful and detailed eye.

Placing special emphasis on the character of each project, Ann takes particular care in specializing each design, making it unmistakably exclusive to each client. Overseeing custom furniture fabrication and upholstery as well as antique selections, each detail receives the greatest respect and personal touch. Ann and her team have also realized a successful real estate staging venture which furnishes upper-end homes that are for sale.

Schooler, Kellogg & Company provides both experience and knowledge, two elements inseparable from quality. The firm has been recognized for its numerous accomplishments in the pages of many prestigious publications including *Veranda*, *D Home* and the book *Spectacular Homes of Texas*. Ann was also honored by *Southern Accents* as one of their "Four Under Forty," a national award given to only the most celebrated designers each year. She was again noted by *D Magazine* as one of Dallas' best designers in 2006.

Ann's team includes six dedicated designers and support staff to whom she gives immense credit for her continued success. "I am incredibly fortunate to have a wonderful, dedicated staff. I have three associates and three support staff, and without them, Schooler, Kellogg & Company would not exist. I could never do it all alone!"

ABOVE TOP:
An 18th-century Provincial screen provides the backdrop for a French faience brazier and whimsical 19th-century child's toy.
Photograph by Danny Piassick

ABOVE BOTTOM:
A collection of 19th-century English tea canisters complements a 19th-century lacquer screen.
Photograph by Danny Piassick

Q&A *more about ann ...*

HOW LONG HAVE YOU LIVED AND PRACTICED IN TEXAS?
I have always lived in Texas and my business was conceived here.

DO YOU HAVE A FAVORITE PIECE IN YOUR OWN HOME?
I have a 17th-century painting of a baby that I originally purchased
for my antique business. My husband and I were absolutely drawn
to it because the baby in the painting looked just like my newborn
son, Sam. It is a beautiful piece and an uncanny resemblance, so
I just had to have it. The painting reminds me what a constant
inspiration my two wonderful children are for me.

WHAT COLOR BEST DESCRIBES YOU?
The color red describes me best because it is invigorating.

TELL US ONE THING PEOPLE DON'T KNOW ABOUT YOU.
I love to fly fish; it is what I do to relax.

SCHOOLER, KELLOGG & COMPANY
Ann Schooler
4514 Travis Street, Suite 320
Dallas, TX 75205
214.521.7772
f: 214.521.7776
www.schoolerkellogg.com

ABOVE:
The dining room hosts a group of 18th-century Chinese export vases as well as a period Rococo French oil painting
over a 19th-century English sideboard.
Photograph by Danny Piassick

167

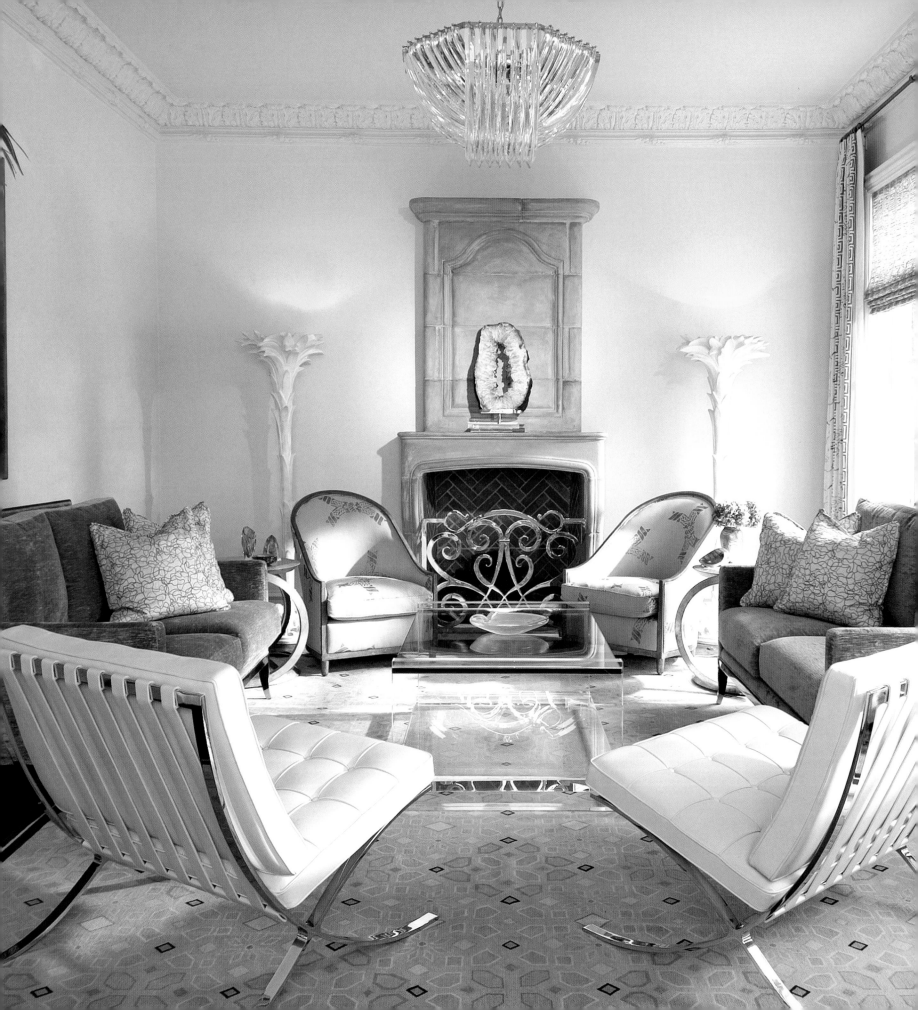

Mary Anne Smiley

MARY ANNE SMILEY INTERIORS

Mary Anne majored in interior design and minored in fine art at Oklahoma State University, earning a Bachelor of Science degree. Since her first drawings in the fourth grade to her current flourishing firm, Mary Anne has enjoyed creating sketches of beautiful rooms and now treasures bringing those sketches to life in residential homes and estates, corporate offices, ranches and getaway homes across the nation, including places such as Texas, Oklahoma, New York, Colorado, California and South Carolina, as well as a villa in Mexico.

Moving across a wide-ranging spectrum of styles, Mary Anne deftly designs spaces around the desires and sensibilities of her clients. From bold strokes of color that set the imagination on fire to soft, soothing backdrops that calm and comfort, Mary Anne's environments are remarkable from the largest piece to the finest detail in the space. From children's rooms that bring to mind the whimsy of fairy tales, luxurious powder rooms that pamper the body and soul, luxurious and elegant living and dining rooms, to utility rooms and kitchens that make day-to-day living easier and more beautiful, each interior is both functional and unique to the client.

ABOVE:
First impression: A blown-glass vase of fresh flowers atop a custom polished-nickel table, embraced by a gracefully curving staircase, makes a statement of simplicity and elegance in this round entry. Floral design by Chris Brown.
Photograph by Danny Piassick

FACING PAGE:
Luxurious furnishings, a custom Kelly Wrestler-wool rug, Nomi painted fabrics and Citron walls combine to create an irresistibly comfortable living room. Antique torchères, Venetian glass lamps and a chandelier along with sparkling metal and painted finishes add verve and elegance. Floral design by Chris Brown.
Photograph by Danny Piassick

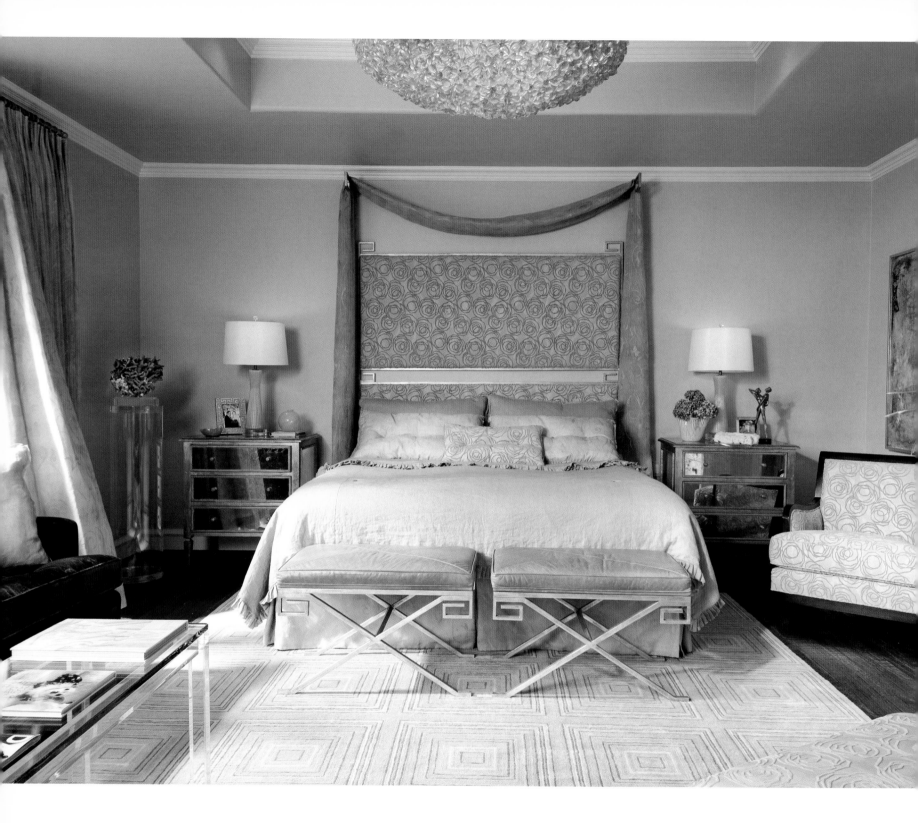

ABOVE:
Soft eggshell walls and complementary custom hand-painted Nomi sheer fabric set the mood for this dreamy master bedroom. Matching Nancy Corzine benches inspired the custom headboard, and a magnificent custom chandelier provides the crowning touch.
Photograph by Danny Piassick

FACING PAGE:
A cosmopolitan mélange of furnishings belies the innovative design of this stunning dining room. Mid-century Lucien Rollins cabinets mix with contemporary Asian-influenced acrylic and antique mirrored pieces, and a Fortuny chandelier illuminates the custom table, which combines the top and base of two others. Floral design by Chris Brown.
Photograph by Danny Piassick

Q&A

more about mary anne ...

WHAT IS THE BEST PART OF BEING AN INTERIOR DESIGNER?
Client satisfaction. It is so great to finish a design for a client who is well pleased, knowing they will enjoy the design for years to come.

HAVE YOU BEEN PUBLISHED IN ANY REGIONAL OR NATIONAL PUBLICATIONS?
I have been honored with pages and mentions in *Southern Accents*, *D Magazine* and *D Home*.

WHAT ONE ELEMENT OF STYLE HAVE YOU STUCK WITH OVER THE YEARS THAT STILL WORKS FOR YOU TODAY?
Creating clean, functional design is the foundation of every project.

HAVE YOU RECEIVED ANY AWARDS OR SPECIAL RECOGNITION?
I have received numerous awards including *D Home*'s "Best Designers in Dallas" in 2005, 2006 and 2007, several ASID "Design Ovation" awards and ASID "Legacy of Design" awards and I was also named to *Modern Luxury Dallas* magazine's "List of Dynamic Women of Dallas 2006."

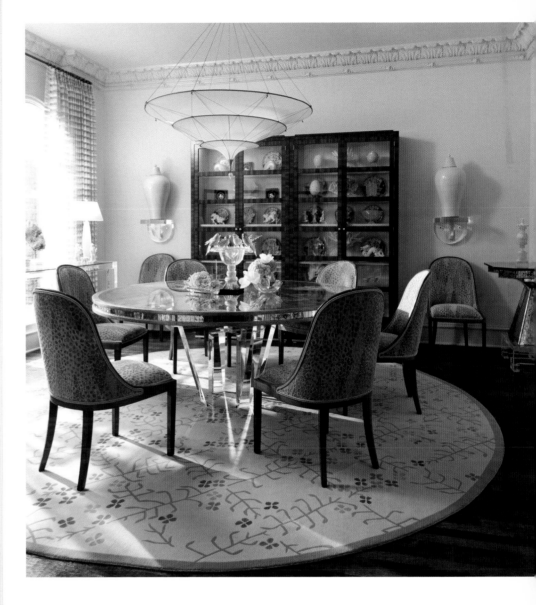

Layer upon layer would describe the process of design as applied by Mary Anne Smiley. Always starting with the structural aspects of the design, creating a firm foundation of well-designed space suitable to the needs of the client, she then moves on to the next layer: exquisite backgrounds and sumptuous lighting details. Following with perfect furnishings in fabulous finishes and luxurious fabrics, she then embellishes the project with a layer of finishing touches including amazing art and art-driven accessories, and appropriate live plants and flowers.

MARY ANNE SMILEY INTERIORS
Mary Anne Smiley, ASID, IIDA
5440 Harvest Hill Road, Suite 234
Dallas, TX 75230
214.522.0705
f: 469.374.0292
www.maryannesmiley.com

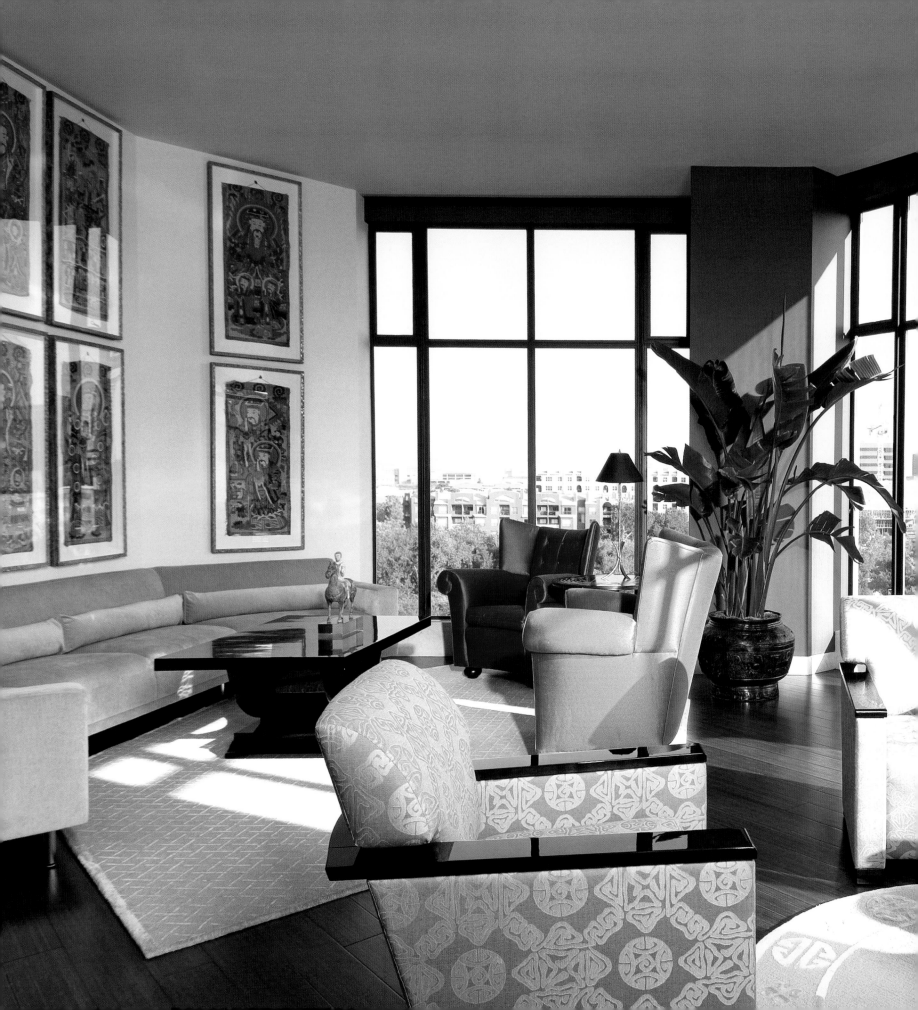

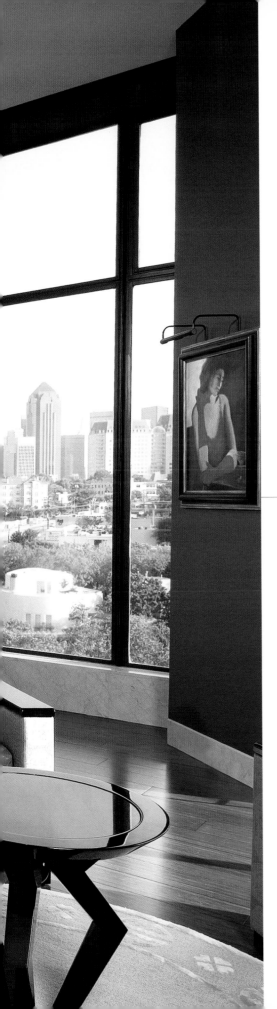

Neal Stewart
Doug Horton

NEAL STEWART DESIGN ASSOCIATES, INC.

Just a few short years after moving to Dallas 25 years ago, Neal Stewart joined forces with Doug Horton, forming a solid and lasting business partnership. Today their client base extends from Dallas to most major United States cities, and also to London and the Caribbean. Their satellite office in Honolulu boasts its own extensive client roster. It is no surprise that these two have done so well for themselves. Since they are so well organized and market-savvy, that leaves plenty of time to concentrate on excellent design.

Neal and Doug's similar career choices and educational backgrounds ensure that they collaborate seamlessly on each client's project. Their specialty is residential design, whether for renovation or new construction. No detail is too small to escape their notice, and every project is managed with established goals that fit the budget and the timeline.

LEFT:
Sun-filled by day, panoramic views by night: The sophisticated living room looking out over Turtle Creek and Dallas' trendy Uptown was designed with spaces to accommodate intimate gatherings by the fireplace or large-scale entertaining.
Photograph by Danny Piassick

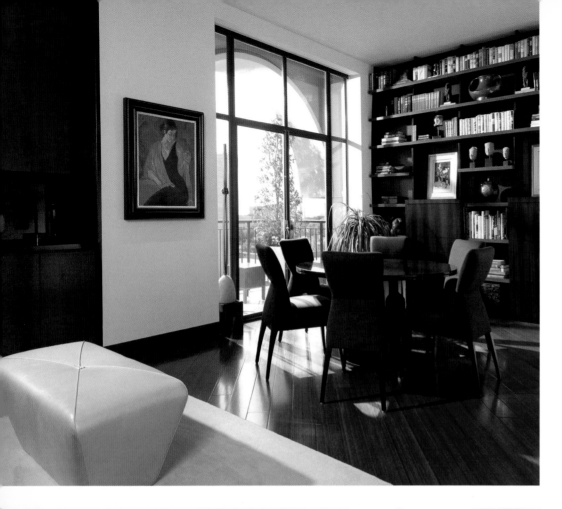

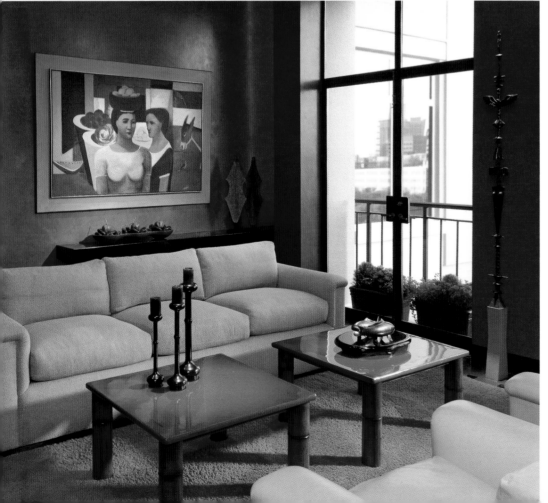

It goes without saying that when it comes to architects and contractors, it is all about quality and impeccable style for Neal and Doug. They work in a wide variety of styles but prefer using a minimalist approach, custom-tailoring each project to the individual client.

Not only do both Neal and Doug learn from every client with whom they work, but they both grow and evolve as designers with each step of every project. Putting their studied skills to work over the years, the pair prides themselves on a great attentiveness to the client and designing spaces that present solutions. A recent project took a client from a large home to a rather small space, in which Neal and Doug worked closely with the homeowners and architect from the very beginning. The smart, creative space planning designed by the team truly allowed the small space to live large while delivering a beautiful environment that became the perfect backdrop for their client's lifestyle.

Pulling together warm, inviting spaces of pared-down luxury, this talented and energetic team imparts the fine tastes of living to every home. Whether designing a high-rise apartment or roomy house, a successful project for Neal and Doug is a pleased customer with an individually defined style.

Q&A

more about neal & doug ...

IS THERE ONE ELEMENT OF STYLE OR PHILOSOPHY YOU'VE STUCK WITH OVER THE YEARS THAT CONTINUES TO WORK?
Less is more.

IN WHAT PUBLICATIONS HAS YOUR WORK BEEN FEATURED?
Southern Accents, Interior Design Magazine, D Home and *House & Garden.*

WHAT WOULD YOUR FRIENDS SAY ABOUT YOU?
They would say that Neal is focused and that Doug has a wonderful sense of humor.

WHAT IS THE BEST THING ABOUT BEING AN INTERIOR DESIGNER?
Designing spaces that solve each client's particular needs and reflect their personal style.

WHAT DO YOU LIKE BEST DOING ABOUT BUSINESS IN DALLAS?
All the resources so readily available to us and the incredible diversity of people.

NEAL STEWART DESIGN ASSOCIATES, INC.
Neal Stewart
Doug Horton
1025 North Stemmons Freeway, Suite 320
Dallas, TX 75207
214.748.6541
f: 214.748.6543

ABOVE:
Sophisticated urban living: The striking entrance with ebony door and floor-to-ceiling glass ushers guests into the residence with numerous unique features like curving plaster walls, onyx tiles in the powder room and a back-lit glass wall in the kitchen.
Photograph by Danny Piassick

FACING PAGE TOP:
Ideal for formal dinners or reading the Sunday paper: Overlooking the living room below, intelligent use of space created a room with many functions—dining, library, bar—to accommodate changing day-to-day needs.
Photograph by Danny Piassick

FACING PAGE BOTTOM:
Eye-catching and stylish: Red Venetian plaster accents walls throughout the residence and serves as a backdrop to an eclectic collection of art ranging from African and Far Eastern artifacts to paintings by Grateful Dead graphic designer, Stanley Mouse to Chihuly glass.
Photograph by Danny Piassick

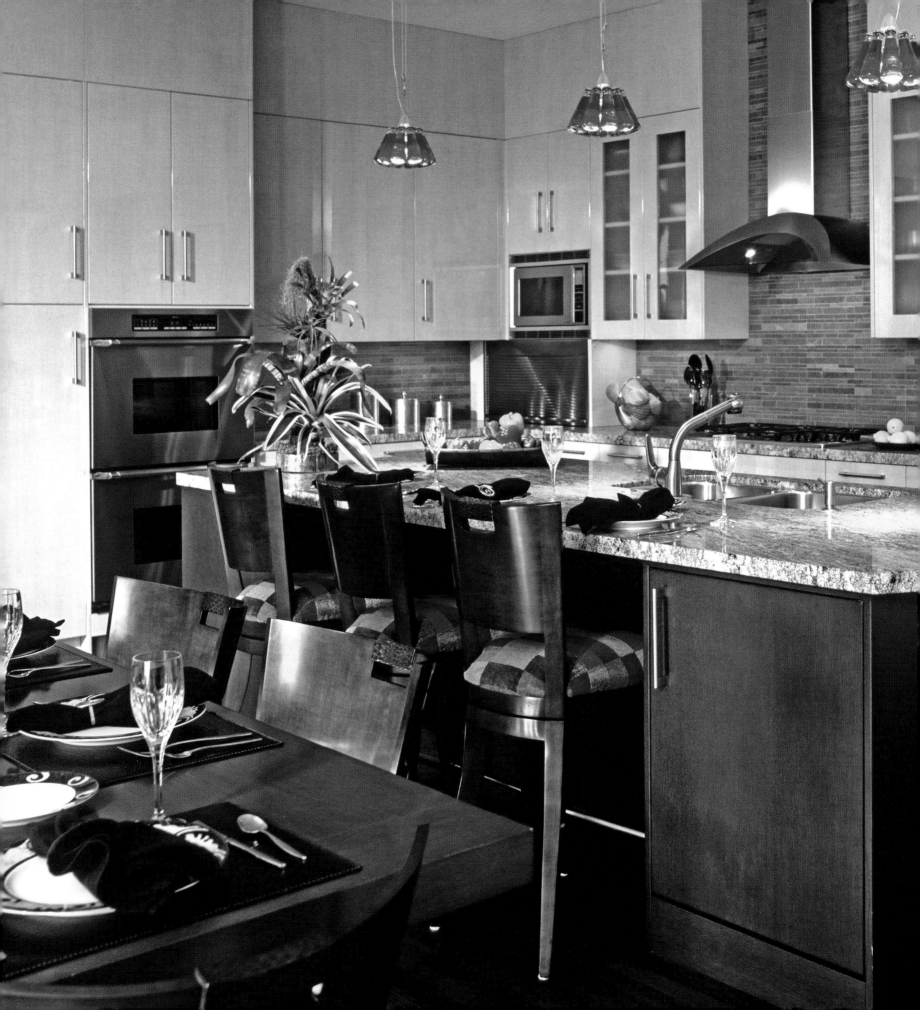

Marilyn Rolnick Tonkon

MARILYN ROLNICK DESIGN ASSOCIATES, INC.

"It is an art, not a science." That definition of interior design leads Marilyn Rolnick Tonkon to listen to and interpret the desires and needs of her clients, and to deliver a product that will stand the test of time and reflects each client's individual lifestyle.

Marilyn manages every project, rarely takes no for an answer and handles details with aplomb. She surrounds herself with talented subcontractors and fabricators who care as much about the success of the project as she does. The designer expressed that quality tops her list of imperatives; stating, "It is not about cost, it is about being appropriate."

Working comfortably in styles that range from Traditional to Contemporary and are classic and never trendy, Marilyn's other requisites are comfort, continuity, timelessness and a sense of humor, which are incorporated into all of her projects across Texas and the United States.

LEFT:
Aniline-dyed maple cabinetry with a high-gloss lacquer finish is a stunning contrast to the dark-stained mahogany island.
Photograph by Danny Piassick

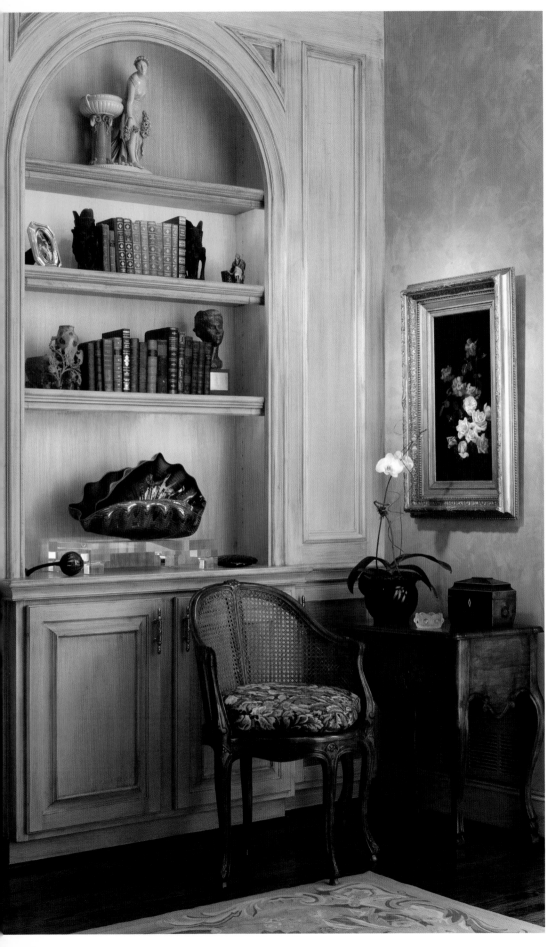

Following her ambitions for over 35 years, Marilyn, who works with talented associate Richard A. Gordon, has won several "Design Ovation" and "Legacy of Design" awards, has been named in *D Home* as one of Dallas' top designers and has received the "Outstanding Service and Contribution Award" from the American Society of Interior Designers. Her work has been featured in many national and regional publications including *Modern Luxury Dallas, D Magazine, Designers West, Southern Living, D Home, The New York Times* and *Dallas Morning News* as well as the books *Spectacular Homes* and *Designed in Texas.*

Her proven philosophy has led not only to top honors, but more importantly has secured the valuable relationships upon which Marilyn's trusted firm is solidly built.

LEFT:
The glazed cabinetry and Venetian plaster wall finish are a fitting backdrop for the still-life painting and Chihuly glass sculpture.
Photograph by Danny Piassick

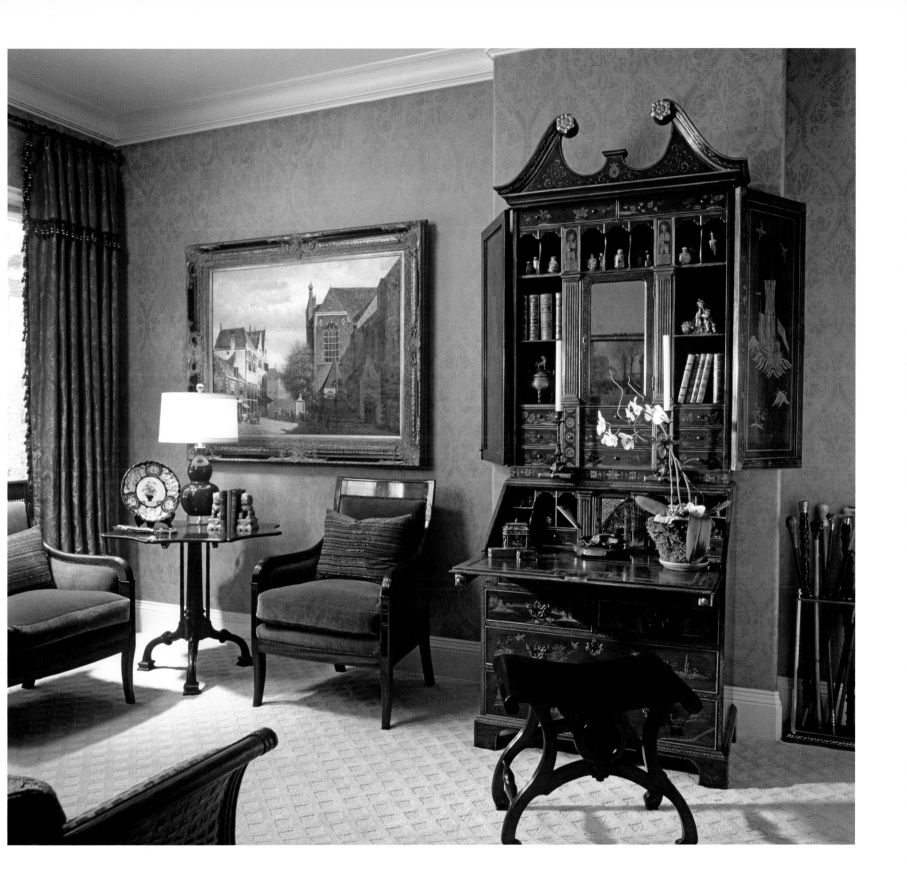

ABOVE:
In a corner of a guest bedroom, the Burton Ching chairs and table are complemented by the tobacco-toned
hand-stenciled wall finish.
Photograph by Danny Piassick

179

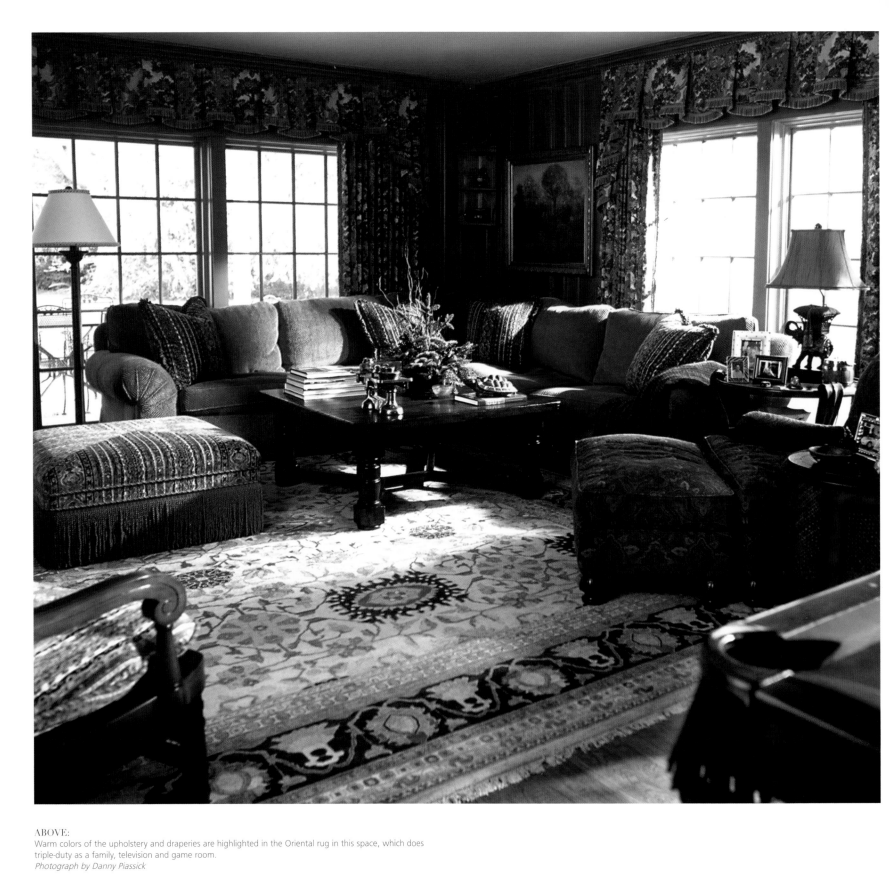

ABOVE:
Warm colors of the upholstery and draperies are highlighted in the Oriental rug in this space, which does triple-duty as a family, television and game room.
Photograph by Danny Piassick

more about marilyn ...

WHAT EXCITES YOU MOST ABOUT BEING A PART OF
BEAUTIFUL HOMES?
Being recognized by my peers.

ON WHAT PERSONAL INDULGENCES DO YOU SPEND THE MOST MONEY?
Books and art.

WHAT COLOR BEST DESCRIBES YOU?
Coral, because it is warm and flattering.

TELL US ONE THING PEOPLE DON'T KNOW ABOUT YOU.
I love the stock market, especially when it is up!

YOU CAN TELL I LIVE IN DALLAS BECAUSE...
I know every street in the city.

DO YOU HAVE A PASSION OUTSIDE OF INTERIOR DESIGN?
Yes, my terrific family. I have a wonderful husband, five children
and six grandchildren. I also love traveling, reading and tennis.

MARILYN ROLNICK DESIGN ASSOCIATES, INC.
Marilyn Rolnick Tonkon
2501 Oak Lawn Avenue, Suite 810
Dallas, TX 75219
214.528.4488
f: 214.528.4860
www.marilynrolnickdesign.com

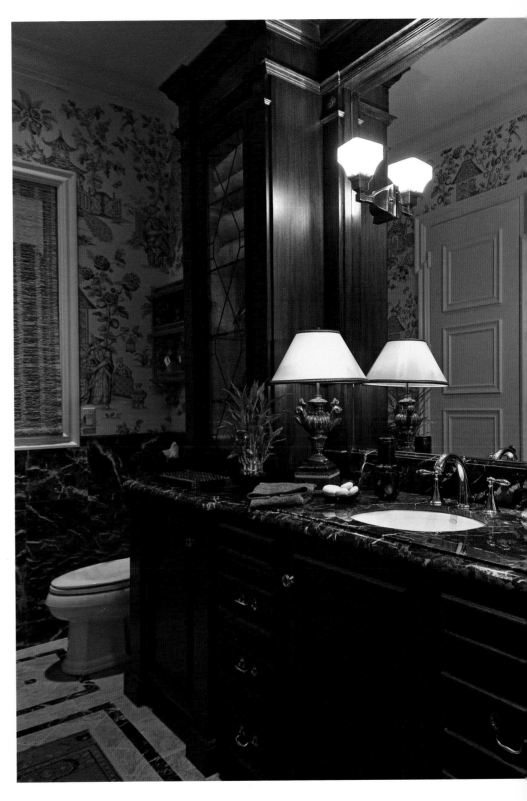

ABOVE:
Black and gold portoro marble covers the vanity and wainscot wall to complement the elegant Brunschwig & Fils wall
covering and handsome cabinetry in the bath.
Photograph by Danny Piassick

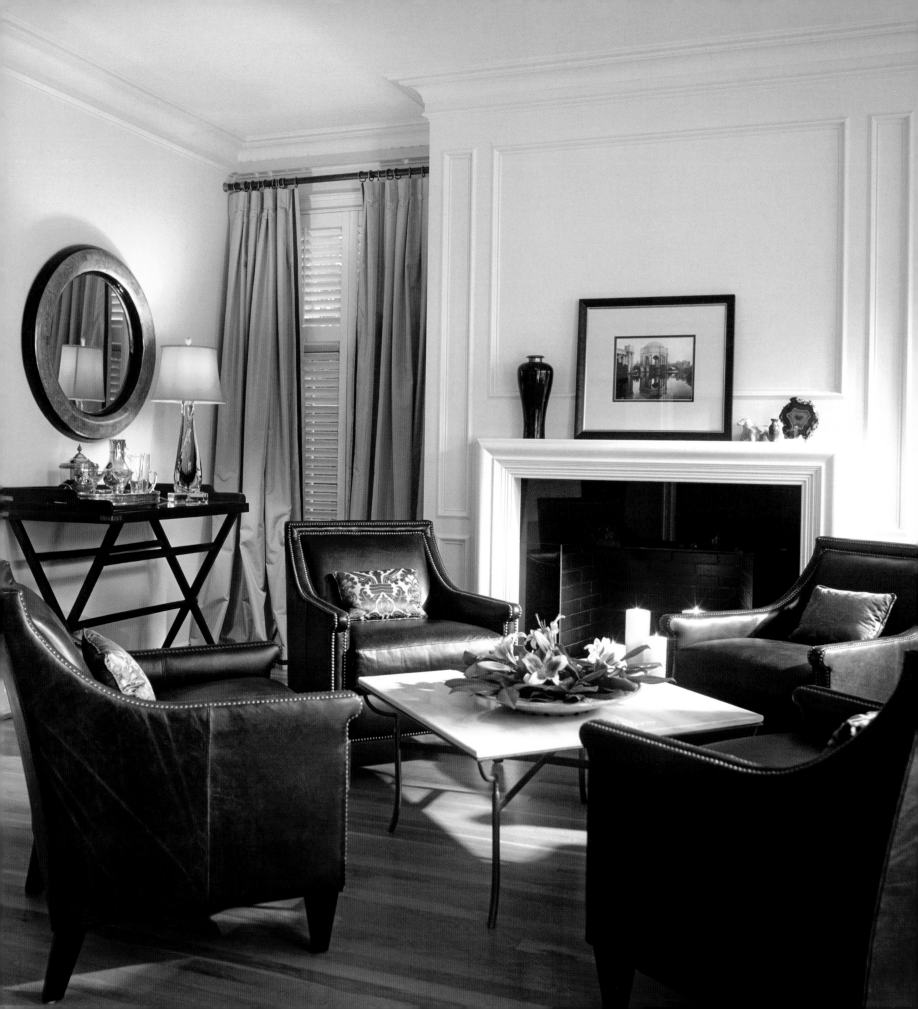

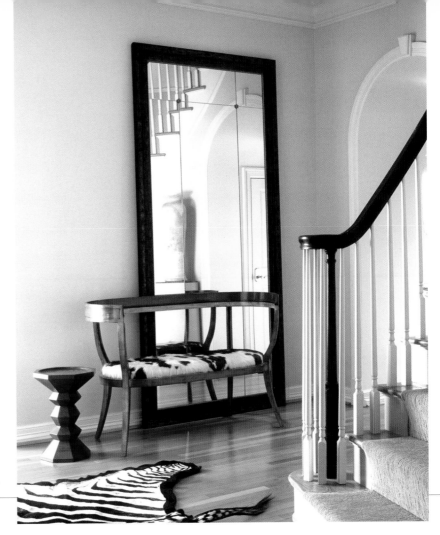

Richard Trimble

RICHARD TRIMBLE & ASSOCIATES, INC.

With three degrees including a BFA in interior design and a BBA in marketing, Richard Trimble has been developing a forte in residential and commercial design since 1976. Known for his work in private residences, Richard's clients are located in Dallas and throughout the United States and Europe. While much of his time is spent designing the everyday living spaces that are his clients' homes, he also spends time working with entrepreneurs and executives for whom he designs banks, restaurants, office spaces, boardrooms and conference spaces.

Working hands-on with clients ensures that Richard's designs are suited to the client while offering classic originality. "I take the time to get to know my clients, and I use that knowledge to create spaces that will best suit the function of their lives and the intricacies of their personalities," he shared.

Richard's work has been featured in many publications, including *D Home, Southern Accents, House & Garden,* and such books as *Provençal Interiors,* *French by Design, Spectacular Homes* and *Designed in Texas.* While best know for his awards in interior design, he also takes time to be actively involved in the community, having served as a board member of organizations such as the Dallas Museum of Art, Dallas Symphony Orchestra and the Dallas Historical Society and as a past president of the Texas chapter of ASID.

ABOVE:
Clean furniture lines, animal prints and an un-hung, floor-length mirror give this traditional entry an updated, relaxed feel.
Photograph by Danny Piassick

FACING PAGE:
Tailored, rich brown leather chairs and long gold draperies add elegance and warmth, while a black fireplace surround lends a contemporary touch to this formal living room.
Photograph by Danny Piassick

RICHARD TRIMBLE & ASSOCIATES, INC.
Richard Trimble, ASID
3617 Fairmont Street
Dallas, TX 75219
214.526.5200
f: 214.526.8444

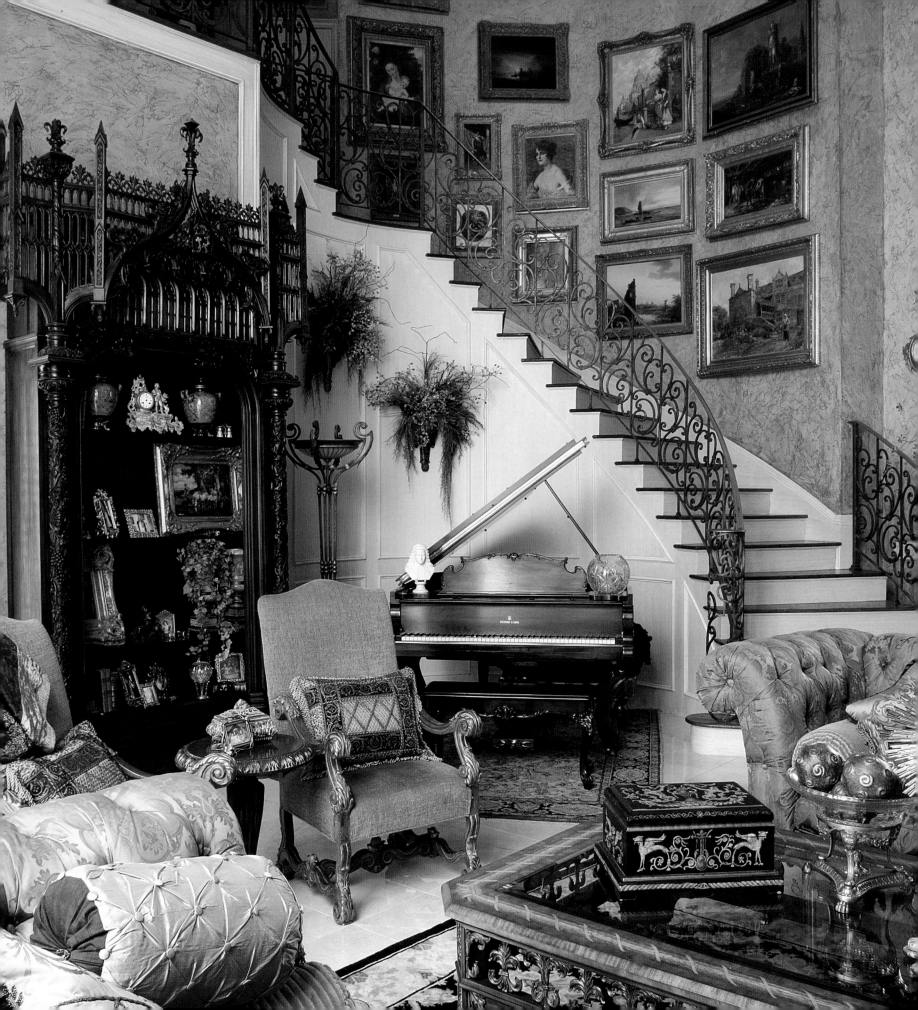

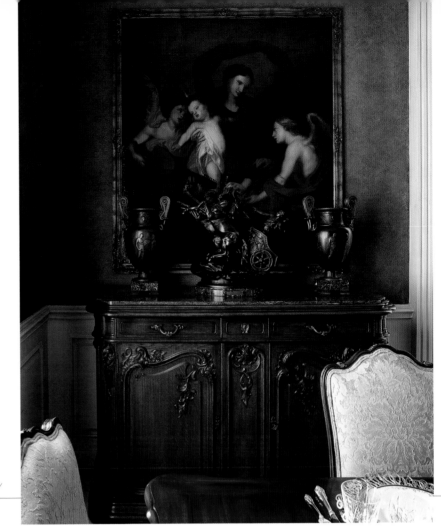

Stacy Urtso

A RARE FIND

Opening A Rare Find on April 1, 2000 in Plano, Texas, was the culmination of a lifetime of design prowess combined with a bit of business intuition. Stacy Urtso opened the unique antique store in the Dallas suburb of Plano after an antique-hunting visit to Europe. The shops she perused there were reminiscent of Dallas' own Design District and Slocum Street shops and she saw a need for the same class of sophistication in Plano.

With a mission to "bring the highest quality antiques, elegant accessories and unique gift items together in one place," Stacy frequently travels to Europe to replenish the shop's inventory of refined, one-of-a-kind furnishings and accessories. Researching the nuances of each antique or piece or artwork, she ensures that each piece she purchases is truly authentic. Even going so far as to employ a European scouting agent, Stacy leaves her clients thrilled with each additional acquisition.

Stacy's own home could very well fit amongst some of the finest showrooms and galleries in the country. With an elegant yet relaxed ambience, her home is adorned with illustrious works of art and antique furnishings and accessories that each have a story to tell. If the objects have narratives, Stacy is their storyteller; she can quickly and easily relay a piece's era, origin and creator and is not hesitant to share the sentimental value that lies within the piece.

ABOVE:
A Madonna and child painting from the school of Raphael hangs above a Country French sideboard, circa 1780.
Photograph by John Smith

FACING PAGE:
Once the entry to a private chapel for nobility in France, this Gothic bookcase, circa 1750, now shares space with oil paintings from the 18th and 19th centuries and an antique Steinway, circa 1919.
Photograph by John Smith

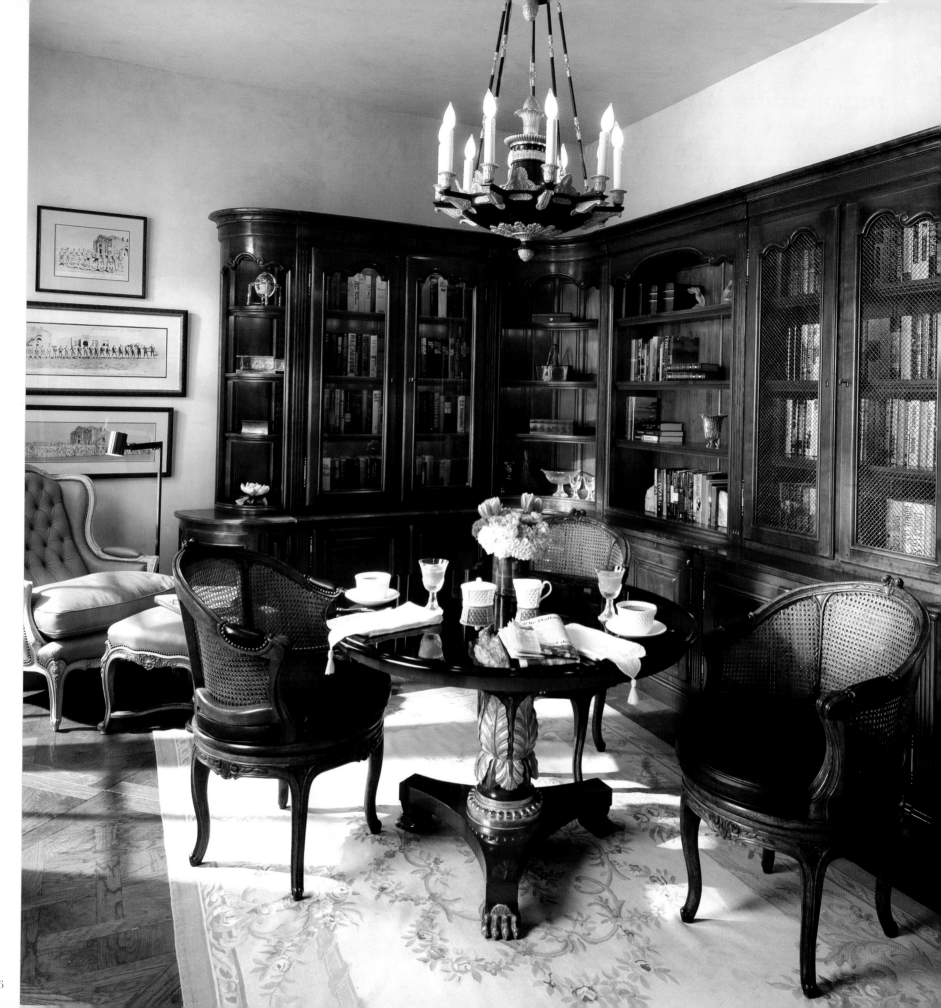

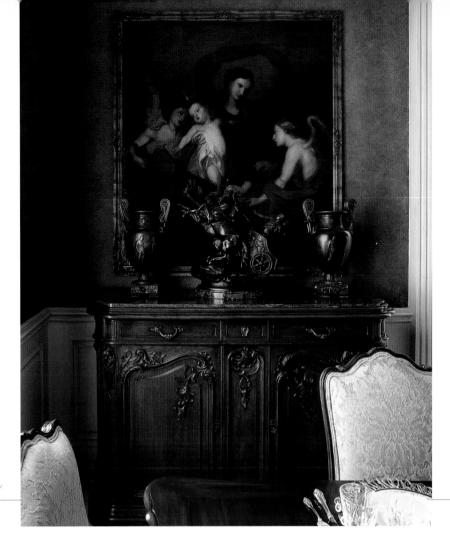

Stacy Urtso

A RARE FIND

Opening A Rare Find on April 1, 2000 in Plano, Texas, was the culmination of a lifetime of design prowess combined with a bit of business intuition. Stacy Urtso opened the unique antique store in the Dallas suburb of Plano after an antique-hunting visit to Europe. The shops she perused there were reminiscent of Dallas' own Design District and Slocum Street shops and she saw a need for the same class of sophistication in Plano.

With a mission to "bring the highest quality antiques, elegant accessories and unique gift items together in one place," Stacy frequently travels to Europe to replenish the shop's inventory of refined, one-of-a-kind furnishings and accessories. Researching the nuances of each antique or piece or artwork, she ensures that each piece she purchases is truly authentic. Even going so far as to employ a European scouting agent, Stacy leaves her clients thrilled with each additional acquisition.

Stacy's own home could very well fit amongst some of the finest showrooms and galleries in the country. With an elegant yet relaxed ambience, her home is adorned with illustrious works of art and antique furnishings and accessories that each have a story to tell. If the objects have narratives, Stacy is their storyteller; she can quickly and easily relay a piece's era, origin and creator and is not hesitant to share the sentimental value that lies within the piece.

ABOVE:
A Madonna and child painting from the school of Raphael hangs above a Country French sideboard, circa 1780.
Photograph by John Smith

FACING PAGE:
Once the entry to a private chapel for nobility in France, this Gothic bookcase, circa 1750, now shares space with oil paintings from the 18th and 19th centuries and an antique Steinway, circa 1919.
Photograph by John Smith

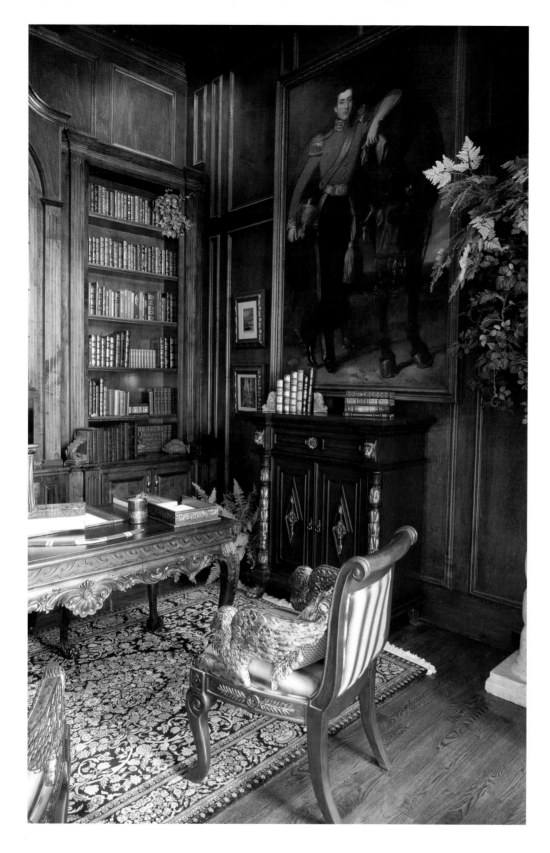

Striving to offer her clients the same complexity and style that she has in her own home, A Rare Find offers only the finest. Stacy's eye for beauty and appreciation for the Old World style is evident in each offering she presents to her clients. Often artwork found in A Rare Find has graced the altars of cathedrals and the walls of private estates throughout Europe, including the art of Cesare Auguste Detti, John Bagnold Burgess, Frederic Soulacroix and Arthur William Devis. With paintings ranging in age from the 17th to 19th centuries, Stacy strives to emphasize the "fine" in fine art.

ABOVE:
Painted by British artist Charles Ambrose in the mid-1800s, the Royal Dragoon Guard stands watch over the formal study.
Photograph by John Smith

FACING PAGE:
The Italian coffer in this sumptuous bedroom hides Christmas treasures each year. Above it reclines a nude by French painter Edward Albert Joannan-Navier, and a mid-1600s' Belgian tapestry cascades down the wall behind the bed.
Photograph by John Smith

Q&A

more about stacy ...

WHAT WOULD YOU DO TO BRING A DULL ROOM TO LIFE?
Although accessory pieces are sometimes the most difficult to find, they can have the most impact on a room. A Rare Find carries a huge variety of elegant accent pieces, florals, candles, frames, lamps and Italian pottery because most often times you need just the right size and shape to fill a certain space.

NAME ONE THING MOST PEOPLE WOULDN'T KNOW ABOUT YOU.
I grew up in a small Texas town.

IS THERE A PROJECT THAT STANDS OUT IN YOUR MIND AS ESPECIALLY DIFFICULT, UNUSUAL OR EXPENSIVE?
I purchase many European pieces which involve some type of painstaking antique restoration.

A RARE FIND
Stacy Urtso
4001 Preston Road, Suite 510
Plano, TX 75093
972.781.2121
f: 972.781.0101
www.ararefindinplano.com

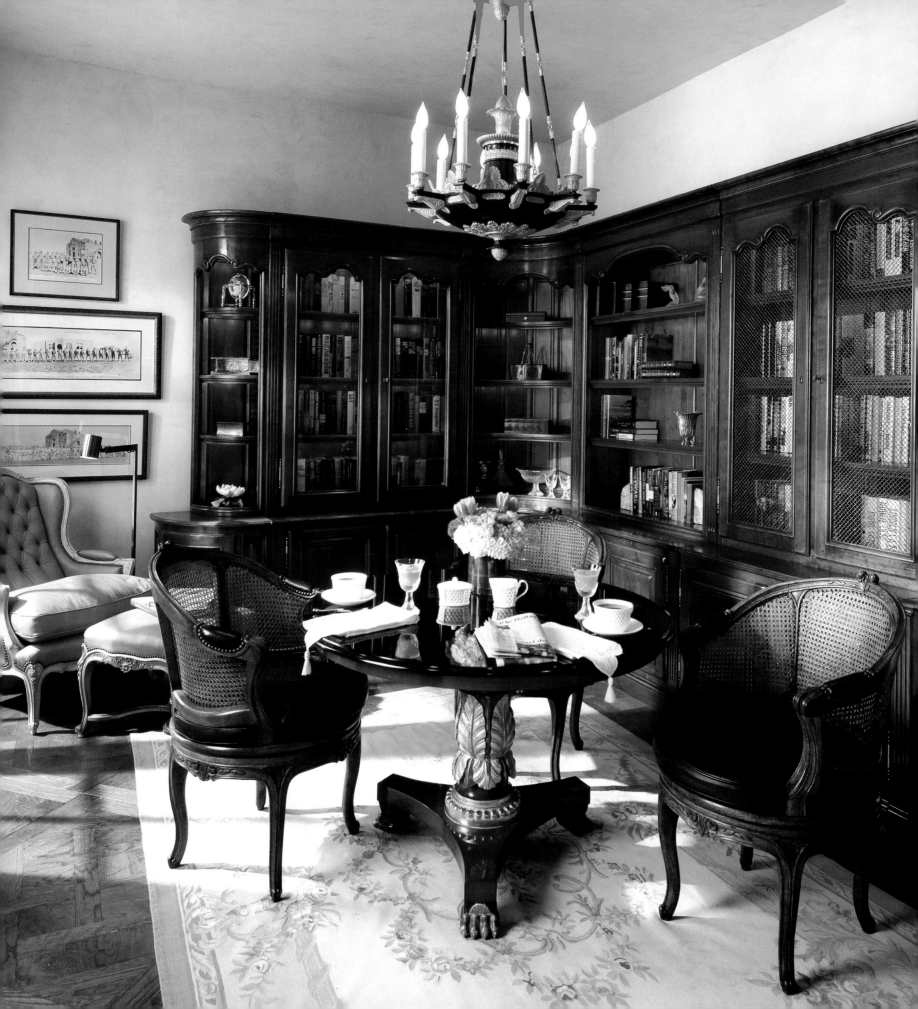

Cheryl A. Van Duyne

CHERYL A. VAN DUYNE, ASID,
INTERIOR DESIGNER

Cheryl Van Duyne, the consummate entrepreneur, has always owned her own businesses; first a retail firm and over the past 20 years, a thriving design business.

Remodeling, often considered the most difficult of projects because of the constant uncertainty and many surprises, just happens to be one of Cheryl's strong suits. Never one to turn down a challenge, she feels the rewards are often the greatest when designing and rebuilding completely unique and beautifully functional spaces. Different needs evolve into new design concepts, and Cheryl deftly balances problem-solving with space-planning to reconfigure rooms, bringing new life into the home.

Exercising her intuitive knowledge of lighting, color and proportion, Cheryl creates environments that are bright and spacious, without being ostentatious. The adage "less is more" is an evident philosophy in her work.

Most importantly, Cheryl's designs flow seamlessly with the architecture of each project. Her uncluttered interiors allow the distinction of each individual structure to create a framework for her stunning designs. It is a fundamental principle she incorporates from the first sketch and a basis that enhances the overall value of the completed design.

Her creative ability, imaginative thinking and critical eye have placed Cheryl's work in the spotlight and her services in high demand across the United States. Her impressive body of work has garnered much attention with her designs

ABOVE:
The exquisite wall finish and soft color palette provide a subtle but interesting backdrop for the beautiful painting by Poteet Victory in the entrance to this man's bath and dressing area.
Photograph by Danny Piassick

FACING PAGE:
As part of a master suite, this intimate room provides a peaceful retreat for reading and enjoying morning coffee.
Photograph by Danny Piassick

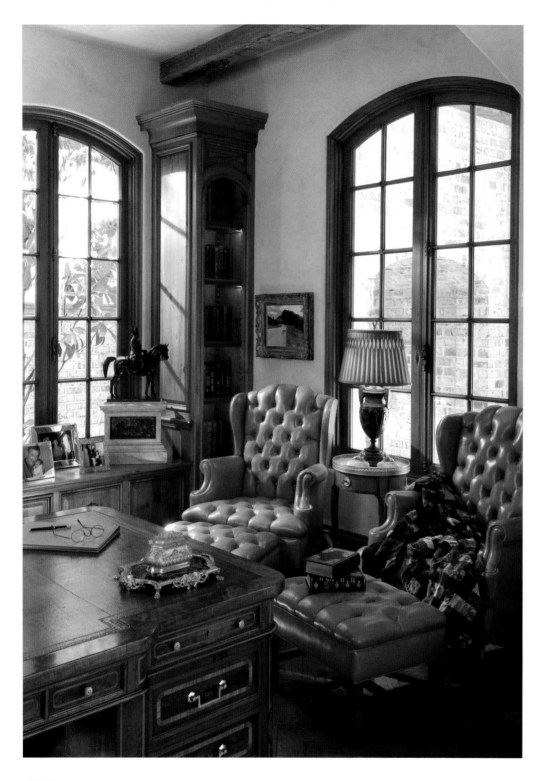

featured in *D Magazine, Dallas Home Design, Southern Living,* HGTV and other media both regionally and nationally. Additionally, Cheryl has been recognized with many state and local awards including "Dallas ASID Design Ovation" and state "Legacy of Design" awards.

"Interior design is all about functional, comfortable and beautiful spaces for people to use and enjoy," declares Cheryl. "It requires concern for clients, dedication, long hours and hard work." As busy as she is, Cheryl always makes time for family and friends, and traveling is her favorite pastime. Coupling pleasure with business, she has earned continuing education credits in both France and England.

ABOVE:
Strong architectural elements provide the perfect backdrop for the elegant antique furnishings in this home office.
Photograph by Danny Piassick

FACING PAGE:
This wine room and service area, designed as part of a large penthouse renovation, provide the perfect place for caterers as well as the owners when entertaining.
Photograph by Danny Piassick

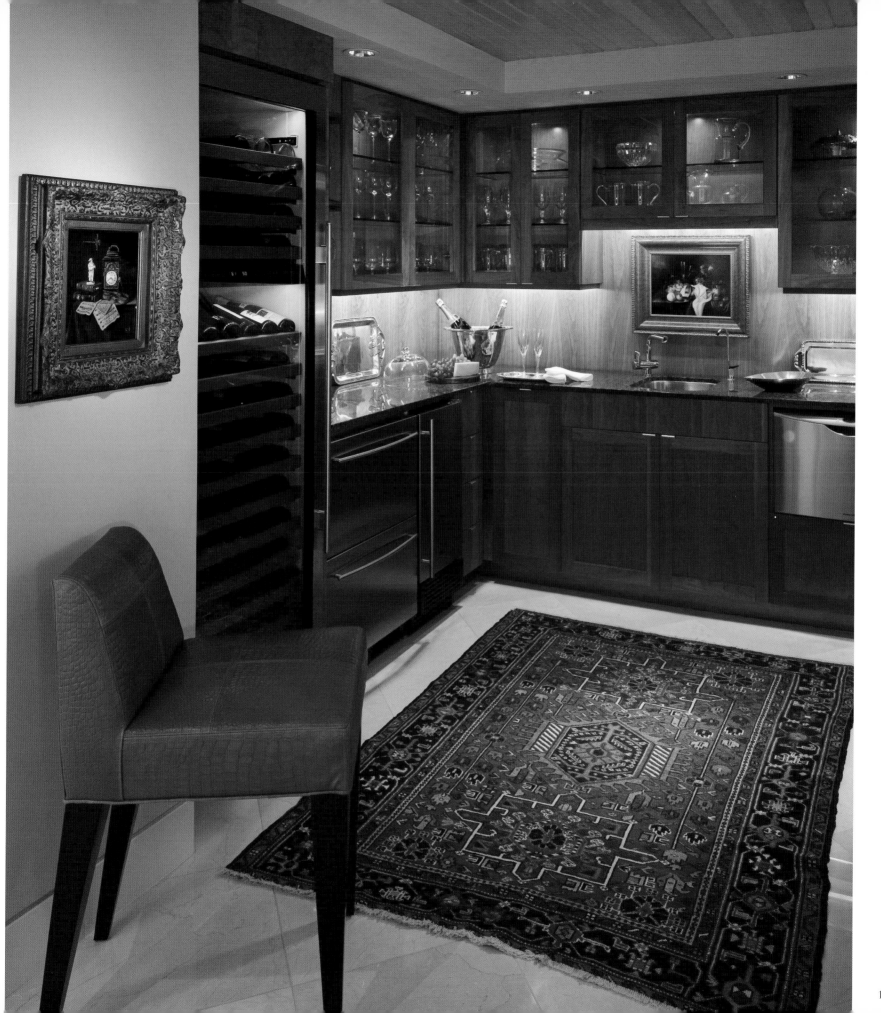

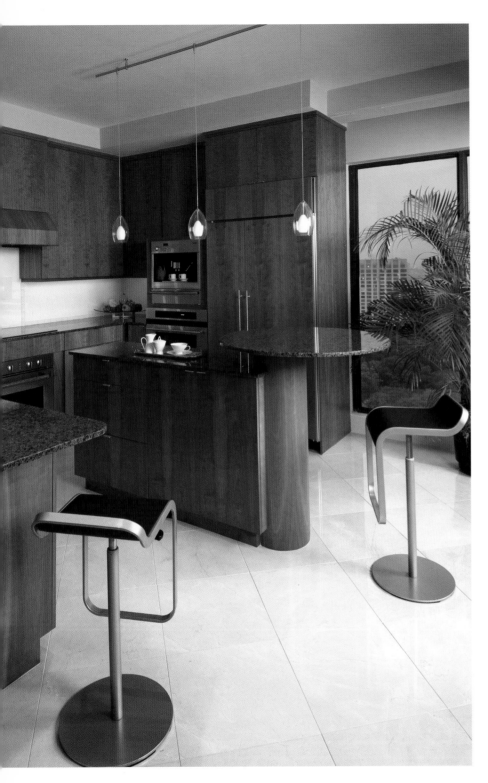

ABOVE LEFT:
Elegant cherry cabinets, a well-thought-out space plan, state-of-the-art appliances, beautiful lighting and the spectacular view from this 24th-floor penthouse make this a very enjoyable space for the owner or caterer to use.
Photograph by Danny Piassick

ABOVE RIGHT:
Adding fiber optics around the perimeter of this glass panel by artist Polly Gessell makes an exciting piece of art come alive.
Photograph by Danny Piassick

FACING PAGE:
Working around existing building columns in this residential high-rise presented some significant design challenges but also brought about some beautiful results as shown in this man's bath.
Photograph by Danny Piassick

Q&A

more about cheryl ...

WHAT IS THE BEST PART OF BEING AN INTERIOR DESIGNER?

It is a truly rewarding art form and I find great satisfaction in the finished product. It is bringing imagination to life. It also allows me to meet many interesting, extraordinary people whom I find I like very much! I have many ongoing and repeat projects with my clients who have become good friends.

WHAT ELEMENT OF STYLE OR PHILOSOPHY HAVE YOU STUCK WITH OVER THE YEARS THAT CONTINUES TO WORK FOR YOU?

Great lighting and uncluttered spaces in which you can see the art, no matter the style!

IS THERE A PROJECT THAT STANDS OUT IN YOUR MIND AS ESPECIALLY DIFFICULT, UNUSUAL OR EXPENSIVE?

I've had a lot of difficult projects as well as design issues that have really tested me, and there are always expensive elements in the projects I do. I recently completed a penthouse that was very involved to say the least. First, we completely demolished it and started all over. It was a logistical nightmare! Everything had to be brought up and down the single freight elevator, and there were many restrictions, such as limited hours the construction work could be done. Meeting the building's criteria, managing the project's timeline and bringing everything together both functionally and aesthetically were formidable tasks, but the results were amazing!

CHERYL A. VAN DUYNE, ASID, INTERIOR DESIGNER
Cheryl A. Van Duyne
14902 Preston Road
Box 404-775
Dallas, TX 75254
972.387.3070
f: 972.385.1169
www.cherylvanduyne.com

Dennis Waters

DENNIS WATERS DESIGN, INC.

A designer with over 35 years of experience, Dennis Waters migrated from Chicago to Texas when Steak and Ale Restaurants came across his eye for design and asked him to design their interiors. More than pleased with his work, the company promoted him to Design Director for the concept. After three additional years as Design Director, he founded his design firm Dennis Waters Design. With widely sought-after talent, Dennis also remained associated with Gabberts Design Studio of Fort Worth for many years while establishing and growing his firm. A state registered interior designer, Dennis is also a professional member of ASID.

Dennis Waters Design now employs two professional designers in addition to Dennis: Darla Feese and Jessica Sparks. Dennis and his firm have developed a distinction based on his broad range of design experience that includes both residential and commercial interior design. His commercial design experience includes photography set design, restaurant design and showroom design while his residential

LEFT:
Light woods and a pale color palette add warmth to this cozy living room, replete with a tiled ceiling and built-in entertainment system. A striped upholstered chair and ottoman and an intricate tapestry accent the lovely muted-mustard color of the leather chair and sofa.
Photograph by Danny Piassick

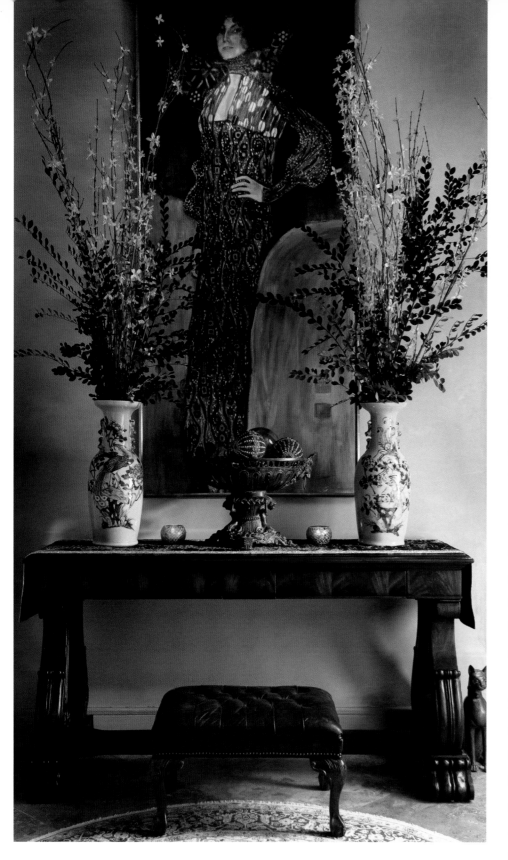

projects appear most often in high-end homes in the Dallas/Fort Worth area and around the country. Clients from cities like Chicago, New York City and Jackson Hole return to Dennis time and time again for the warmth and timelessness of his designs for which he has become so acclaimed.

Working on all the selections and specifications of his clients' homes, Dennis' attention to details and ability to work with his clients from the conceptual stage of house plans all the way to completion is what gives his projects total finesse. Dennis ardently believes that the right accessories are just as important as choosing the furniture selections. "Achieving the right balance is a responsibility that I take most seriously and that requires total commitment to the project," muses the designer.

Truly passionate about his career, Dennis is grateful for the variety of people he comes into contact with on a daily basis; whether they are clients or artisans, everyone has something unique to contribute to his process. The designer also appreciates that in his profession he has the opportunity to work with some of the most beautiful and finest furnishings that can be found in the material world.

But when it comes to his projects, he has no favorites. However, he does believe that the most important projects he has had the good fortune to be a part of are located in Jackson Hole, Colleyville, Southlake and Westlake. These projects have not gone without notice—Dennis' work has been published in *Fort Worth Texas Magazine* and the ASID sponsored book *Designed in Texas*, plus numerous other publications. His eye for interiors was also put into print for nine years while he wrote a monthly column titled "Design Directions" in the *Colleyville News and Times*.

ABOVE:
Vases of tall dried flowers flanking a full-length portrait of an exotic lady foster a sense of height in this hallway.
Photograph by Danny Piassick

FACING PAGE:
Oversized leather armchairs and a pillow-covered divan ensure that comfort and warmth reign supreme in this living room. A beautiful wooden bar and a wooden screen depicting a Renaissance pastoral scene add unique touches.
Photograph by Danny Piassick

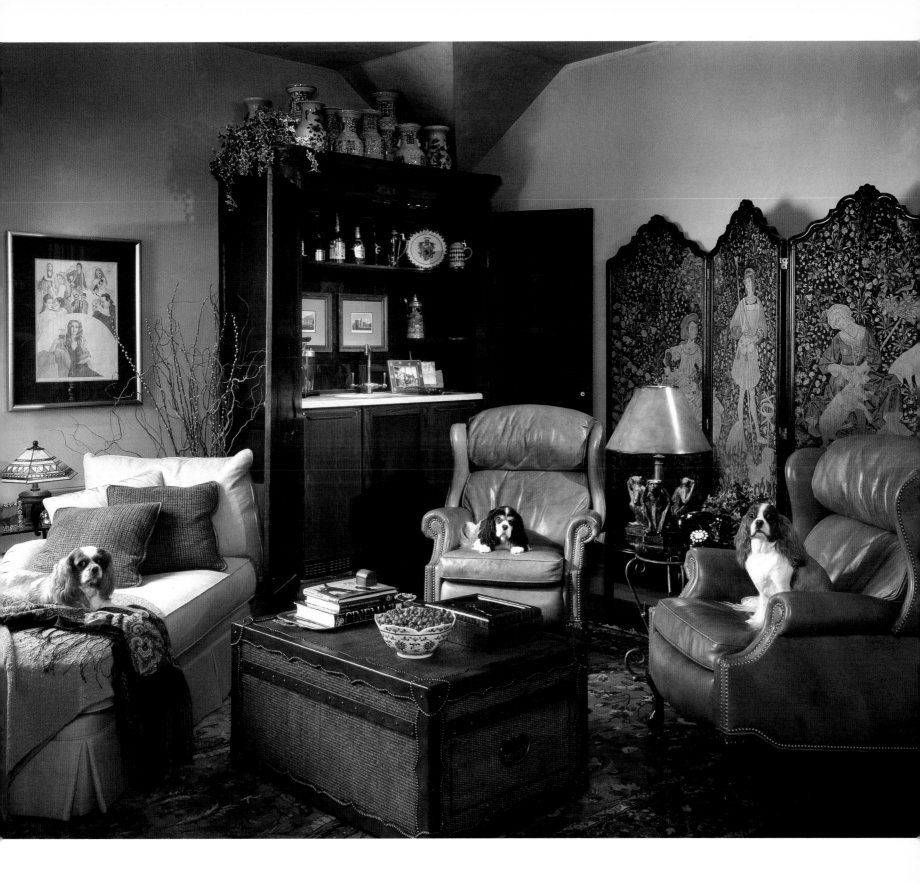

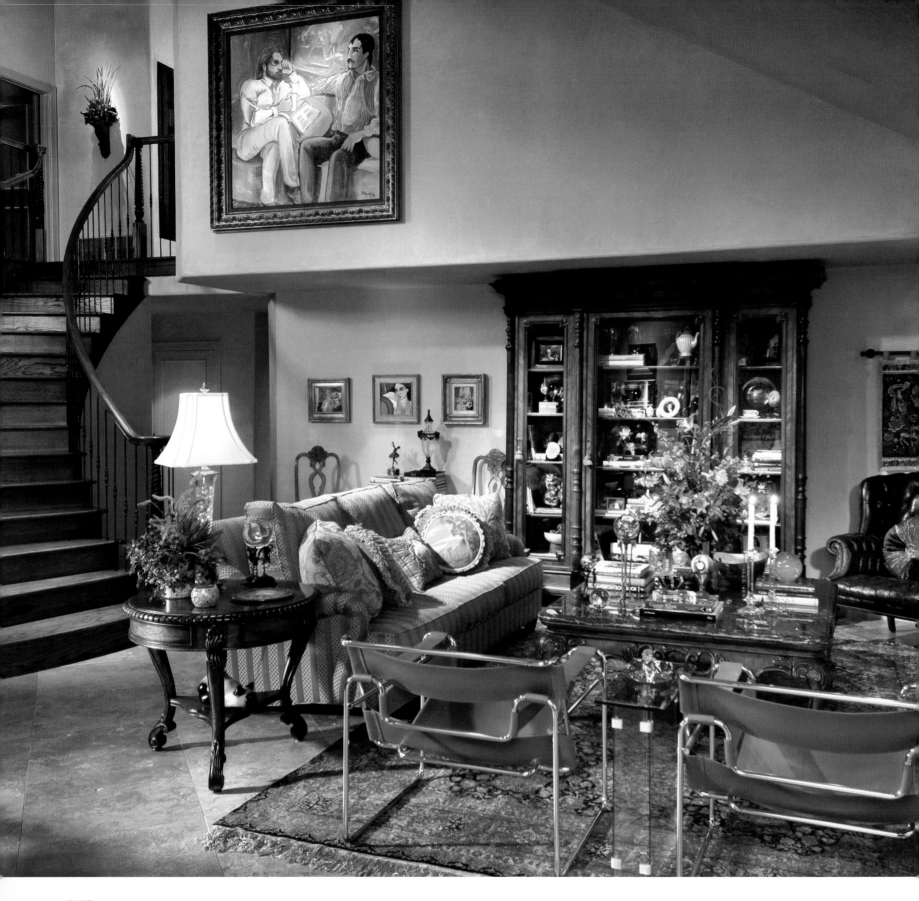

ABOVE:
Bold art and an all-glass table between metal-and-leather chairs lend modern touches to an otherwise traditionally furnished living room. A large china cabinet takes center stage, displaying a multitude of treasures.
Photograph by Danny Piassick

more about dennis ...

WHAT DO YOU ENJOY MOST ABOUT DOING BUSINESS IN TEXAS?

This area is brimming with activity in new construction and remodeling. We have at our doorstep some of the best artisans and creative talent that can be found anywhere.

WHAT IS THE HIGHEST COMPLIMENT YOU HAVE RECEIVED PROFESSIONALLY?

It is knowing that my clients are 100-percent pleased with my work; sometimes that is even expressed with tears of joy.

ON WHAT PERSONAL INDULGENCES DO YOU SPEND THE MOST MONEY?

Travel, art and accessories are among my greatest passions. I love bringing back a handsome or unusual object from each trip.

HAVE YOU RECEIVED ANY PROFESSIONAL AWARDS?

Yes, I was the recipient of the ASID "Design Ovation Award" and listed as one of the top interior designers in *D Magazine*.

DENNIS WATERS DESIGN, INC.
Dennis Waters, ASID
475 Bentwood Lane
Southlake, TX 76092
817.481.7984
f: 817.481.3136
www.denniswatersdesign.com

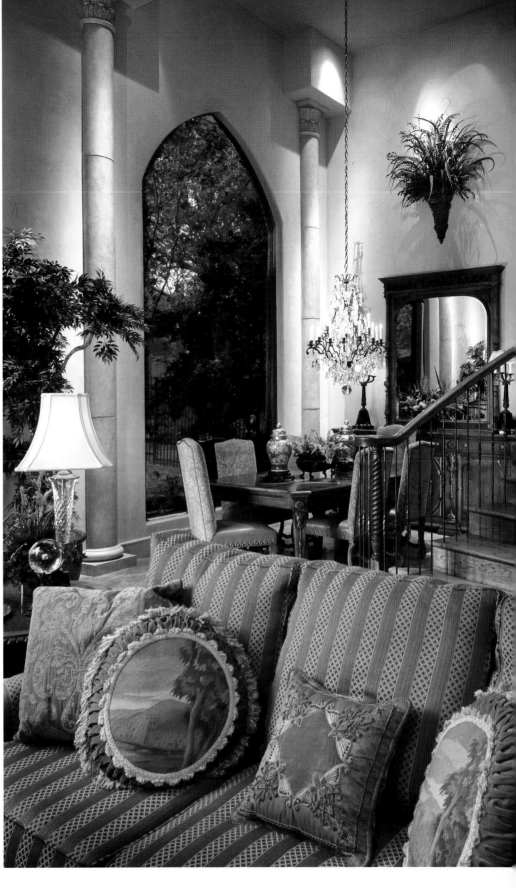

ABOVE:
Surrounded by leather-and-tapestry-upholstered chairs and lit by a long-chained crystal chandelier, the dining room table creates a stunning tableau through the massive arched window, which stretches almost the entire height of the wall.
Photograph by Danny Piassick

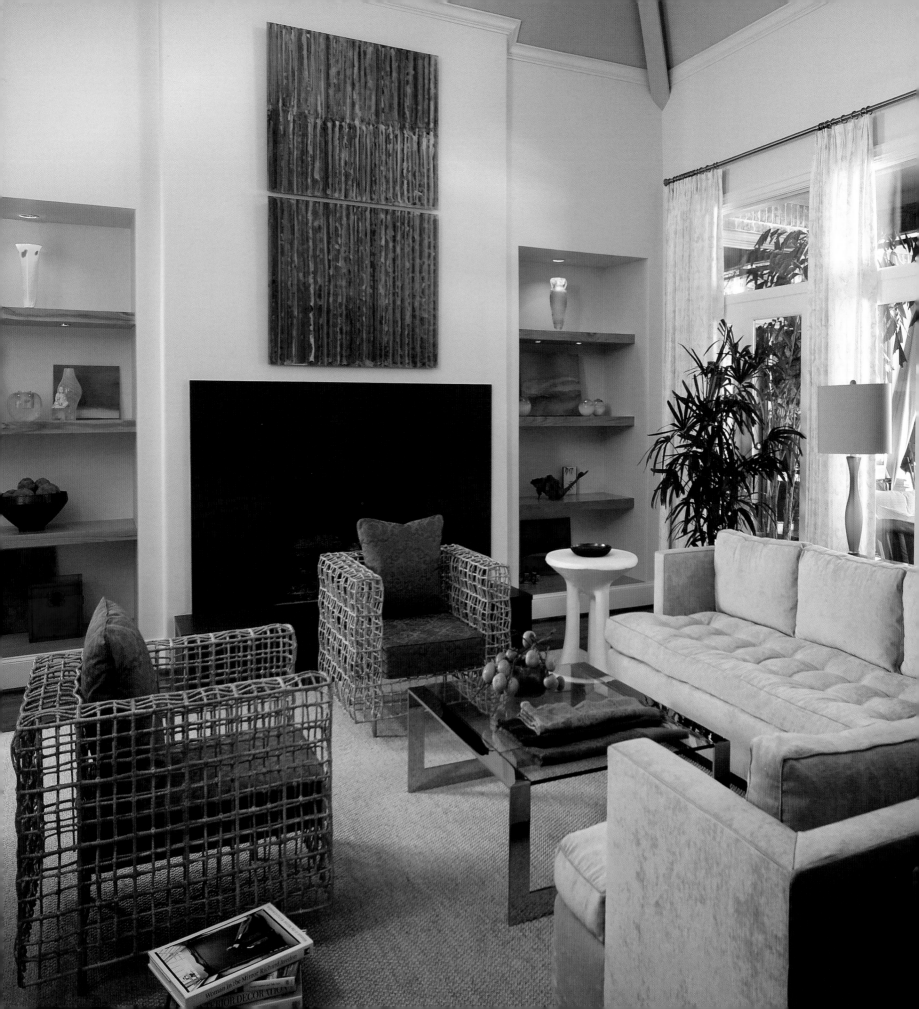

Rodney Woods
Julie Butler

WOODS|BUTLER, INC.

Style is an invisible element, one that is sensed more than seen. It is an innate talent to the two principal partners, Julie Butler and Rodney Woods, of the Dallas-based firm, Woods|Butler, Inc. With more than 27 years of combined experience and numerous ASID design awards, this dynamic team draws inspiration from widely varying perspectives and blends their complementary personalities into elegant, timeless, original designs.

Having worked together since 1999, Rodney and Julie made their business partnership official in 2002. Located in the Design District among the best showrooms and antique dealers in Dallas, Woods|Butler, Inc. has gathered a remarkable portfolio that reflects the pair's shared appreciation for unique environments.

With two bachelor's and a graduate degree between them, Rodney brings a refined design background to the mix while Julie contributes a classically trained sensibility in art history. Striving for perfection, they continue to expand their

LEFT:
Family room sofa and fabric by Nancy Corzine, Yin & Yang chairs through Scott+Cooner, John Dickanson table, Dintiman's hand-painted drapery fabric through David Sutherland, lamps by Donghia, custom-designed sofa table by Woods|Butler. Art by Chris Martin.
Photograph by Bill Bolin

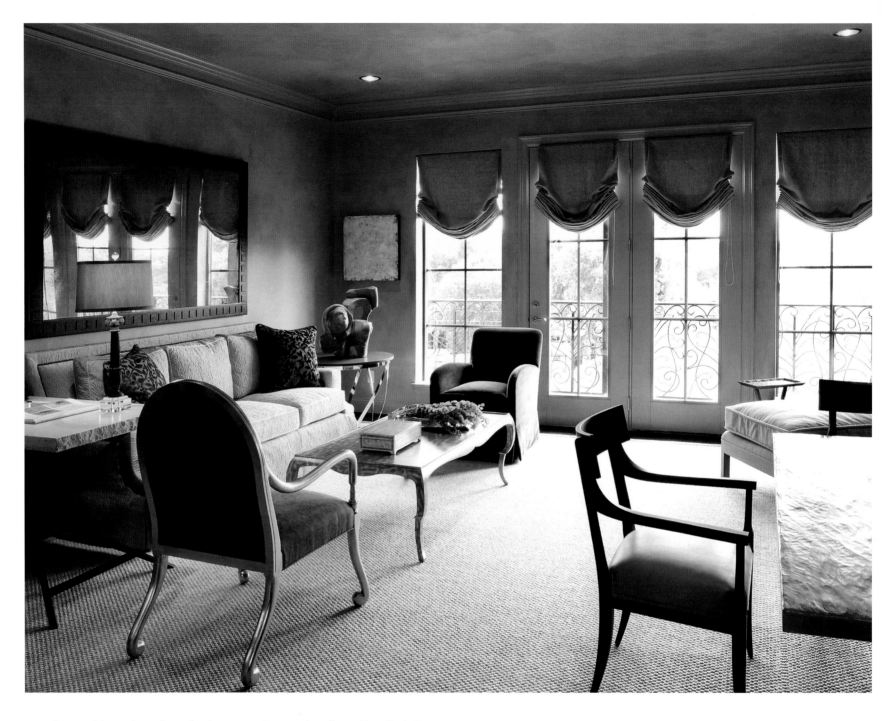

experience with study and production excursions nationally to New York, Los Angeles, Chicago, Miami and New Orleans, as well as the international markets of France, England and Italy. Together, their environments reflect a modern viewpoint drawing on Julie's European cultural experiences and Rodney's contemplative, perfectionist methodology.

With a refined sensitivity to beauty and balance, Woods|Butler, Inc. pursues a philosophy of articulating everyday needs while meeting them with extraordinary solutions. Using artful techniques, Julie and Rodney consistently practice an incisive attention to detail and style, whether designing an eclectic cottage, contemporary high-rise, traditional estate or East Texas ranch.

Both Julie and Rodney are adamant that their clients look and feel good in their spaces and when asked what they enjoy most about interior design, they state, "Our goal is to make sure our clients love walking through their front doors every day. We pride ourselves in knowing that clients' expectations are met and exceeded."

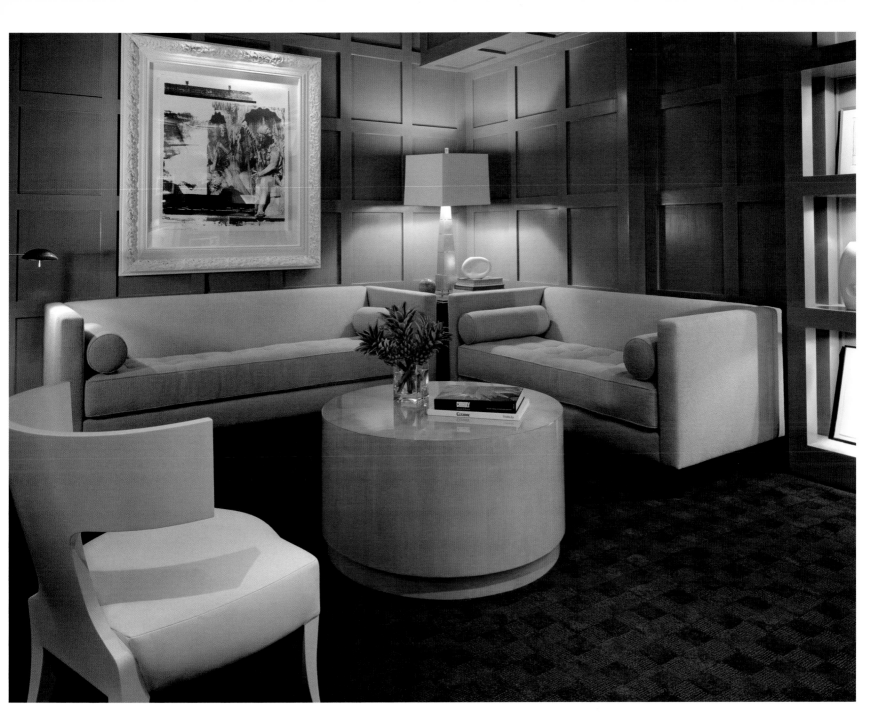

ABOVE:
Parlor lithograph by Rauschenburg, Klismos chair by Donghia with Contemporary Hide's leather sofas by Interior Craft with J. Robert Scott fabric and cocktail table designed by Woods|Butler.
Photograph by Bill Bolin

FACING PAGE:
Living room sofa fabric by Donghia, National Upholstery's Poete chair through David Sutherland with Great Plains velvet and drapery fabric from Rogers & Goffigan, both through George Cameron Nash.
Photograph by Bill Bolin

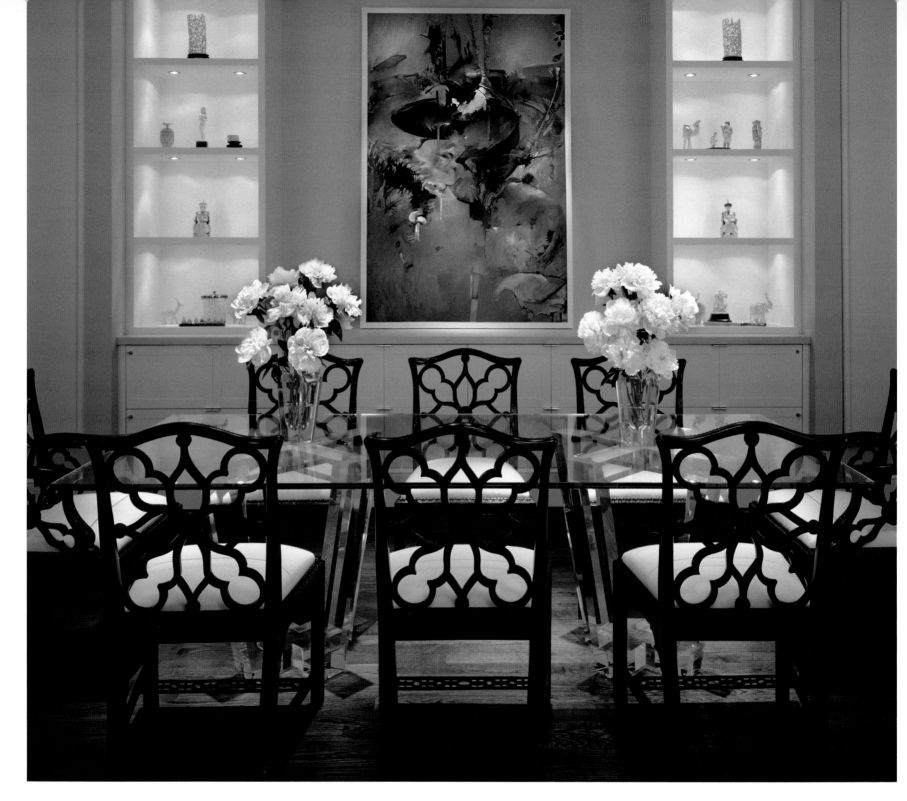

ABOVE:
18th-century Chinese Chippendale dining chairs reupholstered with fabric by Quadrille, custom Lucite dining table, family heirloom antique ivory collection, *Moment* by artist Nancy Rebal, and Baccarat vases.
Photograph by Bill Bolin

FACING PAGE TOP:
1940s' French-style armoire designed by Woods|Butler, art by Michael Kessler through Craighead-Green Gallery, chair fabric from Silk Trading Company, zebra rug through the Mews.
Photograph by Bill Bolin

FACING PAGE BOTTOM:
Four-foot by four-foot custom colored Murano glass chandelier by Algers through David Sutherland, silk for draperies through Walter Lee Culp, limestone table designed by Woods|Butler, dining chair fabrics through ID Collection and Kravet, artwork collected throughout Europe.
Photograph by Bill Bolin

Q&A

more about rodney & julie ...

WHAT DO YOU LIKE MOST ABOUT DOING BUSINESS IN DALLAS?
In Dallas, you get the opportunity to design all kinds of spaces, from high-rises to ranches. We also benefit from the luxury of shopping in a world-class design center. And when we can't find it in Dallas, DFW Airport is not far away.

WHAT SINGLE THING WOULD YOU DO TO BRING A DULL HOUSE TO LIFE?
Add one great piece of art.

IF YOU COULD ELIMINATE ONE DESIGN OR ARCHITECTURAL STYLE FROM THE WORLD, WHAT WOULD IT BE?
McMansions.

WHAT DO YOU DO IN YOUR OFF-TIME TO RELAX?
We both love to read. Whether it is fiction or nonfiction, it is a wonderful way to shake off the day.

WOODS|BUTLER, INC.
Rodney Woods, Allied Member ASID
Julie Butler, Allied Member ASID
1501 Dragon Street, Suite 106
Dallas, TX 75207
214.522.3310
f: 214.522.3320
www.woodsbutler.com

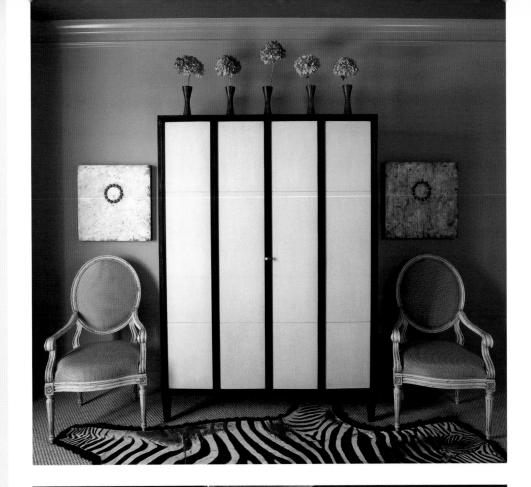

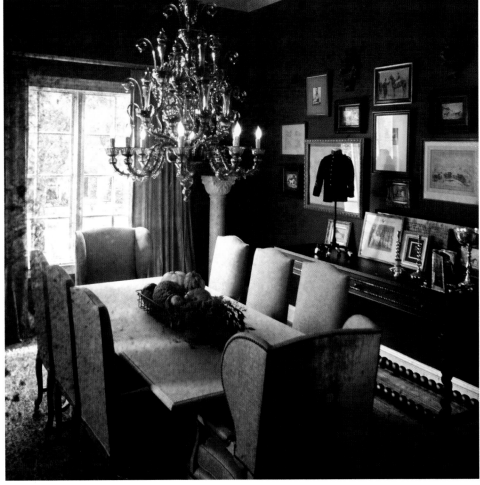

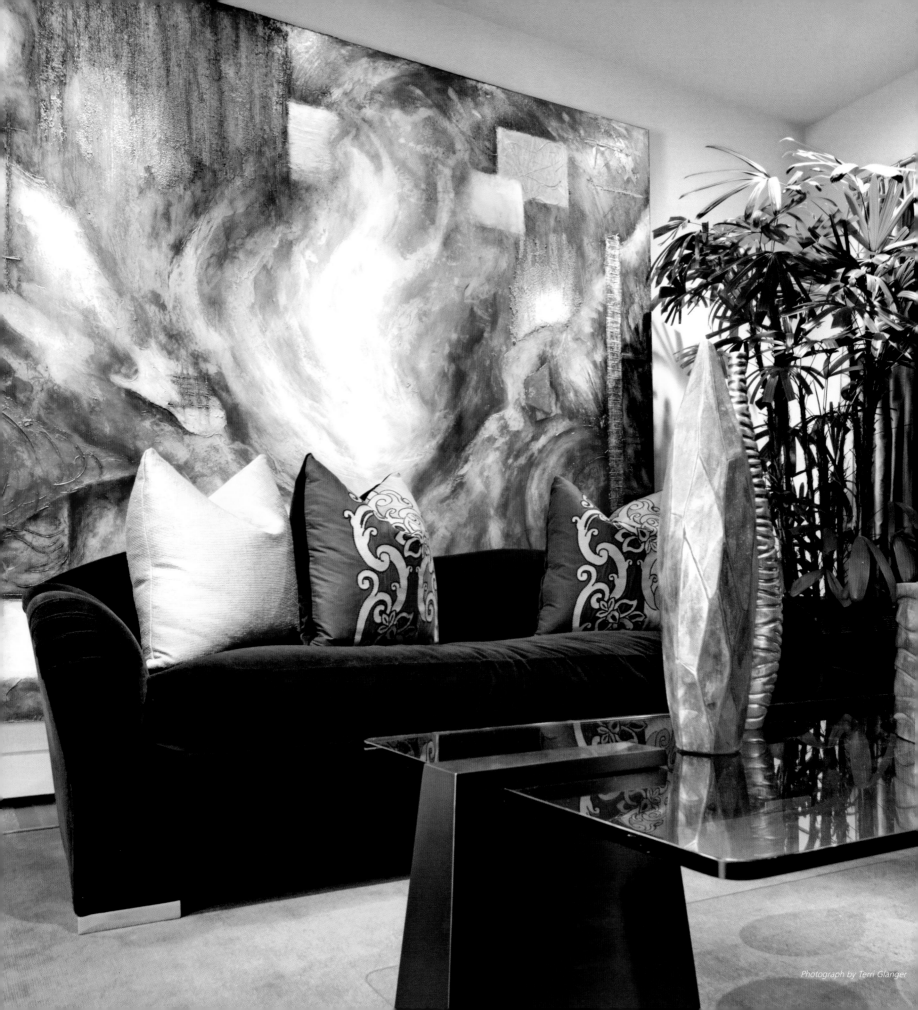

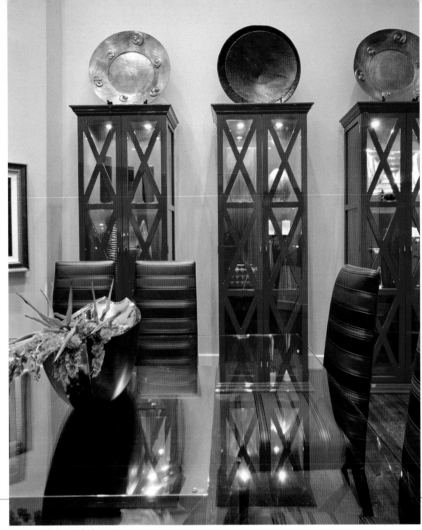

Photograph by Terri Glanger

Joanie Wyll

JOANIE WYLL & ASSOCIATES, INC.

Joanie Wyll, ASID, president of Joanie Wyll & Associates, Inc., consistently amazes her clients with each creation she envisions and completes. From classic traditional spaces to chic contemporary designs, Joanie utilizes her client's personal style as she transforms rooms into masterpieces. With over two decades of experience, Joanie's pioneering passion for custom design and devotion to go above and beyond expectations for her clients has led to a marked standing among her Dallas counterparts.

With over 20 years of experience under her belt, Joanie's talents have been extensively recognized in publications such as *D Home, Dallas Home Design, Robb Report, Estates West, Modern Luxury Dallas, Luxe, Spectacular Homes of Texas* and *The Dallas Morning News.* An ever-evolving sense of style has led Joanie to become the recipient of many awards, among them the honor of being in the top "71 Best Designers in Dallas" by *D Home* and numerous awards from the Texas Chapter of the American Society of Interior Designers.

Specializing in both commercial and residential design, Joanie's keen ability to turn any space into an elegant yet functional setting is unsurpassed.

Joanie ardently believes that an interior designer should be involved with the home from the ground up along with the architect and landscape architect. After the preliminary floor plan is drawn on a new home, she dives into her design plan, establishing essential landmarks throughout the residence. By working with the initial details like fireplaces and media systems, she ensures that every feature of the home will not only accommodate the client, but maximize the use they will receive from the space.

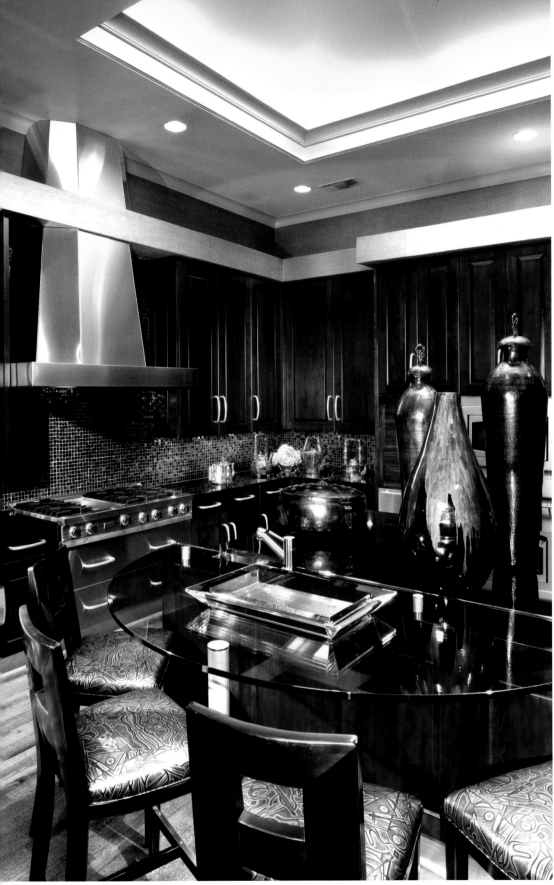

One goal Joanie strives for is to incorporate a clean, "less is more" approach in her home designs; an escape from common hectic lifestyles is something of a luxury for most, but Joanie can help anyone reach that goal. For Joanie, frequent consultations with her clients are a must to jump start her creative juices and to ensure the end result mirrors each client's individual persona. Small details are often what make good design come to life for Joanie, details such as tile proportional to the size of the room and a smooth flow of colors from one room to the next. Joanie will even design the perfect cabinetry to suit any size kitchen for maximum functionality. For one large design project, Joanie worked one on one with the owner of a home for months to develop a customized stain for the cabinetry. Dedication to her work and the lives she touches is one trend from which Joanie never strays.

Imagination is closely related to a willingness to take risks for Joanie, whose innovative aspirations end in splendid gratification on the part of her clients. The element of surprise is something of a rush when the designer gets the okay from a client to creatively interpret the request for the next remarkable pairing or color combination. In the end, it is the contagious enthusiasm with which Joanie works that makes her the distinguished designer she has become.

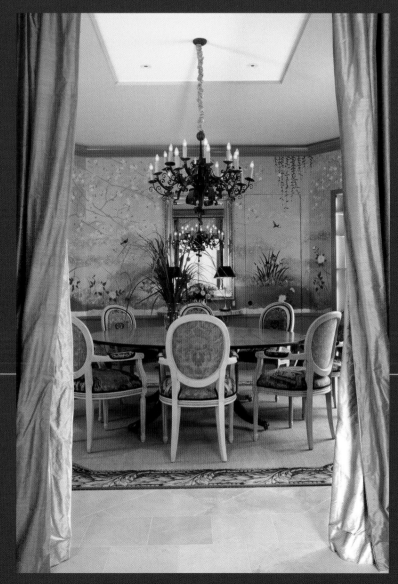

DESIGNER: Richard Holley, Richard Holley, Inc. *Page 249*

Q&A

more about joanie ...

WHAT ONE ELEMENT OF STYLE OR PHILOSOPHY HAVE YOU STUCK WITH FOR YEARS THAT STILL WORKS FOR YOU TODAY?
Elegance with an emphasis on strong architectural lines. My bold vision calls for designs that are innovative, cutting-edge and unique. I work in contemporary and traditional genres, and I constantly strive to create a special look for each client.

WHAT IS THE BEST PART ABOUT BEING AN INTERIOR DESIGNER?
I was always intrigued by interior and architectural design. Even as a child, I enjoyed looking at buildings, fabrics and furniture.

WHAT IS A SINGLE THING YOU WOULD DO TO BRING A DULL HOUSE TO LIFE?
Great art can add life to any dull space.

WHAT COLOR BEST DESCRIBES YOU AND WHY?
I like neutrals and also chocolate brown, steel gray and taupe. I enjoy stepping out of the ordinary. Although my projects include traditional and classic styles, I am not afraid to incorporate unusual and unexpected features throughout the home. I love dramatic, sophisticated spaces.

Photograph by Charles Davis Smith, AIA

JOANIE WYLL & ASSOCIATES, INC.
Joanie Wyll, ASID
12740 Hillcrest Avenue, Suite 160
Dallas, TX 75230
972.380.8770
f: 972.380.8774
www.wyllinteriordesign.com

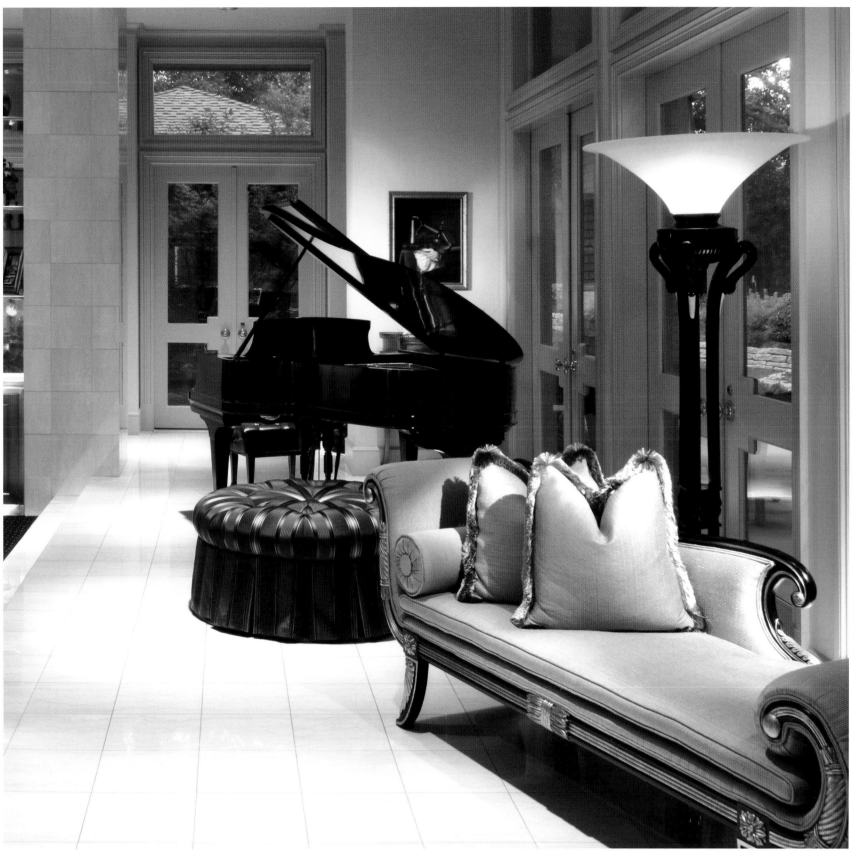

210

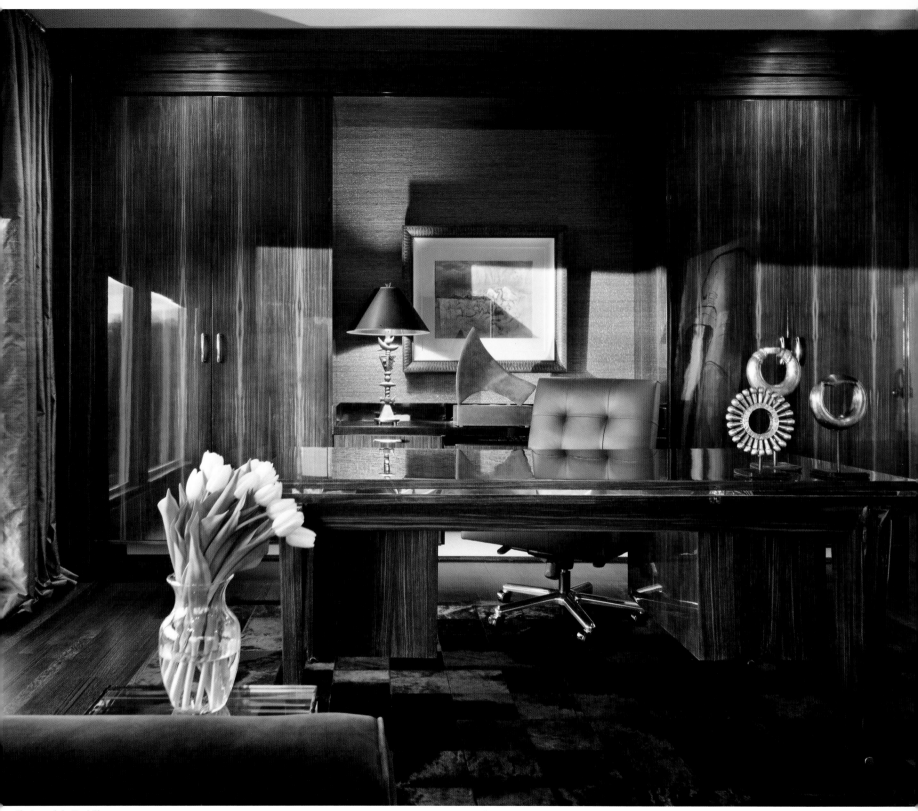

Photograph by Terri Glanger

HOUSTON

AN EXCLUSIVE SHOWCASE OF HOUSTON'S FINEST DESIGNERS

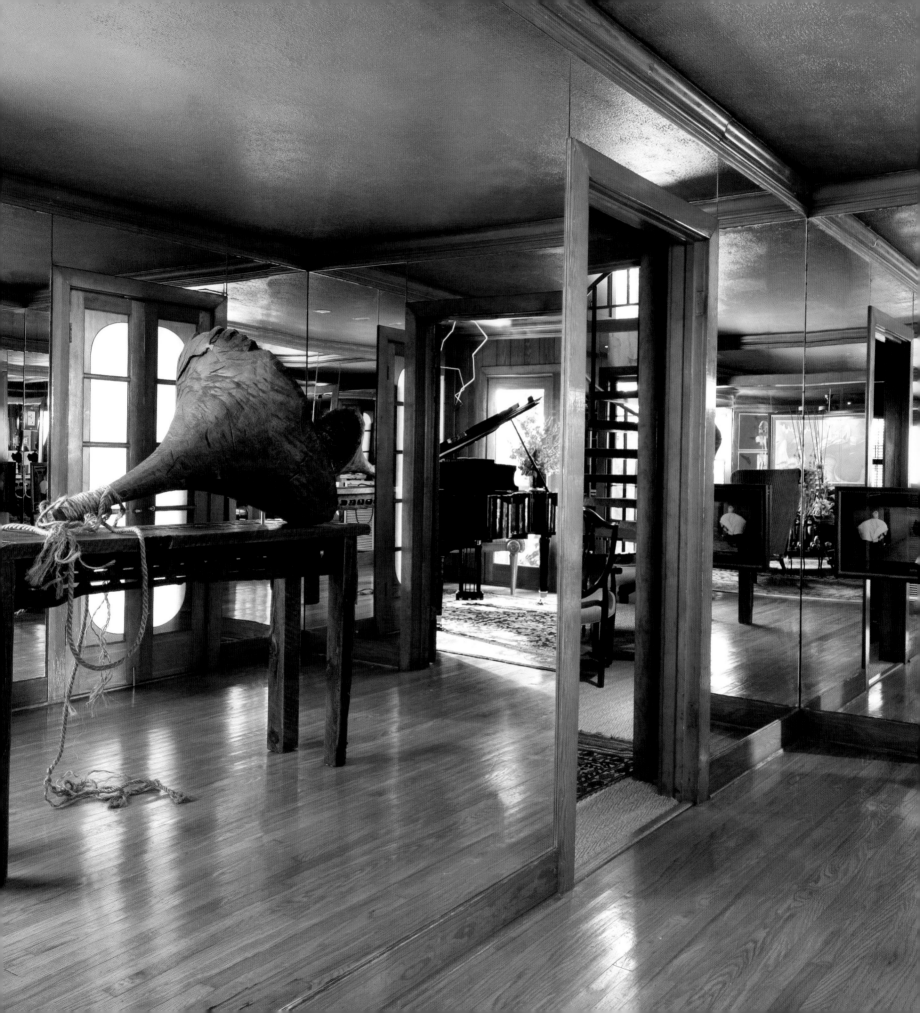

Kelly Gale Amen

KGA

A designer who has been beautifying Houston for 34 years, Kelly Gale Amen does not merely swim in a different direction than other designers; he swims in a different stream altogether. Kelly takes great pleasure in his work and his ability to help people live their lives in a way they never knew was possible. A believer that a good design plan leaves room for the constant joy of experimentation, Kelly's work is impacting the lives of his clients.

"If people realized how much their home environment controls their mental and emotional well-being, they would be much more cautious about choosing their interior designer," says the renowned designer. Kelly seeks to provide a cocoon for his clients' emotions and in order to do this, he customizes the entire project, down to the last detail.

LEFT:
This space reflects perfect light and depth. A Bill Wolf sculpture is featured atop a console by Shel Hershorn.
Photograph by Danny Piassick

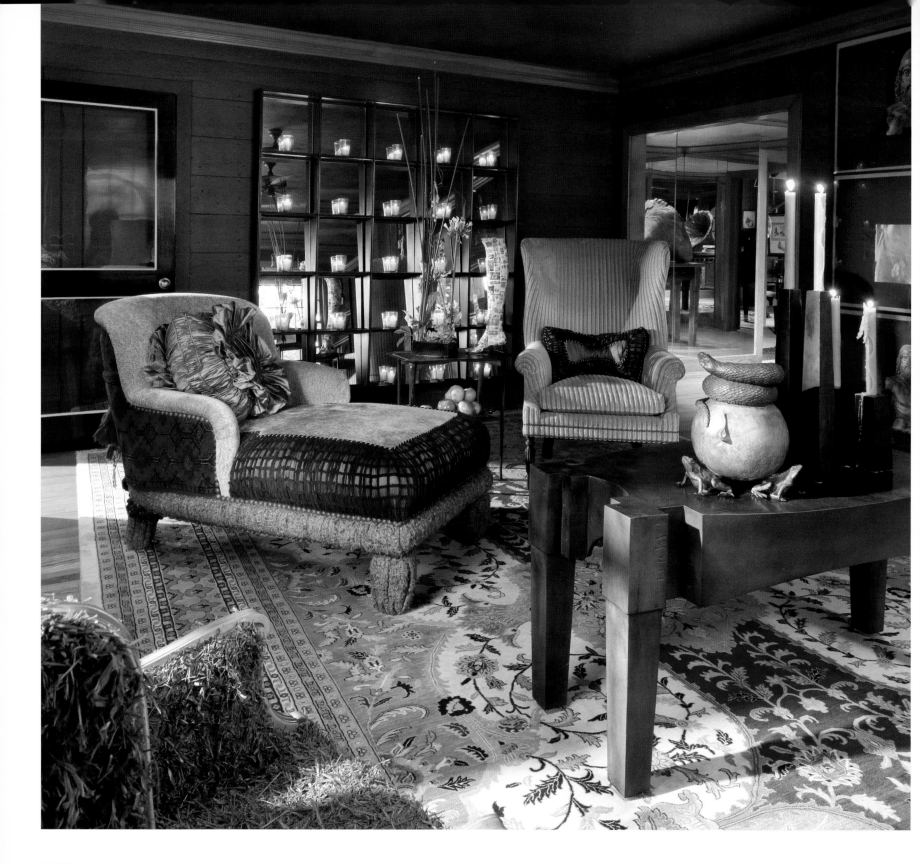

Q&A

more about kelly ...

WHAT ELEMENT OF STYLE HAVE YOU STUCK WITH FOR YEARS THAT STILL
WORKS FOR YOU TODAY?
Always add that certain something you truly love.

WHAT DO YOU LIKE MOST ABOUT DOING BUSINESS IN HOUSTON?
I am constantly surprised by the variety of people and projects!

DESCRIBE YOUR STYLE OR DESIGN PREFERENCES.
Each design is a culmination of layers of life and its usage.

HOW WOULD YOU DESCRIBE YOURSELF TO A STRANGER?
I am living in art with art as art.

KGA
Kelly Gale Amen, ASID
PO Box 66447
Houston, TX 77266
713.522.1410
f: 713.521.1647
www.kga.net

Photograph by
Rudolfo Michel

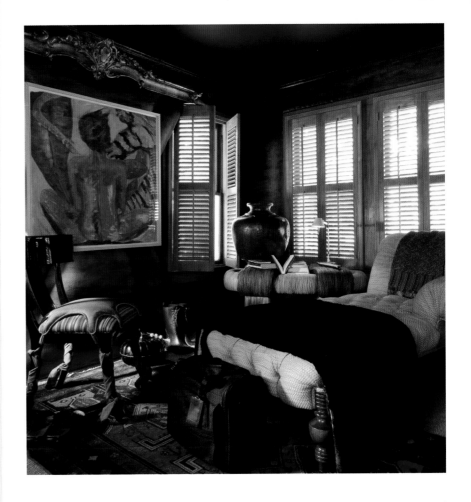

Fifteen years ago, when Kelly could not find the absolute perfect piece of furniture for a client's space, he created his own. His ingenuity displayed in his spontaneous solution not only spurred him onto be one of the state's most sought-after designers, but his art furniture has become a substantial part of his business and given a voice to Kelly's vision.

His vision is such that it is a challenge to find the right words to describe Kelly's artistic abilities. Kelly himself described his work best when he said: "My interior designs have been called capricious and whimsical, non sequitur; a kind of decorative joie de vivre that critics have called both 'shocking and deliciously enchanting.'"

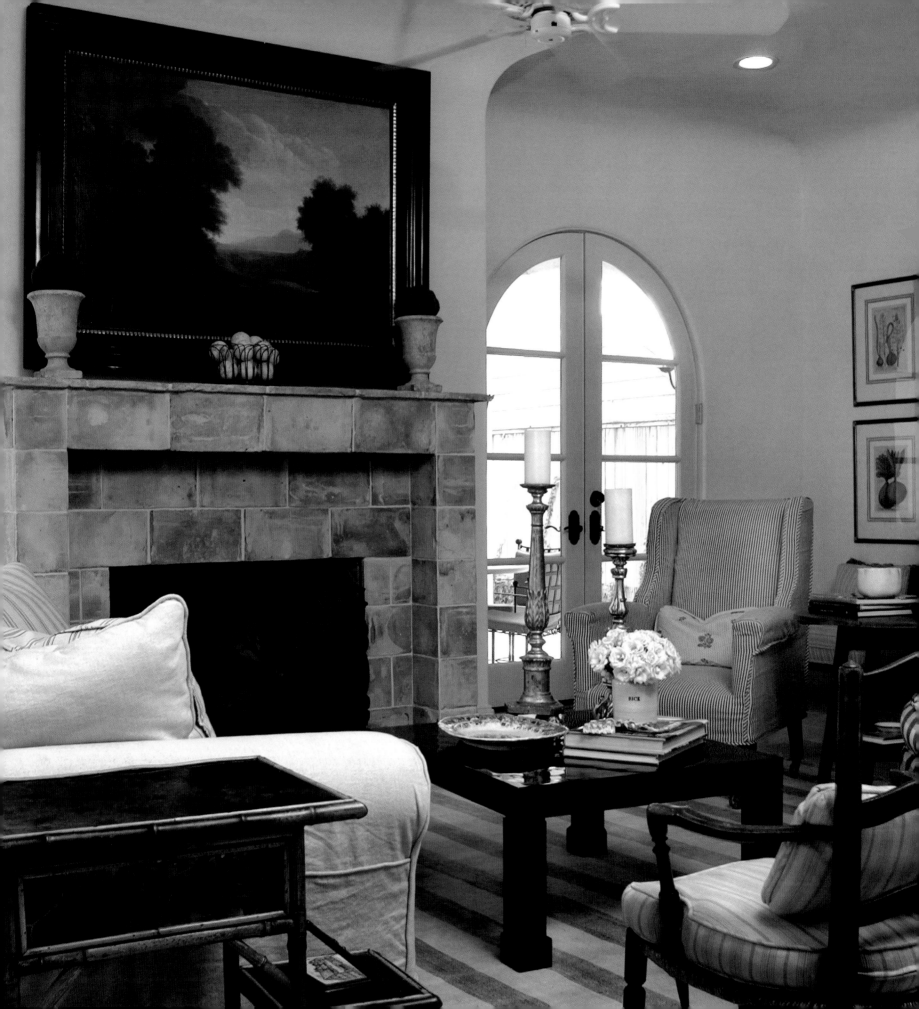

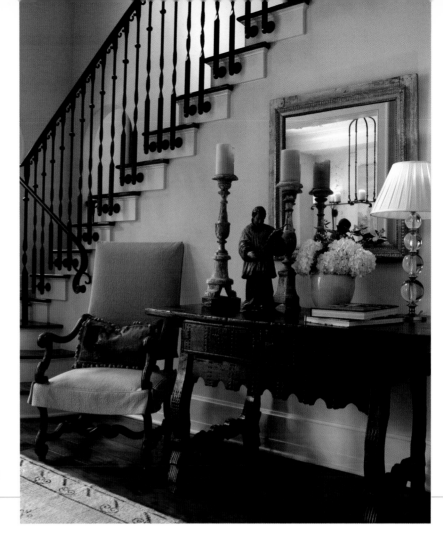

Ginger Barber

GINGER BARBER DESIGN INCORPORATED

Ginger Barber grew up in an old cottage on an island surrounded by breathtaking nature, nurtured by the warm Florida sunshine. Her mother, also an interior designer and Ginger's most sincere influence, created a relaxed, carefree environment favoring natural elements, slip-covered furnishings and sisal mats in her home, a place that Ginger fondly remembers and from which she still derives much of her design inspiration.

Attending the Ringling School of Art and Design in Sarasota, Florida, Ginger majored in interior design. She soon discovered the appeal of the casual lifestyle she enjoyed growing up and began her own design firm. After establishing her successful design business, Ginger also founded The Sitting Room, a Houston shop decorated with real room settings and filled with slip covers, antiques and new and vintage garden-style furniture and accessories.

A broad experience in traditional interiors is evident in Ginger's work. Preferring texture and contrast, Ginger carefully selects elements that complement the existing architecture, expertly combining classic pieces that hint at the past and present.

ABOVE:
An antique French mirror, candlesticks and a Watkins Culver Spanish console adorn this beautiful entry hall.
Photograph by Janet Lenzen

FACING PAGE:
A slip-covered sofa and pinstriped wing chair sit atop an antique Oushak rug, which grounds the composition of this casual Mediterranean-style living room. The fireplace surround created from antique roof tiles and limestone floors imported from Israel further enhance the ambience.
Photograph by Janet Lenzen

GINGER BARBER DESIGN INCORPORATED
Ginger Barber
6213 Edloe Street
Houston, TX 77005
713.523.1925
f: 713.523.1929

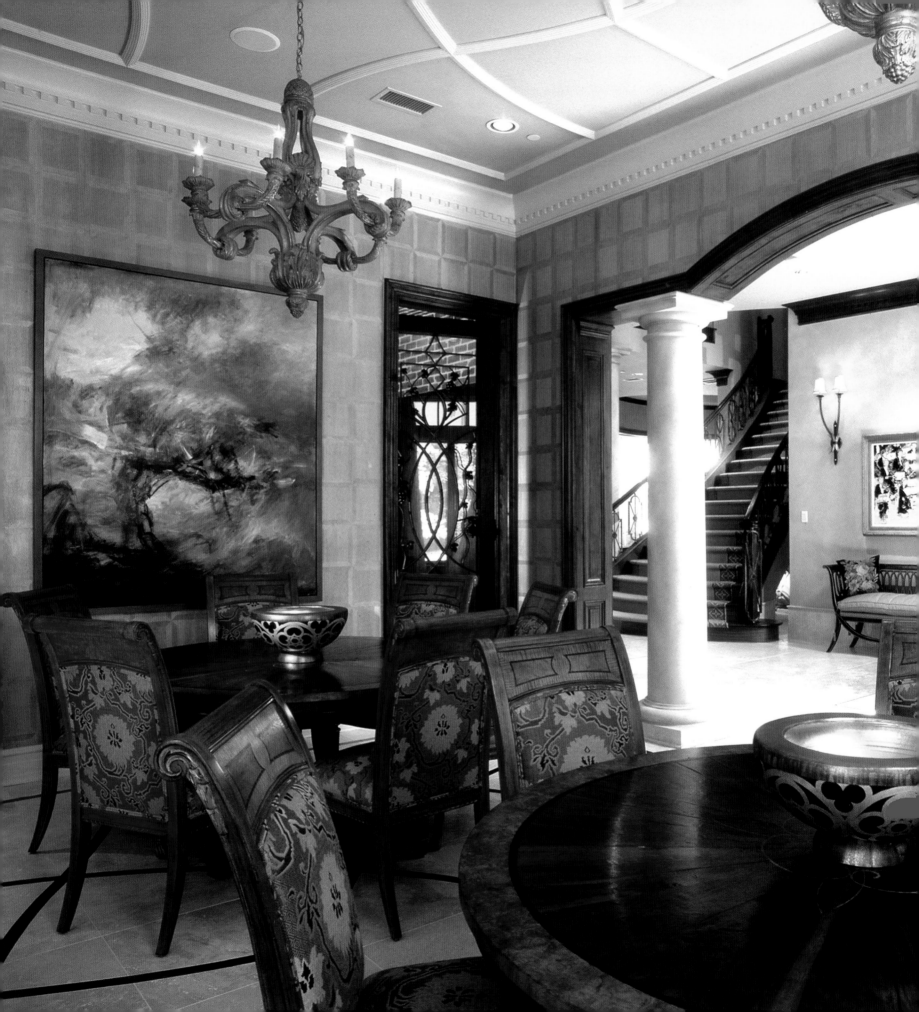

Jane-Page Crump

JANE PAGE DESIGN GROUP

With 30 years of experience in interior design, Jane-Page Crump's Houston-based business and reputation for award-winning designs reaches clients from the West Coast to the East Coast. Known for its elegant and distinctive interiors, Jane Page Design Group works primarily with new construction design and remodeling of high-end residential properties. To effectively serve their impressive client list of Fortune 500 executives, celebrities and political nobles, the firm follows a team approach—they work closely with the finest contractors and architects to ensure that their clients' requirements for budget and custom design are met. "Time is money, and when two or more designers are assigned to a project, someone is always available to make timely decisions," Jane-Page explains. "I believe that the collaboration by a team of designers leads to more sophisticated and detailed designs," she adds.

LEFT:
The design details in this elegant dining room include a plaster ceiling design that is reflected in the stone floor pattern as well as in the metal door motif and the study's leaded glass detail.
Photograph by Rob Muir

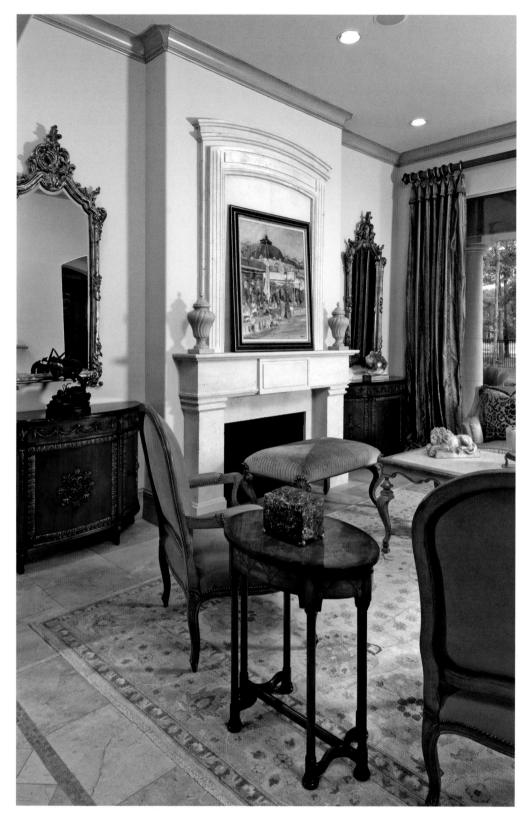

Respect for her clients is a given for Jane-Page, for which she has been abundantly rewarded in recognition for her talent both nationally and locally. Jane-Page's work has been published in *Great Designers of the World*, *Who's Who in Kitchen Design*, *Showcase of Interior Design*, *Southern Edition* and *Designed in Texas*, to name a few. In addition, Jane-Page and her firm have been awarded numerous times for theater, office, kitchen, bath and house designs and have also received an "International Illumination Award of Merit." Jane-Page's passion for design shines through with each individual client and home she touches.

Jane-Page believes being active in professional organizations is key to improving one's self and the world around them. As a past president and present board member of the Texas Association of Interior Design, she works hard to support state legislation that furthers the professionalism of interior design and interior designers. Jane-Page is also a past president and presently a committee chair of the American Society of Interior Designers, Texas Gulf Coast Chapter. Along with her MBA in finance from the University of Texas, Jane-Page draws on her many experiences and awards to further the growth of her firm and to provide her clients with unsurpassed excellence.

ABOVE:
A pair of antique reproduction demilunes and mirrors flank a carved limestone fireplace in this European-inspired living room. Various textures of silk, velvet, and suede are used to make the room cozy, yet clean, fresh and inviting.
Photograph by Hall Pucket

FACING PAGE:
Special details, such as the custom-designed carved stone and stainless hood, and stone-trimmed leaded and beveled glass window give elegance and interest to the space.
Photograph by Rob Muir

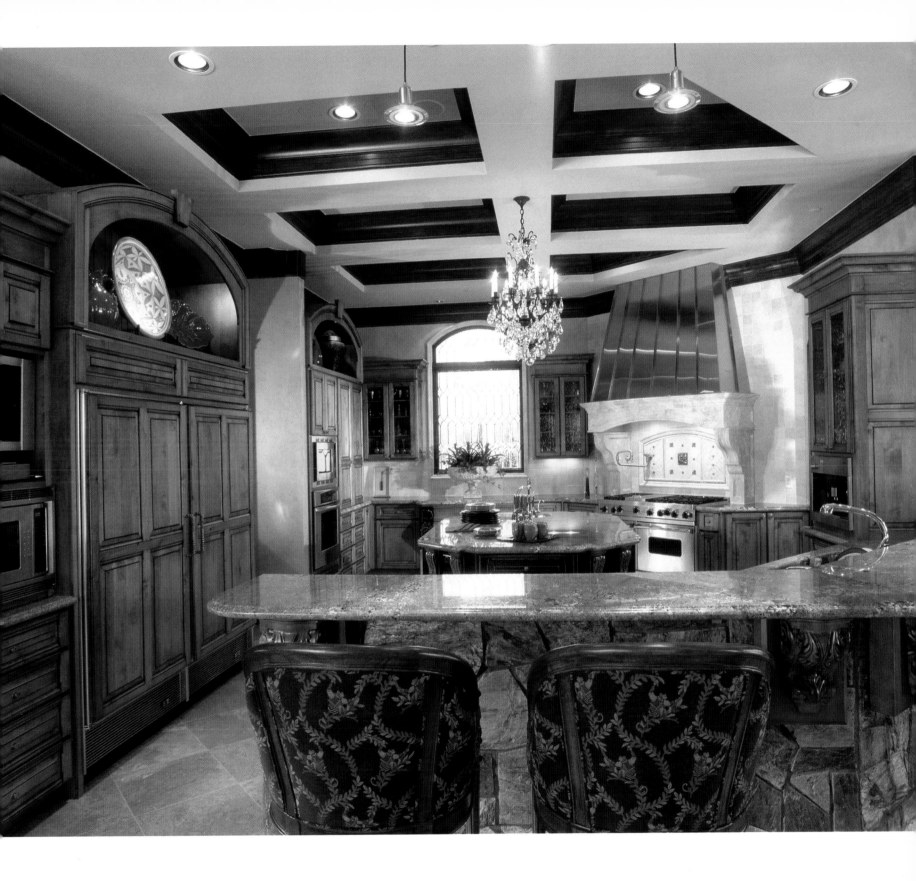

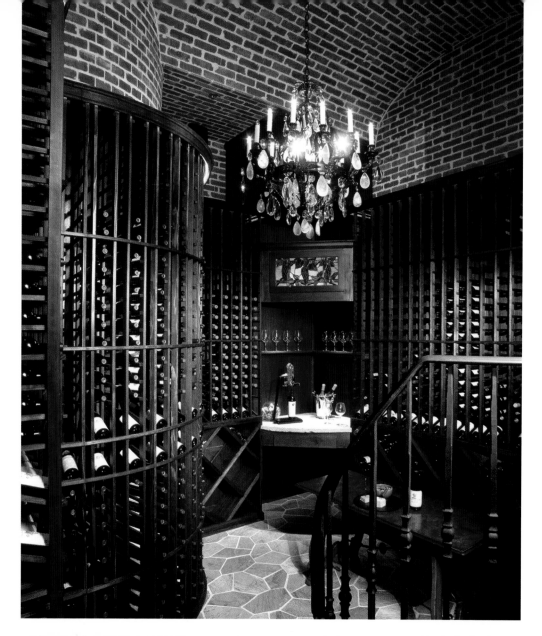

Jane-Page works closely with her clients to ensure that both she and the client are sharing the same vision. In fact, Jane-Page becomes so involved in her clients' lives that most of her clients become very good friends. Through her hard work and dedication, Jane-Page listens and guides every step of the design process, ending with a space that is commensurate with the lifestyle of the owner.

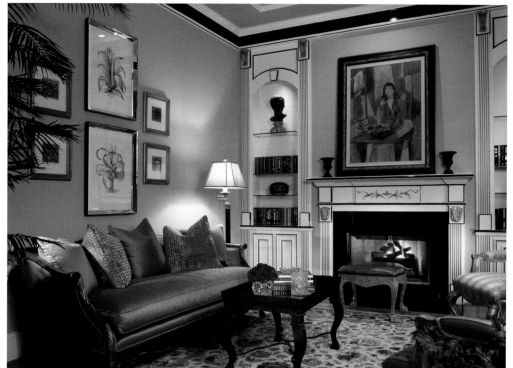

TOP LEFT:
The bronze and rock quartz crystal chandelier provides soft ambient light to the space. Low voltage lighting is built into the crown of the custom wine racks, and lights on the top of the cabinets illuminate the thin brick ceiling. The lighting design as well as all finishes and furnishings were designed by Jane Page Design Group.
Photograph by Rob Muir

BOTTOM LEFT:
A subtle palette of tone-on-tone gold fabrics was selected to accent the delicately carved, silver leafed woodwork on the sofa and chairs. Black details were added for drama.
Photograph by Rob Muir

FACING PAGE:
Stunning paneled pilasters and a coordinating valance were designed to wrap the room. Mahogany was selected to tie in with the finish on the existing speakers, and a gorgeous Sycamore wood was selected for an interesting contrast.
Photograph by Rob Muir

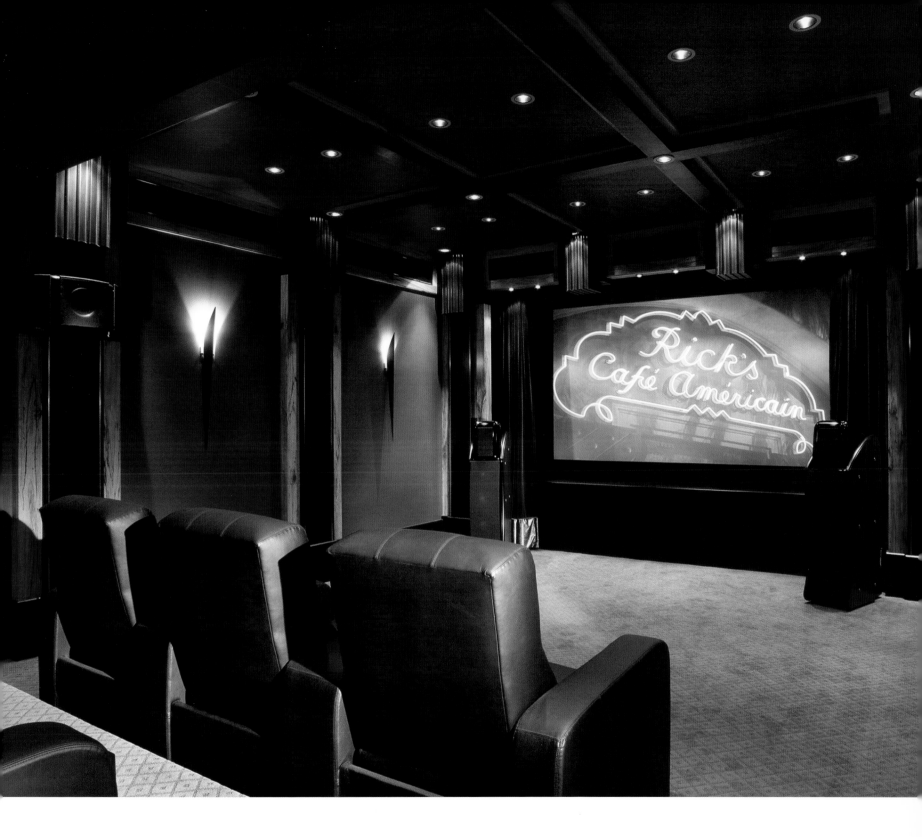

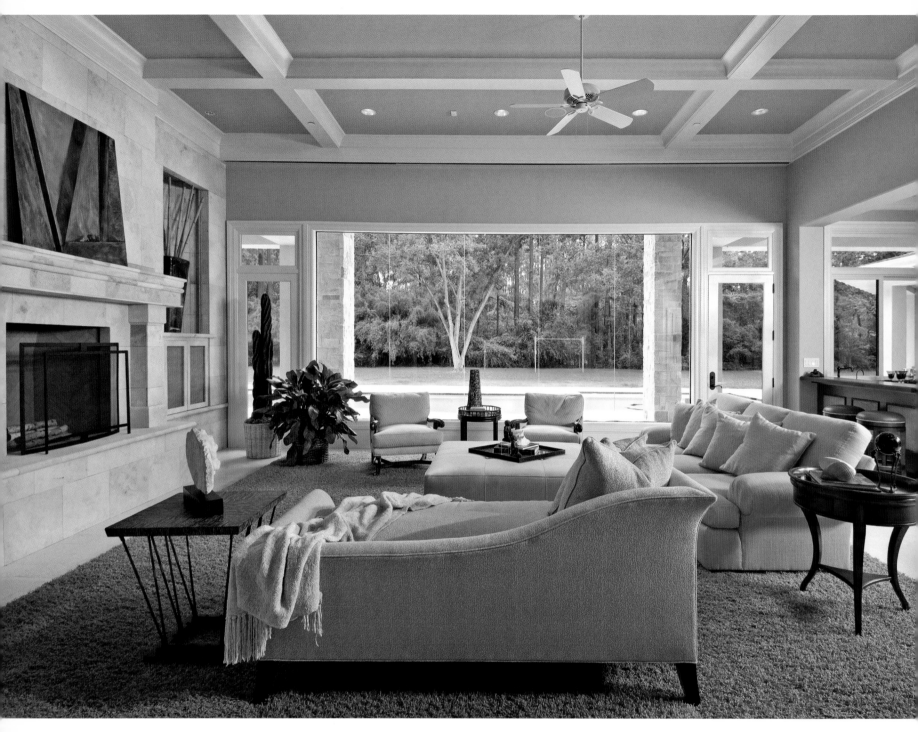

ABOVE:
The dry stacked limestone wall design is comprised of 16-inch by 20-inch stone and carved limestone mantel, made up of seven perfectly symmetrical segments for the shelf. This elegant entertaining space was created with attention to intricate details based on the desire for symmetry.
Photograph by Hall Pucket

FACING PAGE:
This graceful bathroom incorporates a handmade custom wall covering as a textural backdrop for the dramatic triple-arched mirrors and the "woven" mosaic tile inset.
Photograph by Hall Pucket

Q&A

more about jane-page ...

WHAT DON'T MOST PEOPLE KNOW ABOUT YOU?

I once taught French cooking as well as basic cooking techniques for a cooking school in Oklahoma City.

WHAT COLOR BEST DESCRIBES YOU?

Red! When I was a little girl I remember dreaming of being a bride in a red velvet wedding gown. My grandmother said it wouldn't be appropriate! I always feel energized when I wear red. Red is very empowering and brings life to a room.

DESCRIBE YOUR STYLE OR DESIGN PREFERENCES.

Our design style is that preferred by the client. We don't strive to have our own style but to deliver the style that best reflects the client's dreams and lifestyles.

WHAT PERSONAL INDULGENCE DO YOU SPEND THE MOST MONEY ON?

Clothes! Since I was 10 years old I planned on being a fashion designer. Even though I changed to interior design, my love for fabrics and fashion has continued. While growing up my mother always dressed beautifully and also bought me lots of pretty clothes. I accompanied her on many shopping sprees.

JANE PAGE DESIGN GROUP
Jane-Page Crump, ASID
500 Durham Drive
Houston, TX 77007
713.803.4999
f: 713.803.4998
www.JanePageDesignGroup.com

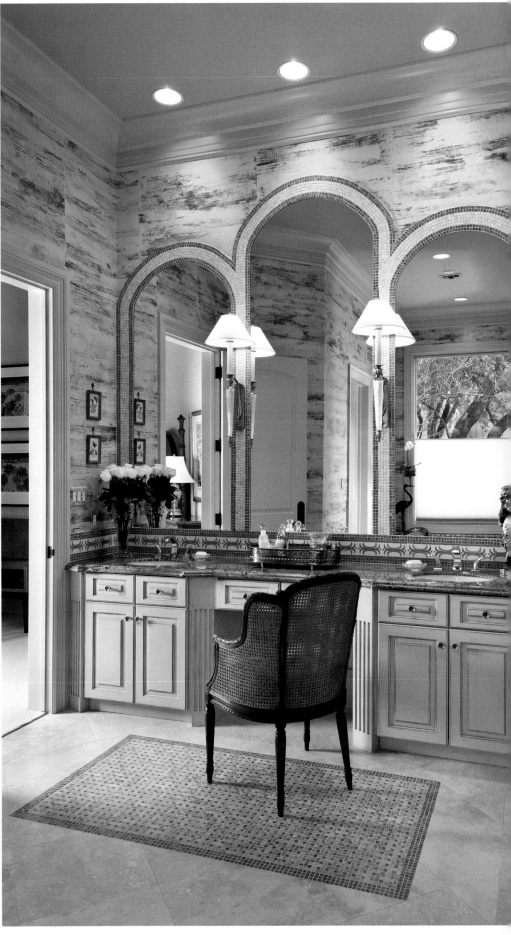

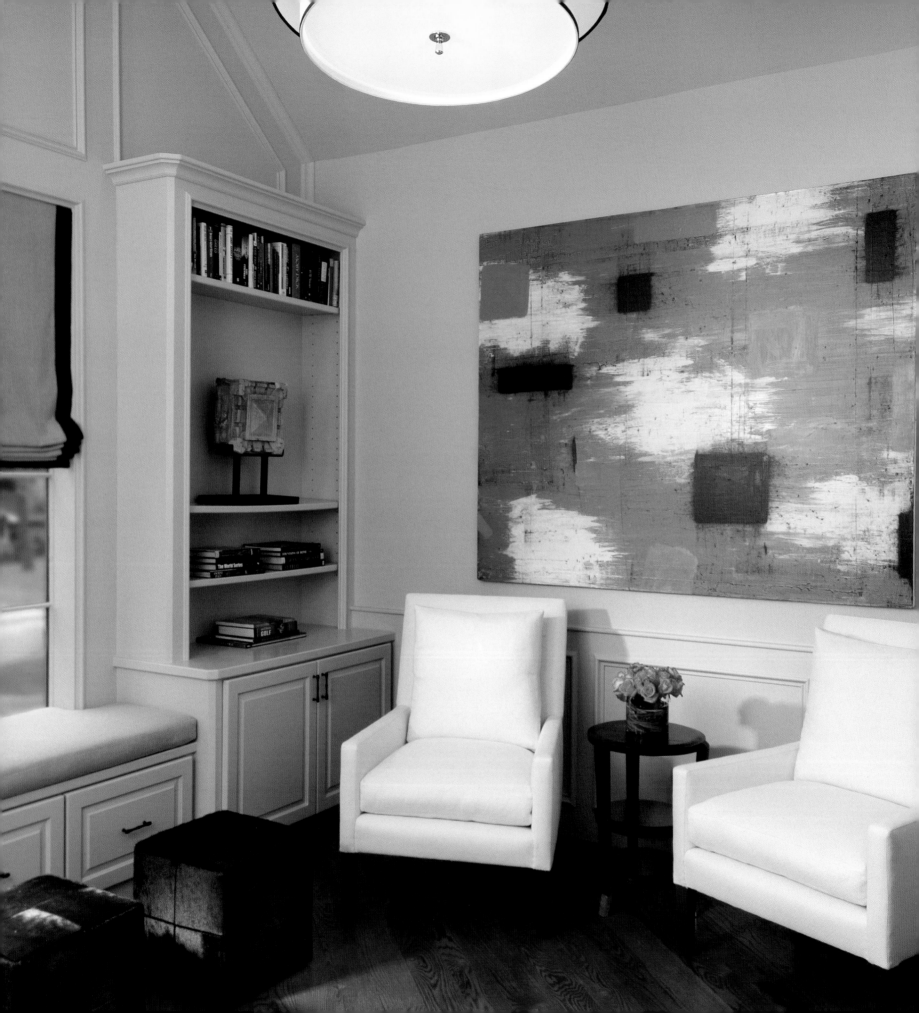

Chandos Dodson

CHANDOS DODSON INTERIOR DESIGN

Established in 2000, Chandos Dodson Interior Design is a firm that strives to create unparalleled and opulent residences. Based in Houston, founder Chandos Dodson graduated with her interior design degree from the University of Texas at Austin, honed her expertise in Atlanta and New York City under several famed designers who graced the pages of *Architectural Digest* and *House Beautiful*'s list of top 100 designers, including Naomi Leff & Associates, Greg Jordan and Dan Carithers.

Chandos's skills transverse style and she possesses a broad range of sensibilities. Carefully articulating her clients' style into extraordinary interior environments, Chandos meets each challenge with the perfect solution, creating chic spaces that serve both function and aesthetics whether traditional or modern. The Houston house featured in this book perfectly illustrates the joining of classic lines with a mix of contemporary and modern pieces. The

client requested the accessories be limited and that the art and furniture be the standouts in the interiors. Stunning artwork and furnishings reflect individual character and focus the style of the client while the flawless design suits the proposed use of the room.

Taking on projects from all over the country, Chandos recently completed a 3,000-square-foot home in Miami Beach overlooking the ocean. The project challenged her to create a space that could compete with the setting, yet not

ABOVE:
Luxe details in this Houston dining room, such as hand-embroidered drapery panels and classic furnishings, mix well with the contemporary painting *Total Organism* by Angelina Nasso.
Photograph by Danny Piassick

FACING PAGE:
The blue study provides impact with classic architectural details painted dust blue to set off the modern furnishings, lighting and the painting *Early Break* by Larry Graeber and selected by S.E. Wheless Fine Art.
Photograph by Danny Piassick

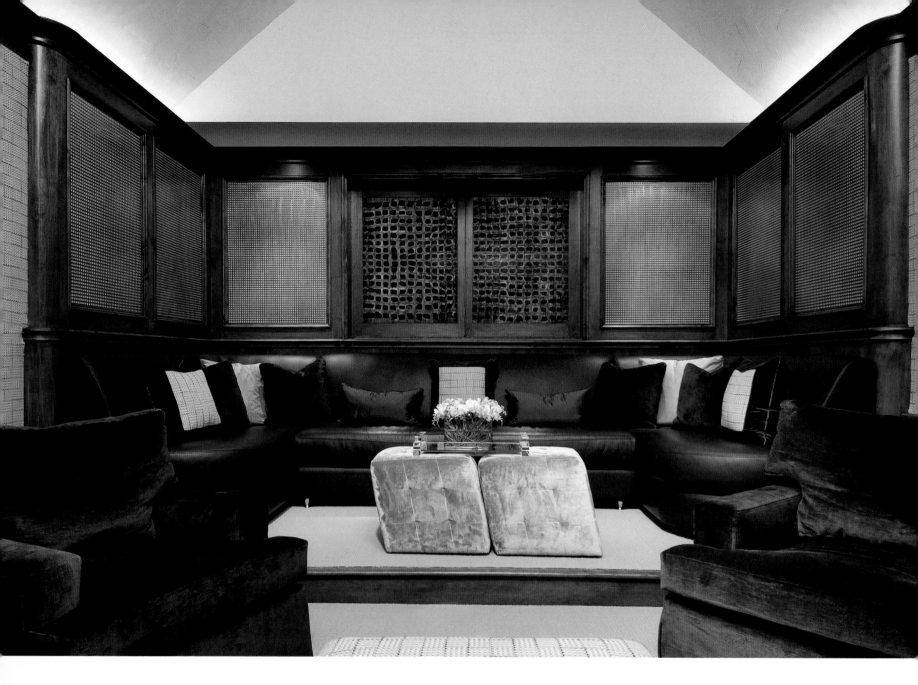

overpower the spectacular view. With the ocean on the horizon just outside the high-rise window, it was an impressive place and one that needed a particular touch to create an interior environment as beautiful as the view just beyond. Meeting the requirements with eloquent strokes of neutral color, organic elements and just the right art to complement the landscape, the reward was a fabulous interior that flowed seamlessly with the natural beauty of the shore.

Chandos's design philosophy requires close attention to detail in order to articulate a sense of style that represents her client's unique personality. "So many times, people neglect to buy the things that give a room a real place in time and create a memorable feeling," she says. "Window treatments, a beautiful rug, unique artwork and the right lighting are all elements which give a space personality and bring it to life."

Living spaces that offer sophistication while imparting a sense of ease and comfort are a signature for this refined designer. Chandos's rich interiors present a relaxing approach to a tasteful, high-end style. Revealing just a bit of what motivates her to continue the beautiful work she does, Chandos says her greatest satisfaction comes from seeing her projects to fruition and doing what she loves every day.

Q&A

more about chandos ...

HOW LONG HAVE YOU BEEN AN INTERIOR DESIGNER?
I have been in design since 1998 and opened my own firm just
two years later.

DESCRIBE YOU STYLE OR DESIGN PREFERENCES.
I love simple, classic and clean lines although anything luxe is
always welcome.

WHAT COLOR BEST DESCRIBES YOU?
My favorite colors are earthy blues; they are still neutral and they
tend to flatter everyone and everything.

WHAT IS THE BEST PART OF BEING AN INTERIOR DESIGNER?
I do what I love every single day. Every day there is a new
challenge and that requires being a problem-solver on many
different levels. Interior design is not only about creating a
beautiful room. It is about being a manager of time, money, and
of a team of skilled artisans whose work ultimately represents
your creativity and skill. This is true from fabrics to the intricate
details of a lighting plan. It's very satisfying to see a project to
completion and to change the environments in which people live
their lives.

CHANDOS DODSON INTERIOR DESIGN
Chandos Dodson, ASID
1510 Missouri Street, Suite 10
Houston, TX 77006
713.942.9350
f: 713.942.9886
www.chandosdodson.com

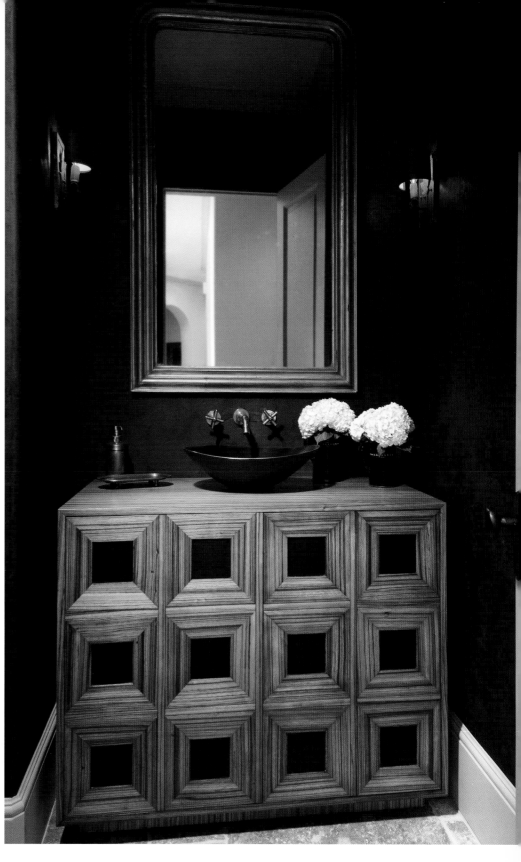

ABOVE:
The powder room with pearl essence black Venetian plaster walls combined with a Louis-Philippe mirror are perfect,
juxtaposed to the contemporary plumbing fixtures and custom-made zebra wood and ebony vanity.
Photograph by Danny Piassick

FACING PAGE:
The media room in this Houston home features a sumptuous mix of textures ranging from leather on the banquette to
silk velvet ottomans and linen velvet chairs.
Photograph by Danny Piassick

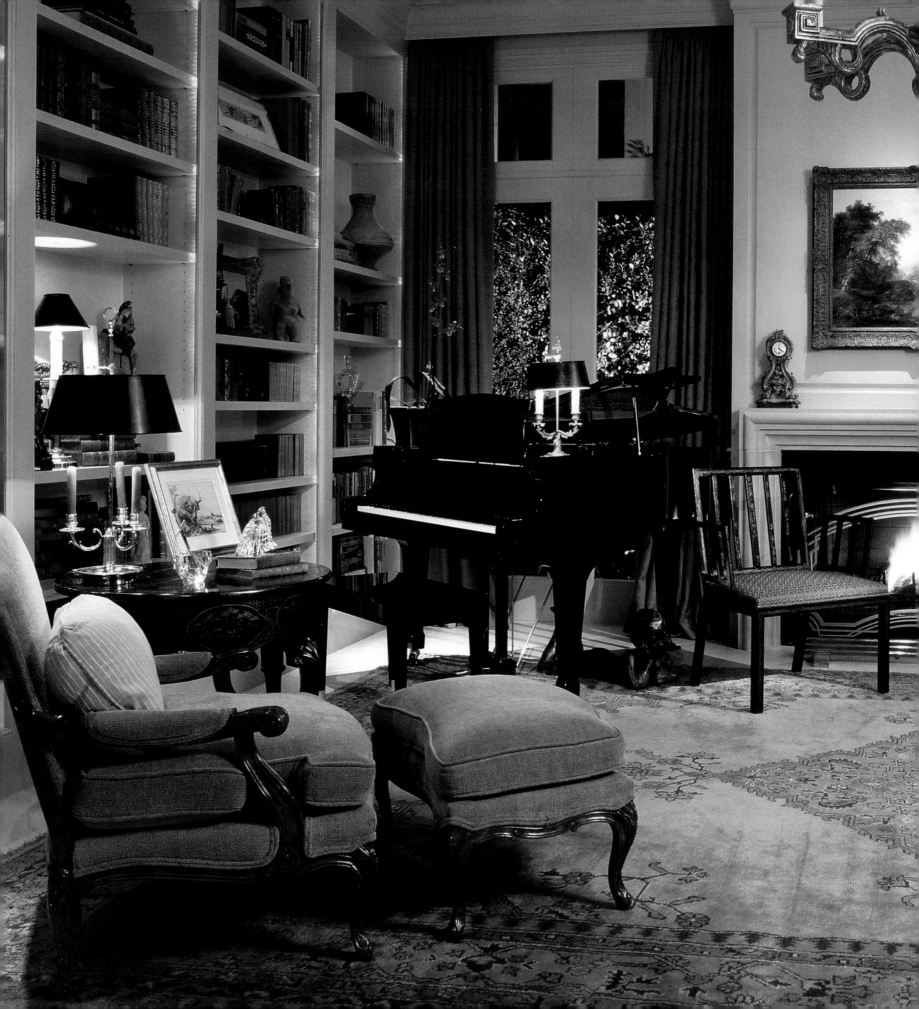

Sylvia Longoria Dorsey

LONGORIA COLLECTION

Sylvia Longoria Dorsey's name is synonymous with pure elegance when it comes to interior design artisanship. She visualizes spaces as blank canvases to be filled with beautiful works of art and elements that are both pleasing to the eye and functional. Her interior design installations reflect her sense of balanced composition and proportion. With her penchant for simple splendor, she utilizes her eye for art to convey to clients that less is more and it is better to have a house with a few exceptional pieces than a house full of things.

Sylvia's affinity for excellence began at an early age. Her mother influenced her love of splendid things and fine art, including work by renowned Mexican artists. Creativity is evident throughout Sylvia's devoted family, with her daughter, Elizabeth Dorsey Fertitta, and sons Thomas and Wayo Dorsey involved in the family business and husband Tommy Dorsey, a well-known custom home builder, contributing to design concepts.

LEFT:
A warm and inviting living area features an antique Oushak rug. The room is graced with an original J.B. Ladbrooke oil painting, antique Bouillotte lamps, Han Dynasty artifacts, a pre-Columbian sculpture and a life-size bronze of Wayo Dorsey at age two.
Photograph by Rob Muir

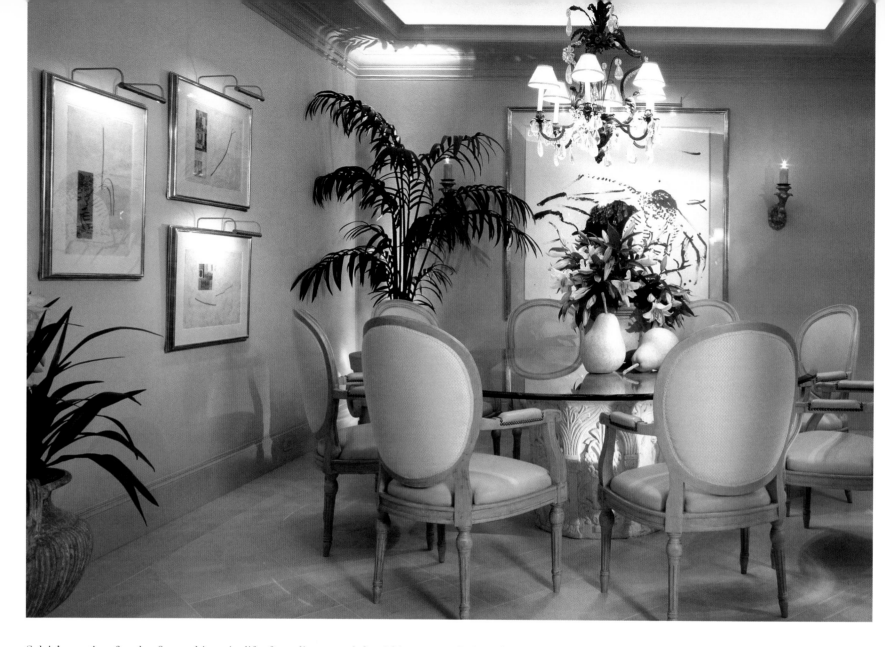

Sylvia's passion for the finest things in life, from linens and furnishings to jewelry and fragrances, influenced her decision to open a luxurious lifestyle boutique. Founding Longoria Collection in 1993, it was Sylvia's goal to provide an exceptional resource for lighting, exquisite accessories, art, and fine Italian linens. Defining these offerings as an extension of her design style, she enjoys every detail of a project, from working with the architect to choosing furnishings and fabrics. Sylvia draws great satisfaction knowing her clients are pleased, as evidenced when they return again and again seeking advice and expert execution for home interior planning.

Sylvia's educational background includes an art history degree from the University of Texas, and accreditations from both the American Society of Interior Designers and Texas Association of Interior Designers. Sylvia insists the best training she has received comes from beautiful, tranquil environments her clients allow her to create. "I believe every room, like every person, has a purpose. I love to mix casual, unexpected elements with timeless elegance," she shares.

ABOVE:
An important David Hockney painting and collage trio by Mary Ellen Long adorn the warm upholstered walls of the elegant dining area. Cove lighting, Italian sconces and a Nesle rock-crystal chandelier create ambient lighting.
Photograph by Rob Muir

FACING PAGE LEFT:
The library features a Botticelli-inspired hand-painted screen leading to the elegant foyer displaying Han Dynasty terracotta figures, a Renoir lithograph and formal Thomas Morgan mirror and console.
Photograph by Rob Muir

FACING PAGE RIGHT:
Luxurious items from Longoria Collection finish the intimate suite with delicate pastel Anichini bed linens and sensual headboard. A natural ammonite fossil and antique chinoiserie container accent the bedside.
Photograph by Rob Muir

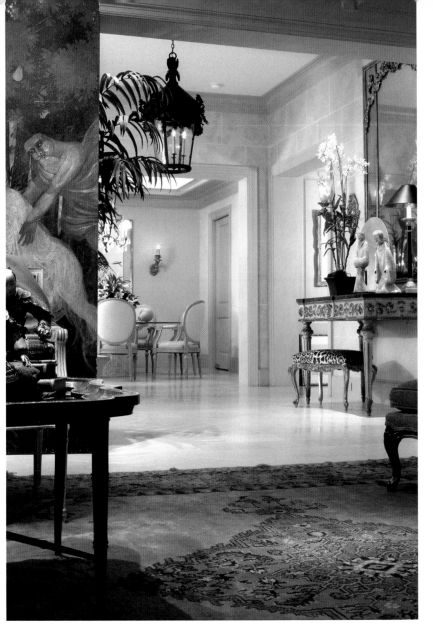

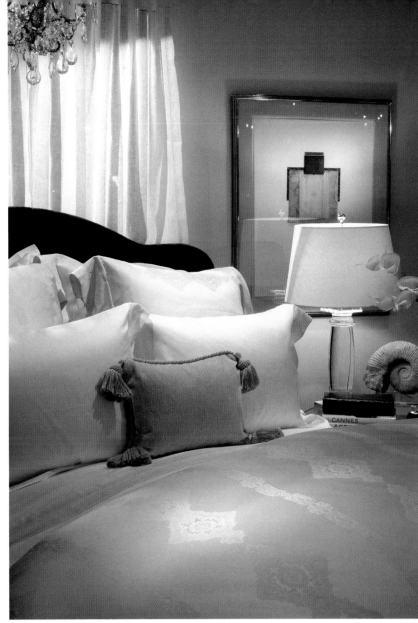

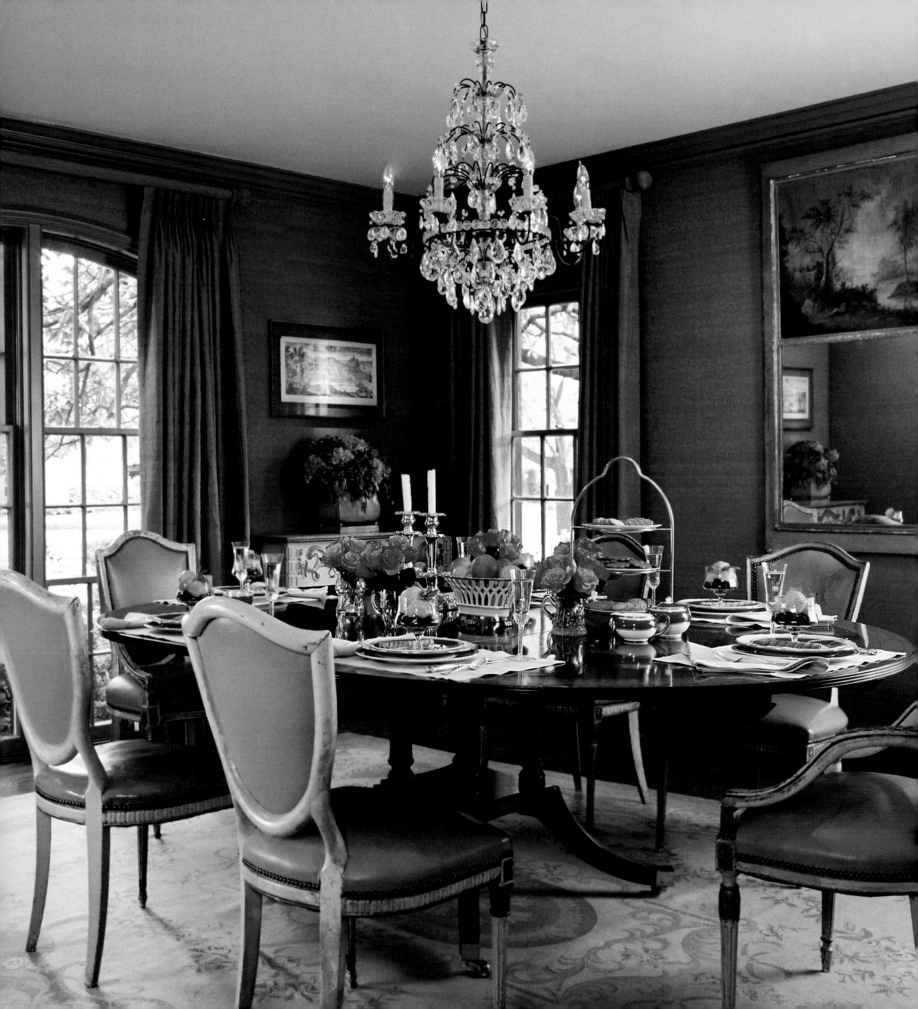

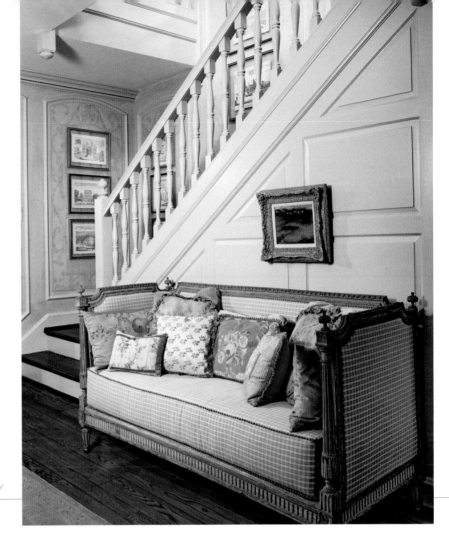

Suzanne Duin

GB DESIGN, INC.

Suzanne Duin designs by a simple yet valuable philosophy: stick with the classics and never compromise quality. It is a philosophy that has served her well over the years and is a testament to her thriving design business.

Introduced to the world of design by her mother, Virginia Beilharz, who founded GB Design, Inc. in 1974, Suzanne worked side by side with her for many years. Garnering much of her knowledge of design from their close relationship, Suzanne furthered her study of design at The University of Texas at Austin, earning a bachelor's degree in fine arts. Upon her graduation, Suzanne decided to try her hand at sales, working as a representative in the Houston area for a New York-based textile manufacturer. After five years, Suzanne returned to GB Design, Inc., working with her mother to pursue her first and true passion, interior design.

Taking the reins of GB Design, Inc. in 1997, Suzanne integrated the firm into the opening of her own store, Maison Maison. Located in the River Oaks area, Maison reflects Suzanne's tastes and style, specializing in French antiques and home accessories. Renowned for their selection of unusual and beautiful lamps as well as antique pillows, Maison Maison's collection of furnishings, period reproductions, exclusive fabrics and one-of-a-kind art pieces is well-known throughout the country. Certainly, no project is complete without a visit to this gorgeous store.

ABOVE:
The stairwell holds a vast collection of Swedish landscapes. The French daybed, upholstered in an informal cotton check, anchors the entry.
Photograph by Fran Brennan

FACING PAGE:
In the dining room, contemporary silk-upholstered walls are blended with antique Swedish chairs, 19th-century French trumeau and an English pedestal table.
Photograph by Fran Brennan

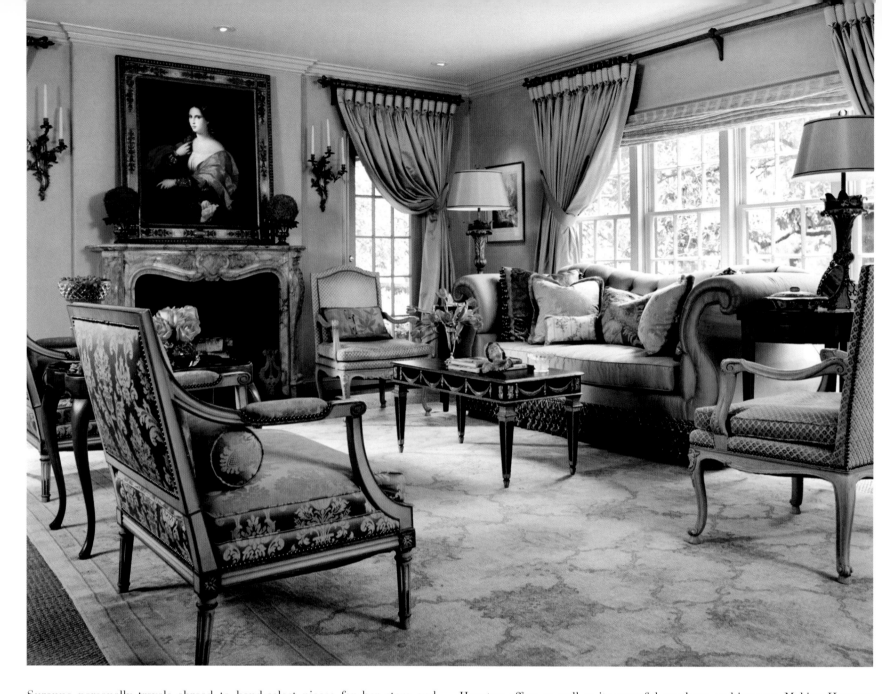

Suzanne personally travels abroad to hand-select pieces for her store and her clients' homes. Her goal in designing their living spaces is to bring in timeless elements with an emphasis on the details while creating a warm and comfortable environment, a place that says "home." Antiques give a collected look to the space, infusing a sense of elegance and history into the décor as neutral palettes and subtle pops of color provide a translucent backdrop from which art pieces show dramatically. Creating distinct, personal spaces exclusively for each client has proven a cornerstone of her firm.

This proud mom of three boys and member of the Houston Antiques Dealers Association is a true big-city girl, enjoying the eclectic environment that

Houston offers as well as its graceful southern architecture. Making Houston the hub of her business for more than 25 years, both regional and national publications have taken notice of her remarkable work. With features in *Beautiful Homes, Country Homes, Kitchen and Bath Design, The Houston Chronicle, Houston Lifestyles, Fort Bend Lifestyles* and the book *Designed in Texas*, Suzanne has no shortage of recognition in her impressive portfolio. Most gratifying, however, is the caliber of happiness she creates for her clients.

ABOVE:
The Old World elegance of the formal living room is dominated by an 18th-century Venetian portrait. Rich fabrics such as silk and satin add to the drama.
Photograph by Fran Brennan

Q&A

more about suzanne ...

WHAT ONE THING WOULD YOU DO TO BRING A DULL HOUSE TO LIFE?

I would bring it to life with a coat of beautiful paint. Either that or call the moving truck!

ON WHAT PERSONAL INDULGENCE DO YOU SPEND THE MOST MONEY?

Clothes, of course ... I am a self-admitted clotheshorse.

IF YOU COULD ELIMINATE ONE DESIGN TECHNIQUE OR STYLE FROM THE WORLD, WHAT WOULD IT BE?

Faux painting is the first thing that comes to mind.

TELL US ONE THING PEOPLE MIGHT NOT KNOW ABOUT YOU.

The one thing that people probably don't know about me is that I am not really French!

GB DESIGN, INC.
MAISON MAISON
Suzanne Duin, ASID, TAID
2129 Westheimer Road
Houston, TX 77098
713.520.1654
f: 713.521.2724
www.maisonmaisonantiques.com

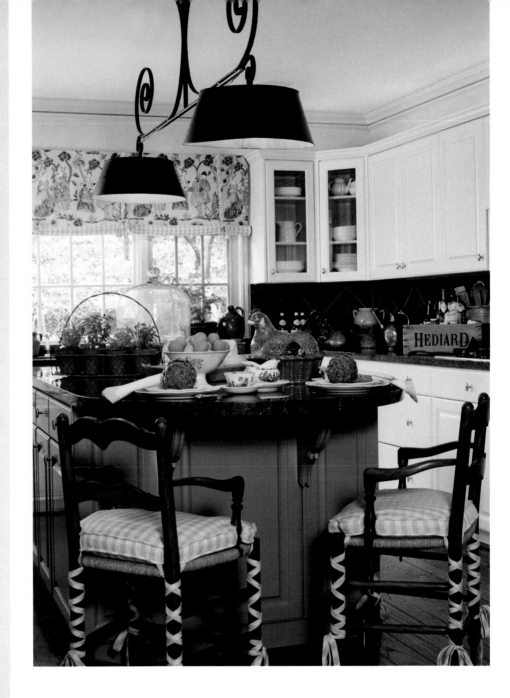

ABOVE:
The original contemporary elements of the kitchen were subdued by adding the antique fixture and charming accessories from France.
Photograph by Fran Brennan

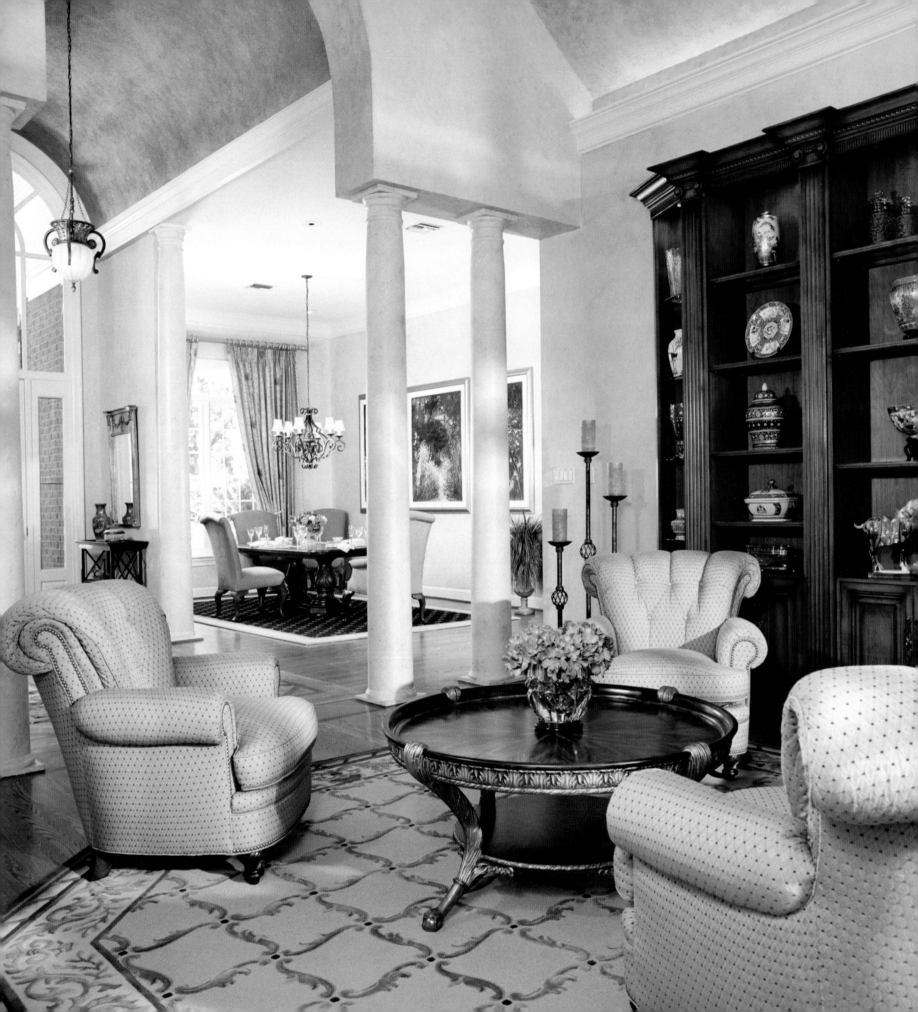

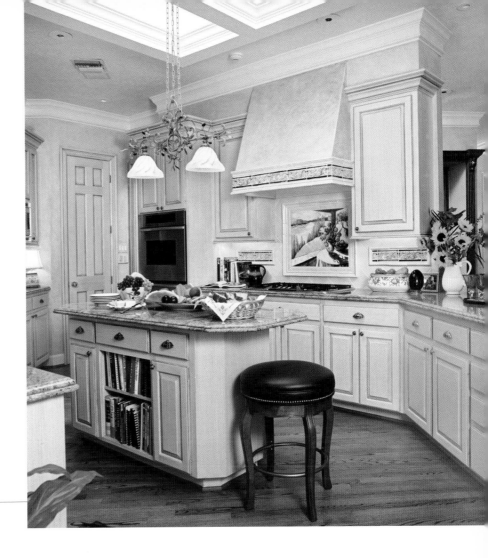

Louise B. Girard

GIRARD INTERIOR DESIGN, INC.

Among her peers, Louise Girard stands out as an extraordinary designer. Her academic accolades speak for themselves; having graduated with honors with a Bachelor of Arts degree from Rice University in Houston, Louise also went on to The Art Institute of Houston where she attained an associates degree in interior design and once again achieved the school's highest honor.

Louise, ever the insatiable learner, then trained under renowned lighting designer Bernard Woolf and gleaned from her tutelage a firm grasp of the subtle nuances and refined technical lighting techniques that truly make a room come alive. Now, in her wide-ranging experience of many exquisite projects from day spas, executive offices, restaurants to country clubs, large ranches and quaint homes, Louise firmly believes that lighting is the single design element which can most highly impact a room, permeating it with mood and drama.

Traveling extensively over the last 35 years, this award-winning, internationally published designer has journeyed through 38 countries all lending their own cultural inspiration to her breathtaking designs. Drawing upon her experiences, she is able to blend an assortment of art, antiques and textiles to create interesting spaces while weaving a tapestry of warmth, light, depth and color.

ABOVE:
Lapis and gold painted ceramic tiles set the color palette for the kitchen. An artist's lively rendering of the owner's ranch painted on limestone hangs colorfully between cabinets finished in muted shades of cream and indigo blue.
Photograph by Fran Brennan

FACING PAGE:
A silk and wool custom-designed Hokanson area rug centers the formal living room seating arrangement beneath illuminated metallic-finished ceilings. A 12-foot mahogany display case lends scale, warmth, and pattern opposite a carved limestone fireplace.
Photograph by Fran Brennan

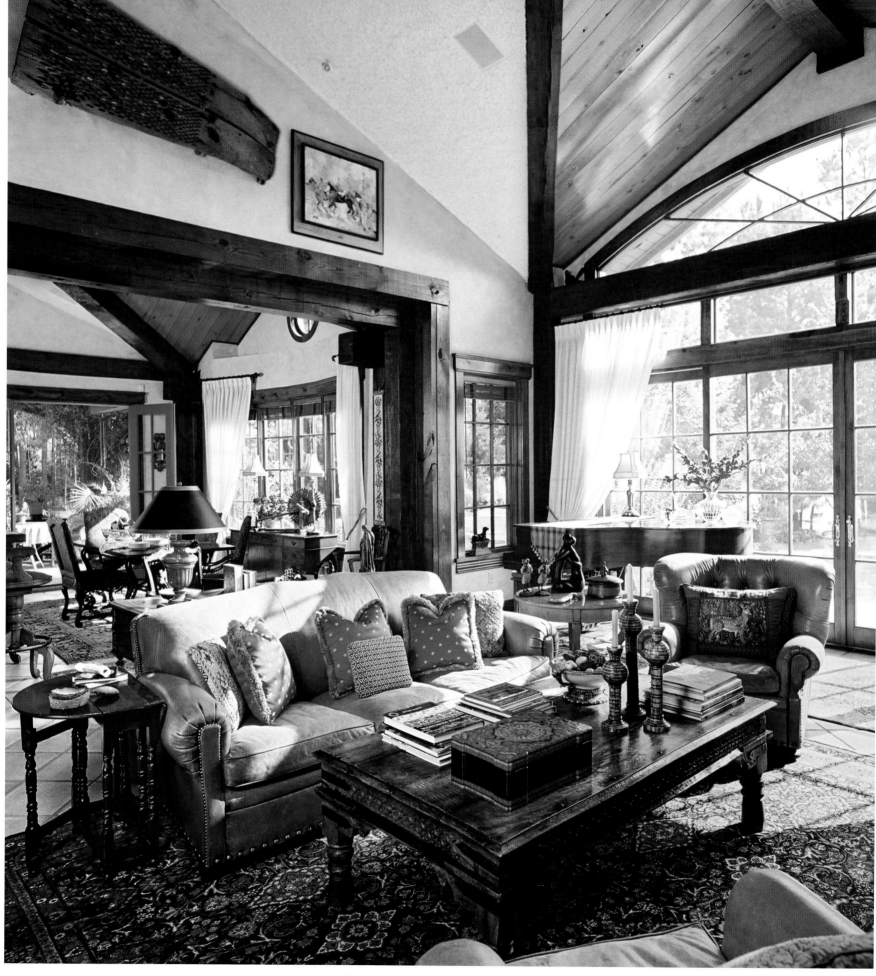

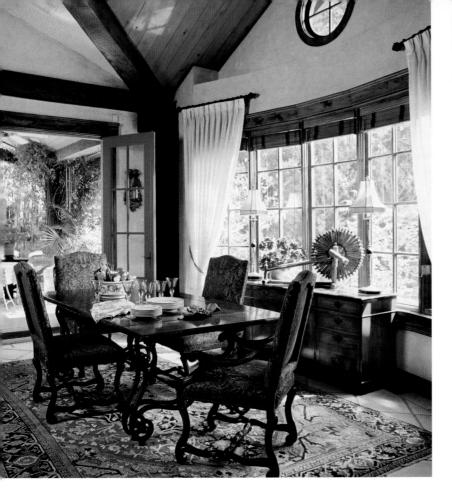

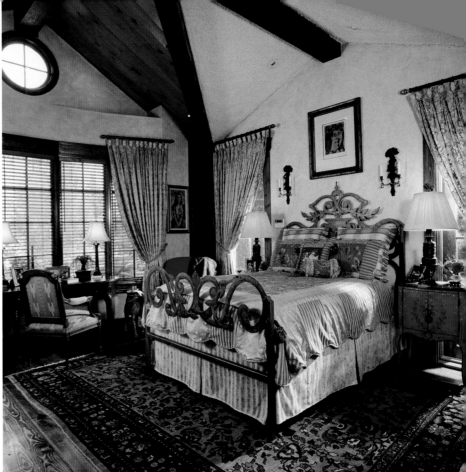

Though Louise describes her own style as classical and traditional, she loves the challenge of creating spaces for her clients that pique her interest through different styles, compel exploration of her own talents and extend the reach of her knowledge.

FACING PAGE:

ABOVE LEFT:
An antique Persian Serapi rug beneath Panache dining chairs and wrought iron-based table lead out to the covered dining porch beyond. An antique Dutch yarn winder and ocular window overhead lend whimsy and amusement to this intimate setting.
Photograph by Fran Brennan

ABOVE RIGHT:
A massive stone fireplace faces the ornamental iron bed and bronze lamps in this luscious master suite. Rich textiles, antique Persian Sultanabad rug, Picasso lithograph and a hand-painted bedside chest embellish pattern and texture in this charming bedroom.
Photograph by Fran Brennan

FACING PAGE:
Antique oriental rugs, East Indian day bed, a Turkish sleigh, Brazilian artifacts and Israeli sculpture all add visual interest and a richness of cultural diversity to a picturesque hand-crafted country home.
Photograph by Fran Brennan

Q&A
more about louise ...

WHAT ARE YOUR PASSIONS OUTSIDE OF INTERIOR DESIGN?
I am passionate about gardening. We have five-and-a-half acres of lakefront property where I have created a "monster" of upkeep in our yard by designing flower beds ringed with stones around our tall pines and oaks, planted with seasonal flowers and shrubs, which the abundance of deer, who also reside here, take great delight in devouring.

WHAT PHILOSOPHY DO YOU APPLY TO YOUR WORK?
I know I have done a great job for my clients if upon the completion of the project they feel reinforced, reassured and increasingly pleased with their environment as a result of my efforts on their behalf.

GIRARD INTERIOR DESIGN, INC.
Louise B. Girard, ASID
20126 Indigo Lake Drive
Magnolia, TX 77355
281.798.2631
f: 281.356.8269
www.girardinteriordesign.com

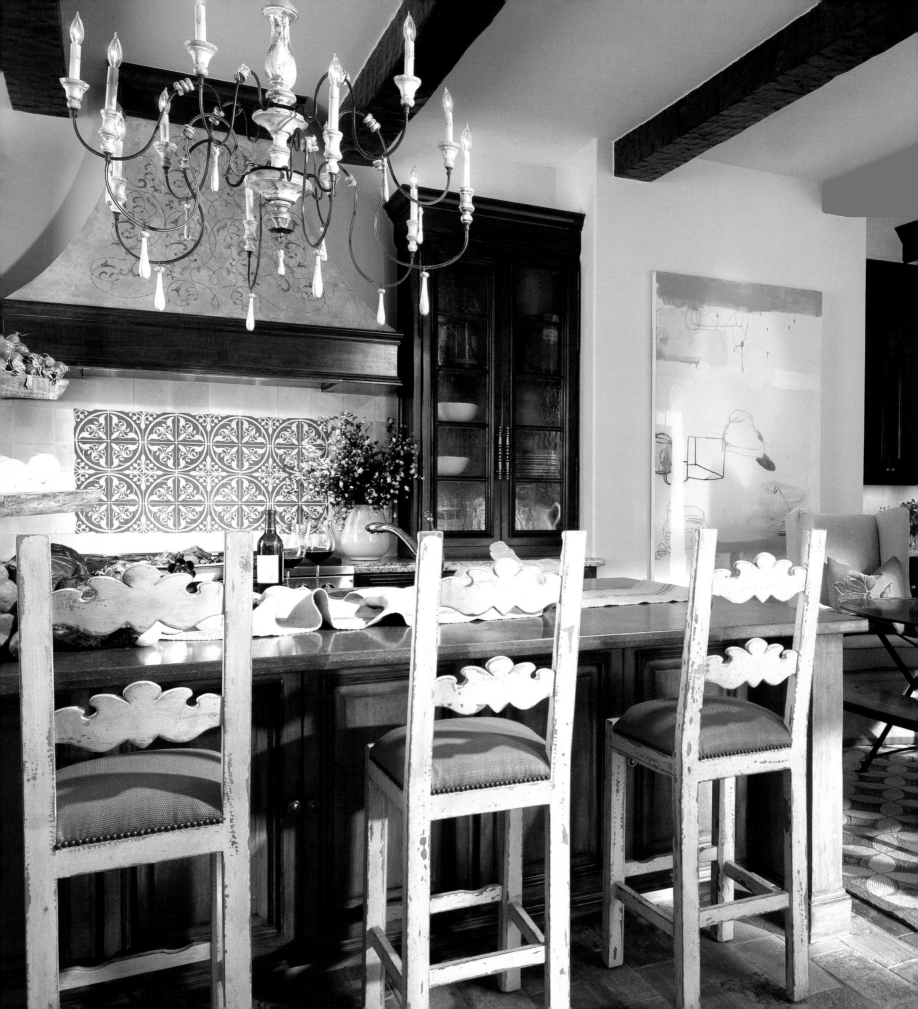

Janet Gust

TWINS DESIGN II

Twins Design is owned and operated by Janet Gust, a designer who has built a solid reputation over the past two decades in both the commercial and residential design industries.

Educated at The Art Institute of Houston, Janet's ambition and drive for perfection has resulted in an enormously successful business promoted by referrals from satisfied and appreciative clients. She not only believes in the beauty of what a space can be, but its comfort and functionality as well, and to accomplish that Janet has sought after and commissioned only the finest of artisans in the design field. With over 20 years of experience, Janet has developed a winning design team and strong working relationships with her clients.

Specializing in new construction and remodeling of up to 20,000 square feet, incorporating old elements and revealing the unexpected is Janet's forte. She loves to hunt for old doors and windows, reclaimed floors, old

LEFT:
Richly stained ceiling trusses visually unite the kitchen, breakfast nook and living room beyond. Antique flooring grounds the composition while art, courtesy of Gremillion & Co. Fine Art, Inc., adds a splash of color.
Photograph by Danny Piassick

fireplaces and other architectural elements from abroad, bringing their old character to the new spaces of today.

From Old World to Contemporary, Janet enjoys all realms of design and takes pride in bringing uniqueness to all of her projects. She has a genuine love and passion for design, and that translates into her work. To Janet, the words of Aristotle say it best, "pleasure in the job puts perfection in the work."

ABOVE:
A hooked rug by Carol Piper sits atop the light-infused sitting area's hardwood flooring. La Cantina doors, an antique clock and fabrics by Galbraith & Paul enhance the casually elegant ambience.
Photograph by Danny Piassick

FACING PAGE:
The master bath is replete with an antique Oushak rug, Dessin Fournir lighting and custom cabinetry antiqued by Houston-based Anything But Plain.
Photograph by Danny Piassick

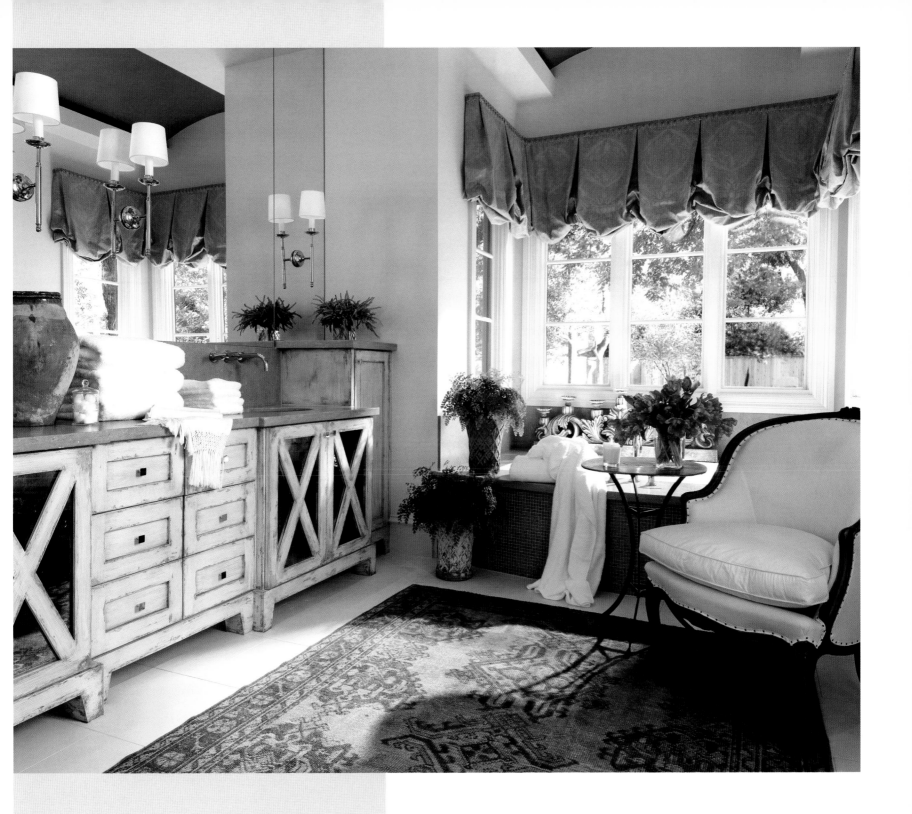

TWINS DESIGN II
Janet Gust
2035 West Alabama Street
Houston, TX 77098
713.524.3300
f: 713.524.3732
www.twinsdesign.net

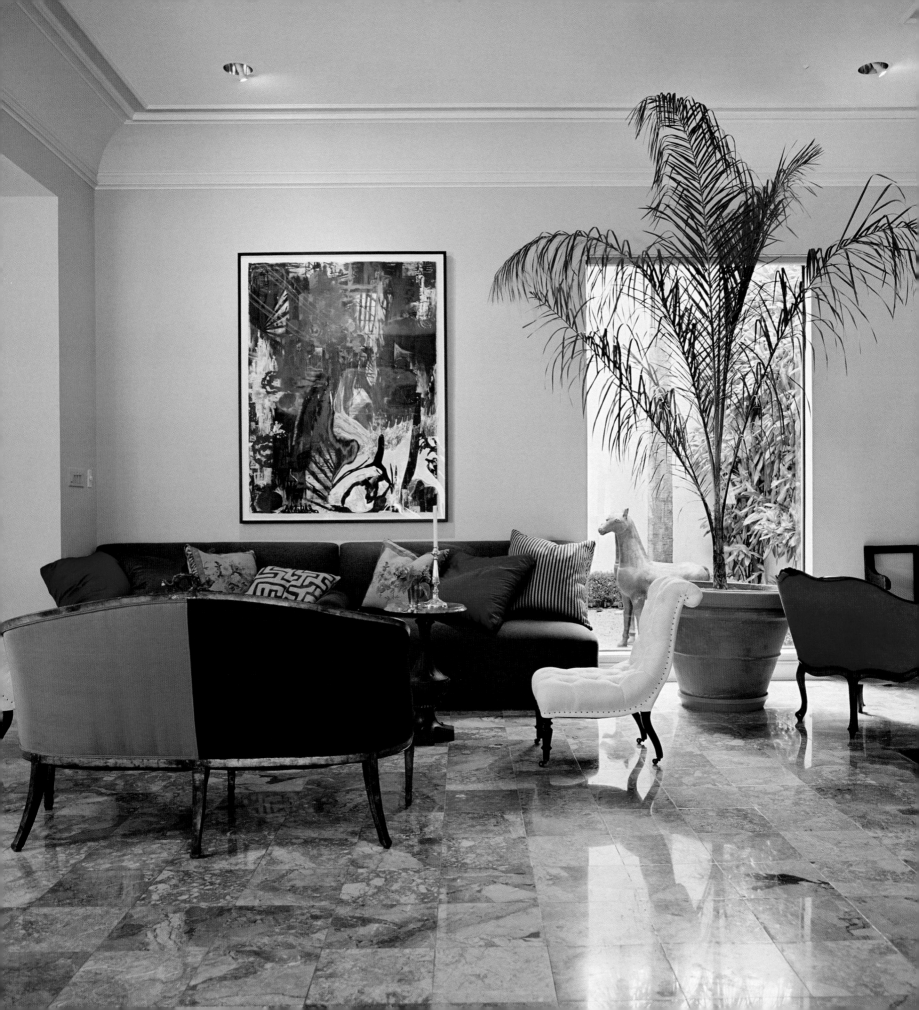

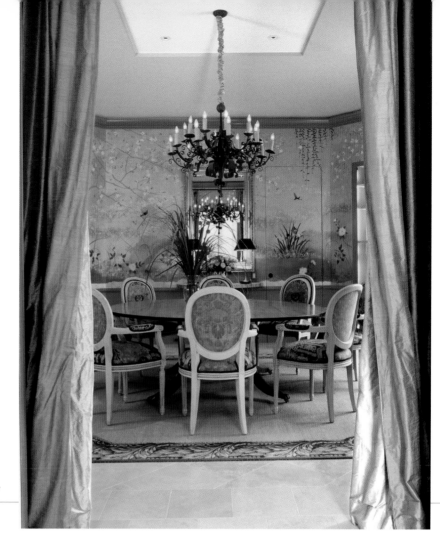

Richard Holley

RICHARD HOLLEY, INC.

Evidence of veteran designer Richard Holley's work, spanning the last 40 years, has been published in periodicals as varied as are the styles in which he is comfortable working. *Architectural Digest*, *Southern Accents*, *House Beautiful*, *Veranda* and *Paper City* have all given a glimpse into the very private designer's approach to "putting things together," as he refers to his work. With an education beginning at Pratt Institute, supplemented with eleven years in London absorbing architectural and decorative elements, he believes the process of learning never stops.

With an experienced team of interior and architectural specialists, Richard Holley, Inc. is able to provide personalized environments executed with particular attention to individual preferences and needs.

ABOVE:
Octagonal dining room with hand-painted wall on gold leaf by artist Jerry Pennick.
Photograph by Fran Brennan

FACING PAGE:
Corner of living room designed for international art collection.
Photograph by Fran Brennan

RICHARD HOLLEY, INC.
Richard Holley
3412 Audubon Place
Houston, TX 77006
713.524.0066
f: 713.524.5659

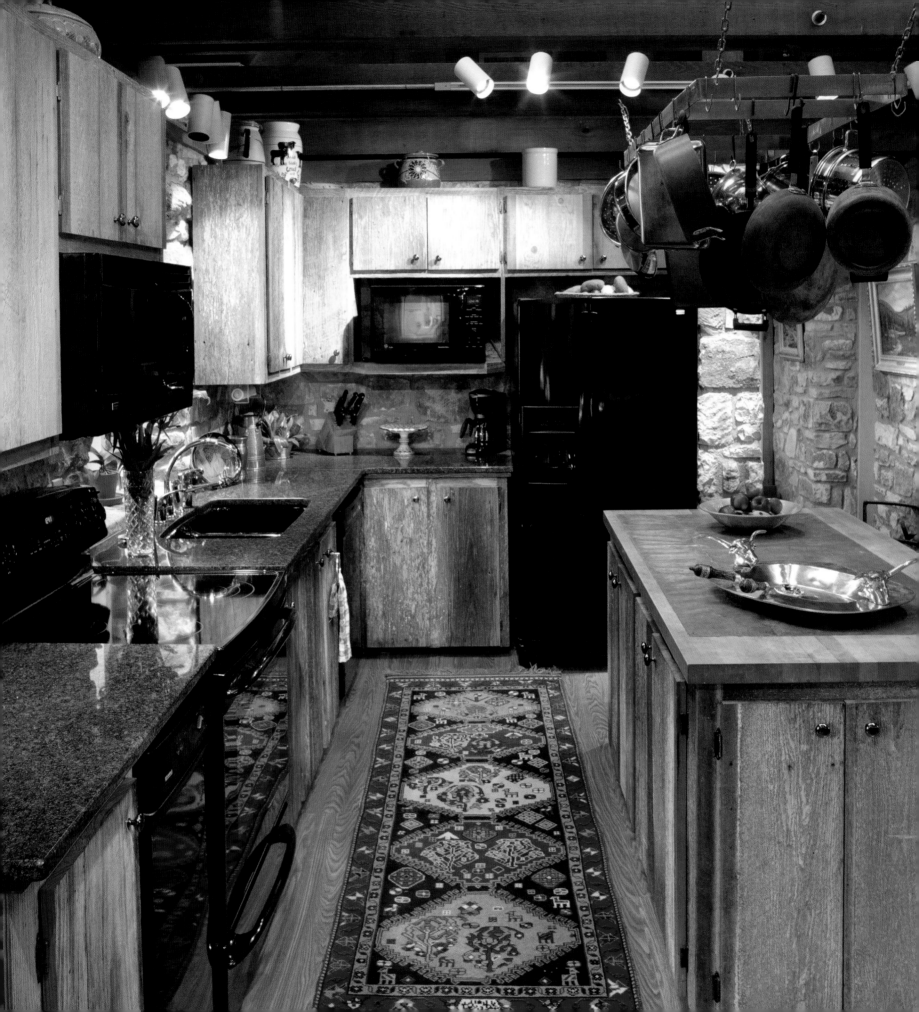

Lynne T. Jones

LYNNE T. JONES INTERIOR DESIGN

Since graduating from Texas Tech University with a degree in Interior Design, Lynne T. Jones has gone on to provide Houston residents with quality design for over 25 years. From color schemes to accessories to installations and more, Lynne and her staff have the means and the ability to make every client's specifications come to life in one harmonious space.

With features in publications such as *Better Homes and Gardens, Decorating Ideas, Southern Living, Houston Home* and *Living* and even contributions on "Designer Tips" for HGTV, one cannot help but be drawn to Lynne's passion for fantastic design. Her style of choice is often a mingling of classic traditional furnishings with unique accessories. Add a splash of contemporary artwork and a few showcased specimen antique pieces, perhaps an accent table resting atop a unique Oriental rug over hardwood floors, and a beautiful home is alive with style and pizzazz.

Lynne appreciates her position as an interior designer as it allows her to generate a positive impact on the lives of others by improving the world around them, the homes in which they live life everyday. Inspirations of Lynne's include designers Angelo Donghia, Sister Parish and Mark Hampton, along with several local peers. Not a huge fan of the retro look of the 1950s, Lynne remains true to her philosophy of sticking with the classics without veering too far off from quality, clean-lined design pieces.

ABOVE:
The entry to Fall Creek Ranch features a hand-carved settee with needlepoint fabric, all lovingly made by the client's great-grandfather in the 1930s.
Photograph by Michael Hart

FACING PAGE:
This Kerrville country kitchen contains cabinets of reclaimed wood and a zinc-top island that originally served as a surface to wrap butter on the grandfather's dairy farm.
Photograph by Michael Hart

Lynne has been a part of a variety of projects, ranging from law firms to log cabins to high-rise apartments and everything in between. This project in Kerrville, Texas, has been one of the most rewarding, however. She worked with a couple that were getting married and would be living in 'his' home in the Texas Hill Country. They asked her to help them meld their two households to create 'their home.' Lynne took on the challenge and had both sets of furnishings re-upholstered, added a few new pieces and some interesting rugs to complement the rustic style of the home, as well as their extensive Southwestern art collection. The result is a warm, inviting interior that reflects the couple's personality and taste.

Q&A more about lynne ...

NAME ONE THING MOST PEOPLE DON'T KNOW ABOUT YOU.
One thing most people don't know about me is that I play on more than one tennis league and I love to compete on the court. Hitting that little yellow ball is a great stress release!

WHAT DO YOU FEEL SEPARATES YOU FROM YOUR COMPETITION?
I feel that what separates me from my competition is my ability to truly listen to my client's needs and then to implement those needs in a creative and unique way. I try to work with their existing furnishings, especially if something has sentimental value to them.

WHAT COLOR BEST DESCRIBES YOU AND WHY?
I think that the color turquoise best describes me because it is the color of my favorite stone. I collect turquoise jewelry and inherited several old pieces that belonged to my mother. I have a Native American heritage and I am drawn to the turquoise jewelry for a variety of reasons.

WHAT IS A SINGLE THING YOU WOULD DO TO BRING A DULL HOUSE TO LIFE?
The one single thing that I would do to bring a dull house to life would be to repaint the walls and give the house a lift with color.

ARE YOU INVOLVED IN ANY INTERIOR DESIGN ORGANIZATIONS?
Yes, I am a professional member of ASID, (The American Society of Interior Designers), which is a national design organization that includes more than 20,000 practicing interior designers, nationwide. I am the current President-Elect of the Texas Gulf Chapter of ASID, which is based in Houston and includes all of the surrounding Gulf Coast areas. ASID promotes the professionalism of our industry and also keeps its members updated on new and cutting edge products and methods to further the health, safety and welfare of the public.

Houston is the ideal place for Lynne to create and become inspired for the benefit of her clients. With a diverse blending of inhabitants, great art galleries, antique dealers and artisans, Lynne has at her fingertips multiple creative choices for her projects which in turn benefit her loyal clients.

LYNNE T. JONES INTERIOR DESIGN
Lynne T. Jones, ASID
3506 Highway 6 South, Suite 365
Sugarland, TX 77478
281.437.3307
f: 281.835.6801
www.lynnetjones.com

ABOVE:
The limestone fireplace and old wooden window header came from an 1880s' log cabin located on the property. Artwork from Santa Fe and comfortable furnishings create a cozy sitting area right off of the kitchen.
Photograph by Michael Hart

FACING PAGE:
Architect A. Ray Payne, AIA, and landscape architect Stephen K. Domigan created a dramatic outdoor entertainment area for the Kerrville country house, complete with a limestone infinity pool.
Photograph by Michael Hart

Ken Kehoe
KMK INTERIORS

Ken Kehoe, native Texan and founder of KMK Interiors, provides his clients with environments above and beyond all expectations. One could characterize Houston as "worldly cosmopolitan" and Ken enjoys the freedom to please his diverse clientele. Ken's design philosophy perhaps says it all; "Design is not about competition, it is about pleasure."

Developed closely with his staff, which includes Kathy Karotkin, Hillary Gulledge and Ollie Wilson, Ken's work has been featured in several publications, including *Spectacular Homes of Texas*, *Fort Bend Lifestyles & Homes* and *Houston Lifestyles & Homes*. He and his firm have also received several awards including the Houston Design Center "Up and Coming Designer" award. Known for exceptional customer service, Ken never repeats his designs; his ultimate goal is to bring each client's dreams into reality. He receives the greatest satisfaction knowing that each morning his clients wake up surrounded by things they love. This gives both Ken and his clients a satisfying sense of accomplishment for having worked together.

Ken's artistry extends into the balance he can create through eclecticism. Unique pieces, whether they are art, furniture or accessories, draw the eye to the room from different perspectives.

ABOVE:
Italian marble inlaid backsplash and unique bath accessory, both custom-designed by Ken Kehoe, bring this powder room to life.
Photograph by Danny Piassick

FACING PAGE:
Custom-designed sofa by Ken Kehoe, set among antiques found while shopping around Europe, make a comfortable family room.
Photograph by Danny Piassick

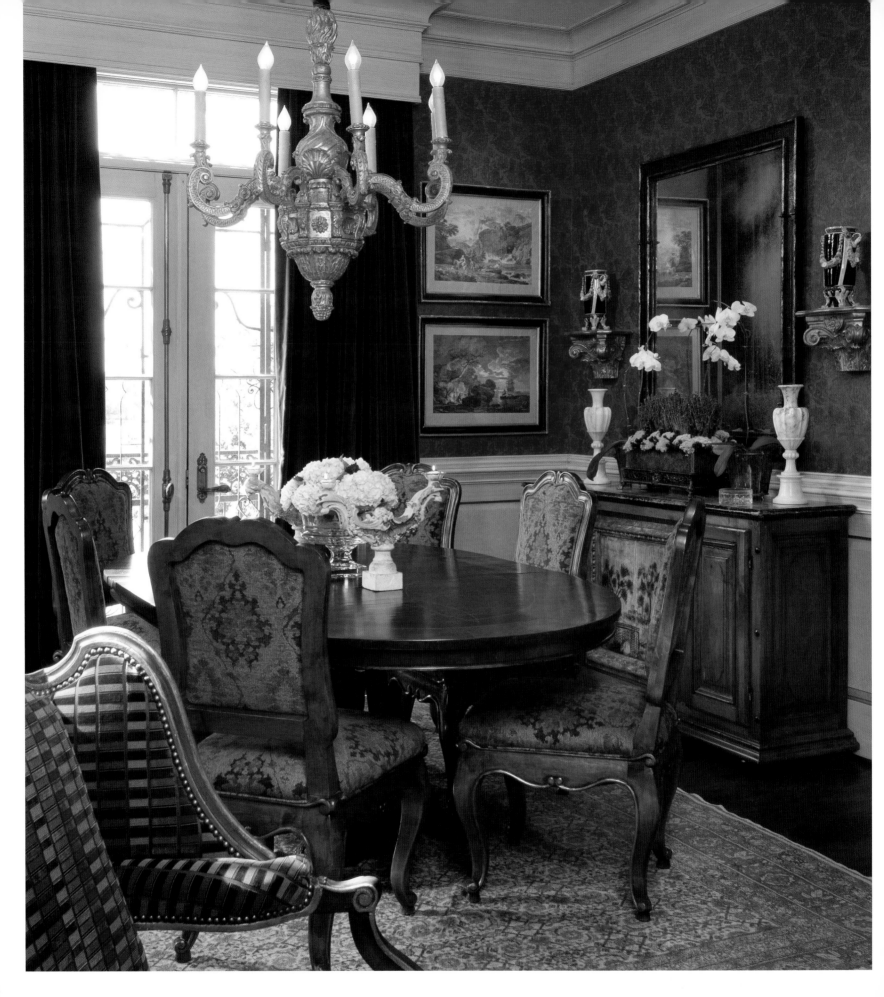

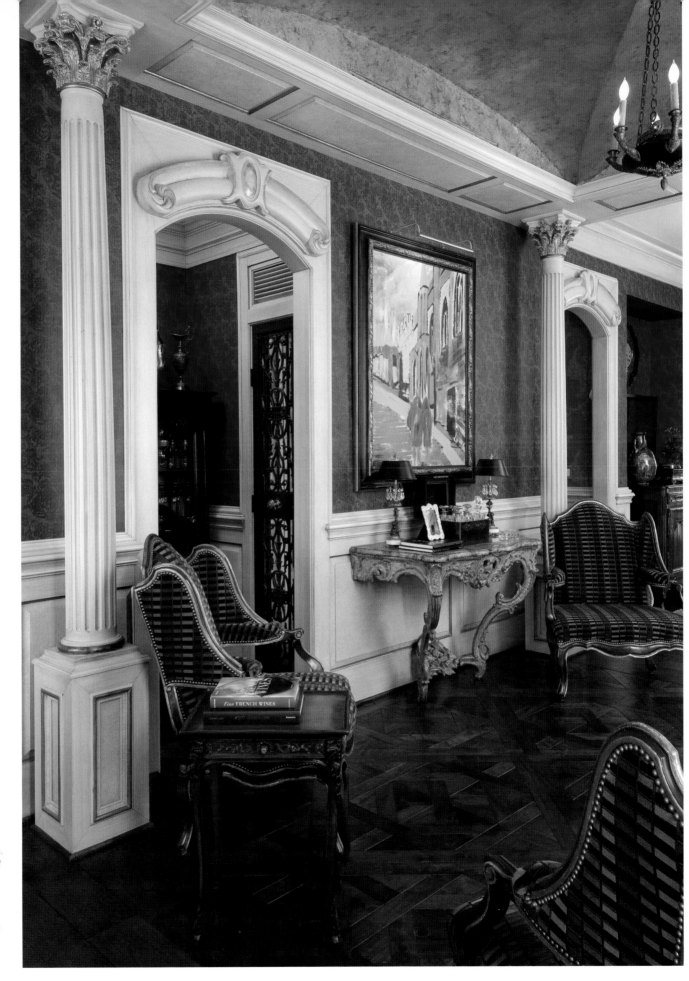

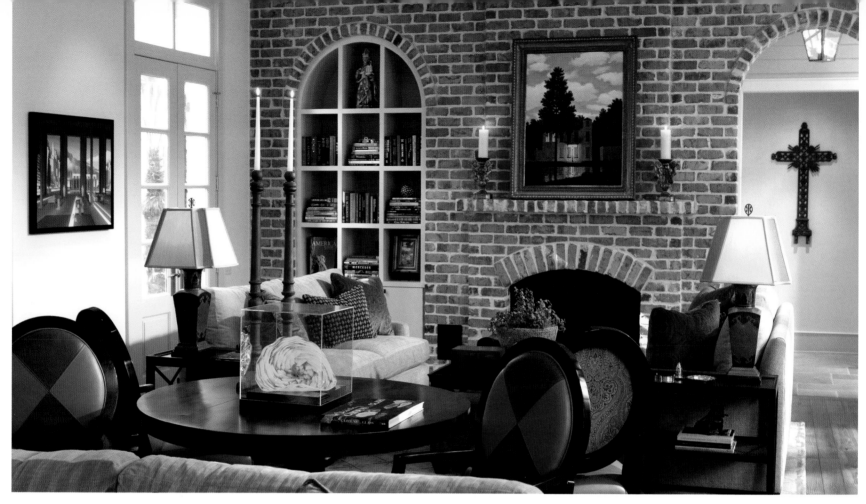

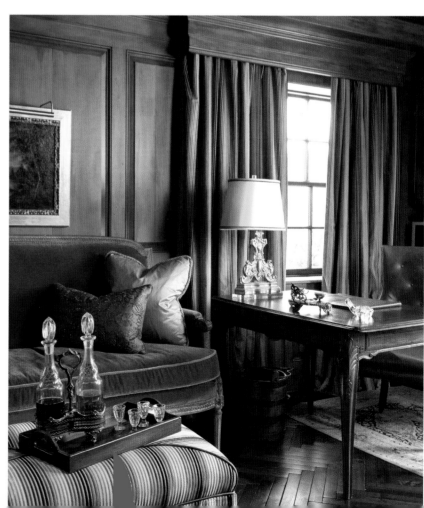

Q&A

more about ken ...

WHAT ONE ELEMENT OF STYLE OR PHILOSOPHY HAVE YOU STUCK
WITH FOR YEARS THAT STILL WORKS FOR YOU TODAY?
We listen to our clients' needs, desires and dreams, and we're
known for giving our clients what they want.

WHAT IS ONE PIECE OF ADVICE YOU WOULD GIVE TO ANY CLIENT?
Architectural plans need to be reviewed to ensure the client's
interior needs are met and exceeded; simple adjustments prior
to construction can save you thousands of dollars in interior
finish decisions.

WHAT IS THE BEST PART OF BEING AN INTERIOR CONSULTANT?
Being told, "I never thought my house could be this beautiful."

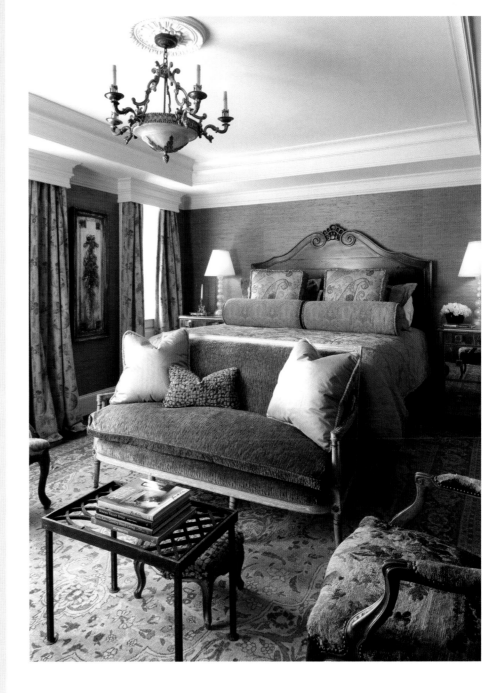

ABOVE:
Ultimate luxury is the only way to describe this master retreat, filled with period pieces used in both traditional and
innovative ways.
Photograph by Danny Piassick

FACING PAGE TOP:
Traditional Louisiana style provides a perfect backdrop for this client's eclectic tastes in both antique and
contemporary design.
Photograph by Danny Piassick

FACING PAGE BOTTOM LEFT:
Sealed concrete floors and outdoor fabric on tropical furniture make this convertible pool room easy to use, whether you
are wet or dry.
Photograph by Danny Piassick

FACING PAGE BOTTOM RIGHT:
Hand-milled paneling with hand-painted finishes cuddle the sumptuous antiques picked up around France for this client's
elegant home office.
Photograph by Danny Piassick

KMK INTERIORS
Ken Kehoe
8 Chelsea Boulevard, Suite B
Houston, TX 77006
713.523.0580
f: 713.523.2894
www.kmkinteriors.com

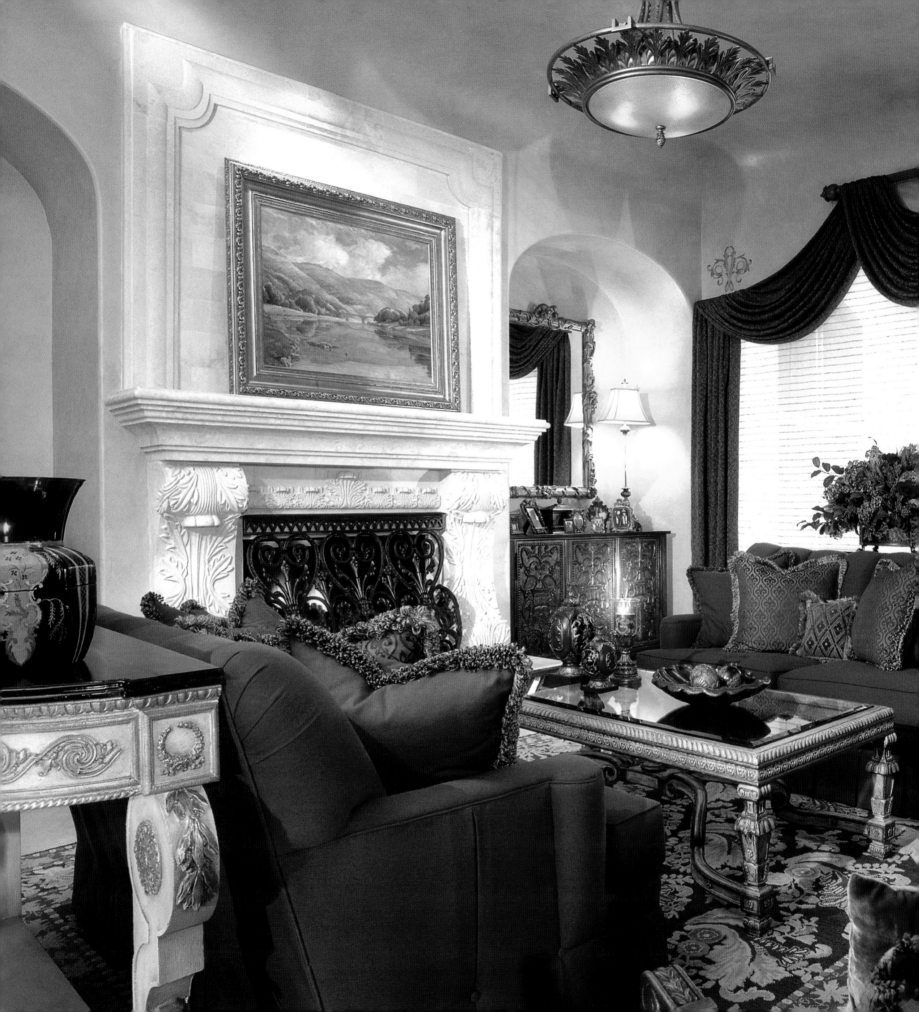

Sheila Lyon

SHEILA LYON INTERIORS, INC.

Sheila Lyon has always been an entrepreneur. Opening a retail store specializing in window coverings, carpet, re-upholstering and furnishings, interior design seemed like a natural progression in her career. Now, 28 years and one full-service Houston design firm later, Sheila is tastefully designing around the needs and lifestyles of her very contented clients.

You can easily sense that Sheila is a native Texan. Warm, friendly and outgoing, her sincere nature shines through. It's just that welcoming spirit that puts her clients at ease, allowing them the comfort to express their true needs and concerns and empowering Sheila to find the core of their style.

The longevity of her firm speaks volumes to the quality and creativity of her work. And though her businesslike demeanor and excellent organization bring confidence to her presentation, she never

LEFT:
The hand-carved Mexican limestone fireplace is a focal point in this opulent but inviting living room.
Photograph by Rob Muir

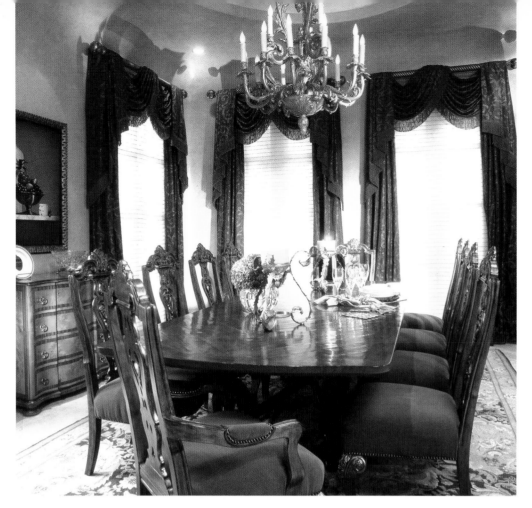

forgets to bring fun into each project. Building on custom palettes, Sheila brings a refreshing and pleasing twist to her interiors while complementing the space with unique family treasures that truly say "home."

Her most recent projects are always her favorite, as she infuses each project with color and personality through accessories, texture and furnishings. Versatile and practical, the understated elegance and individual spirit that defines each client also defines each thoughtful and well-proportioned room.

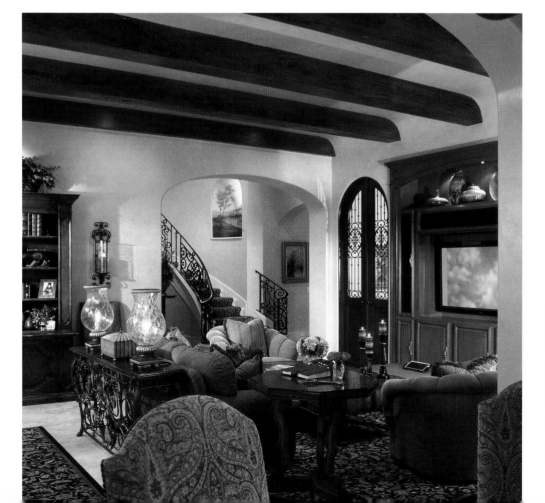

TOP LEFT:
Elaborate draperies, Italian chandelier and Ukrainian rug create a backdrop for this dramatic dining room.
Photograph by Rob Muir

BOTTOM LEFT:
Hand-hewn cedar beams, glazed walls and rich textiles warm the neutral palette of this family room. The intricate iron work spotlights the architectural details of the space.
Photograph by Rob Muir

FACING PAGE:
This powder room "jewel" with its lighted onyx sink, opulent fixtures and superb artistry was fashioned in Old World grandeur.
Photograph by Rob Muir

HOW DO YOU RELAX IN YOUR OFF-TIME?
I love to cook, especially Sunday dinners for my family.

WHAT IS THE BEST PART OF BEING AN INTERIOR DESIGNER?
Being able to make another dream come true with each
completed project.

WHAT IS ON YOUR READING LIST?
I love to read mysteries because they literally take you to
another place!

TELL US ONE THING THAT MOST PEOPLE DON'T KNOW
ABOUT YOU.
My background was originally in accounting.

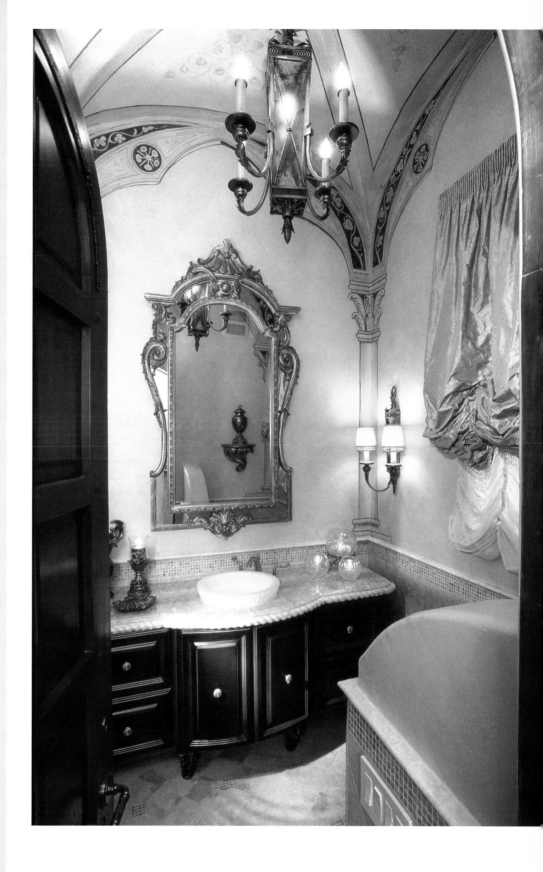

SHEILA LYON INTERIORS, INC.
Sheila Lyon, ASID
5120 Woodway, Suite 7000
Houston, TX 77056
713.993.9001
f: 713.993.9018

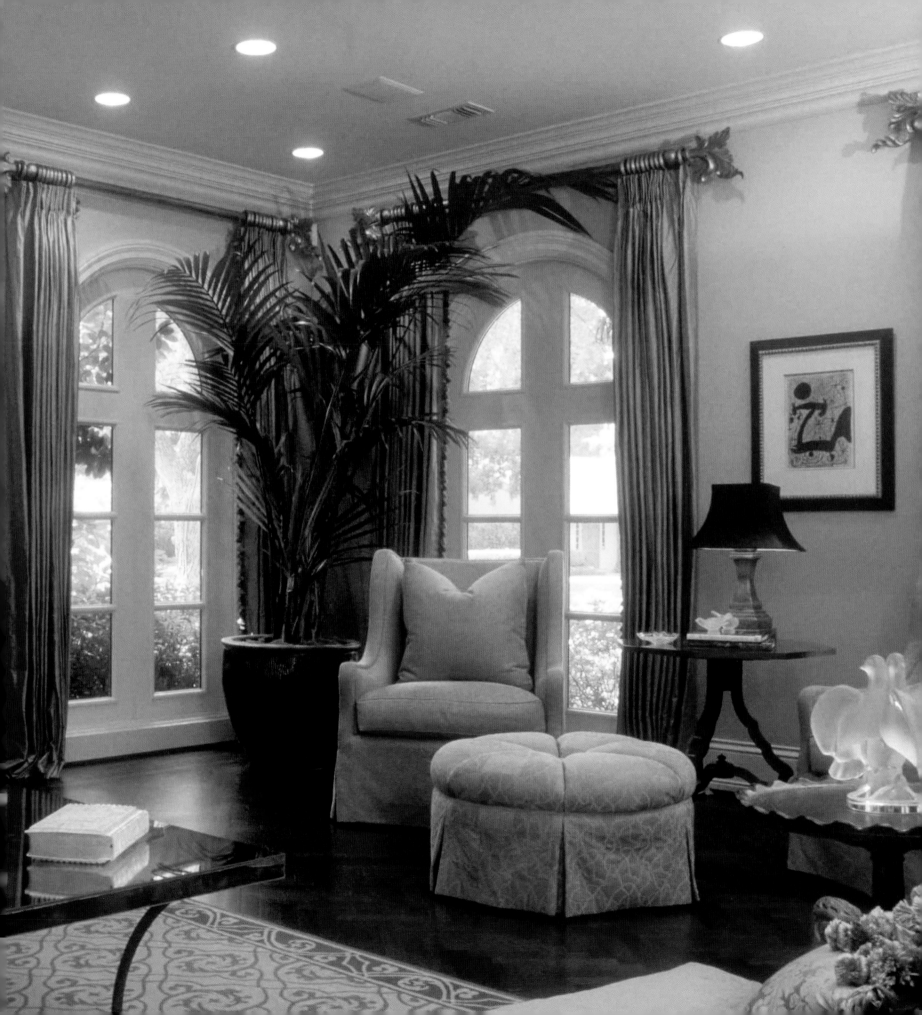

Shannon Mann

MANN DESIGNS

A graduate of The Art Institute of Houston, Shannon Mann founded her design studio, Mann Designs, in 1990 with a focus on residential projects. While Houston is the center of her work, it is by no means the circumference. Every project, no matter the location, is an opportunity to create a sanctuary for the client. "Step off a bustling city street and into a place of beauty and comfort... home.

Inspiration for each of Shannon's projects always results from initial dialogues with the client. From these sessions come classic designs—realized in a way which is inviting to the eye and comfortable to the touch. Shannon's work is characterized by careful attention to scale and proportion, both of which are difficult to define, but are easily recognizable when achieved. The goal of each and every Mann Designs project is to ensure that the finished product is always more than the client hoped for.

ABOVE:
Objets d'arts . . . handcrafted driftwood console table; antique African bracelets. Painting by Clay Wagstaff.
Photograph by Rex Spencer

FACING PAGE:
Formal living area with walnut herringbone floors, custom-designed Edward Fields rug, Cameron Collection Linden Court wing chairs in Quadrille, antiqued iron and mirror cocktail table and a painting by Joan Miro.
Photograph by Rex Spencer

MANN DESIGNS
Shannon Mann
2703 Wroxton Road
Houston, TX 77005
713.664.6707

Michael Pilié

PILIÉ

Classically trained as an artist by the famed John McCrady Art School in New Orleans, Michael Pilié brings a unique perspective to his projects through the greatly refined and highly skilled eye of an artist. Michael honed his skills under the instruction of John McCrady himself, to whom he owes much of his career, first as a fine artist, then as an interior designer. On this path, his prolific creativity has found its most recent outlet.

It was during his intensive study at art school when Michael learned many of the techniques he has since applied in 35 years of design. He examined the subtle effects of light in a space and learned how to emphasize and minimize to create the desired focus in a piece. Daily, Michael draws upon that inspiration to create drama and mood in his brilliantly appointed interiors. Translating directly into the

LEFT:
This living room typifies Michael's basic design concept of a soft contemporary, eclectic look. Touches of the exotic from his many travels abound—from the Russian lynx throw to the antique Chinese Queen yin. A perfect setting to sip morning coffee.
Photograph by Michael Pilié

design of a room, Michael's artistic and eclectic sensibilities flawlessly contrast contemporary with traditional, striking a delicate balance.

Michael takes pleasure in finding unusual, exciting and often exotic pieces. Ordinary is never something that will be found either in his interior designs or his showroom. Supporting creativity with extraordinary furniture and accessories, Pilie´ is a diverse showroom, bringing together hard-to-find furnishings from all over the world. Blending classic with modern, Pilie´ provides exclusive lines that cannot be found anywhere else, including Dino Mark Anthony designs and Jimeco's remarkable pieces, such as goat bone chairs with matching tables, which bring uncommon beauty to any project.

Pairing the super contemporary with well-aged, historical and international pieces, Michael originates incredible rooms that pleasure the senses. Through his extensive travels, each culture has also left its unforgettable mark on Michael's design. You'll find a French antique chair placed next to a contemporary side table or a formal dining room dressed with a traditional African mask. Each element, though widely different in design and style, fits perfectly together. Whether French, Mexican, Italian, Asian or African, each unforgettable spirit is represented in surprising and enduring ways.

ABOVE:
An Icelandic grey granite fireplace wall is a perfect foil for the Empire sofa and lounge chairs, all family pieces. The Baldwin piano, candlesticks, and Italian silver candelabra are from a personal collection assembled over many years.
Photograph by Michael Pilie´

FACING PAGE:
From the living room looking through the entry into the dining room, one of Michael's prized possessions is the elephant mask from Cameroon, with alligators, doves, and bronze details. In the dining room is an original painting by Joseph Culotta. The living room features an armoire of exotic woods and bronze fittings, accentuated by two fabric collages from India.
Photograph by Michael Pilie´

Lush interiors with expertly placed lighting and exceptional art are benchmarks of Michael's dramatic style. Creating ambience, Michael takes interior environments to another level with proper lighting. Whether natural light or illumination from a purposefully placed lamp or spotlight, the end result evokes emotion and lends a powerful effect to each living space.

Most importantly, Michael's work impacts his clients' lives on a daily basis. Each project is carefully deliberated based on their desires and necessity as he marries vision, concept and authenticity completing environments that enhance his clients' emotional well-being. "My work is what a client wakes up to every morning, it is what they live in every day and it is the last thing they see as they slip into bed. It is very important that their space fosters a sense of comfort, happiness and vitality."

At the end of the day, each of Michael's interiors is a work of art, a blank canvas that has been filled with clean lines and balance. Proportion, color and style all play an integral part in creating a flow of harmony within each space that calms with breathless splendor, becoming a living masterpiece.

ABOVE:
The paintings in this space are all originals by Michael, from a period in which he exhibited widely, prior to entering the Interior Design field. They beautifully play off the 18th-century cabriole-legged writing desk. The African, Chinese, Italian and French sources emphasize Michael's dedication to a totally eclectic environment.
Photograph by Michael Pilie'

FACING PAGE:
This room once again reveals what Michael thinks eclectic is all about. Antique Chinese cinnabar lacquer chests and the silver fox throw are ideal contrasts for the contemporary bed. African, Mexican and Asian art round out this design statement.
Photograph by Michael Pilie'

Q&A

more about michael ...

WHAT DO YOU FEEL SEPARATES YOU FROM YOUR COMPETITION?
My formal art training is what sets me apart; my creativity naturally flowed into interior design.

TELL US ONE THING THAT PEOPLE MIGHT NOT KNOW ABOUT YOU.
I have had several solo exhibits of my artwork in New Orleans, Dallas and Denver. My work has been shown in the 2719 Gallery in Dallas, where I have opened their season eight years running.

ON WHAT PERSONAL INDULGENCE DO YOU SPEND THE MOST MONEY?
I spend a great deal of time focusing on my business and in the last several years, I've started to take more time for myself and to travel. I have been to many magnificent places including Thailand, China, Italy and France and each culture leaves its unique and indelible mark on my design.

WHAT SINGLE THING WOULD YOU DO TO BRING A DULL HOUSE TO LIFE?
Light it properly! I have 32 spotlights in my living room alone. Once the lights were set in place, it was as if the space came to life. Great lighting makes all the difference in the world; it is as important as the right furnishings.

PILIE'
Michael Pilie'
3621 West Alabama, Suite 2
Houston, TX 77027
713.961.1619
f: 713.961.1780

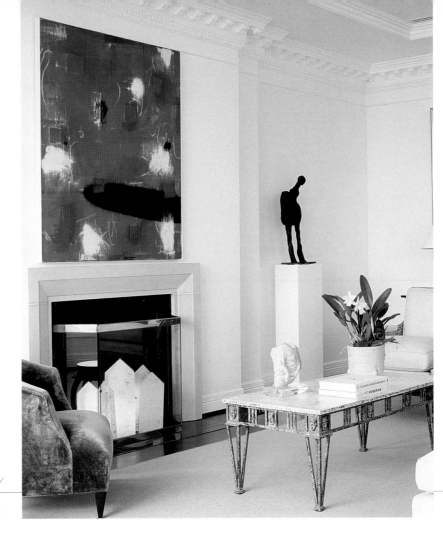

J. Randall Powers

J. RANDALL POWERS INTERIOR DECORATION

Randy Powers is known throughout the design community as a designer with a clean, classic style and an eye for detail and quality. Renowned with both his clients as well as design publications like *Paper City, Elle Décor* and *Southern Accents*, Randy's 14 years of design experience is evident in each project he completes. While his design philosophy is "keeping it simple," the designer stands apart from his peers because of his ability to edit coupled with his knowledge of fine contemporary art. These two fortes ensure that while his designs are clean and simple, they evoke sophistication and elegance.

Largely influenced by design great Kalef Alaton, Randy stops short of nothing to achieve the desired result for his clients. From adding simple details like exotic orchids to brighten up a space to fulfilling unusual client requests like lining ceilings in leather, he ensures that each design suits the function of the room while also creating something unique and exciting for each client. Often

acknowledged by his peers in recognition of his work, J. Randall's clients are the true testament to his design acumen as they return to him time and time again for a unique design they know will surpass their expectations.

ABOVE:
Painting above fireplace by Larry Graeber. Cocktail table by Niermann Weeks. Sculpture on pedestal by Alberto Giacommetti. Sculpture (torso) on cocktail table; 2nd-century Roman Chair; Donghia. Quartz crystals in fireplace from J Randall Powers Home, Inc. White chair from Maison Jansen circa 1940.
Photograph by Tria Giovan

FACING PAGE:
Goat skin cocktail table by Karl Springer; circa 1960 Sotheby's 19th-century African stool. Antique orange glass match striker by Ralph Lauren, London Saladino glass lamps. Painting in background by Oliver Legrande.
Photograph by Tria Giovan

J. RANDALL POWERS INTERIOR DECORATION
J. Randall Powers
2626 Westheimer Road, Suite 211
Houston, TX 77098
713.524.5100
f: 713.524.0833

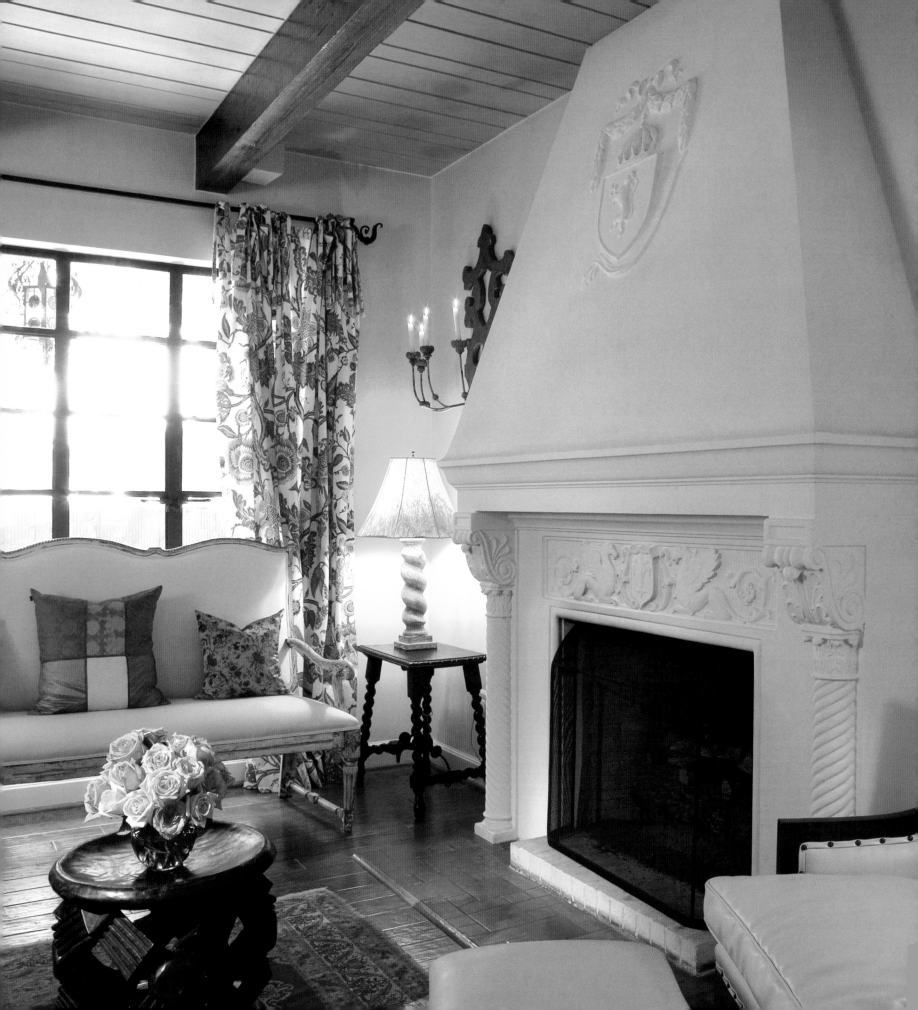

Edwina Vidosh

EDWINA ALEXIS INTERIORS, INC.

Award-winning Houston designer Edwina Vidosh asks her clients a very important question at the inception of their design consultations: "How do you want your home to feel?" She has made it her mission to help her clients identify and define their style so she can personalize each room to meet their unique needs. "It is easy to make a space beautiful," she explains, "but it is much more interesting for each space to have the client's personality."

A degree in interior design from Texas Christian University and 18 years of experience enables Edwina to harness her client's character and individualize each room. "Every house should have a place that is more formal and a place to relax," she says. "I like to layer rooms, especially bedrooms, which should be personalized. By combining interesting textures, I create rooms with an inviting feel." Edwina's elegant, yet comfortable designs often extend the boundaries of the house to include outdoor living areas.

The splendor of nature inspires Edwina's design plans, which typically include the spaces outside the walls and windows of her clients' homes. Her attractive interiors flow seamlessly into the outdoor living areas, creating lush environments. "I intertwine the inside with the outside," said Edwina. "I'll bring the comforts of nature inside, using plants and flowers to add life to the design details. Outside I'll plant something red, for example, to coordinate with red accents in the interior. It tricks the eye to extend outward and enjoy the beauty."

ABOVE:
The intimate sitting area just below the restored stairway is the perfect place to just take a moment to relax.
Photograph by Felix Sanchez

FACING PAGE:
A beautiful restored fireplace and ceiling are the perfect addition to this relaxing living room. This setting creates a perfect space for the family to enjoy together.
Photograph by Felix Sanchez

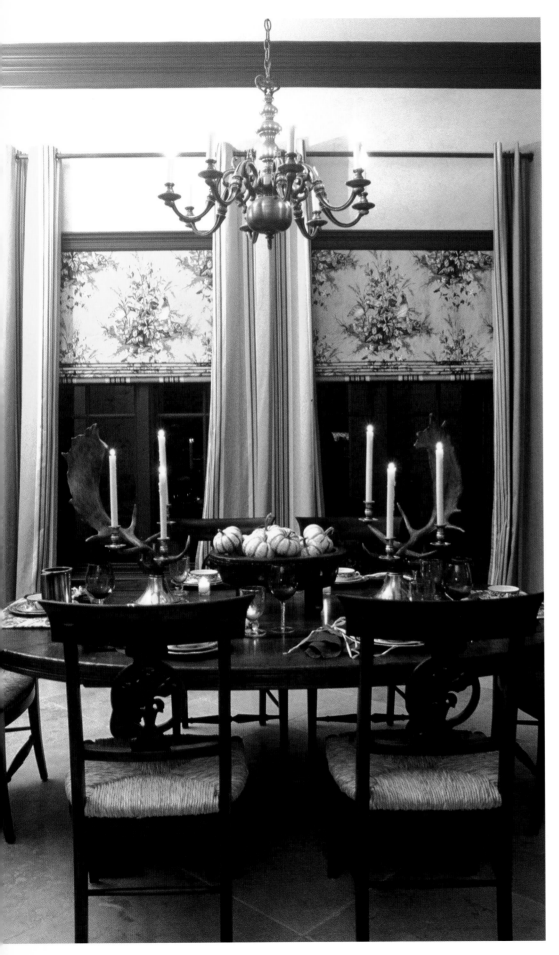

Her unique approach to design has earned the seventh-generation Texan numerous accolades, including glowing reviews in national publications and features in the local press. While recognition for her work is appreciated, Edwina's reward comes from her satisfied clients. "I love it when, at the end of the project, my clients find their rooms to be beautiful, elegant and fitting for their lifestyles. I know then that my designs were successful."

LEFT:
Taking inspiration from Scalamandrés "Edwins Covey" printed fabric used on the window shades, Edwina creates a casual, yet elegant breakfast area.
Photograph by Edwina Vidosh

FACING PAGE:
Edwina designed this library with the entire family in mind. The table may be used for homework, wine tasting, book club meetings, or a workspace for the parents. The reading area is designed with comfortable chairs to enjoy that special book. The green color used was inspired by views of the lush outdoors.
Photograph by Fran Brennan Photography

Q&A

more about edwina ...

WHAT COLOR BEST DESCRIBES YOU?
Red best describes me because it is exciting yet elegant.

WHAT STYLE HAVE YOU USED FOR YEARS THAT STILL WORKS FOR YOU TODAY?
I often use architectural remnants in my designs to add interest in unexpected places.

HOW WOULD YOUR FRIENDS DESCRIBE YOU?
My friends would say I am spontaneous, fun, whimsical and have a strong spiritual foundation.

EDWINA ALEXIS INTERIORS, INC.
Edwina Vidosh, ASID
3815 Garrott Street
Houston, TX 77006
713.533.1993
f: 713.533.0171

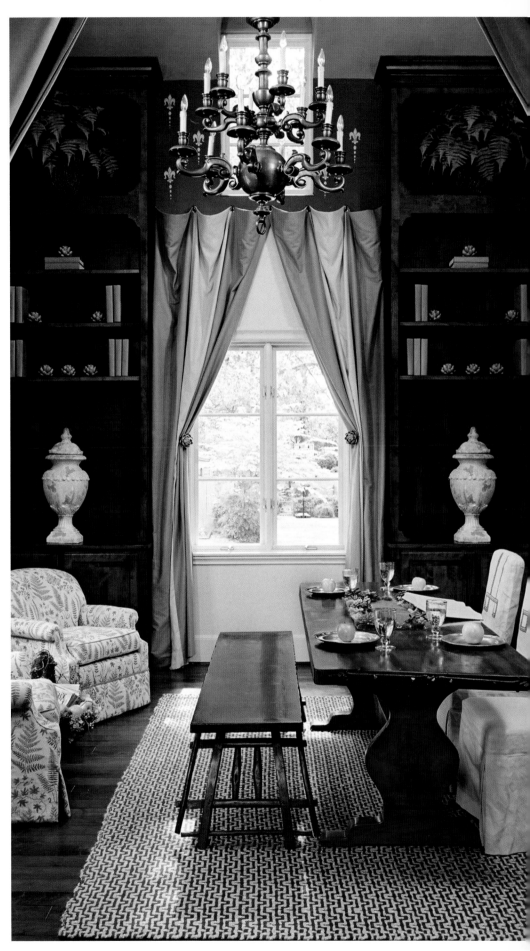

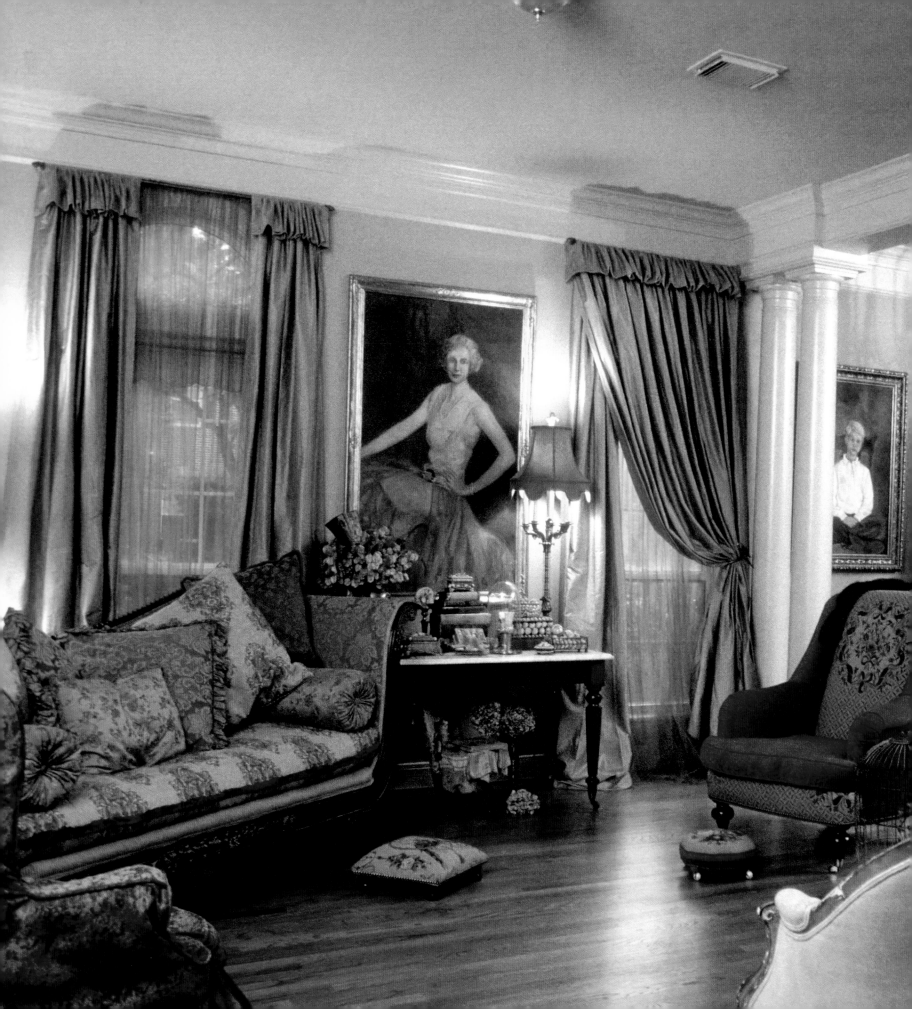

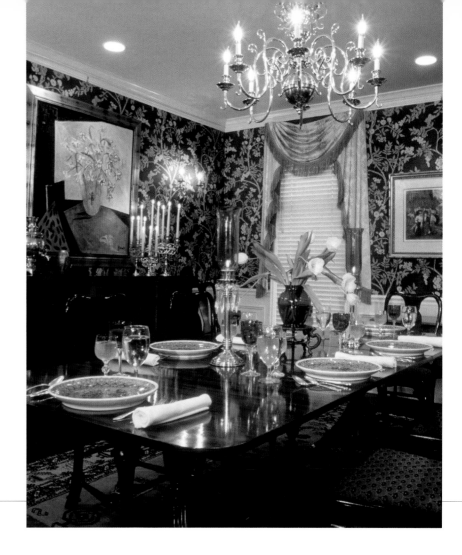

Januari Works

DESIGN WORKS

The ultimate goal of good design for Januari Works is to achieve an easy, artful style that meets her client's high expectations while encompassing her own classic design sense. She strives to marry form and function using solid design principles, good lighting, generous use of color, and always a touch humor.

Januari was inspired by her mother, also an interior designer. She began assisting her, and though her aim was for other areas of artistic pursuit, she consistently returned to the creativity and stylistic freedom that the design field allowed. Januari's love of all things beautiful drives her talent to find inspiration in all the diverse elements of design. Never limiting herself, she welcomes the opportunity to explore English, French, Neoclassic and Contemporary styles and ideas.

One of her favorite projects was a Georgian Colonial, vast in proportion but with the welcoming atmosphere of a much smaller home. The project showcased a stunning collection of art and antiques while serving a large family. With children and grandchildren too numerous to count, "It was important that the home be accessible to all," says Januari. To her client's delight, she created a fresh, pleasing environment using custom color palettes, durable yet lush fabrics and noteworthy finishes deserving of the home's fine furnishings. The

ABOVE:
The original Barucah Guy oil painting sets the tone for this formal dining room. Hand-painted Turkish dinnerware complements the dramatic wallcovering and 19th-century antiques.
Photograph by Rex Spencer

FACING PAGE:
A nostalgic formal living area is enhanced by lavish fabrics, muted tones and a mixture of vintage and new furniture lending an invitation to linger.
Photograph by Rex Spencer

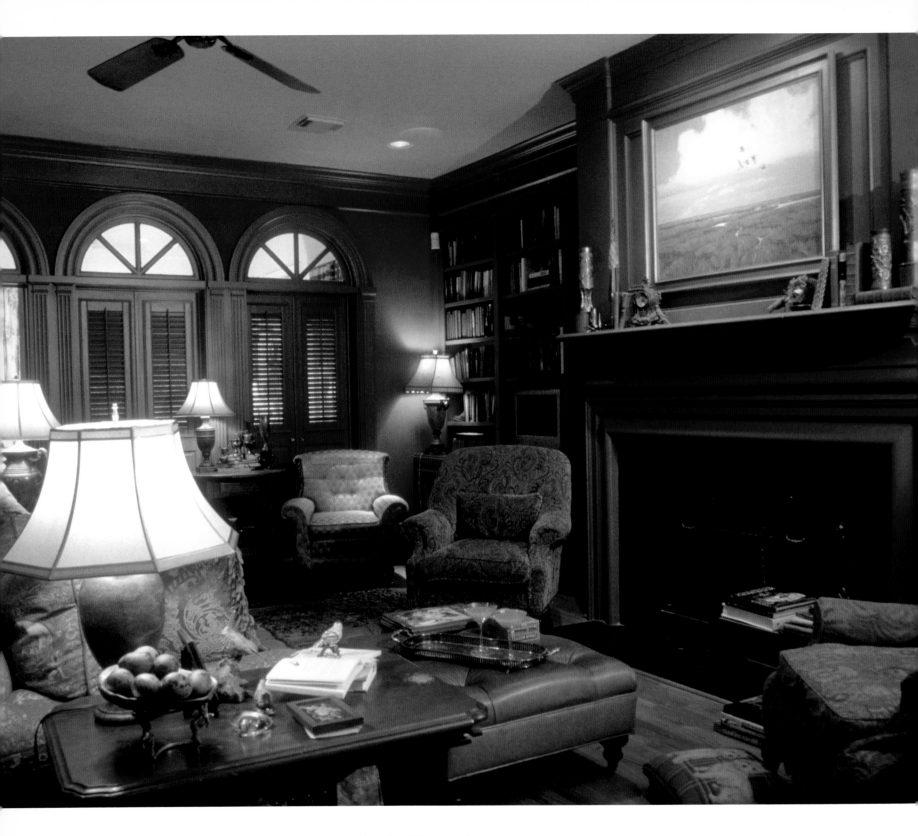

result was a totally approachable home with no "don't sit here" or "don't touch this" signs. The result reflects a carefully crafted, livable style that was inviting, functional and above all, beautiful.

ABOVE:
A love of reading and good conversation makes its own statement in this comfortable room. An original Al Barnes oil painting graces the fireplace which also hosts a collection of vintage WWI trench art.
Photograph by Rex Spencer

FACING PAGE:
Careful attention to architectural details and extensive use of recycled materials make this classic Texas great room an ideal escape for family members.
Photograph by Rex Spencer

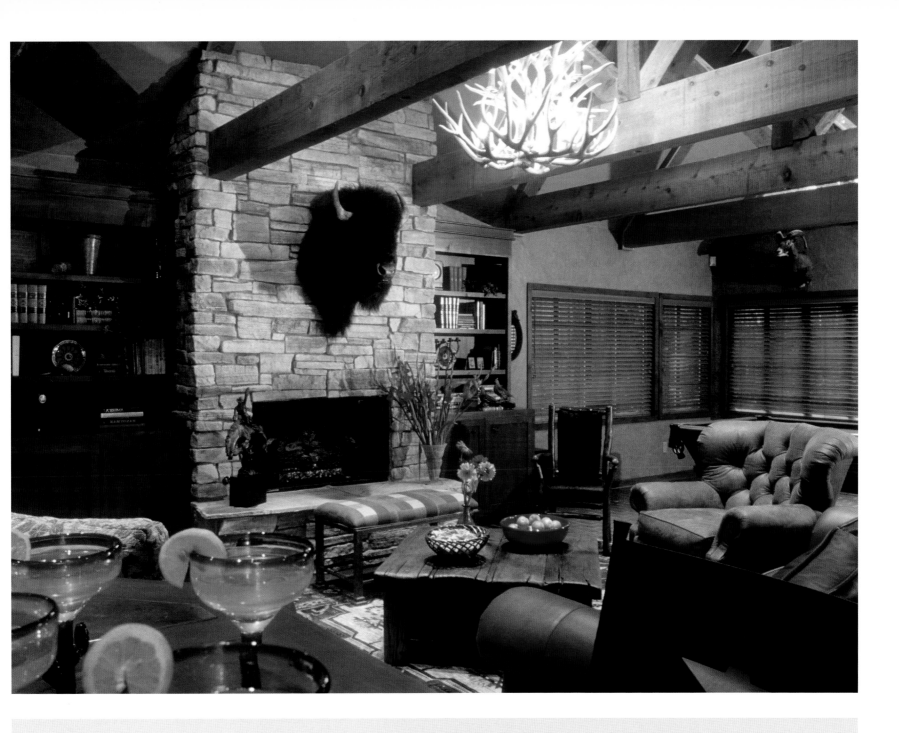

Q&A

more about januari ...

YOU WOULDN'T KNOW IT BUT MY FRIENDS WOULD TELL YOU I AM ...
A great cook!

WHAT BOOK ARE YOU READING RIGHT NOW?
Le Morte D'Arthur by Sir Thomas Malory. I love the classics; all the beautifully written old stories. Old English is not easy to read, but it's a challenge with great reward.

DESIGN WORKS
Januari Works
PO Box 130783
Houston, TX 77219
713.868.4877
c: 713.303.5756
www.designworkstx.com

TELL US ONE THING PEOPLE MIGHT NOT KNOW ABOUT YOU.
I have the best marriage in the world.

YOU CAN TELL I LIVE IN THIS LOCALE BECAUSE ...
My hair is always in a frizz!

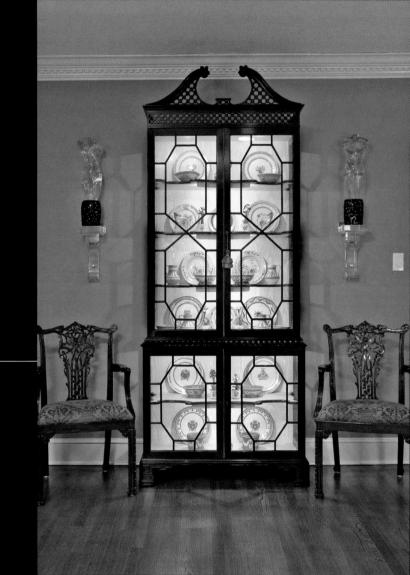

SAN ANTONIO

AN EXCLUSIVE SHOWCASE OF SAN ANTONIO'S FINEST DESIGNERS

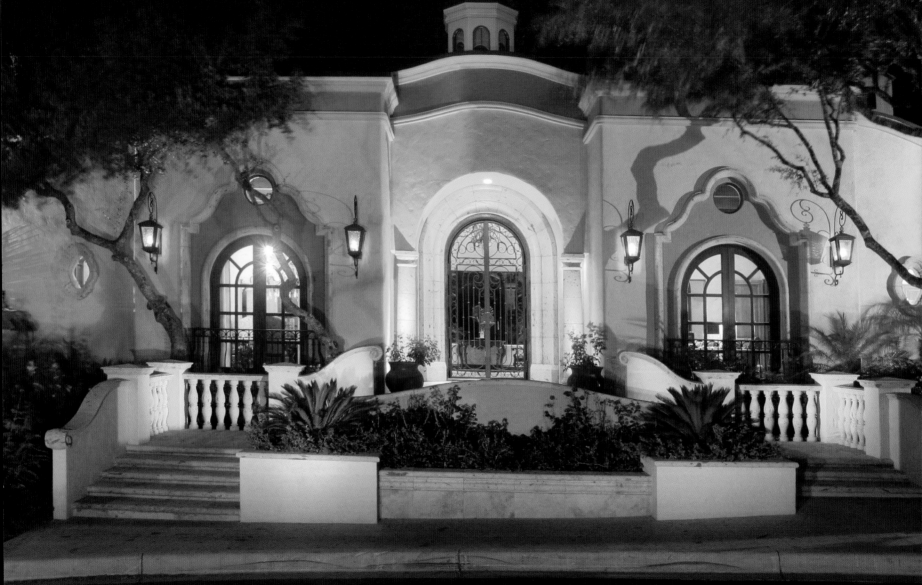

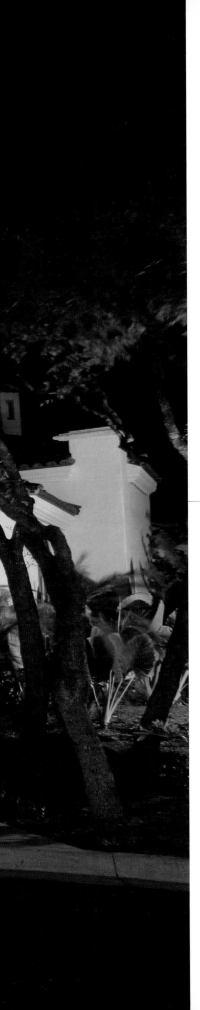

Ernesto Bustamante

DOMAIN DESIGN INC.

Ernesto Bustamante, founder of Domain Design Inc., is a rare find in the realm of designers because he can create a custom home from the ground up. Domain Design has been designing and furnishing homes for 12 years and has an impressive portfolio from some of the most distinctive clientele in the region.

Born and raised in San Antonio, Ernesto strives for an "imperfect perfection." More specifically, "It is hard to consistently achieve imperfection. Creating a beautiful patina that looks as if it has always been there requires an imperfect look that is difficult to accomplish."

The key to his success is working closely with his clients to cultivate a connected relationship. Ernesto prides himself on his close bond with the client, translating the client's desires into elegant exteriors inviting guests to enter and explore.

LEFT:
Design concept by Ed Urbanek.
Photograph by Ad Imagery

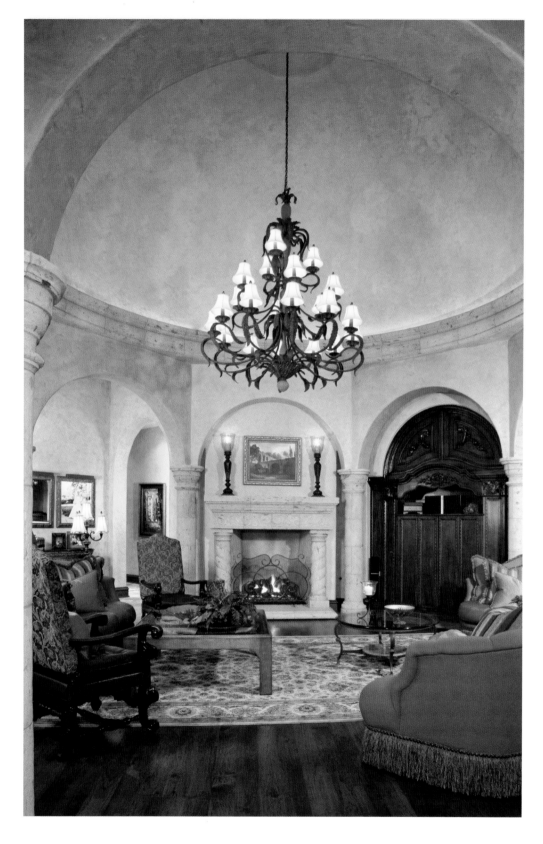

"It doesn't matter how good you are with design if you can't connect with your client," he says. That connection provides the foundation from which Ernesto creates a design. To the delight of his clients, his work and his client's vision fuse seamlessly.

Ernesto's style is unique in that he does not design from the front door. "Rarely does a client actually enter their own home from the front door, so why make it the focus?" Instead, the homeowner's entrance is the starting point. This creates a welcoming atmosphere for the people who actually live there. For interior environments, Ernesto strives to create a collected look, favoring an eclectic mix with a feeling of history. "I had an art teacher years ago that said, 'It's not what you're looking at, but what you are seeing.' That statement has really stuck with me and influenced my designs."

ABOVE:
Design concept by Ed Urbanek.
Photograph by Ad Imagery

FACING PAGE:
Design concept by Ed Urbanek.
Photograph by Ad Imagery

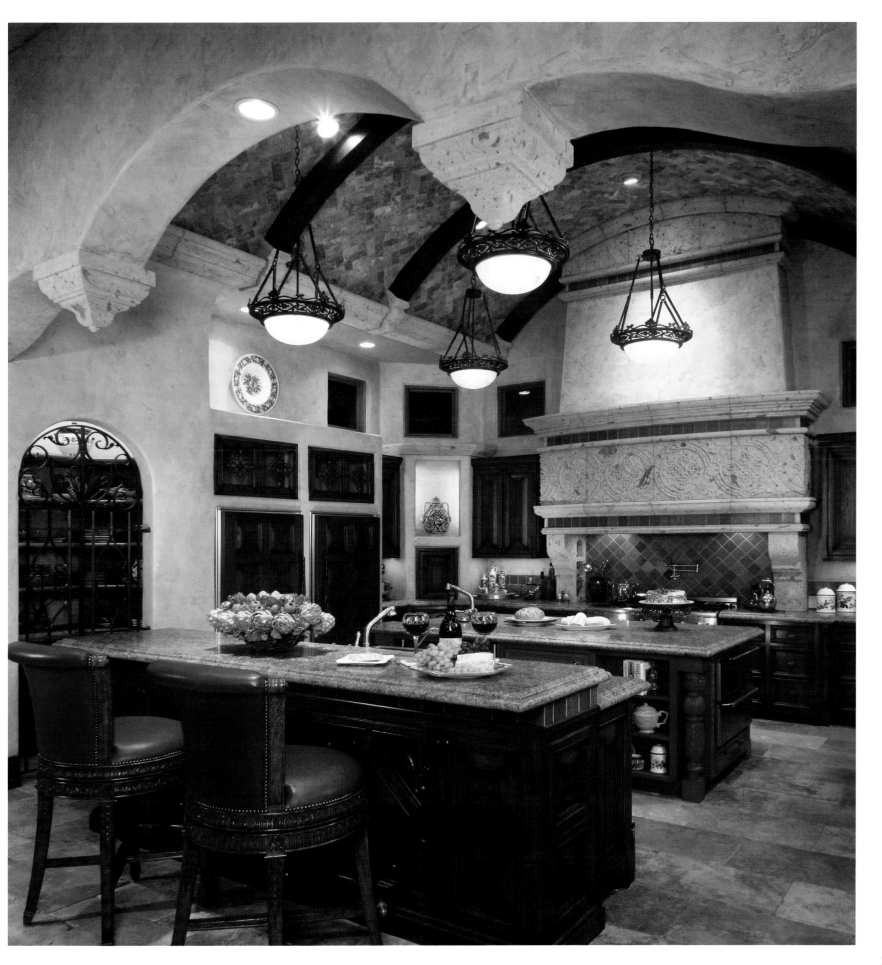

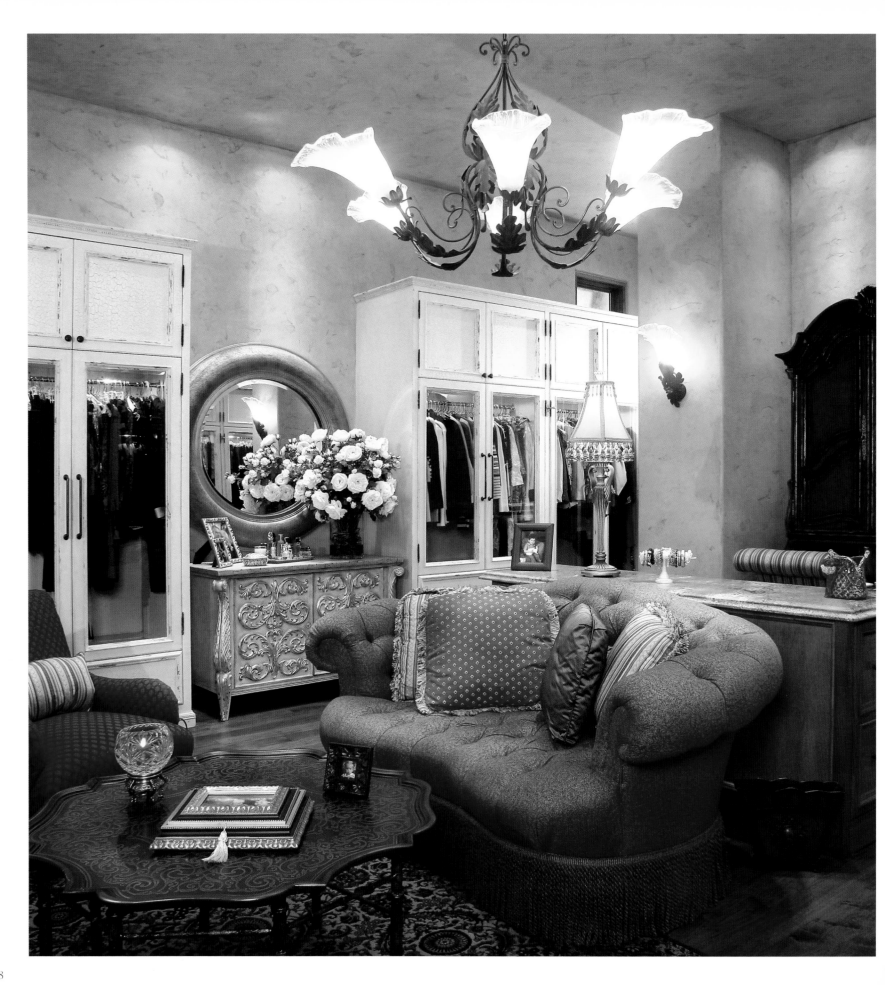

Q&A more about ernesto ...

WHAT ONE ELEMENT OF STYLE HAVE YOU STUCK WITH OVER THE YEARS THAT STILL WORKS FOR YOU TODAY?
I like for things to be true to themselves. Natural, earthy elements and materials can achieve a sense of crude elegance.

WHAT IS THE HIGHEST COMPLIMENT YOU'VE RECEIVED PROFESSIONALLY?
My clients tell me that my work has an aged look, as if it took years to achieve.

NAME ONE THING THAT PEOPLE MIGHT NOT KNOW ABOUT YOU.
Integrity is the most important thing.

WHAT EXCITES YOU MOST ABOUT BEING A PART OF *BEAUTIFUL HOMES*?
I have always operated my business very low key; I tend to fly under the radar. This book gives me the opportunity to highlight one of my designs.

WHAT IS YOUR FAVORITE STYLE PERSONALLY?
I tend to be influenced by the spirit of San Miguel, which is Spanish Colonial with Italian and French.

HOW DO YOU APPROACH THE DESIGN PROCESS AND WHAT INSPIRES YOU?
I meet with my clients, and we have a sketch session. This involves them in the design process and helps me understand their vision. My inspiration comes from that with which my clients want to surround themselves. I begin to get a sense of their style, ideas and needs. Together we create that vision.

DOMAIN DESIGN INC.
Ernesto Bustamante, ASID
PO Box 6093
San Antonio, TX 78209
210.860.9609
f: 210.822.7336

ABOVE:
Design concept by Ed Urbanek.
Photograph by Ad Imagery

FACING PAGE:
Design concept by Ed Urbanek.
Photograph by Ad Imagery

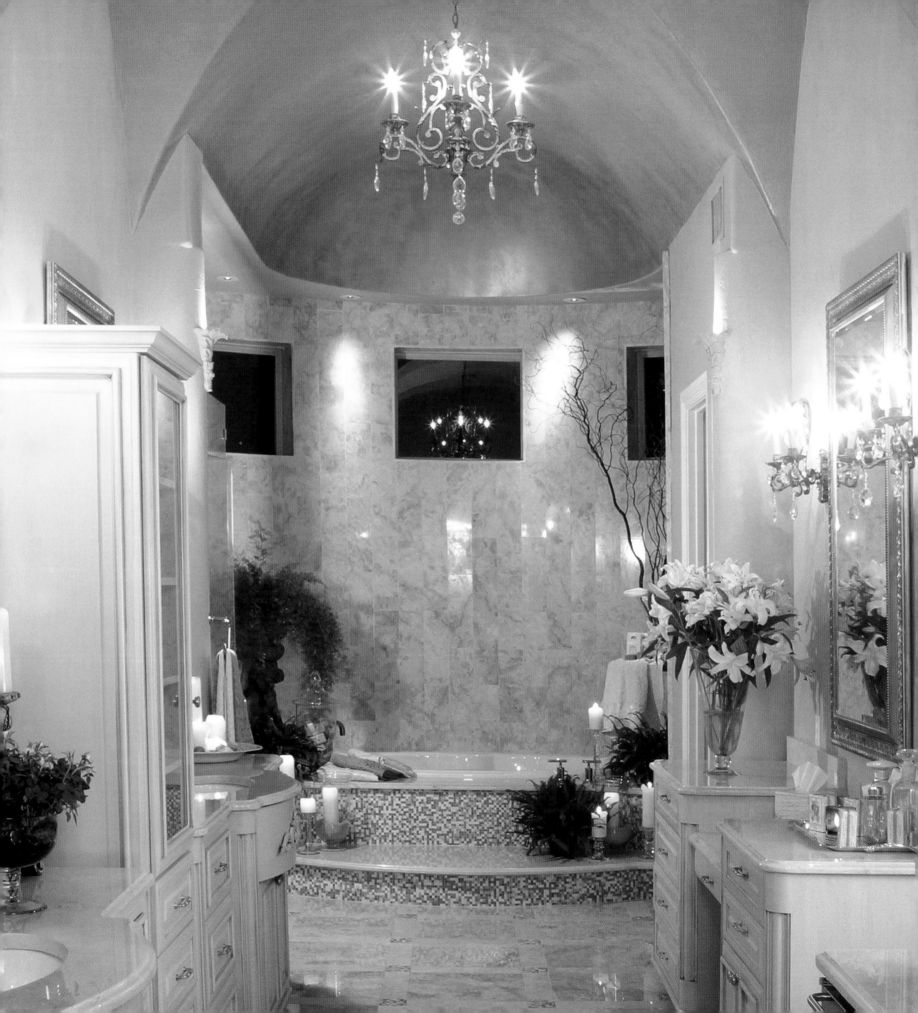

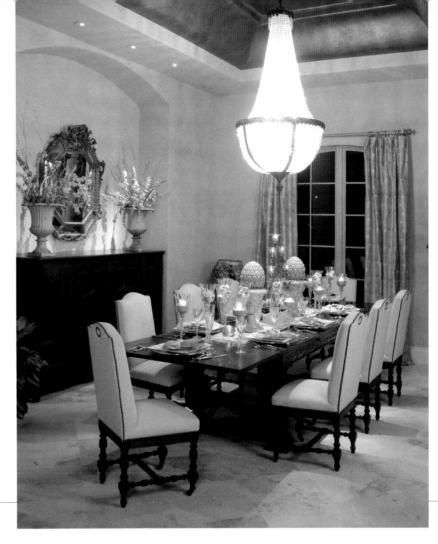

Lori Caldwell

LORI CALDWELL DESIGNS

An artist working with textures as her palette and interior spaces as her canvas, Lori Caldwell steers clear of what is currently trendy, preferring to work with natural materials to create timeless spaces where design and architecture meet in symbiotic harmony. Creating art on a blank canvas, she leaves her clients astounded with her intuitive designs that never fail to leave a space dignified, yet comfortable.

Rather than approaching design with a cookie-cutter methodology so often seen in the interior design arena, Lori enjoys the challenge provided and inspiration derived from her competition. She approaches each project from a unique perspective to create a distinct space reflecting the client's mental picture. "I believe a really first-rate designer can make an architect or builder," said Lori.

Broadening her design scope to her community and beyond, Lori Caldwell Designs is a member of the Greater San Antonio Builders Association.

An acclaimed decorator, Lori has been awarded the "Texas Star Award" and received accolades from the Parade of Homes in 2001, 2002 and 2003. While recognized by the designation of "Best Decorator in Texas" from the Commercial Office Builders Association, it is the appreciation she receives from her clients for a job well done that truly defines her success.

ABOVE:
A large, uniquely shaped chandelier coupled with the contrast of crisp white upholstery and dark wood furniture creates a dramatic effect in this formal dining room, which garnered significant attention at the 2004 Dominion Parade.
Photograph by Vernon Wentz

FACING PAGE:
Warm yellows, marble countertops and an elegant, crystal-accented chandelier commingle in this sumptuous master bathroom, which was featured in the 2004 Dominion Parade.
Photograph by Vernon Wentz

LORI CALDWELL DESIGNS
Lori Caldwell
16248 San Pedro Avenue
San Antonio, TX 78232
210.663.9325
f: 210.496.8903

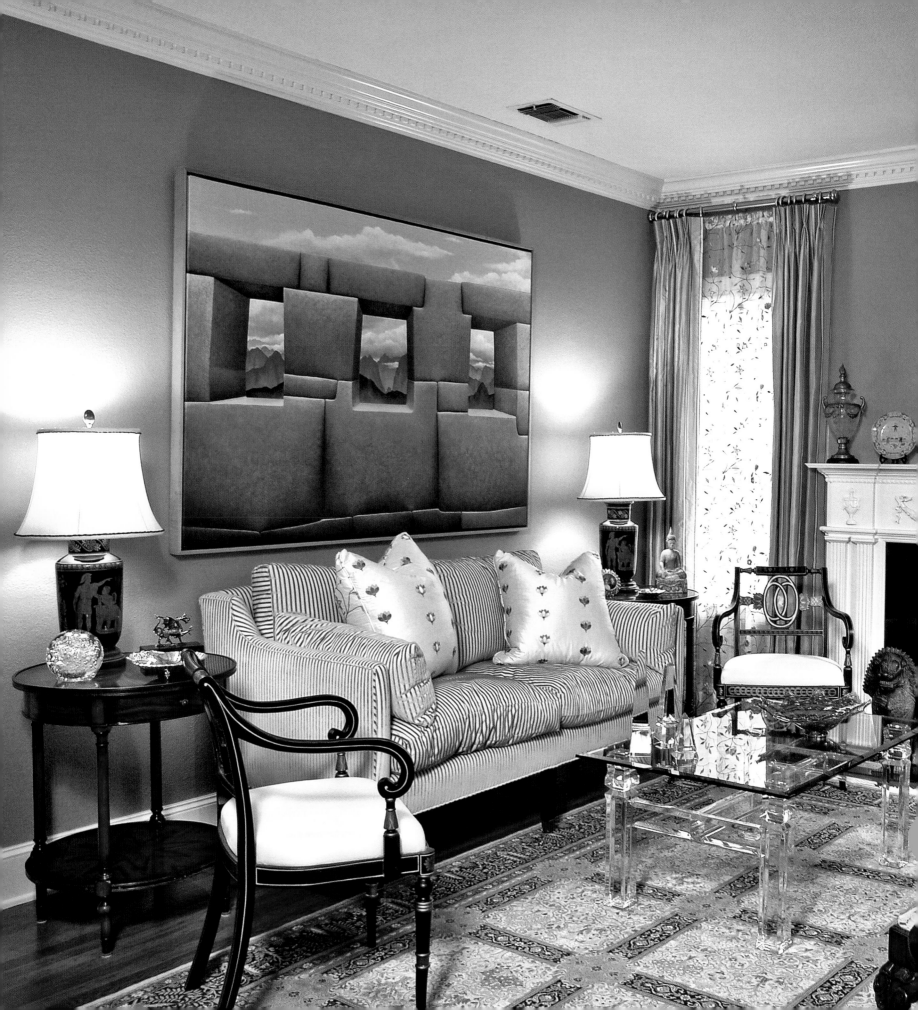

Orville Van Dorn Carr
Charles A. Forster

ORVILLE CARR ASSOCIATES, INC.

*B*orn in San Antonio, it was the path less traveled that led Orville Carr back to his roots in the Alamo City and found him designing residences from San Antonio to southern France and back again. Following service in the military, the acclaimed designer began cultivating his design style at Bloomingdale's antique and design department in New York. After designing a few Westchester homes, it was certain to both Orville and his clients alike that design was his calling. In 1957, Orville Carr Associates, Inc. was established.

Orville was later given the opportunity to mentor and encourage the now acclaimed designer Charles A. Forster. Charles was born a designer; starting at the age of five, he began transferring accessories, including priceless crystal vases, from his parents' living room to his bedroom. Earning a bachelor's degree in interior design from San Antonio's University of the Incarnate Word, he began studying under Orville, who Charles says taught him everything he knows. Charles was instrumental in the

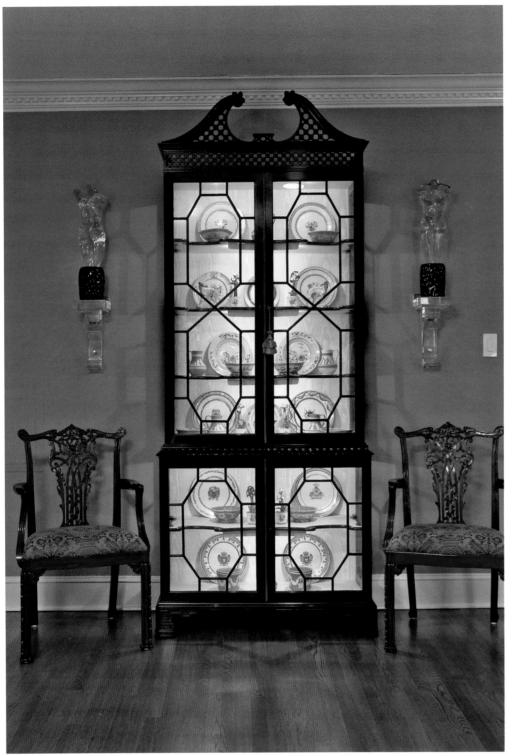

Photograph by Al Rendon

development of Orville Carr's exclusive fabric and furniture line, O.C. Couture. Clients appreciate Charles' straightforward manner and his appreciation for quality and detail that is so in line with Orville's.

Now in the design business for over 50 years, Orville Carr Associates, Inc. has developed an astute following including the friends, children and associates of Orville's first generation of clients. With so much industry experience, it would be easy to think that the designer could be set in his ways; but Orville's case is quite the opposite. He enjoys the developments that have been made in the industry since he first began and appreciates that clients today recognize the value of interior design in both a business environment as well as in the art world.

Recognized in the community on many counts, Orville is just as well known for his involvement in philanthropy as he is for being the local design authority. Involved with organizations including the San Antonio Museum of Art, the Southwest Foundation, the McNay Art Museum, the Witte Museum and Trinity University, his life path has proven to not only consist of beautifying spaces, but enhancing the community and the lives of individuals as well.

Q&A

more about orville & charles ...

ON WHAT PERSONAL INDULGENCE DO YOU SPEND THE MOST MONEY?
We both love to travel, having visited such places as Europe, Egypt and Mexico.

WHAT PHILOSOPHY HAVE YOU STUCK WITH FOR YEARS THAT STILL WORKS FOR YOU TODAY?
Orville: The client is always right. Offering my own showroom is one of the best things I can do to ensure that the finest interior design, furniture, accessories, fabric and lighting are available to my clients at a moment's notice.
Charles: Clients tell me they admire my straightforward manner as well as my appreciation for quality and detail.

HOW DO YOU SPEND YOUR TIME OUTSIDE OF WORK?
Orville: I spend a lot of time on art, travel and my car collection.
Charles: As an art lover and painter, I have organized a splinter group associated with the San Antonio Museum of Art, Artepreneurs, which visits museums, galleries and artists' studios.

ORVILLE CARR ASSOCIATES, INC.
Orville Van Dorn Carr, FASID
Charles A. Forster, ASID
8015 Broadway Avenue
San Antonio, TX 78209
210.226.8251
f: 210.225.1700

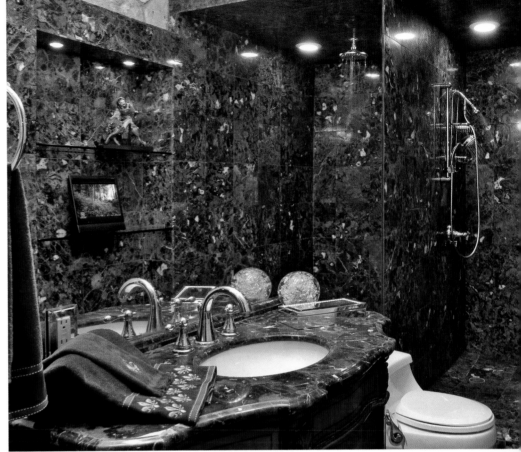

Photograph by Al Rendon

Photograph by Al Rendon

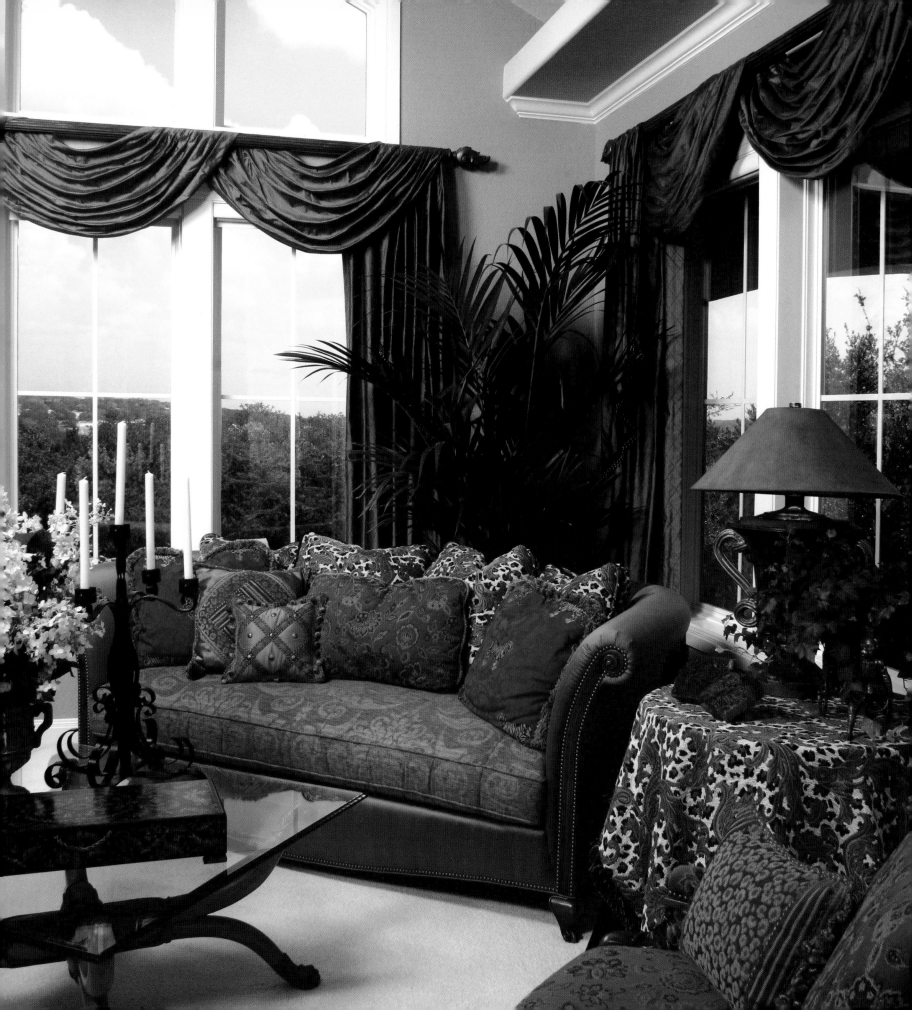

Bryan Kruse

SPS DESIGNS

San Antonio designer Bryan Kruse is well known among both clients and peers for his approach to designing residential and professional spaces with an eclectic mix of European and Country French and a splash of sophisticated Ranch style. While he is heavily influenced by the predominant styles seen in San Antonio, including techniques imported by German craftsmen as well as the Spanish Colonial marvels of Mexican artisans, Bryan's favorite style is Country French. His appreciation for a variety of styles leaves the majority of his looks with a touch of eclectic flair that allows him to take clients' pieces and grant them a new purpose and new life.

He brings impressive professional qualifications to each project, having completed a master's degree in architecture from Texas A & M, which complements his 15 years of experience as a licensed designer. Following graduation, Bryan gained six years of experience designing commercial interiors with an architecture firm. It was during this time that he learned the nuances of color and began developing his forte. From that point, he moved into residential building and eventually into interior design, a field in which he is now commended for his professionalism and sense of style. His broad background can be seen in his current projects, which run the gamut of styles from Italian and formal French to Metropolitan and Neoclassical.

Bryan has made a name for himself within the industry as the designer who is present from the laying of the slab to the placing of the pillows. "I want to be

ABOVE:
The beauty of an SPS design is in the unique details: Architectural artwork and an antique stone statue combine to achieve sophisticated rusticity.
Photograph by Vernon Wentz

FACING PAGE:
Elegant bronze draperies frame a spectacular view in this elegant living room. Gold walls and upholstery and an abundance of pillows create a warm, inviting atmosphere, and live plants bring the outside in.
Photograph by Vernon Wentz

involved as early as possible," he comments. "It is important to me to remain involved throughout the entire process. From the structural framing and electrical work to all the integral details and components of the project, these are all parts of the building blocks that enable a successful interior. There is no detail I overlook; even air conditioner grills, switches and lights will all be in the right spot when the project is completed."

A rare breed of designer who truly enjoys his profession, Bryan wakes early every day, ready to get started. "I live vicariously through my clients' style, so I am passionate about really listening and helping them make decisions to create a space based on their needs and vision." He likes to mix subtle patterns and layers of textured fabrics, believing this approach is an inspirational and important starting point. The best reward the designer receives from his work is when he is finally able to step back and see the conclusion of a finished project and observe the clients enjoying their home.

ABOVE:
A variety of styles blend beautifully in this formal living room. Black chairs with tropical upholstery provide a provocative contrast to the orange wall, brightened by tall iron candelabras.
Photograph by Vernon Wentz

FACING PAGE:
Gold and animal print abound in this exotic bedroom. A live palm brings the chair upholstery to life, adding to the Polynesian feel.
Photograph by Vernon Wentz

Q&A

more about bryan ...

ON WHAT PERSONAL INDULGENCE DO YOU SPEND THE
MOST MONEY?
I love indulging my children and working on home renovation.

NAME ONE THING MOST PEOPLE DON'T KNOW ABOUT YOU.
I was raised on a farming and cattle ranch.

WHAT ONE PHILOSOPHY HAVE YOU STUCK WITH FOR YEARS THAT
STILL WORKS FOR YOU TODAY?
I listen to clients carefully and help them make decisions, but I
don't make the decisions for them.

WHAT COLOR BEST DESCRIBES YOU?
Red is the color that best describes me because it is a bold tone
that is somewhat daring and always unexpected.

SPS DESIGNS
Bryan Kruse
15667 San Pedro Avenue
San Antonio, TX 78232
210.490.1919
f: 210.490.8132

Toni McAllister

MCALLISTER DESIGNS

Commended interior designer Toni McAllister, founder of McAllister Designs located in San Antonio, believes that the function of good design is to enhance the lives of her clients and strives to achieve this result in each and every project. Asserting that her clients' homes should reflect their individuality and style, Toni works to fulfill what she identifies as her responsibility: to listen closely to the practical needs of her clients and artfully express their personal history.

Rather than focusing on a particular design style and even going so far as to say the notion of such makes her feel "uncomfortable," Toni treats each project as an individual one, paying careful attention to the needs and preferences of each client and neglecting to compare one project to the next. "It is not about me; it is about my clients. I am just there to help them through the process," she expressed when commenting on her style.

LEFT:
Unique details add elegance to this rustic patio: An old iron sconce lights the lounge chair, which sits atop an exotic zebra skin rug and holds an ornate needlepoint pillow.
Photograph by Swain Edens

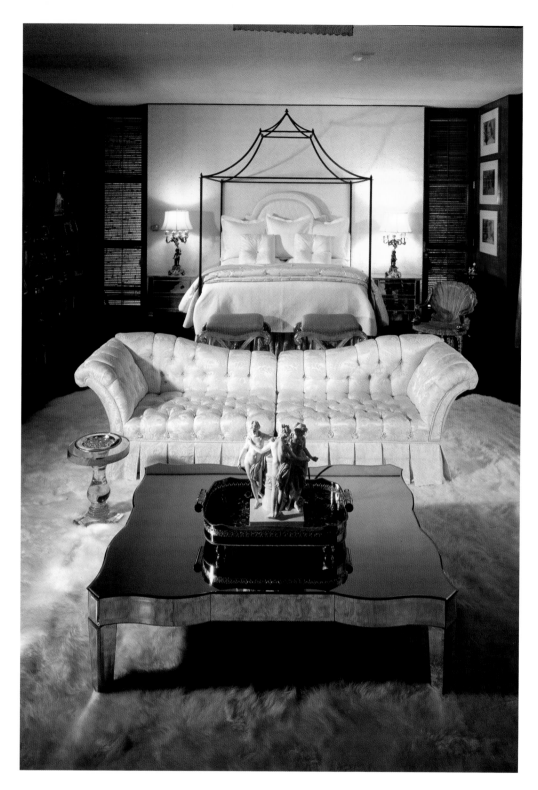

A 25-year resident of San Antonio, Toni has been an avidly practicing designer for 20 years. Throughout that time, she has had the opportunity to work on projects as challenging as they are varied. In fact, a recently published article showcased the designer's remarkable ability to transform small, often unused spaces in her clients' homes into libraries. In the eyes of the designer, a library is an excellent way to express the client's individuality as the room serves as a "quick snapshot" of the family.

When left to follow her own natural inclinations, Toni leans toward spaces that suggest an Italian-Californian attitude, with the appropriate fusion of clean and balanced design poised against quiet but opulent backdrops. A hopeless lover of animals, Toni's gentle, soothing nature is evident in each of her designs; it is her ultimate goal to use her artistic touch to improve the lives of each client with whom she works.

ABOVE:
Glamorous old Hollywood defines this sumptuous bedroom, replete with a custom New Zealand wool rug and a wall upholstered in white silk with pearl embroidery. Custom bed and silk damask sofa by McAllister Designs.
Photograph by Swain Edens

FACING PAGE TOP:
Simple cotton eyelet panels cascade down a perfectly scaled bed, custom designed by McAllister Designs. A large carved mirror hangs above the limestone and iron table, adding luxury.
Photograph by Swain Edens

FACING PAGE BOTTOM:
Raw silk sofas and a pale color palette complement without competing with the sweeping lake view from this placid living room.
Photograph by Swain Edens

Q&A
more about toni ...

ON WHAT PERSONAL INDULGENCE DO YOU SPEND THE
MOST MONEY?
I spend an incredible amount of time and money on my horse.

WHAT COLORS BEST DESCRIBE YOU?
Pale, soothing neutrals.

WHAT IS A SINGLE THING YOU WOULD DO TO BRING A DULL
HOUSE TO LIFE?
I would give it a fresh paint job!

YOU CAN TELL I LIVE IN TEXAS BECAUSE ...
I wear cotton and linen 10 months out of the year.

McALLISTER DESIGNS
Toni McAllister
3435 Twisted Oaks Drive
San Antonio, TX 78217
210.602.1307
f: 210.590.1307

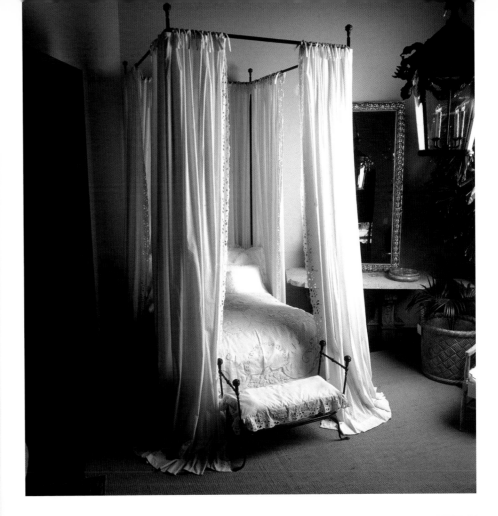

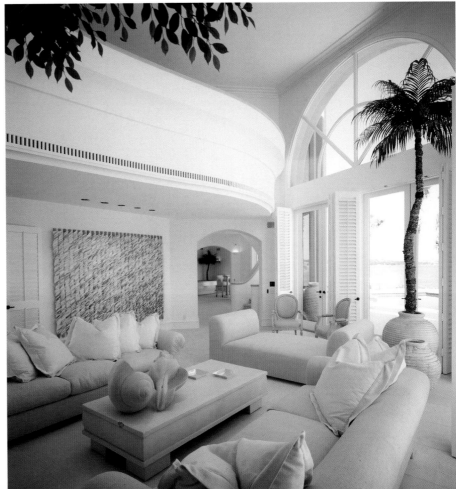

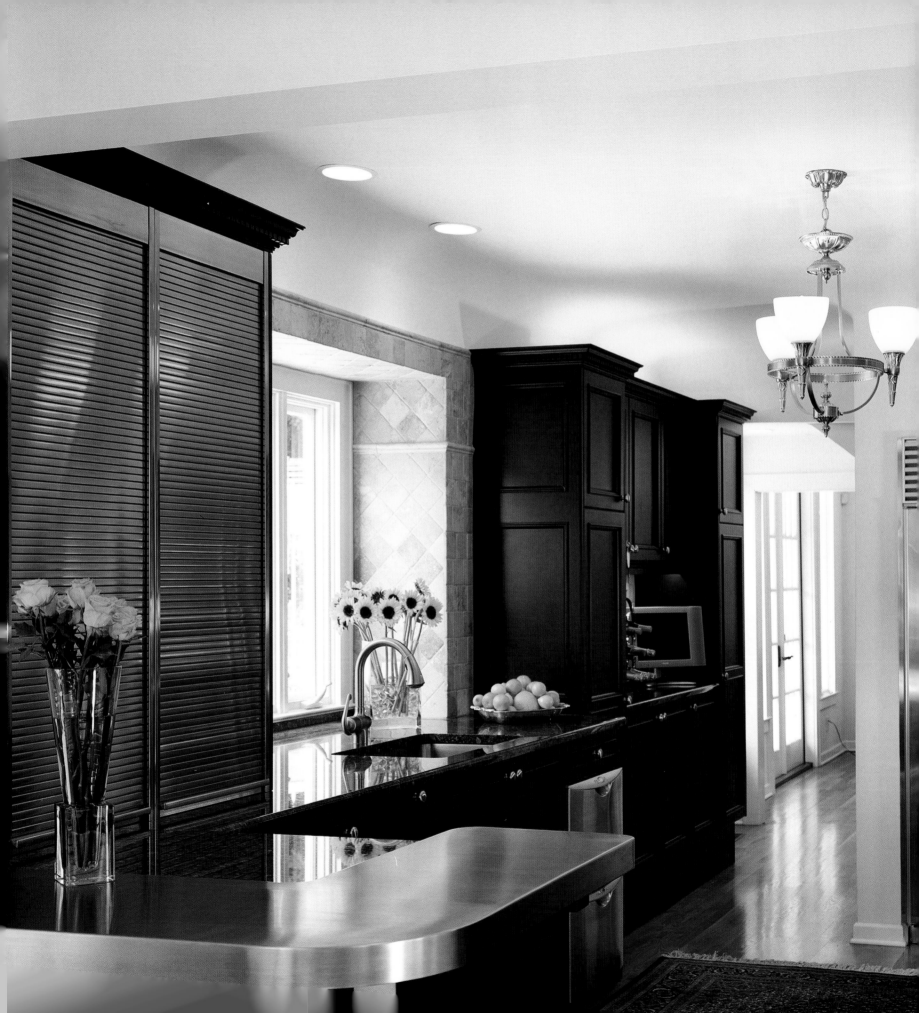

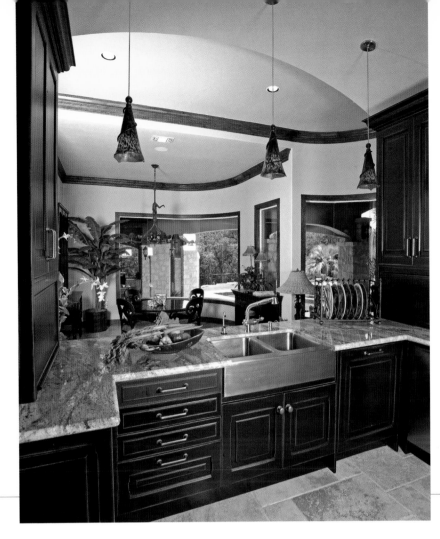

Christi Palmer

PALMER TODD, INC.

Christi Palmer, principal of San Antonio-based Palmer Todd, Inc., specializes in creating award-winning kitchen designs. A firm believer that the kitchen is the heart of every home, Christi offers an exquisite showroom featuring five kitchen vignettes accompanied by tile and lighting studios. Working hands-on in each project, often side-by-side with architects and interior designers, she is a key project team member, offering creative and practical insights into kitchen mystique whether the project is new construction or renovation.

In addition to Palmer Todd's remarkable kitchen space, the showroom also offers a variety of products to complement and complete any living space. With fully accessorized displays featuring luxury cabinetry, lighting, granite, limestone, wood, concrete and tile, Christi and her team convey to each and every client that the unique style of their space is only limited by their imagination.

Palmer Todd has developed a stellar reputation for offering high-quality furnishings and impeccable customer service. The Palmer Todd in-house staff which includes award-winning designers licensed in their respective fields has helped cultivate that reputation for some of the best service in the field. Christi and her staff utilize the latest technology for designs, accounting, warehouse operations, job scheduling and any other service their clients might require. Another facet of their superior customer service is their expert installation

ABOVE:
Opening to the breakfast room and providing a full view of the pool beyond, this elegant kitchen features an apron-front sink nestled between pocket-door storage units, illuminated by whimsical pendant lights.
Photograph courtesy of Palmer Todd, Inc.

FACING PAGE:
Granite and stainless steel countertops combine with Downsview's custom-glazed cabinets and stainless steel tambour units to create the eclectic flavor for this early-1900s' home's restoration.
Photograph by Mike Osborne, Osborne Photography

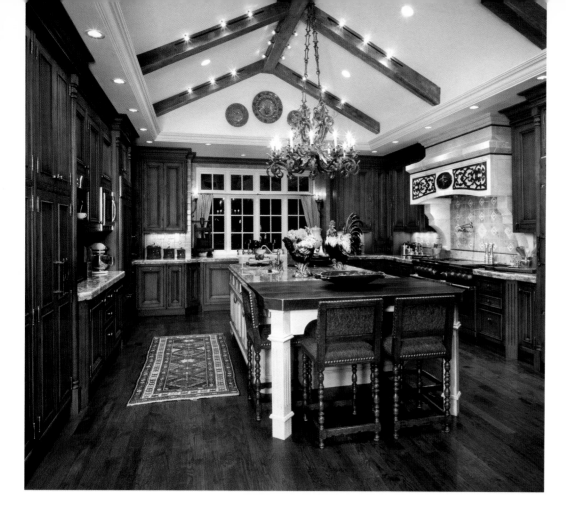

team that completely installs cabinetry, moulding and other specified project details.

But more than any other service Christi offers, clients come to her time and time again for her creative input and firsthand know-how. Christi approaches each and every project knowing there are infinite possibilities, and it is this winning attitude that brings clients back to her to design their second and third kitchens. From a seven-foot by nine-foot kitchen in a New York City apartment to a 1,000-square-foot kitchen in a Texas ranch house, her design graces have touched kitchens in every shape and size all across the country. In fact, Palmer Todd is soon opening a second location in the Austin area.

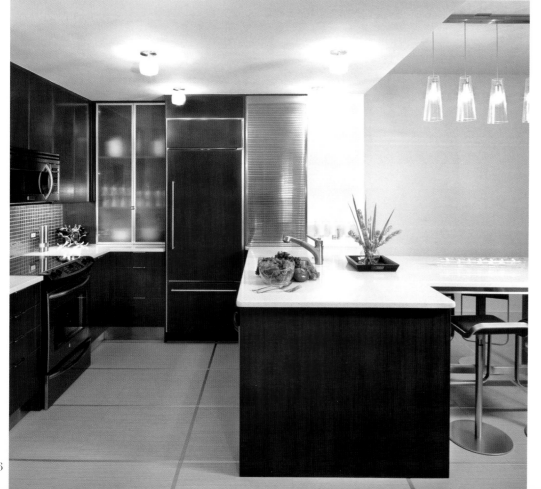

TOP LEFT:
A custom stone hood with metal onlays and an island measuring a modest 6' x 12' in size anchor this massive space. The ceiling's pop-up beamed center allows for a multitude of lighting options.
Photograph by Tre Dunham, Fine Focus Photography

BOTTOM LEFT:
Downsview's faux-wood laminate and stainless steel provide the contemporary flavor for this compact loft-style kitchen. Decorative surface light fixtures perfectly illuminate a space otherwise limited by concrete ceilings.
Photograph by Tre Dunham, Fine Focus Photography

FACING PAGE:
Honey onyx tiles provide the perfect accent for the granite countertops and custom apron-front limestone sink. Angled base cabinets allow for easy transition between countertop depths without creating sharp corners.
Photograph by Tre Dunham, Fine Focus Photography

Q&A
more about christi ...

WHAT ONE PHILOSOPHY HAVE YOU STUCK WITH FOR YEARS THAT STILL WORKS FOR YOU TODAY?
It is all about making the daunting task of kitchen design sound simple. With some efficient space planning, anything is possible.

WHAT IS ONE PIECE OF ADVICE YOU WOULD GIVE TO ANY CLIENT?
It is most important for me to get to know my clients and their needs. Rather than giving them advice, I will adjust my design to meet their specifications. I am always sure to educate them about the innumerable options they have when it comes to cabinetry, lighting, tile, flooring and surfaces.

WHAT IS YOUR FAVORITE PART OF THE DESIGN PROCESS?
I particularly love when I am able to design multiple kitchens for satisfied clients and often those clients' children and friends become clients as well.

WHO HAS HAD THE BIGGEST INFLUENCE ON YOUR CAREER?
I met William J. Todd years ago while designing a kitchen for him and his wife. Since that time, he has provided so much encouragement to me and eventually became my close friend and business partner.

PALMER TODD, INC.
Christi Palmer, ASID, CKD
203 West Rhapsody Drive
San Antonio, TX 78216
210.341.3396
www.palmertodd.com

500 Park Boulevard
Austin, TX 78751
512.206.0444

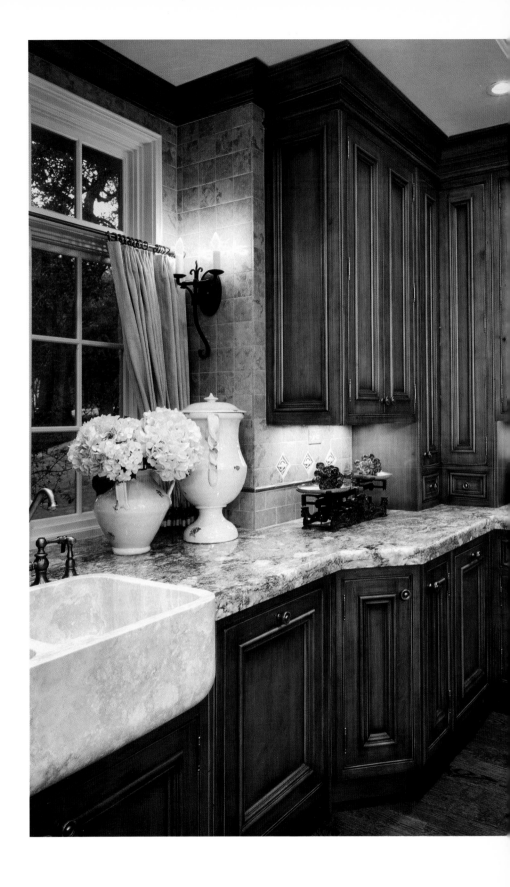

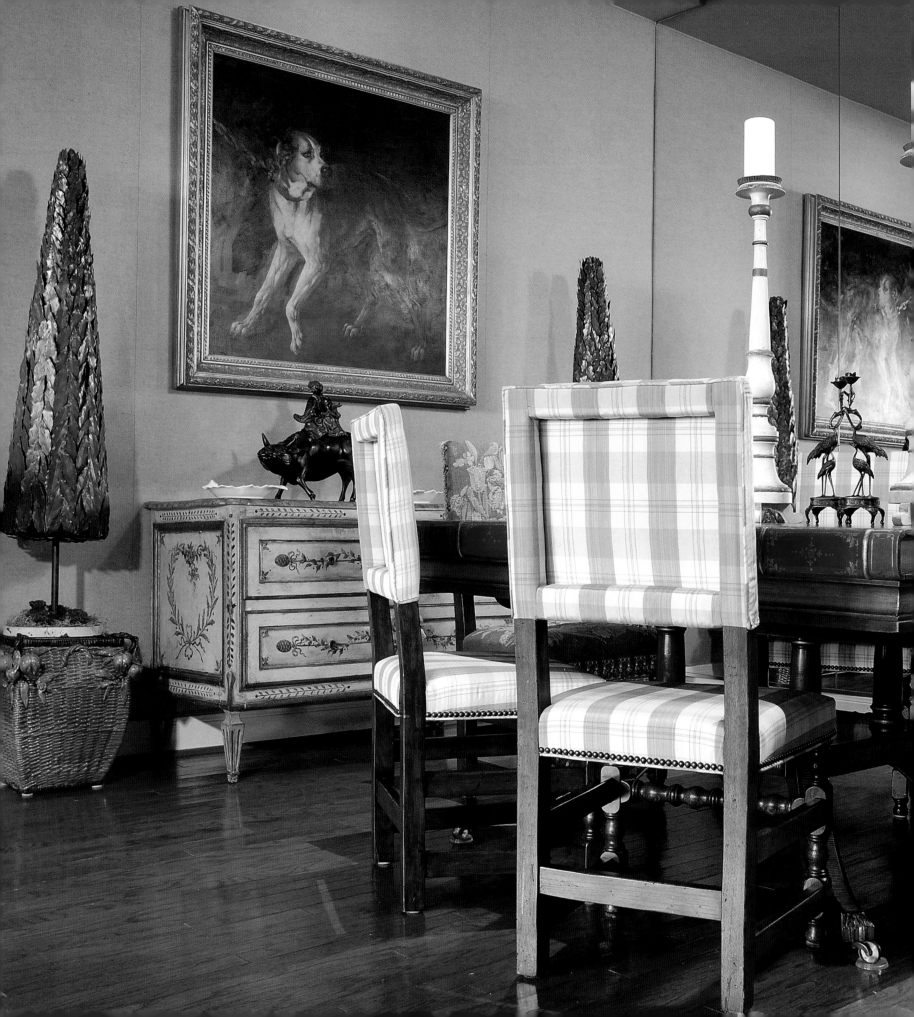

John Tarr

JOHN TARR AND ASSOCIATE

*J*ohn Tarr attributes his approach to good design to his creativeness, professionalism and ability to listen. John excels in working with neutral colors and adding a splash of the client's personality with some exciting individual color. When John has put together a project that pleases the client while fulfilling their dreams and creating a one-of-a-kind interior, he knows a great job has been done.

John is a graduate of the University of Texas at Austin and has been a practicing interior designer since 1976. In 1991, he partnered with Western Kentucky University graduate Robert Tisdal to form John Tarr and Associate based in San Antonio, Texas. The two have designed spaces throughout the United States, including California and Oklahoma as well as Washington, D.C. and Chicago. Both John Tarr and Robert Tisdal are members of the American Society of Interior Designers.

ABOVE:
The small guest room has the feeling of New Orleans with vintage linens. The collection of French botanicals are from the Bienville Shop & Gallery in New Orleans. A carved French antique mirror hangs above.
Photograph by Michael Hunter

FACING PAGE:
The focal point of the dining room is an antique English leather-bound book table purchased in Europe. The chairs are a mixture of copies and old chairs. The Italian painted chest was a gift from a client. The metal topiaries are from the estate of the late Bob Gorman and Charles Thompson.
Photograph by Michael Hunter

JOHN TARR AND ASSOCIATE
John Tarr, ASID
361 West Sunset Road
San Antonio, TX 78209
210.313.4377
f: 210.822.5457

publishing team

Brian G. Carabet, Publisher
Jolie M. Carpenter, Publisher
Karla Setser, Associate Publisher

Michele Cunningham-Scott, Art Director
Mary Elizabeth Acree, Graphic Designer
Emily Kattan, Graphic Designer
Benito Quintanilla, Graphic Designer

Elizabeth Gionta, Managing Editor
Lauren Castelli, Editor
Anita Kasmar, Editor
Sarah Toler, Editor
Rosalie Wilson, Editor

Kristy Randall, Senior Production Coordinator
Laura Greenwood, Production Coordinator
Jennifer Lenhart, Production Coordinator
Jessica Garrison, Traffic Coordinator

Carol Kendall, Project Manager
Beverly Smith, Project Manager

SIGNATURE PUBLISHING
CORPORATE OFFICE
13747 Montfort Drive
Suite 100
Dallas, TX 75240
972.661.9884
www.spgsite.com

DESIGNER: Susie Johnson, Susie Johnson Interior Design, Inc., *Page 43*

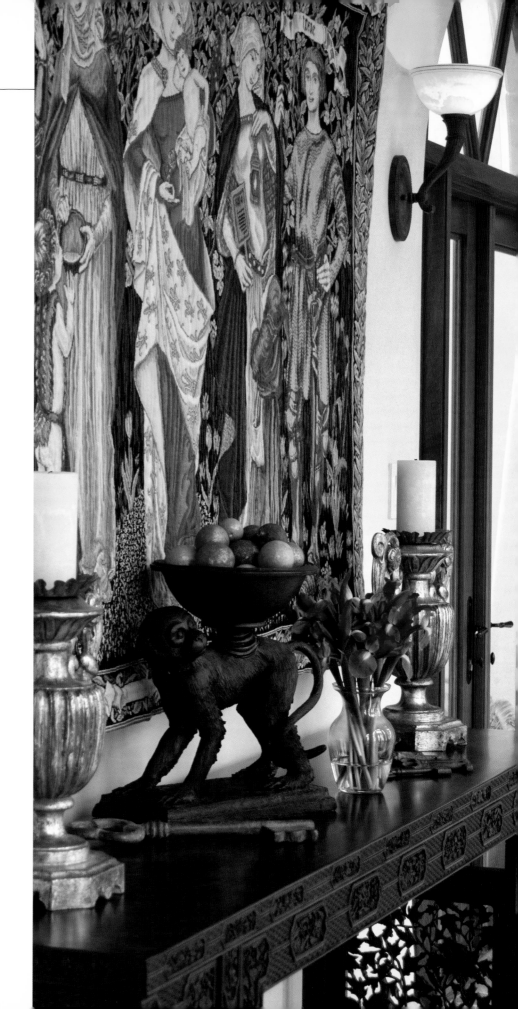

DIFFA
DESIGN INDUSTRIES FOUNDATION FIGHTING AIDS

*T*he Design Industries Foundation Fighting AIDS recently observed its 20th year. With 15 chapters and community partners, DIFFA is one of the largest funders of HIV/AIDS service and education programs in the United States. Since its founding in 1984, DIFFA has mobilized the immense resources of the design communities to provide more than $35 million to hundreds of AIDS organizations nationwide.

Started with volunteers from fashion, interior design and architecture, DIFFA now has supporters from every field associated with fine design. DIFFA's fundraising activities are among the most celebrated in AIDS philanthropy.

DIFFA grants are available to AIDS service organizations that provide preventative educational programs targeted at populations at risk of infection, treatment and direct-care services for people living with AIDS, and public policy initiatives that contribute resources to private sector efforts.

AIDS is not over. Find out how you can help DIFFA work toward a world without AIDS by visiting www.DIFFA.org.

DIFFA DALLAS
1400 Turtle Creek Boulevard
Suite 147
Dallas, TX 75207
214.748.8580

DIFFA HOUSTON
PO Box 131605
Houston, TX 77219
713.528.0505

INDEX